The Kingdom of Siam

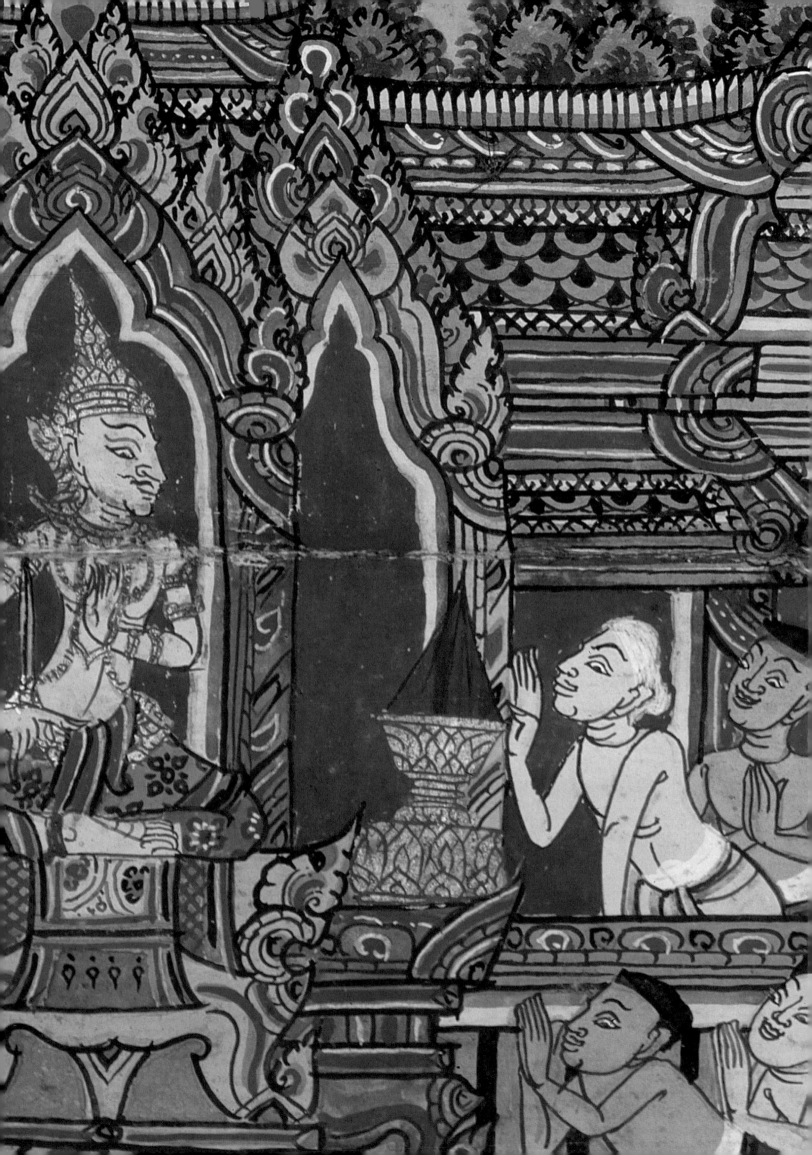

The Kingdom of Siam

The Art of Central Thailand, 1350–1800

Forrest McGill, Editor and Curator

M. L. Pattaratorn Chirapravati, Co-Curator

Essays by Forrest McGill, Dhiravat na Pombejra, Hiram Woodward,
Santi Leksukhum, M. L. Pattaratorn Chirapravati, and Henry Ginsburg

Entries by Forrest McGill, with M. L. Pattaratorn Chirapravati,
Tushara Bindu Gude, and Natasha Reichle

Photography by Kaz Tsuruta and others

A JOINT PROJECT OF SNOECK PUBLISHERS, BUPPHA PRESS,
ART MEDIA RESOURCES, INC., AND THE ASIAN ART MUSEUM OF SAN
FRANCISCO — CHONG-MOON LEE CENTER FOR ASIAN ART AND CULTURE

Published on the occasion of the exhibition *The Kingdom of Siam: The Art of Central Thailand, 1350–1800*, presented from February 18 through May 8, 2005, at the Asian Art Museum in San Francisco, California, and from July 16 through October 16, 2005, at the Peabody Essex Museum in Salem, Massachusetts.

This exhibition is made possible by generous support from the National Endowment for the Arts, the Bernard Osher Foundation, the Columbia Foundation, and the Flora Family Foundation with additional support from the Asian Art Museum's Jade Circle and from Lotus Fine Arts Logisitics. This exhibition is also supported by an indemnity from the Federal Council on the Arts and the Humanities.

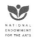

The Asian Art Museum–Chong-Moon Lee Center for Asian Art and Culture is a public institution whose mission is to lead a diverse global audience in discovering the unique material, aesthetic, and intellectual achievements of Asian art and culture.

Published by Snoeck Publishers, Noordstrasat 30, 9000 Ghent, Belgium. Legal deposit D/2004/0012/32.

Co-published and distributed in the USA by Art Media Resources, Inc., 1507 South Michigan Avenue, Chicago, IL 60605, www.artmediaresources.com.

Co-published and distributed in Southeast Asia by Buppha Press, 687 Taksin Road, Bukkalo, Thonburi, Bangkok, Thailand tel. +66 (02) 877-7755, fax +66 (02) 468-9636.

ISBNS
0-939117-27-4 (Asian Art Museum)
1-58886-085-x (Art Media Resources, Inc.)
1-932476-19-9 (Buppha Press)
90-5349-528-2 (Snoeck Publishers)

2 4 6 8 9 7 5 3
FIRST EDITION

Contents

Foreword

Her Royal Highness Princess Maha Chakri Sirindhorn

The people of Thailand look back to the era of the kingdom of Siam, or Ayutthaya, as one of the most important in their history. From modest beginnings, the kingdom grew to be one of the largest and most prosperous in Southeast Asia.

Siam, like Thailand today, was a self-confident and cosmopolitan place, interested in and open to people and ideas from around the world. Over the course of four centuries it developed, in addition to great literature and performing arts, highly sophisiticated architecture, sculpture, painting, and luxury crafts.

The artistic accomplishments of Ayuutthaya are unfortunately not well known outside Thailand. I am pleased that an exhibition of many wonderful examples of these accomplishments – in fact, the first to focus on the arts of Ayutthaya – will be traveling to the United States. Equally important is this accompanying publication, in which are contained essays by both Thai and foreign scholars presenting the latest research on and analysis of the arts of Ayutthaya, their history, and their profound meanings. I hope the exhibition and publication will bring pleasure and intellectual stimulation to wide audiences, and encourage new interest in and appreciation of our rich cultural heritage.

Preface

Emily J. Sano

Globalization is one of the buzz words of the twenty-first century. International developments in communication, trade, and economics are hailed as the advent of a new world culture. At the same time, museum exhibitions in the United States and around the world are demonstrating that internationalism played a greater role historical past – even among some of the world's earliest civilizations – than had been recognized. Recently, for example, new light has been shed on the influence of East Asia on the indigenous cultures of the New World, an influence spread by European missionaries who circled the globe. Similarly, the remarkable extent of cross-cultural connections among East Asia, West Asia, and Europe through land and sea trade has been underscored by new archaeological discoveries.

When we undertook the reinstallation of the Asian Art Museum's collection for the opening of our new home in Civic Center in March 2003, one of the principal themes we sought to emphasize was that of trade and interchange of goods, people, ideas, and religion throughout the enormous area we now call *Asia*. We also sought to contribute to highlight the role played by under-recognized parts of Asia's diverse cultures. *The Kingdom of Siam: The Art of Central Thailand, 1350–1800* does just this. Although the kingdom of Ayutthaya – called *Siam* by foreigners – lasted four centuries, from 1351 to 1767, its role in the development of modern Thailand and the remains of its glorious material culture are virtually unknown outside of Southeast Asia. Equally unknown is the kingdom's important role as a cosmopolitan trading center, where merchants from Persia, India, China, and Japan (and later the Netherlands and France) met to exchange goods and ideas.

Bringing together eighty-nine superlative examples of art and architecture from the Ayutthaya period was an ambitious undertaking. We are deeply indebted to Her Royal Highness Princess Maha Chakri Sirindhorn for her interest in this project from its early stages, and for accepting the role of Honorary Patron. With the exhibition we wish Her Royal Highness every happiness for her fiftieth birth-

day. The Asian Art Museum also owes profound thanks to numerous individuals and institutions in Thailand for helping to realize our dream, as Forrest McGill and Pattaratorn Chirapravati indicate in their acknowledgments on the following page. Our special recognition goes to the most prominent museum in Thailand, the National Museum of Bangkok, for its cooperation, guidance, and support throughout the preparation of the exhibition, and to the National Endowment for the Arts, the Bernard Osher Foundation, Columbia Foundation, and Flora Family Foundation for financial support that helped to make the exhibition and this accompanying catalogue possible.

The Kingdom of Siam seeks to create an awareness of a forgotten era and its arts and crafts, which are revealing of centuries of dynamic change and cultural interaction. The Ayutthaya period has been the life-long passion of Dr. Forrest McGill, the Asian Art Museum's Chief Curator and Wattis Curator of South and Southeast Asian Art. He and his co-curator, Dr. Pattaratorn Chirapravati, California State University, Sacramento, conceived of the exhibition as honoring cultural traditions with an accurate account of the artistic developments of the period and new societal and environmental impact for artistic change. For a Western audience that may be familiar with a cross-section of highlights of the arts of Southeast Asia through publications and occasional shows, this sharply focused exhibition will be a visual surprise – among the stone and bronze Buddha images, sculptures of Hindu deities, figural and decorative wood carvings, temple furnishings, illuminated manuscripts, jewelry, and textiles, some works will strike the viewer as exotic, even puzzling in form and decoration. The superb catalogue, containing significant contributions by eminent specialists in the field, is intended to bring forth new scholarship and interpretations. It is hoped that this exhibition and publication will break new ground in the public understanding of a significant and important period in the history of Southeast Asia.

Acknowledgments

Forrest McGill and M. L. Pattaratorn Chirapravati

The planning for this exhibition has been underway since 1998. From the beginning HRH Princess Maha Chakri Sirindhorn of Thailand took an interest in our work and has graciously agreed to be the Honorary Patron of the exhibition. We hope she will accept our sincere thanks.

During the last six years many kind colleagues have helped us with advice and assistance. We are deeply grateful to them, and want to reiterate what perhaps goes without saying: that without the cooperation of these individuals and their institutions, the exhibition would never have been possible. Not all those who have helped can be listed, but to those unnamed as well as to those whose names and institutions are given below, we would like to express our deep appreciation. (It should be noted that a number of these colleagues have moved from one job to another, or from one institution to another, during the planning period.)

AT INSTITUTIONS IN THAILAND

Chantharakasem National Museum, Ayutthaya, Sariya Dardarananda, Sarinya Pata; Chao Sam Phraya National Museum, Ayutthaya, Patrawan Pakrot, Patcharee Komolthiti, Rutaiwan Manosa; Prince Dhani Nivat Collection, M.R. Nivatvar na Pombejra, M.R. Subijja Sonakul, Prof. Dhiravat na Pombejra; Fine Arts Department, Bangkok, Arak Sunghitakul, Sirichaicharn Fachamroon; National Museum, Bangkok, Somchai Na Nakhonphanom, Somchai Vorasastra; Office of Conservation, National Museums, Chiraporn Arunynark, Chalit Singhasiri, Thitima Wangteraprasert, Sanee Mahaphol, Sopit Panyakhan, Supaporn Suntayoutin; Office of Museum Planning and Development of Thailand, Mongkol Samransuk; Office of the National Museums of Thailand, Somlak Charoenpot; Somdet Phra Narai National Museum, Lopburi, Manita Khunkhun; Suan Pakkad Palace Museum, Bangkok, M.R. Sukhumbhand Paribatra.

AT INSTITUTIONS OUTSIDE OF THAILAND

Arthur M. Sackler Museum, Harvard University Art Museums, Thomas W. Lentz, Francine Flynn, Anne Rose Kitagawa, Toni MacDonald-Fein, Robert D. Mowry, Melissa Moy; British Library, Lynne Brindley, Henry Ginsburg, Barbara O'Connor; British Museum, Neil MacGregor, Lindsey Belcher, T. Richard Blurton, Maureen Theobold; Cooper-Hewitt, National Design Museum, Paul Warwick Thompson, Steve Lange Hough, Matilda McQuaid, Sandra Sardjono; Metropolitan Museum of Art, Philippe de Montebello, Minora Collins, Judith Smith; Museum für Indische Kunst, Staatliche Museen zu Berlin, Marianne Yaldiz, Katherine Israel-Koedel; New York Public Library, Paul LeClerc, Robert Rainwater, Roseann Panebiance; Oxford University, Bodleian Library, Lesley Forbes; Philadelphia Museum of Art, Anne d'Harnoncourt, Felice Fischer, Darielle Mason, Shannon N. Schuler; Stanford University, Department of Special Collections, John Mustain; Stanford University, Green Library, Robert Trujillo; Textile Museum, Ursula E. McCracken, Rachel Shabica; University of California San Diego, Mandeville Special Collections Library, Lynda C. Claassen; Walters Art Museum, Gary Vikan, Barbara Fegley, Joan Elisabeth Reid, Hiram Woodward.

For good counsel, assistance, and kind hospitality in Bangkok, we are indebted to the Chirapravati family and Dr. Vichai Poshyachinda.

AT THE ASIAN ART MUSEUM

Our colleagues at the Asian Art Museum have spent untold hours over a number of years helping make the exhibition possible. Director Emily Sano supported the project, spoke in its favor, and provided valuable advice at many critical points.

Nancy Kirkpatrick, director of museum services, and Cathy Mano, registrar, have with their accustomed professionalism and good humor drafted the exhibition contract and worked thorough the very complex steps of seeing it through to approval; planned all the packing, crating, and shipping of artworks; written the successful indemnity application; and taken care of other complicated insurance arrangements. Donna Strahan, head of conservation, surveyed the objects in Thailand when the final object list was being decided upon, and later worked for more than a month, together with Thai colleagues, to ensure the stability of art objects for travel and to clean and prepare them for display. She and the museum's other conservators have also provided us with very helpful information on the materials and fabrication of certain objects. Vincent Avalos, mount maker, spent time in Thailand planning and preparing display mounts for art objects. Kaz Tsuruta, the museum's photographer, traveled to Thailand twice to take the superb photos for this publication. The publication itself was designed and its production coordinated by Thomas Christensen, whose many talents, as well as his sensitivity and patience, are manifested in the handsome finished product.

We are also very grateful to J Mullineaux, director of resource development, Dino Piacentini, manager of foundation and government relations (and his predecessors), and their colleagues in the museum's development department for raising the large amounts of money necessary for such a complex project.

Others whom we must not fail to thank individually are Brian Hogarth, Deborah Clearwaters, and Ana Hortillosa in the museum's Education department; Tim Hallman in the Public Relations and Marketing department, Stephen Penkowsky, Christina Balberan, and Debra Baida in the Museum Services department; John Stucky in the museum's library; Debra Fox in the Conservation department; and Elisa Kamimoto in the Curatorial department.

Other persons at the museum whose work is vital to a major exhibition cannot all be named. They labor out of the public eye and do not receive the recognition they richly deserve. We are very aware, however, how much work such an exhibition imposes on all the behind-the-scenes heroes in a museum, and we offer them our thanks and recognition of jobs well done.

At the Peabody Essex Museum we offer our hearty appreciation to Dan Monroe, Lynda Hartigan, and Christine Bertoni for their interest and cooperation.

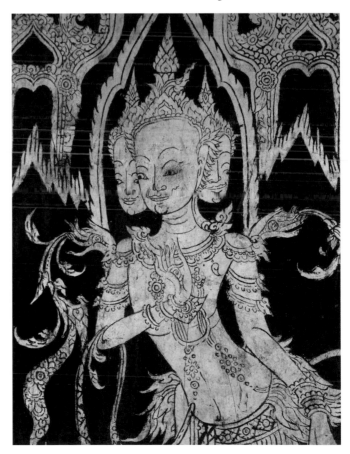

Detail of cat. no. 60.

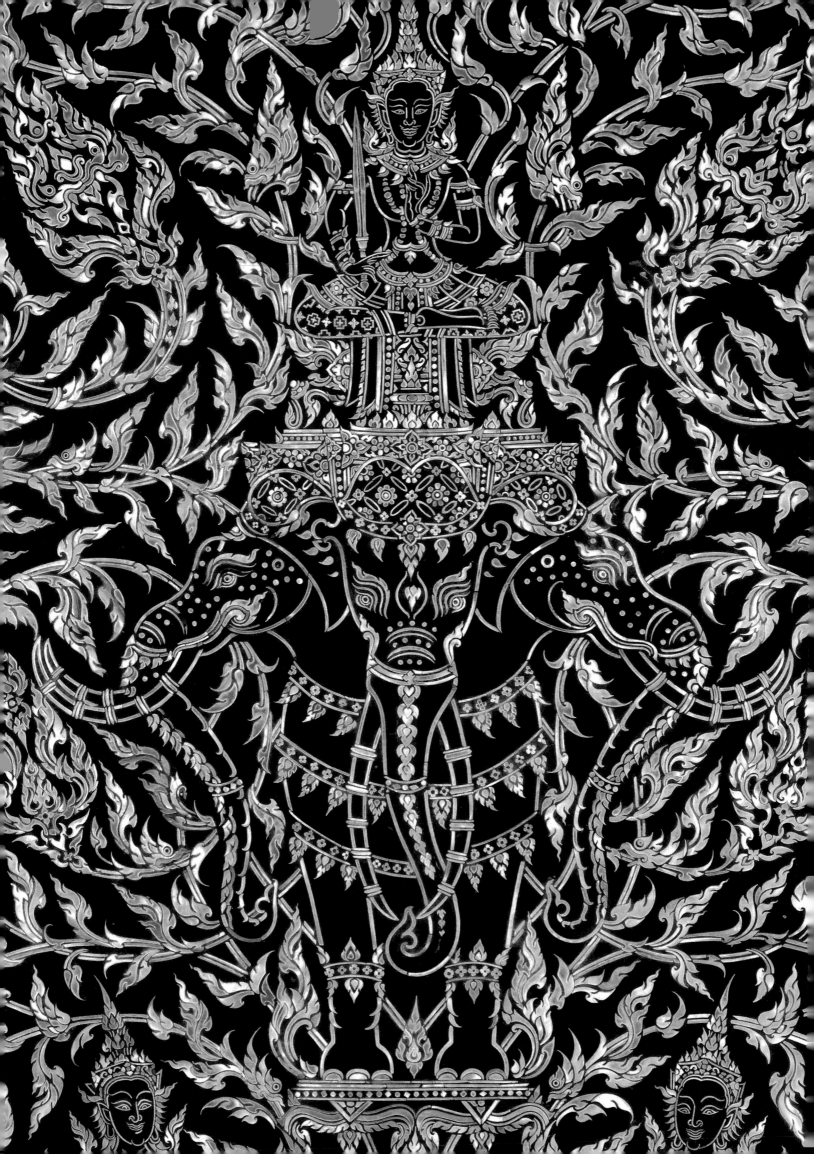

The Kingdom of Siam

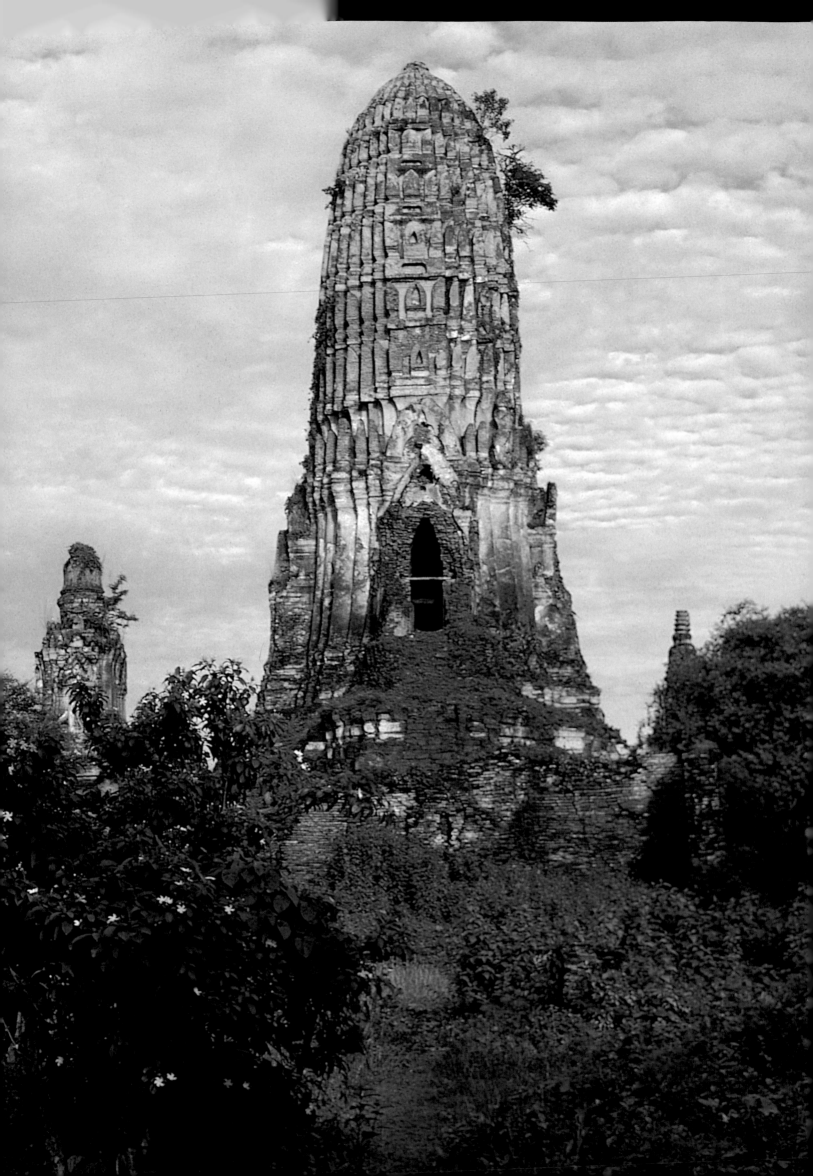

Introduction to the History and Culture
of the Kingdom of Siam

Forrest McGill

> The great and fortunate capital Ayutthaya was founded in 712 of the Era, Year of the Tiger, Second of the Decade [1351]. . . . The court brahmans calculated the auspicious moment to carry out the ritual of warding off evil omens. A clockwise-turning conch shell was obtained from under a *man* bush. Then three palaces . . . were constructed. Then Prince U Thong, at the age of thirty-seven years, entered and commenced his reign. The brahmans presented him with the title "His Majesty King Ramadhipati . . . of the City of the Gods, Excellent Great Capital Dvaravati Shri Ayudhya, Great Nine-Jeweled Ornament of the World, Royal City Abounding in Delights."

The foundation of the city and kingdom of Ayutthaya (called Siam by foreigners) sounds straightforward enough in this account from the Royal Chronicles.[1] But the Chronicles as they have come down to us were compiled centuries after the events described, and of course present an official narrative intended to enhance royal prestige. Trying to understand something of Ayutthaya's early history is by no means easy. Records are few and difficult to interpret.[2] What buildings and artworks remain from the decades before and after the kingdom's founding are often ruinous, or heavily restored, and assigning them dates – not to speak of attempting to interpret them in historical and cultural context – is mired in uncertainty and contention.

The century prior to the ceremonial founding of Ayutthaya had seen rapid change in mainland Southeast Asia.[3] The once-great kingdom of Angkor in Cambodia weakened, ceasing – after many hundreds of years – to build huge state temples and to compose inscriptions in learned Sanskrit.[4] Other major powers in the region, the kingdoms of Dai Viet in northern Vietnam and Pagan in north-central Burma, faced a host of challenges that led, eventually, to profound change in the one and the collapse of the other.[5]

A number of jostling competitor states surrounded Siam in its early years. Siam itself incorporated the earlier principalities of Suphanburi to the west and Lopburi, sometimes under the domination of Angkor and sometimes independent, to the east. Further to the west was Ra-manya, the Mon-speaking area of southern and eastern coastal Burma. To the north lay the Thai-speaking kingdom of Sukhothai, which Siam would struggle for generations to dominate. An adversary in this struggle was the next kingdom to the north, Lan Na, centered at Chiang Mai, which also sought to dominate the territories of Sukhothai. To the east was a reduced, but still significant Angkor, with which Siam shared important cultural traditions, while continuing to vie for power and status. On the southern horizon lay the proud old peninsular city of Nakhon Si Thammarat, now a major Siamese provincial capital, and beyond, the Malay world, into which had begun to appear the Muslim merchants and travelers who presaged the conversions to Islam of the next two centuries.

Scholars of past generations tended to emphasize kings and battles, religious developments, and, to a lesser extent, trade, as shaping forces in the history of mainland Southeast Asia between 1350 and 1800. In recent years they have paid ever more attention to trade, and have investigated other sorts of forces – climate change, epidemics, advances in technology, the introduction of new crops and livestock – with illuminating results.[6] These new approaches have yielded insights with implications for our understanding of the culture of Siam. For instance, from about the seventh century to the ninth or tenth, the main polity in central Thailand (it may not have been centralized enough to be called a "kingdom")[7] was Mon-speaking Dvaravati, the name of which is referred to in the long formal name of Ayutthaya quoted above. The art of Dvaravati and aspects of its Buddhist traditions had a degree of influence in early Siam. In 1981 two Thai scholars published research showing that, while Dvaravati towns and settlements were distributed over much of central Thailand, they were not found in the low-lying areas around Ayutthaya and southward beyond Bangkok to the sea. Correlation of the locations of Dvaravati remains with topographical maps and the findings of geographers suggests that the areas without

Fig. 1. Main tower, Wat Phra Ram, Ayutthaya.

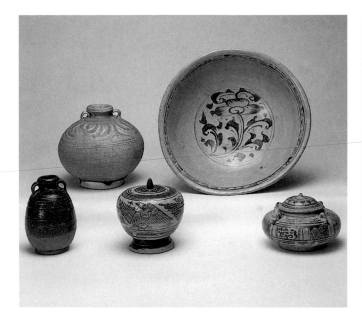

Left: fig. 2. Ceramics from the kilns of north-central Thailand, late fourteenth–sixteenth centuries. The spherical bottle is from the "Nanyang" shipwreck off the coast of Malaysia. Asian Art Museum, left to right, B66P4, The Avery Brundage Collection; 1989.34.29, 1990.130, 1989.34.34, The James and Elaine Connell Collection of Thai Ceramics; and F2001.50.5, Gift of Dennis Kending. Right: fig. 3. Wat Ratchaburana, Ayutthaya.

these remains were in fact below sea level, and that Dvaravati towns ringed the former coastline. It seems very likely that even in the early Ayutthaya period some of the land around and south of the city was swamp, and that making use of it for agriculture was a challenge.[8]

Who were the people of the new kingdom? The answer is not simple. The kingdom of Dvaravati was, according to the historian David Wyatt, "not nearly as monocultural (or mono-linguistic, or monoethnic) as any of its major neighbors." Its people used the Mon language, but this "does not necessarily mean that the people were ethnically Mon.... The actual population probably was very ethnically diverse, composed possibly of people who at another time might have been considered Mon, Khmer [Cambodian], Malay, Cham, or Karen, and who in later centuries might be successively 'Khmer' and 'Thai.'"[9] The situation in the Ayutthaya kingdom seems to have been similar. Generation by generation there were more speakers of Thai and fewer of Mon, but for centuries Ayutthaya's official documents were often written in Cambodian, and Cambodian may have continued to be spoken fairly commonly.[10]

Another component of the new kingdom's population – significant beyond their numbers – would have been Chinese and Indian traders and their descendents. The founding king himself is sometimes said to have been the son of a Chinese merchant,[11] and the exchange and transport of goods both local and foreign was a major source of the kingdom's wealth throughout its history. Ceramics made in the Sukhothai region and exported through Ayut-

thaya in the fifteenth and sixteenth centuries are found by the thousands all over island Southeast Asia (fig. 2). As will be seen, Ayutthaya became one of the richest entrepôts of Asia. Of course trade was more important to some parts of the kingdom than to others in its early years, and in various ways regional differences and regional interests made themselves felt.[12] Historians have noted that in the kingdom's first century there seems to have been competition between one family with its power base in the Lopburi area in the east and another with its power base in the Suphanburi area in the west, and between their "Khmer-oriented" and "Thai-oriented" (or Sukhothai-oriented) outlooks.[13] Signs of these differences and this competition appear in the arts as well, and have been thought to account for the simultaneous production of sculptures in different styles or modes.[14]

The religious life of early Ayutthaya was also by no means unitary. Foreigners and their descendents must have practiced varieties of Hinduism and Islam as well as Chinese religions. The Buddhism of the Siamese was itself a complex mix. In the background were the Mahayana and Hinayana strains of Dvaravati, the Vajrayana of the temple of Phimai in the northeast (completed approx. 1112),[15] and the complicated royal Mahayana of Jayavarman VII of Angkor (1181–early 1200s). In central Thailand in the 1200s, what has been termed an "Ariya sect" of Hinayana Buddhism – characterized by a bundle of iconographic features such as Buddhas in groups of three – had been prevalent, and may have continued to exert influence in the early Ayutthaya period.[16] By about

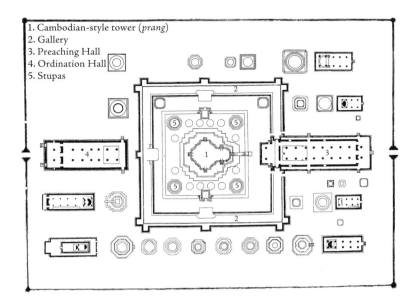

1. Cambodian-style tower (*prang*)
2. Gallery
3. Preaching Hall
4. Ordination Hall
5. Stupas

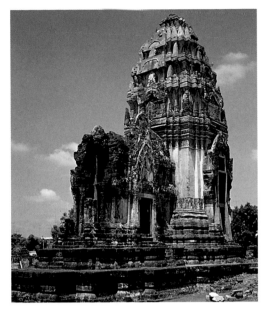

Left: *fig. 4. Plan, Wat Ratchaburana, Ayutthaya. Right: fig. 5. Main tower, Wat Mahathat, Lopburi.*

1400, Theravada Buddhism from Sri Lanka seems to have won the day in Siam (as in the other kingdoms of Thailand, as well as those of Burma, Laos, and Cambodia), but only by making room for local beliefs, spirit cults, and the importance of Hindu gods in court traditions.

Several Buddhist temples are named by the Royal Chronicles as having been founded during Ayutthaya's first century. The remains of these temples can still be seen, and would be thought to exemplify the early art and architecture of the Siamese kingdom. There are, however, a number of challenges to using them in this way, and these challenges suggest why the study of Ayutthaya-period art has progressed so slowly.

First, it is necessary to jump from the kingdom's early years to its last, to consider its conquest by the Burmese in 1767. According to the Chronicles,

The Burmese troops lit fires in every vicinity and burned down buildings, houses, hermitages, and the Holy Royal Palace Enclosure. Then they toured around to chase and capture people, and to search out and confiscate all their various sorts of valuables, whether silver or gold, or other belongings. Those who had removed their precious things and hidden them by burying them, the Burmese accordingly whipped, beat, and roasted to make them lead the way to their belongings. Then the Burmese used fire to melt off the pure gold which encased the large standing statue of the Holy Buddha within the Monastery of the Glorious Omniscient One. . . . As for all the families of the nobles and the commoners, the Burmese commander divided them up and swept them away [to Burma].[17]

Afterwards, the capital was largely abandoned and left to decay. Thus, in modern times, matching names of temples mentioned in the Chronicles with surviving ruins has sometimes proven difficult. Nor, as implied earlier, can the accuracy of the facts and dates in the Chronicles necessarily be taken for granted. One important Thai scholar has rejected much of what they say about early buildings, arguing, for instance, that Wat Ratchaburana (fig. 3), dated by the Chronicles to 1424, was in fact built sometime after 1687.[18] (As will be seen, a date for Wat Ratchaburana of approximately 1424 is accepted by the authors of this publication.)

Even if the date given in the Chronicles for the founding of a temple is accepted, issues of what was built when still remain. Thai temples are complexes of several, even many, buildings and free-standing monuments, some of which clearly have been built decades or centuries later than others. Often, too, there is evidence of repeated repairs or alterations. Because the buildings were made of brick and stucco rather than of stone, surface decorations and reliefs frequently suffered damage over the years, and repairs may have covered or replaced original materials.

Nevertheless, enough evidence has come down to us to give a fair picture of the art and architecture of early Ayutthaya. The remains of such as complexes as Wat Phra Ram, said to have been founded in 1369, and Wat Mahathat, founded in 1374, suggest that the main components of the Siamese temple developed early. Among these were:

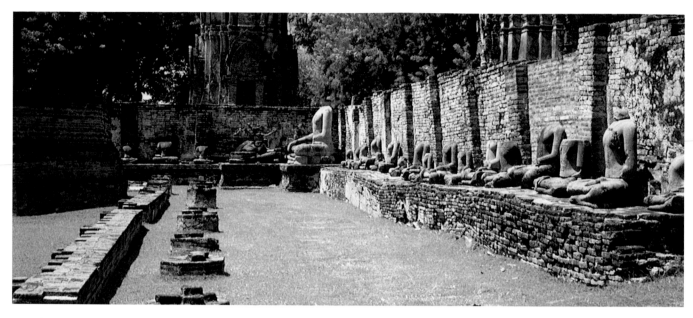

Above: fig. 6. Ruined gallery, Wat Mahathat, Ayutthaya. Opposite, top: fig. 7. Gallery, Wat Phra Chettuphon (Wat Pho), Bangkok. Bottom left : fig. 8. Ordination hall, Wat Na Phra Men, Ayutthaya. Bottom right: fig. 9. Stupa, Wat Mae Nang Plum, Ayutthaya.

THE CAMBODIAN-TYPE TOWER, OR PRANG

These towers (figs. 1 and 3 and cat. no 55), ultimately related to those of Cambodian monuments such as Angkor Wat, evolved in Thailand from such models as the twelfth- to thirteenth-century central tower of Wat Mahathat in Lopburi (fig. 5).[19] Built of brick covered and decorated with stucco, rather than of the stone of the Cambodian examples, the towers had a central sanctuary raised on a high base with layer upon layer of moldings. Four steep flights of stairs mounted to the level of the sanctuary from the four directions, but three of these stairs ended at false doorways. Only on the east was there a real opening to the sanctuary; this was often preceded by a forechamber. Above the sanctuary rose a tall, bullet-shaped superstructure decorated with rows of antefixes. Indentations at the corners of the whole structure continued from ground level to top, giving a strong sense of the vertical. From the summit of the tower projected a many-pronged finial. The Cambodian-type tower sometimes stood alone, or might be flanked by two similar but smaller towers, or might have four other towers (of various sorts) standing at its corners, forming a symbolically potent quincunx.[20]

THE GALLERY

A major Cambodian-type tower, with or without other towers in relation to it, was usually situated in a courtyard surrounded by a square gallery (figs. 6, 7). The gallery would have presented a solid wall to the outside world, but was open on the inside in a colonnade. The roofs, now vanished, must have been of wood and perhaps tiles. The sides of the gallery were lined with rows of Buddha images. Usually both the corners of the gallery and its midpoints were marked by special features such as larger Buddha images or higher, more ornate roofs.

THE ORDINATION HALL AND PREACHING HALL

Both were large rectangular buildings of stucco-covered brick, with wooden roofs (fig. 8). A very general impression of what they looked like is given by cat. no. 50. Inside would have been a large Buddha image usually surrounded by several, or many, others. The interior walls were no doubt painted with scenes from the present and previous lives of the Buddha and other religious subjects, but these have usually been lost to war and the elements. The ordination hall, in which various monastic ceremonies were conducted, stood on consecrated ground marked by eight boundary stones (cat. no. 49).

THE STUPA (FIG. 9)

A large stupa (or arrangement of stupas) sometimes stood at the center of a temple complex in place of a Cambodian-type tower. Smaller stupas, presumably memorializing high-ranking monks or nobles, or well-to-do citizens, might be erected in considerable numbers throughout the complex. Cat. nos. 53 and 54 exemplify the appearance of some late Ayutthaya stupas.

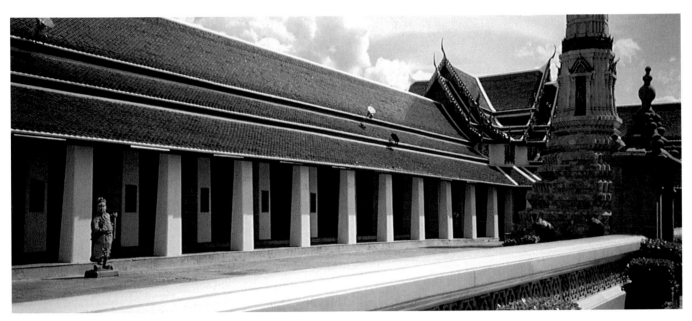

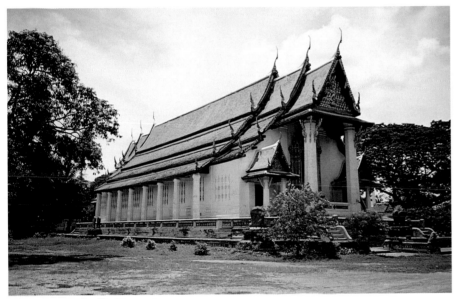

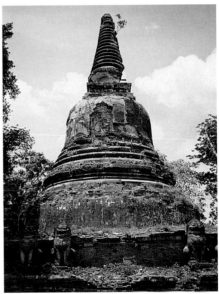

THE BUDDHA IMAGE

Buddha images were made in a variety of materials and in all sizes from tiny to colossal. The seated image to which a one-meter-tall stone face in the exhibition belonged (cat. no. 3) must have been over seven meters (twenty-three feet) in height, and a famous image at Wat Phanan Choeng across the river from the city of Ayutthaya (fig. 30), supposedly founded in 1324, is nineteen meters (over sixty-two feet) in height.[21]

In images, the Buddha is shown sitting, walking, standing, or reclining (cat. nos. 5, 8, 34, 46) with hands held in a variety of gestures. By far the most frequent pose in Ayutthaya-period art is seated with the right hand touching the ground below the right knee. This pose recalls the moment in the life story of the Buddha when, as he progresses toward the attainment of buddhahood, he gains victory over the demon Mara by calling upon the Earth to bear witness to his worthiness.

THE NARRATIVE RELIEF

The walls or pediments of pre-Ayutthaya–period temples throughout Southeast Asia – both Buddhist and Hindu – often bore narrative reliefs of episodes from holy legends. Those of the temples of Ayutthaya must also have done so, but relatively few such reliefs (which in Ayutthaya would have been made of stucco or wood) survive. For those that do survive, it is often hard to determine how often they have been restored. Occasionally an artwork suggests what an early Ayutthaya narrative relief in architecture might have looked like (cat. no. 9, fig. 124).

Fig. 10. Ruins of palace buildings, Ayutthaya.

For secular art and architecture, the evidence is meager. As in the excerpt quoted at the beginning of this chapter, the Royal Chronicles note the construction and dedication of palaces in the kingdom's very first years, but nothing is left of any early palaces except foundations, and we can only imagine their appearance (fig. 10). Probably not until the 1600s were palaces built of brick rather than of wood. Few decorative art objects survive other than the jewelry, crowns, weapons, and ceremonial vessels deposited in the crypt of Wat Ratchaburana in 1424 (cat. nos. 16, 17, 18). This dated crypt is like a time capsule from Ayutthaya several generations after its founding. As M. L. Pattaratorn Chirapravati details in her essay in this catalogue, the crypt held hundreds of Buddha images, votive tablets, and decorative art objects of the sorts just mentioned. In a field such as the arts of early Ayutthaya, with much uncertainty and few fixed points, the discovery in 1957 of a trove of artworks necessarily created at or before a certain known date came as a revelation. Among the objects found in the crypt were coins from a Muslim court in Kashmir, amulets with Chinese inscriptions and wall paintings in Chinese style, and Buddha images from India, Tibet, and Sri Lanka.[22] They testify to the significance of trade and foreign contacts for the kingdom of Siam in its first century. From the 1370s, kings had sent trading missions to China every two or three years, and sometimes more often; missions from China to Ayutthaya were not infrequent.[23] Trade with China (and Korea and Japan) was also conducted, from at least the 1390s, through the intermediary of the kingdom of Ryukyu (Okinawa).[24] The extended Indian Ocean trading network, connecting Siam with not only India and Sri Lanka but also Persia and the Arab world, though less well documented, clearly was important from the beginning.[25] In all, a noted historian suggests, "until the late sixteenth century . . . [Ayutthaya] may have been the single most active Southeast Asian port."[26]

Siam's relations with several of its close neighbors were characterized, in the 1400s, by its expansionism. The kingdom of Sukhothai, having been under increasing pressure from Ayutthaya for many decades, lost much of its autonomy in the 1430s and was incorporated as a province.[27] In the same decade, Angkor, with which Siam had long been skirmishing, fell to a Siamese invasion. The returning Thai forces brought back with them a number of large Angkorian bronze statues (some of which survive) and presumably cartloads of treasure and many prisoners.[28] In mainland Southeast Asia, with its low population densities, capturing large numbers of people and marching them back to the victorious kingdom was usually a higher priority in warfare than capturing and holding territory.[29] Captives with valuable knowledge and skills were particularly prized. It would seem likely that the art objects and the people – perhaps including artisans and ritual specialists – brought from Angkor to Ayutthaya would have had an impact on the arts of Siam, but such an impact has not yet been identified.

King Borommatrailokkanat, the son of the conqueror of Angkor, assumed the throne upon his father's death in 1448. His long reign is an important one for the arts, because several buildings he founded, and even a group of sculptures, are still extant, and give a picture of the arts of Siam in the mid-1400s. The group of sculptures, of which six are included in the exhibition (cat. nos. 19, 20, 21, 22, 23, 24), represent the Buddha in his former lives. The king probably commissioned them as part of an effort to counteract the ill effects of the arrival of the two-thousandth year after the Buddha's death. It seems to have been feared that this anniversary boded the accelerated disappearance of the holy teachings.[30] The sculptures fall into several distinct styles – those with knobbly crowns and square faces, those with smooth crowns and long faces, and so on. They suggest that various workshops maintained independent traditions, and that uniformity of style had not been achieved and was not demanded.[31]

King Borommatrailokkanat spent a number of years in the important north-central city of Phitsanulok, to which, several decades earlier, the last independent king of Sukhothai had moved his capital. In Phitsanulok the Ayutthayan king built two versions of the Cambodian-type temple tower that seems to have been associated with Ayutthayan royal authority (figs. 11, 49).[32] The king had moved north

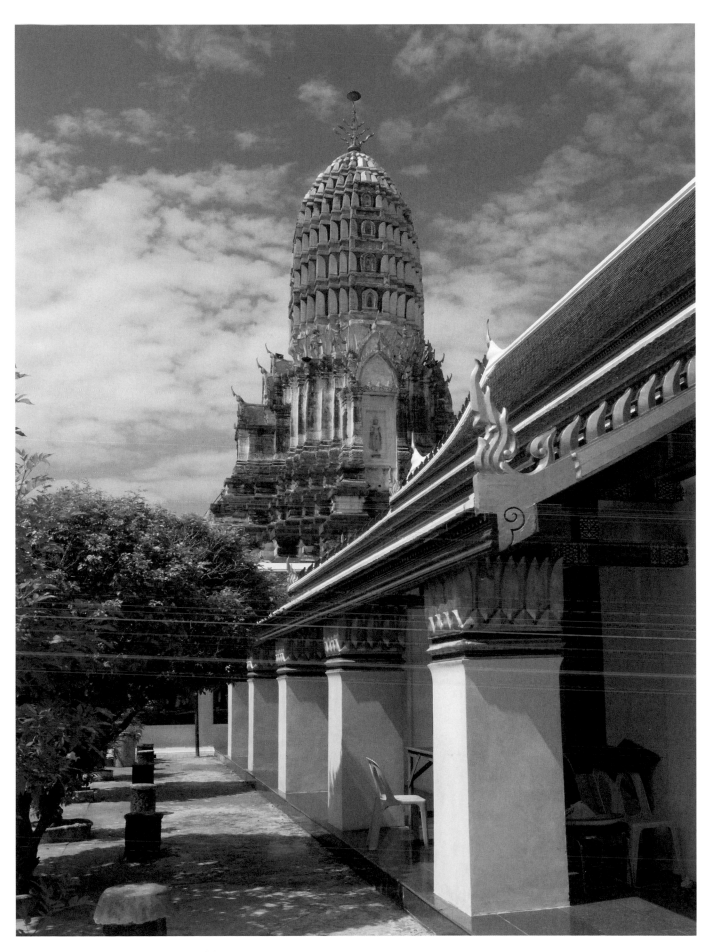

Fig. 11. Wat Mahathat, Phitsanulok.

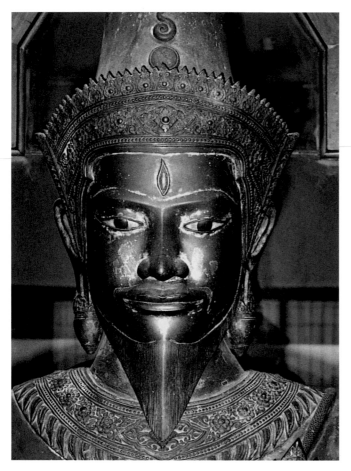

Fig. 12. Face of the Shiva of Kamphaeng Phet, 1510.

in part to direct a long-running military struggle with Lan Na. What was at stake was control over the old territories of Sukhothai and, it seems, of their lucrative ceramic production. From the 1420s or before to the 1560s, wares from the many kilns of the region were widely exported through Ayutthaya,[33] and this trade must have been vital in allowing the Siamese court to obtain many needed or wished-for foreign goods such as high-quality weapons, textiles, Chinese porcelains, and exotic luxuries. The exhibition does not emphasize Thai ceramics, but includes one particularly elaborate example from the north-central kilns. Unlike most of these ceramics, which comprised dishes, bowls, bottles, and lidded boxes, this elephant with attendants (cat. no. 25) has no obvious utility, and must have served some symbolic or ritual purpose. But even lacking an everyday use, such elephants were in demand abroad; several have been found in Indonesia.[34]

In the late–fifteenth-century battles between Siam and Lan Na ominous new weapons appeared: firearms. An arms race had begun that would push rulers to compete to acquire the latest Chinese and Persian – and, in the next century, the even more effective Portuguese – guns and cannon.[35] Also

needed, and competed for, were foreign mercenaries and specialists who could teach new military tactics, set up gun foundries, and design the heavy fortifications required to defend cities against explosives and cannon shot. The alloy composition of Thai (and Chinese) metal sculpture changed during the fifteenth century; were new techniques related to weapons production somehow an influence?[36]

Though conflict with Lan Na continued, Siam entered a period of increased prosperity and power. In the years around 1500 the temple adjoining Ayutthaya's royal palace was enlarged with a new preaching hall, a colossal bronze Buddha image, large stupas serving as memorials to former kings (fig. 43), and probably other major buildings and images as well.[37] Of these, only the stupas and some Buddha images survive as more than ruins and fragments. In the exhibition, a pair of doors carved with guardian figures (cat. no. 29) came from this royal temple and may have been part of the additions of about 1500; a head from a Buddha image (cat. no. 32) suggests the "remote grandeur" associated with its Buddha images.[38]

As far as is known, no major Cambodian-type temple towers were built in Siam during the 1500s, and the period has sometimes been seen as favoring Sri Lankan-related architectural and artistic forms, such as the bell-shaped stupa like those at the royal temple just mentioned. To put it another way, forms with orthodox Theravada Buddhist associations have been seen as favored over those associated with other strains of Buddhism, or with the worship of the Hindu gods.

Several facts complicate this view. The Royal Chronicles relate that, later in the reign of the king who expanded the main royal temple, there were discovered, during the dredging of a canal, metal images of "the Lord of the Hundred Thousand Eyes" and "the Lord Holding a Conch Shell," that is, the Hindu deities Indra and Vishnu. "The King had offerings made to them . . . a building was erected, and they were enshrined."[39] These images are not known to have survived, but must have been left from the days when central Thailand was under the dominance of the kingdom of Angkor. Furthermore, some years earlier, in 1510, the ruler of the north-central city of Kamphaeng Phet commissioned a group of large bronze statues of Shiva (fig. 12), Vishnu (cat. no. 37), and other Hindu deities in a strongly archaizing, Angkor-related style, and dedicated the merit of this act to his overlord in Ayutthaya.[40] Thus the Siamese court and its representatives do not appear to have been avoiding either the Hindu deities or associations with ancient Cambodia.

For much of the remainder of the 1500s, developments in the art and culture of Siam are not easy to follow, for lack

Fig. 13. Mainland Southeast Asia around 1540.

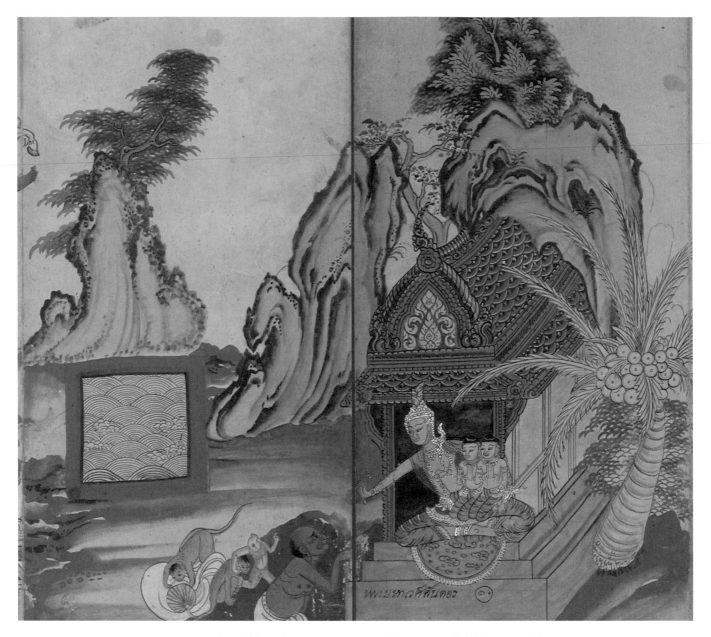

Fig. 16. Prince Vessantara gives away his children, from a manuscript with paintings of the Three Worlds, *cat. no. 79.*

For all the documentation available for Narai's reign, not a great deal is known of the development of its arts (cat. nos. 56, 57, 58, 59, and 60 may date from the reign). The Royal Chronicles describe the casting of Buddha images and a number of statues of Shiva, Ganesha, and other Hindu deities, but none can be identified today.[52] One Chronicle entry describes a certain commissioned Buddha image in detail, saying that it was crowned and bejeweled and in the position of "restraining the ocean," that is, standing with both hands raised palm out. An example in the exhibition (cat. no. 63) is probably from some decades after Narai's reign. This type of image continued to be made in some numbers into the early twentieth century; in the early nineteenth, and perhaps before

and after, it was associated with memorializing deceased members of the royal family.[53]

The end of Narai's reign saw a backlash against the French, and an increased wariness of Europeans seems to have lasted through the kingdom's final years. But "a wider employment at court of Indians, Malays, Persians, and Chinese easily compensated for a decline in European specialists" and a rise in trade with China counterbalanced a falling off in trade with Europe.[54]

From the 1700s many more artworks – and types of artworks – remain than from previous centuries. Works in perishable materials, such as paintings on cloth and paper, pieces of furniture, wood and ivory carvings, even textiles, survive to delight us – and to remind us of the similar mate-

rials from Siam's earlier days that have vanished irretriev-ably: cat. nos. 52, 54, 67, 72, 74, 77, and 81. Oddly, both the history and the art history of the 1700s have been less stud-ied, and are less well understood, than those of the 1600s.[55] European records and accounts are scarcer, and the Royal Chronicles themselves say relatively little about the com-missioning of buildings and artworks, but a great deal about provincial rebellions, palace intrigues, hunts for auspicious white elephants, frequent pilgrimages to the Shrine of the Buddha's Footprint (fig. 15), and the inappropriate fondness of several kings for catching fish.[56]

Restoration, as well as creating anew, was a primary artis-tic activity of the later kings of Ayutthaya. Several are credited with repairing and enriching the Shrine of the Buddha's Foot-print, and King Borommakot, who reigned from 1733 to 1758, is said to have restored a number of important temples in the capital. His efforts have not yet been studied in detail, how-ever, and the important task of distinguishing the repairs of his period from the older fabric of temples has hardly begun.

It is difficult to think about the kingdom's last decades without indulging in hindsight and ascribing to those years a sense of decline and impending doom. Many trends were in fact positive. Trade continued to flourish, and imported luxury goods made specifically for Siamese taste, such as high-quality Indian painted and printed cotton textiles and Chinese "five-color" porcelain, were available as never before (cat. nos. 82, 83, 84). Literacy seems to have spread, literature and the performing arts throve, and cultural and dialectical differences between the capital and the provinces lessened.[57]

Increasingly from the 1750s, however, problems seemed to multiply. The king was getting old, and there was the usu-al prospect of succession disputes; jostling among potential claimants had already begun. Then the king died and a new king reigned only a few days before abdicating under pres-sure. As had been the case all too often in the past, the next king could not count on the unified support of the nobles in the capital and the provincial governors, and was unwilling or unable to act decisively. In 1760 Ayutthaya faced a siege by the Burmese that ended only when they withdrew for reasons of their own. But soon enough they returned, cap-turing one province after another and attacking Ayutthaya from two directions. Famine and plagues weakened the populace; military efforts failed; the city walls gave way, and the invaders destroyed the city.

The human suffering in the next years must have been very great. The country as a whole, however, was pulled back together faster than seemed possible. The Burmese, distracted by conflicts at home, largely withdrew. Though

at first a number of Thai leaders took advantage of the dis-order and seized control of various cities, by 1770, just three years after the fall of Ayutthaya, one of them, Taksin, had retaken all the territories of the old kingdom and installed himself as king in a new capital across the river from Bang-kok, at Thonburi. Within a few more years he had even secured the vassalage of the Chiang Mai region – the old kingdom of Lan Na. But Taksin, for all his military success, was unable to establish a dynasty. Powerful families with closer connections than he to the ruling elites of Ayutthaya held back their support; meanwhile, it was said, the king indulged in unacceptable religious views and acted cruelly and unpredictably. In 1782 he was deposed by a leader later known as Rama I, who took the throne making Bangkok his capital. Soon the new Siam was as wealthy as, and larger and more powerful than, the old Siam had ever been.[58] More than two hundred years later, today's king is a distinguished descendent of Rama I.

Though the destruction of Ayutthaya and its aftermath wiped out much of the kingdom's literary, historical, and artistic heritage, some of its artists and artisans survived to take up their tools again. A famous, superbly illustrated manuscript of Buddhist cosmology (figs. 16, 17) was created in Thonburi in 1776, just nine years after the Burmese con-quest. Its painters and calligraphers had their training, their apprenticeships, and their early careers in the old kingdom, and witnessed its devastation: they must have lost friends and family members and seen beloved temples and imag-es – perhaps their own works – go up in flames. Their resil-ience is hard imagine; even harder to imagine is how they summoned up the calm and radiant playfulness of this great manuscript. They and their descendents were passing on the lifeblood of Ayutthaya's arts to a thriving new kingdom.

NOTES

1 *Phra ratchaphongsawadan krung si ayutthaya chabap phan chanthanumat*, 1. I appreciate the advice of Professors Prapod Assavavirulhakarn and Pattaratorn Chirapravati on points of translation. See also Cushman's translation, *Royal Chronicles*, 10. On the Chronicles themselves, see Wyatt, "Chronicle Tradi-tions" and "Introduction to *Chronicle*," and Vickery, "Composi-tion and Transmission." Note that the transcriptions "Rama-dhipati" (Rama the supreme lord) and "Ayudhya" reflect Thai spelling (derived from Indic languages), rather than pronuncia-tion, and make clear the references to Rama, the great hero of Indian mythology, and his capital of Ayodhya. "Ramathibodi" and "Ayutthaya" are the same names transcribed to reflect pro-nunciation, as terms in this book normally are.

2 Unlike the kingdoms of Angkor and Sukhothai, Ayutthaya produced very few stone inscriptions. Most documents written

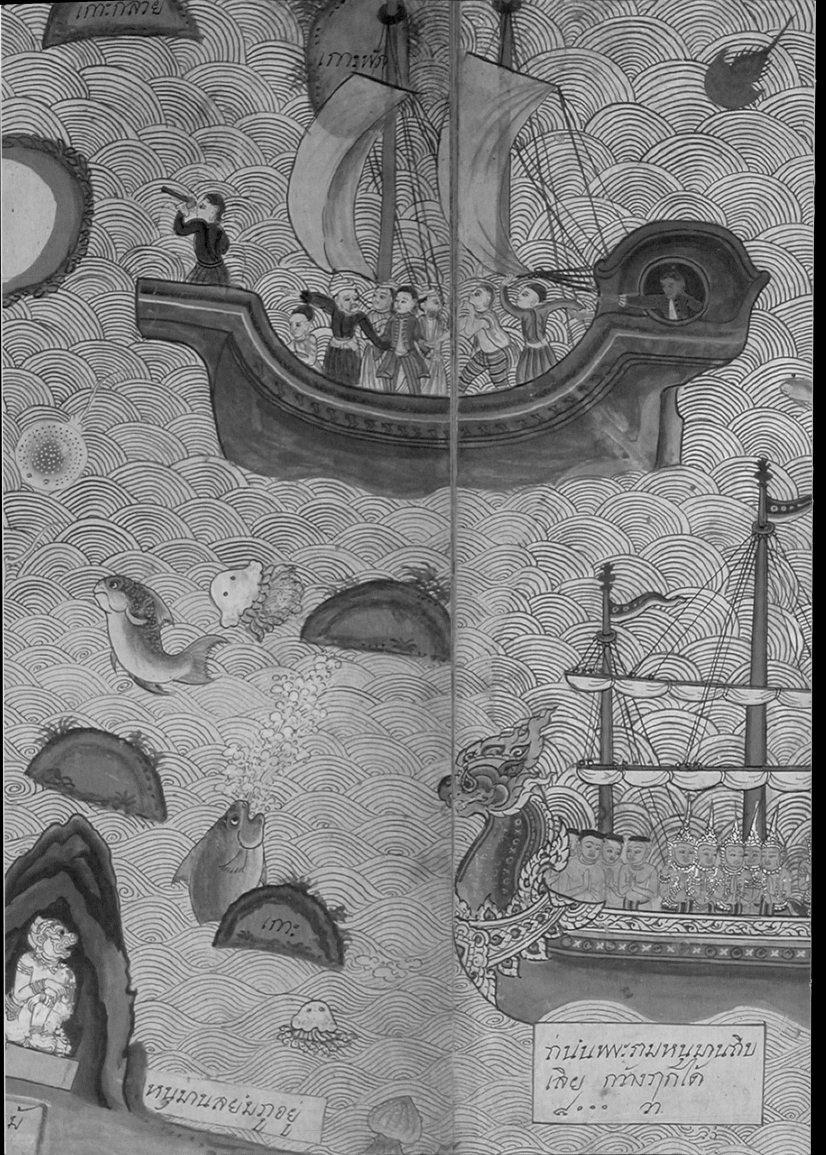

เกาะกลาย

เกาะพ

เกาะ

หนุมานลอยมาลอย

ก่อนั่นพระรามหนุมานกลับ
เลย ก้างวากได้
๘๐๐๐ ว.

Siam's Trade and Foreign Contacts in the Seventeenth and Eighteenth Centuries

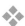

Dhiravat na Pombejra

The ruins of the ancient city of Ayutthaya testify to the architectural and artistic splendor of old Siam. Among the hundreds of historical and archaeological sites that may still be visited today are those of several Buddhist monasteries, two royal palaces, a large royal temple within the grounds of the king's palace, two Roman Catholic churches, and a European trading factory. The city of Ayutthaya was the royal seat of the kings of Siam and the Siamese kingdom's administrative, cultural, and commercial center for over four hundred years, between 1351 and 1767. During the seventeenth and eighteenth centuries Ayutthaya was not only the residence of the kings of Siam, but also a thriving port, where people of many races, cultures, and religions coexisted and interacted (fig. 17).

The art of Ayutthaya, which may be seen in Thailand and abroad (including some examples in museums in the United States), evokes a rich past and long traditions of craftsmanship. Such sophisticated schools of art and architecture entail sponsorship and patronage. The ruling classes of Ayutthaya must therefore have played an instrumental role in the creation of these buildings and works of art. What made this prosperity and material culture possible? The skills and ideas of artists and artisans alone cannot explain the splendor of the city and the kingdom. For a fuller explanation we must consider economic and political contexts.

The agenda and terms of research into Southeast Asian history of the early modern period were set a decade or so ago by Anthony Reid in his major two-volume work *Southeast Asia in the Age of Commerce, 1450–1680*. In this and other works, Reid contends that between 1450 and 1680 trade, largely maritime, flourished in Southeast Asia, making the produce of the region, such as spices and pepper, commodities of world trade. This commerce spurred the processes of urbanization and state formation. Reid also contends that the Age of Commerce in Southeast Asia led to important structural changes in many of the region's states. There was more centralization, more royal trade, and more influence from the great universal religions, Islam, Christianity, and Buddhism.[1]

Much contemporaneous and subsequent research on Southeast Asia has dealt with the trade, trade routes, trading networks, and other aspects of what has been perceived as a predominantly maritime world. The analysis of urban, cosmopolitan societies, material civilization, the role of gender, and the various links between areas in the region, has also occasionally included Siam, although the kingdom of Siam, or Ayutthaya, had always hitherto been classified as a hinterland state relying for its prosperity and power on manpower control and military might.

In a recent major work, Victor Lieberman discusses the long-term process of administrative integration or centralization in mainland Southeast Asia, including the Siamese state, which developed over a span of several centuries, though not without violent breaks, among them the successful Burmese invasions of Siam in the 1560s and the 1760s. Lieberman pays detailed attention to the complex issues of foreign trade, a cosmopolitan elite, and the role of the Chinese in the eighteenth century. Chris Baker, in another recent work, notes the rise of Ayutthaya as a result of maritime commerce and concludes that access to the sea preceded the kingdom's expansion and development as a territorial state.[2]

GEOGRAPHICAL SETTING AND NATURAL RESOURCES

It is widely accepted that geography can determine the destiny of cities, states, even civilizations. The city of Ayutthaya, about eighty kilometers from the Chao Phraya river mouth, and thus the Gulf of Siam, and at the confluence of three rivers, the Chao Phraya, one of continental Southeast Asia's major rivers; the Pasak, which flows down from the northeast; and the smaller Lopburi, was certainly well placed to rise

Fig. 17. Ships at Sea, from a manuscript with paintings of the Three Worlds, cat. no. 79.

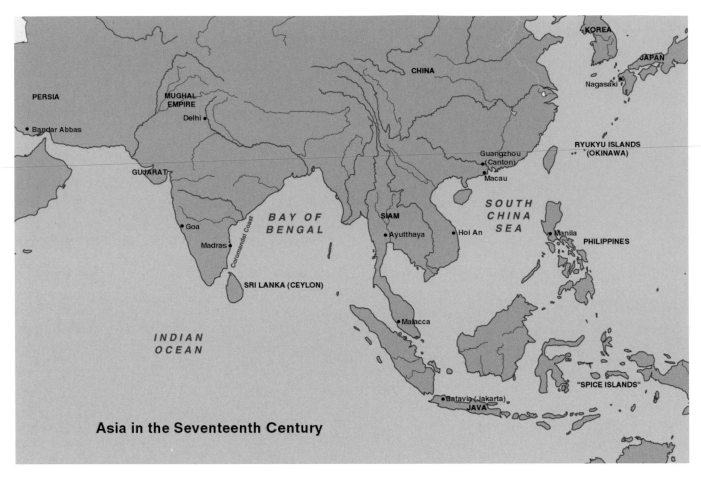

Asia in the Seventeenth Century

Above: fig. 18. Asian in the seventeenth century. Below: fig. 19. The lower course of the Chao Phraya River, from The History of Japan *... Together with a Description of the Kingdom of Siam, by Engelbert Kaempfer, cat. no. 87.*

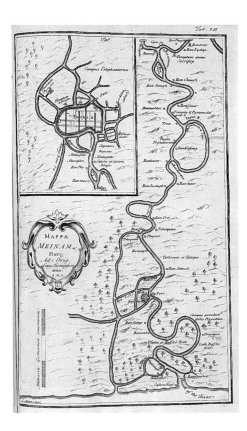

to regional prominence. When Ayutthaya was the capital of the Siamese kingdom, it took two or three days to travel from the river mouth to the city (fig. 19). The Chao Phraya River was navigable by smaller ocean-going ships and junks right up to the walls of Ayutthaya. The port area of the old capital was situated near the key fortress of Pom Phet.

A navigable river meant that good fortifications had to be built to guard access to the capital city. Fortresses were erected at Bangkok and Thonburi in the seventeenth century, because, as the French astutely observed, Bangkok was "the key of the Kingdom [of Siam]."[3] To counter the possibility of a rapid foreign invasion upriver, chains were put across the Chao Phraya River at a point just south of Ayutthaya, near the Bang Tanao tollhouse. A network of canals also helped to ensure quick and efficient communications in the central plains of Siam.[4] A key factor in the geography of Ayutthaya was the riverine or waterborne nature of life and society in the lower Chao Phraya Basin, with annual inundations (during the monsoon season) of the rice fields and of parts of the city itself (fig. 21). The rice fields to the north, east, and west of the city were of crucial importance

Above: fig. 20. On the river near Ayutthaya. Below: fig. 21. Landscape near Ayutthaya.

to the growth and development of the city, and to the state's economic self-sufficiency. The rice yield was able to feed the population every year and, during the seventeenth and eighteenth centuries, rice was imported into Siam only immediately after the fall of Ayutthaya in 1767, when agriculture was severely disrupted in the Chao Phraya basin. It appears, however, that in most years there was even a surplus and some was exported to neighboring states, such as Melaka (Malacca) and Pattani on the Malay peninsula. When there were emergencies elsewhere in Asia, such as those encountered by the Dutch on Java in the 1620s (immediately following the establishment of Batavia) and by the Chinese in the 1720s (following floods and famine in Fujian), Siamese rice was exported in large quantities to the stricken areas.[5]

Nonetheless, rice was not a major export commodity. Apart from its advantages of geographical situation and the productivity of its rice farmers, Siam had access to the natural resources available in the seas, forests, and land of its territories or tributaries. At the time Siam was an underpopulated land (as was the rest of Southeast Asia), with vast forested hinterlands and long coastlines on the

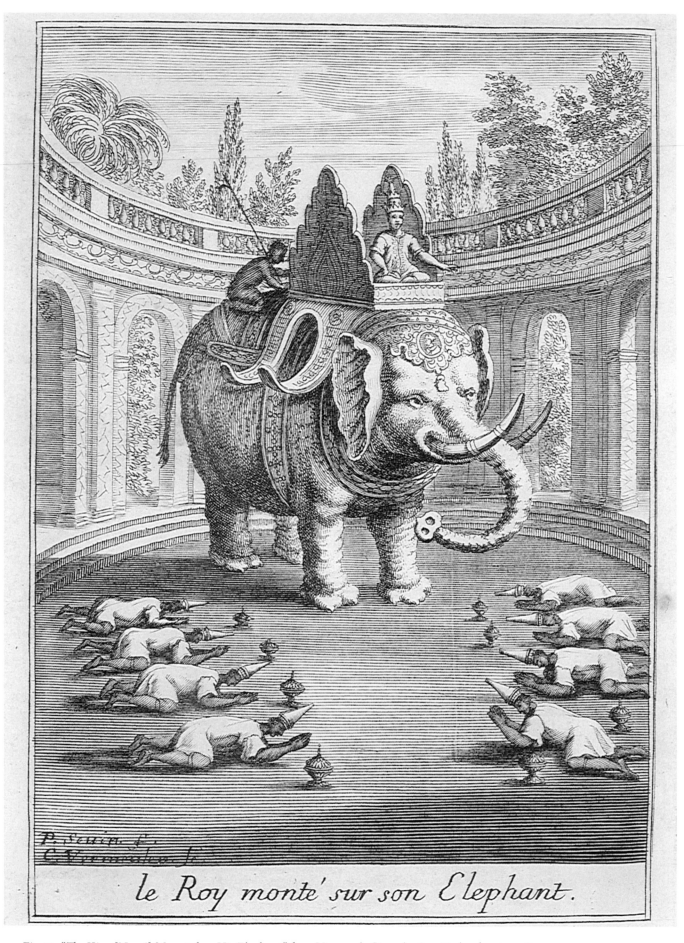

le Roy monté sur son Elephant.

Fig. 22. "The King [Narai] Mounted on His Elephant" from Voyage de Siam, by Guy Tachard, cat. no. 85.

Bay of Bengal and the Gulf of Siam. Ports grew up on the Gulf of Siam and the Andaman Sea. Apart from Ayutthaya, the towns of Nakhon Si Thammarat (Ligor), Songkhla, and Chanthaburi on the gulf were key ports during the seventeenth and – in the case of Chanthaburi – during the eighteenth century. On the Bay of Bengal, Mergui/Tenasserim was the principal port, but Phuket and Trang were also mentioned in Western accounts of the East Indies and marked on their maps of the region. People living in these towns were able to harvest riches from the sea, or dig and pan for precious minerals from their land. They could also gather forest products from the hinterland and resell them to foreign merchants.

Certain commodities appear very prominently on the cargo lists of the European ships that left Siam in the seventeenth century: chief among them, deerskins, wood, and miscellaneous goods such as ivory, rhinoceros horn, wax, benzoin (gum benjamin), gumlac, and namrack. These goods came from Ayutthaya's extensive hinterland, and from places connected by internal trade routes, such as the territories of the Lao kingdom of Lan Xang, which supplied the Siamese capital with gold and benzoin. The forests of Ayutthaya's northern provinces were abundant in wildlife. Animal skins were exported in large quantities from Ayutthaya. Cowhides, buffalo hides, and deerskins were grouped together by the Dutch East India Company (Vereenigde Oostindische Compagnie or VOC). Among the animal skins, deerskins were the most notable. They were divided into three large categories according to quality, and during some years in the mid-seventeenth century the Dutch exported over one hundred thousand deerskins per year to Japan. Indeed, between 1633 and 1694, the Dutch exported over three million deerskins from Ayutthaya.[6]

Elephants were closely associated with Siamese royalty (fig. 22), especially albino or so-called white elephants. Ordinary elephants served in war and peace, and each Siamese monarch had thousands of them to call upon. (In 1688 an equerry of the royal elephants, with access to tens of thousands of men in the elephant corps, staged a successful coup d'état in Lopburi and usurped the crown, being known to posterity as King Phetracha.)[7] Elephants were also export items, much in demand in parts of India, and, during the seventeenth and eighteenth centuries, royalty held a monopoly in the trade.

Of all the resources to be found in the seas of Siam, none was as valuable as the skins of stingrays. These rayskins, along with deerskins, were very much in demand in Japan, where they were used in the making of samurai armor and sword handles.[8] The local shipping in the Gulf of Siam, and

occasionally the larger craft too, carried shipments of what was called "dried fish," presumably the dried or salted fish from the area.

Wood of various types formed part of many cargoes out of Siam. Of these, sapanwood was the most important. In pre-industrial society red dye was obtained from various sources. Sapanwood yields a reddish purple dye that was used in the production of textiles all over the world, including Japan and Europe. Another key export was eaglewood, or aguila wood, an aromatic wood that could be used to make incense and was prized by both Chinese and Indians. Timber for building, including ironwood and teak, was also exported by the Dutch from Siam during the seventeenth century.[9]

Siam's exports included lead and especially tin. The trade in tin, which was used not only in the manufacture of household utensils such as jugs and containers, but also by the Chinese to line their tea chests and to burn in ceremonies of ancestor worship, created several prosperous port communities. The rich lode of tin that stretches from lower Burma down to the southern tip of the Malay peninsula and onto the island of Sumatra was much coveted by the European trading companies. The Dutch East India Company obtained what it hoped was to be a lucrative export monopoly in the tin of Nakhon Si Thammarat (Ligor). The trade had its ups and downs, but was profitable enough to allow the Dutch to retain their factory there for about a century. The Dutch company and its rivals, the English and French East India companies, contested the tin market of Phuket ("Junkceylon") and Bangkhli on the west coast of southern Siam. By the treaty of 1685, which the French concluded with King Narai's court, the French East India Company (Compagnie Royale des Indes Orientales) acquired the monopoly rights to the export of tin from Phuket. The European traders, however, more than met their match in the Chinese traders, who were more flexible and operated with lower overhead costs.[10]

One must not, however, overemphasize the riches of Siam and her natural resources. It is true that the Kingdom of Ayutthaya was ruled by kings who had access to several thousands of able-bodied men through a system of manpower mobilization. Yet to argue that Siam was a powerful kingdom with the military potential to resist the Western nations would, however, be to tell only part of the truth. The Western powers did not covet the land of Ayutthaya as eagerly as they coveted the spice islands of Indonesia; the Dutch, for instance, did not try to seize Siamese territory because there were no cloves, nutmeg, mace, or cinnamon there, and pepper was much more plentiful in Sumatra and India than in territories controlled by the Siamese king.

into the service of the royal court at Ayutthaya. The Chinese entered royal service not only in the capital and the royal court, but also in the provinces; they probably first became tax farmers in this period and then became involved in the mining of tin in the south of the kingdom, at Nakhon Si Thammarat.[29] The Chinese influence that came from the two key factors of trade and migration did not fade away in the rest of the eighteenth century, or indeed in the nineteenth century. It appears that, after being dominated by Hokkien (or Fujian) elements, the Chinese communities in Siam during the mid- to the end of the eighteenth century became predominantly Teochiu. In the chaos that followed the Burmese invasion of 1765–1767, the leader of the Siamese was indeed a half-Teochiu military official, Phya Tak or Taksin. The mother of King Rama I of the Chakkri dynasty, and the establisher of Bangkok as the royal capital, was herself the daughter of a Chinese merchant in the old capital of Ayutthaya. When King Taksin (reigned 1767–1782) revived the country's economy and fought his rivals as well as the Burmese, he was aided by the considerable resources of the Chinese communities on the eastern seaboard of Siam.

IMPACTS AND INFLUENCES

What was the impact of foreign trade and diplomacy on Siam? The commercial impact was clear for all to see: increased exports, increased royal shipping, selective royal monopolies, and the development of various foreign settlements in the city of Ayutthaya and other ports. The noncommercial impact may be divided into two categories: the introduction of new technologies and the evolution of taste and fashion (fig. 27).

Among the most far-reaching developments was the introduction of firearms and Western military technology from the Portuguese and others. Although the Siamese knew about the advances in European military technology, and had even hired Portuguese mercenaries from well before the 1590s, it is significant that during the most decisive land battle fought by the Siamese against Burmese invaders, the Battle of Nong Sarai in 1593, it was a duel on elephant back between the Siamese king and the Burmese crown prince that settled the issue.[30] The introduction into Siam of Western-style cannon and ordnance, however, necessitated the construction of new fortresses and city walls that could withstand the firepower of Western artillery. In the mid-sixteenth century the walls surrounding the city of Ayutthaya were reinforced and built of bricks the better to withstand the cannon fire that besiegers were likely to use. The Siamese armies themselves now used cannons and

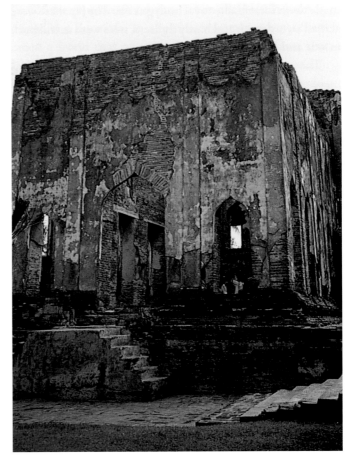

Fig. 29. Audience hall, Royal Palace, Lopburi.

muskets. There was thus an ironic episode in the history of Ayutthaya's relations with Burma when both armies used Western firepower and the skills of Western mercenaries (in this case the Portuguese).

Yet, because the kings maintained a monopoly over firearms and ammunition, the proliferation of Western-style firearms was more limited than it was in sixteenth-century Japan. The only way that ambitious princes or officials could get hold of European or European-style weapons was to enlist the help of the mercenary troops in Ayutthaya (which, of course, was what some of them did). The importation of Western and other foreign military expertise had led to the formation of several bands of mercenaries serving the kings of Siam. The most notable among these would have been the Portuguese sharpshooters, the Muslim (Mughal-Persian) cavalry, and the Japanese *ronin* who had migrated to Siam during the tumultuous civil wars in Japan during the sixteenth century. Many of the Portuguese who lived in the large Portuguese "camp" in Ayutthaya were indeed mercenaries, lançados or free agents, who had left the service of the king of Portugal.[31] As for the "Moor" cavalry, their tall stature and expertise in matters equestrian must have

Fig. 28. Indian textile with alternating roundels and eight-pointed motifs, for the Siamese market, cat. no. 82.

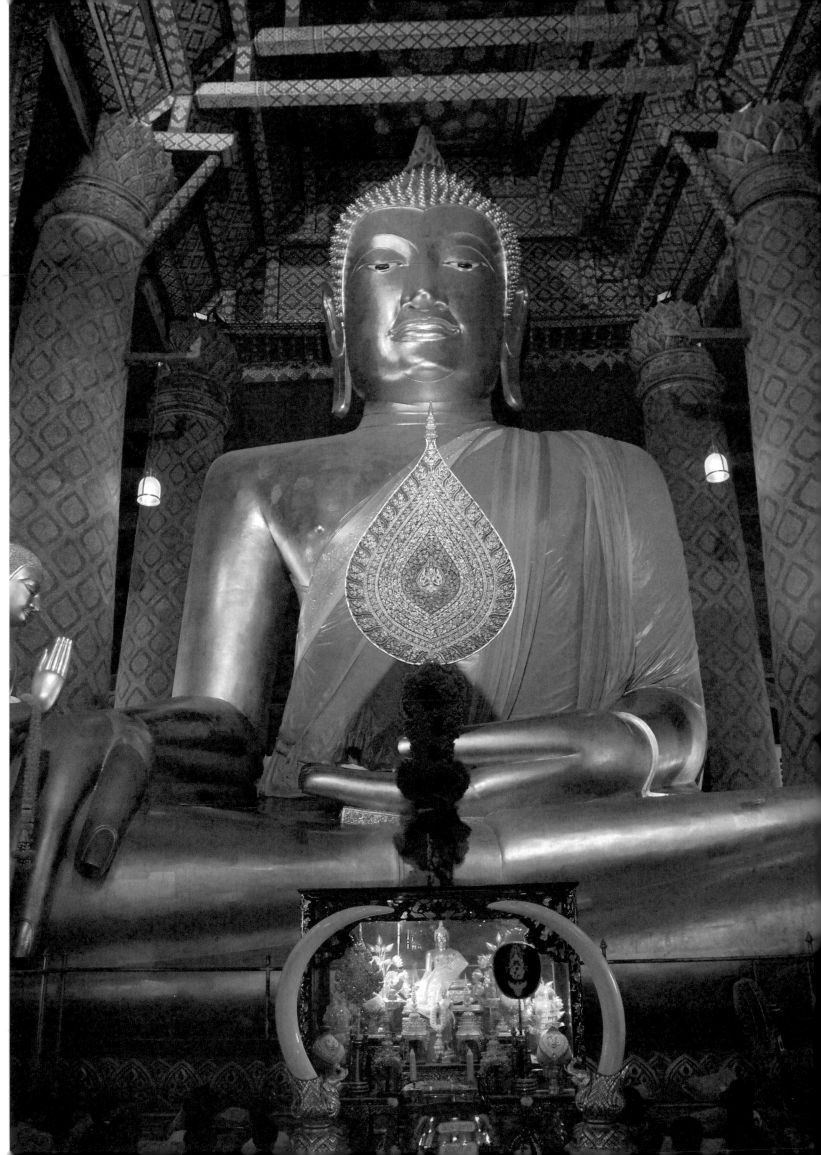

The Buddha Images of Ayutthaya

Hiram Woodward

We know something about what a high-ranking Thai thought were the most important Buddha images of Ayutthaya, as he looked back after the momentous defeat of the kingdom in 1767. One of the texts scholars consult to learn about the city, where that conflagration destroyed not only buildings but also vast libraries, is an account compiled by the Burmese following their victory, based upon information received from one or more Thai officials. This account, the *Evidence Given by the Inhabitants of Ayutthaya* – read in printed editions of a translation back into Thai – includes a list of great *chedi*, consisting of both Buddha images and stupas.[1] The word *chedi* is commonly used in Thai to refer to what in India is called a "stupa," a solid commemorative structure that can hold a relic of the Buddha's body. But the same word, in the Pali language of the Buddhist texts, which were composed in India, has a technical meaning; a *cetiya* is a "reminder" of the Buddha, and so an image of the Buddha is also a *cetiya*.

The Buddha is in the state of nirvana, and so, from the orthodox Buddhist point of view, he is totally removed from the world; he cannot interact with human beings, he cannot reward them for their gifts or punish them for their misdeeds. (Such actions, instead, will inevitably earn their proper rewards, in accordance with the laws of cause and effect. Commissioning a Buddha image is an especially fruitful action, resulting in the accumulation of what is known as merit. The act of worship produces merit as well.) Filling the space of the absent Buddha are his bodily relics, which became objects of worship shortly after his demise, and images, which were first produced centuries later. In Thai monasteries (monasteries, because Buddhist monks live there), or temples (temples, because they are places of public worship), the structures are almost always laid out in such a way that both images and stupas, which may or may not actually contain relics of the Buddha, can be worshipped simultaneously. The principal image is placed at the western end of a large brick-and-stucco image hall (sometimes an ordination hall, sometimes a preaching hall). Further west, along the same axis, in a very common scheme, stands a stupa. When the worshipper pays homage to an image, he or she is also honoring the stupa that stands behind it. Relics and images, therefore, not only belong to the same class of object (cetiya), they also form a kind of partnership.

The Burmese intelligence document lists twenty "great sites" with cetiya, and it is an indication of the little knowledge we have of Ayutthaya that so few are identifiable. The first seven items on the list are Buddha images in the city of Ayutthaya; the next two, relics in Ayutthaya. Number ten is the Buddha's footprint, in Saraburi, and number eleven, another site, Khao Patthawi. Numbers twelve through fifteen are all, or nearly all, famous Buddha images in the kingdom's second city, Phitsanulok, and numbers sixteen through twenty are too vaguely named to be identified. I shall return to the first seven, the Buddha images in Ayutthaya, but let us first focus upon these images from the perspective of a modern counterpart to such a list.

A MODERN VIEW: TWO FAMOUS IMAGES

One of the many books about the Buddha images of Thailand, appearing in 1982, was the work of a travel writer, Pramot Thatsanasuwan. He described sixty-two Buddha images in all parts of the country, some famous for their size, some for their age, and many for their intrinsic powers, potentially benefiting those who worship them. The images, Pramot wrote in his preface, stimulate us to recall, and to behave in accordance with, the principles and truths of the religion, beginning with Buddhist virtue, Buddhist practice, and Buddhist morality.[2] Just about all of these Buddha images have proper names. Most of the names are formal, beginning with "Lord Buddha" and incorporating epithets taken from scriptures, written in the Pali language; others are informal, beginning with the Thai words Luang Pho,

Fig. 30. Buddha image known as "Lord Phanaeng Choeng," Wat Phanan Choeng, Ayutthaya.

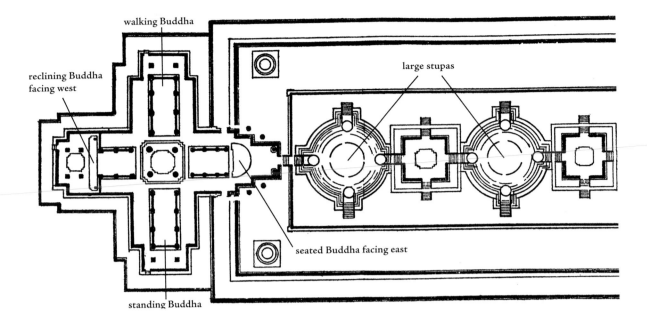

Fig. 31. Western end of Wat Phra Si Sanphet, Ayutthaya.

"Honored (or Royal) Father," and sometimes including the name of the monastery in which the image resides.

Of the sixty-two images in the book, only two are to be seen today in the once-great city of Ayutthaya. Both are too large to be easily moved. One, according to an early history of the kingdom, was the very first image to be constructed at the site, in 1324 or 1325, twenty-six years before the official establishment of the city in 1351.[3] This stucco image, Lord Phanaeng Choeng, nineteen meters in height, remains in worship today, housed in a building that is not much larger than the statue itself, within the monastery officially called Wat Phanan Choeng (fig. 30). The name *phanaeng choeng* is Khmer, or Cambodian, and means "sitting-down-with-folded legs."[4] There are many Cambodian loanwords in the Thai language, but perhaps the people who gave the image its original name were Cambodian speakers. The absence of evidence from inscriptions means that it is hard to be certain what language was dominant in the region in the fourteenth century: perhaps Thai, the language of the newcomers, spoken in the kingdom of Sukhothai, to the north; perhaps Cambodian, the language of the political overlords in the eleventh, twelfth, and thirteenth centuries; perhaps, but less probably, Mon, the language of the local residents in the first millennium. The words "phanaeng choeng" appear in a later Ayutthaya-period Thai text, said to date from 1472, which recounts the story of Vessantara, the prince who was so filled with loving kindness that he even gave away his own children.[5] Vessantara, in his next life, was born as Gautama, the Buddha. In this text, the words translate the scriptural Pali-language *nisidi*, "sat down": the Buddha himself sat down, and then he told

his disciples the story of his life as Prince Vessantara. (The Buddha remembered his past lives.) Someone aware of the literary occurrence of the name might attribute to this giant Buddha the power to recite the story of Vessantara.

Nevertheless, this Buddha, along with the great majority of the Buddha images of Thailand, is shown in the position called in Thai by an Indic term, *Maravijaya*, "victory over Mara." On the night of his awakening, his achievement of Buddhahood, the Buddha was attacked by the devil Mara, but the Buddha remained firm in his resolve; he took his right hand from his lap, where it lay as he was meditating, and placed it upon his leg, calling upon Mother Earth to affirm his steadfastness. This she did by letting forth a great flood; her hair became a conduit for all the waters of the ocean – this ocean, in turn, standing for the accumulated good deeds performed by the Buddha over countless lives. Mara is conceived as a devil, but he stands for death, as well as for the forces of evil and for the components of the personality, all of which are overcome in the ultimate state of nirvana.

In common usage, both in Thai and in English, Buddha images are classified according to their hand gestures, and these gestures refer to specific moments in the Buddha's life. There is, however, another system of classification, according to posture, with roots in the following scriptural passage concerning consciousness of the body, from the *Mahasatipatthana Suttanta* of the Pali-language *Digha Nikaya*:

He [a brother, anyone embarked upon the Buddhist path of meditation] keeps on considering how the body is something that comes to be, or again he keeps on considering how the body is something that passes away, or again

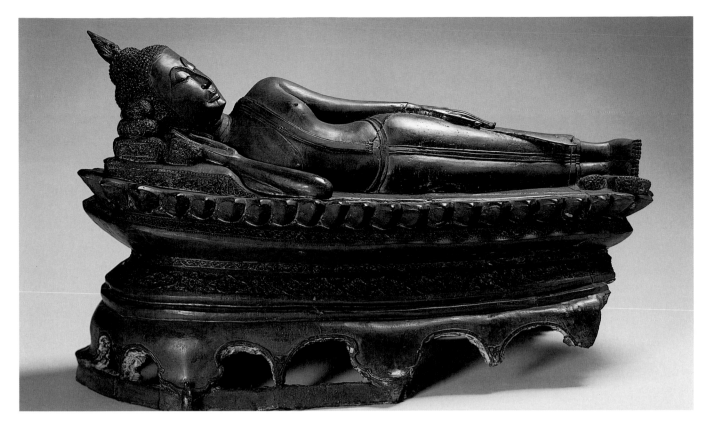

Above: fig. 32. Reclining Buddha, cat. no 46. Below: fig. 33. Walking Buddha, cat. no. 8.

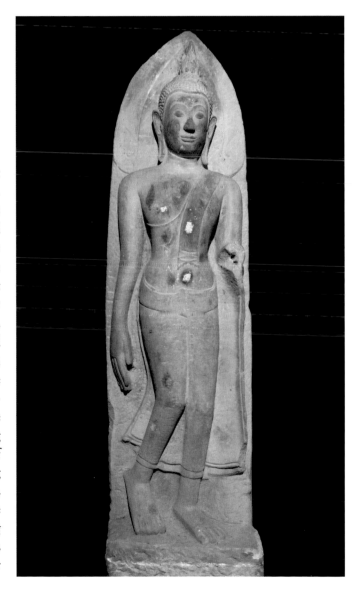

he keeps on considering the coming to be with the passing away. . . . And he abides independent, grasping after nothing in the world whatever. Thus, *bhikkhus* [monks], does a brother continue to regard the body.

And moreover, bhikkhus, a brother, when he is walking, is aware of it thus: "I walk"; or when he is standing, or sitting, or lying down, he is aware of it. However he is disposing the body, he is aware thereof.[6]

In the later Buddhist literature the four attitudes, or modes of deportment, were referred to as the four *iriyapatha*. According to a passage in the *History of Buddhism in India* composed in 1608 by the Tibetan monk Taranatha, an aged woman who had a memory of seeing the Buddha during her childhood was, before her death, able to pass judgment on the very first Buddha image, which was produced in secret by celestial architects, who disappeared as soon as their work was completed. Overall, she thought, the likeness was good, but one of the discrepancies was that the image showed the Buddha in only one – sitting – of the four postures.[7] In Thailand, the four postures were given material form. At the palace temple in Ayutthaya (Wat Phra Si Sanphet), a cruciform structure at the western end (that is, the back) of the complex (fig. 31) held a seated image facing east (thus facing a worshipper in the image hall who stands on the far side of a row of stupas); a walking Buddha facing north; a standing Buddha facing south; and a reclining Buddha facing west, thereby echoing the pull of the setting sun.[8] Awareness of the four postures could well have given the name *phanaeng choeng* ("sitting with folded legs") currency and legitimacy. Similarly, the reclining Buddha is, in Thailand, just that – reclining or

The second image in Ayutthaya noted by Pramot That-sanasuwan is another giant image (22.45 meters in height), the Si Mongkhon Bophit, or, in Indic spelling, Shri Mangala Pavitra ("glorious auspicious pure one")(fig. 34). Constructed of sheets of bronze alloy over a brick-and-mortar core, this image stood unprotected for decades after the fall of Ayutthaya; it is now covered by a structure built in 1957. The Ayutthaya Chronicles mentions the image just once, saying that it was moved from the east side to the west side, and a *mondop* (Indic *mandapa*; in Thailand a square building with a tiered roof) was built over it, purportedly in 1603.[14] Scholarship suggests that it was founded in the previous century, in 1538 at Wat Chi Chiang.[15] Most probably a group of images discovered in the shoulder of the great Buddha in the 1950s – some of which are in this exhibition (figs. 35, 36, 37) – were deposited at that time.

In 1827, King Rama III (reigned 1824–1851) called upon a panel of senior monks to resolve a dilemma in his mind: the big Buddha at Wat Monkhon Bophit, exposed to the elements, was disintegrating, and His Majesty's heart was filled with pity. He wanted to know if it would be proper to remove the metal covering, bring the Buddha to Bangkok, melt it down, add gold, and have a new image cast. The monks searched the scriptures, and the only relevant text they discovered was one that describes the application of ointment by Jivaka Komarabhacca to the ailing body of the Buddha, bringing it back to a normal status. Since nothing in the scriptures could be found to sanction the king's proposal, the Buddha was left in Ayutthaya.[16]

The king humanized the image because he felt sorry for it; the monks by comparing it to the Buddha when ill. In both cases, they reinforce the conclusion that the equivalence of Buddha, teaching (*dhamma*, *dharma*), and monkhood – the three aspects of the Triple Gem – affirms that the Buddha image is alive. The Buddha image consecration ceremony as practiced in northern Thailand provides confirmation. The ritual opening of the image's eyes at sunrise reenacts the Buddha's dawn enlightenment. This follows a night of chanting in which the image is ritually infused with the Buddha's biography and with twenty-six aspects of the teaching, which are lodged in specific parts of the body, from the laws of cause and effect (in the navel) to the perception of the nature of nirvana (in the hair). The words of the chant alone do not invest these qualities in the image; the spiritual accomplishments of the chanting monks are also crucial.[17] The equivalences between aspects of the doctrine and the parts of the body are spelled out in a *dhammakaya* ("truth body") text, known also from an inscription erected in Phitsanulok in 1548.[18]

FAMOUS IMAGES OF AYUTTHAYA: PHRA SI SANPHET

Neither of these two giant images seems to appear among the seven images listed in the *Evidence Given by the Inhabitants of Ayutthaya*. Number seven on the list, *phra nong klin*, "Lord Little Brother Fragrance," speculated the Thai editors, could be the Phanaeng Choeng Buddha, but the name suggests a much smaller image made of fragrant sandalwood – sandalwood being the material of the very first Buddha image, according to ancient legends, preserved primarily in Chinese sources.[19] In fact, in its historical narrative, the *Evidence* states that King Narai (reigned 1656–1688) brought a *naga*-protected Buddha carved from sandalwood to Ayutthaya from Chiang Mai, and perhaps "Lord Fragrance" is the same image.[20] Number six on the list, the *sayambhucharamoli* is described as a diamond-meditating (*samadhi vajra*) Buddha, that is, one seated with crossed, not merely folded, legs, but it cannot be identified. Of the remaining five images, however, all can be discussed at greater length (numbers one and five and numbers three and four fall together).

The first image on the list is the Phra Si Sanphet, described as gilded, in the palace (actually, it stood in Wat Phra Si Sanphet, which was the palace temple), and established by King Ramathibodi II (reigned 1491–1529). This accords with statements in the Chronicles. Number five on the list, the Phra Maha Lok ("Lord Great World") is identified by the Thai editors as the Phra Lokkanat ("Lord Sovereign of the World"), which also once stood in Wat Phra Si Sanphet. Both images were brought to Wat Phra Chettuphon (Wat Pho) in Bangkok in the late eighteenth century, at a time when an effort was being made to reconstitute the sacred geography of Ayutthaya in the new city of Bangkok. The Phra Lokkanat (fig. 38) was brought first, and the larger of the two images, the Phra Si Sanphet, which had suffered in the fall of the city, arrived subsequently. When it was realized that the Phra Si Sanphet could not be restored to the extent that it would compare in beauty to the Phra Lokkanat, King Rama I suggested that it be melted down and a new image cast. But the board of monks who had to advise about such an action discouraged it (as would happen again in 1827), and so, in 1794, the fragments of the image were deposited in the principal stupa at the monastery, together with relics of the Buddha.[21]

Standing at the head of the list, the Phra Si Sanphet must be reckoned the most important Buddha image in Ayutthaya. This is what might be surmised from other evidence; after all, it was the principal image at the most important temple in the city, which took shape in the late fifteenth century and

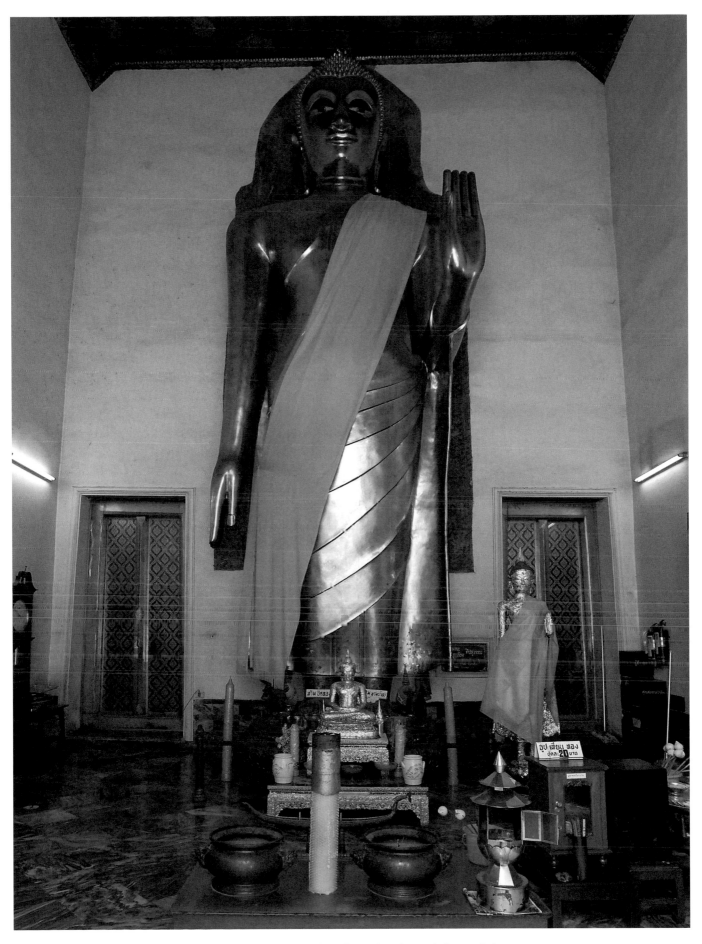

Fig. 38. Buddha image known as "Phra Lokkanat," Wat Phra Chettuphon (Wat Pho), Bangkok.

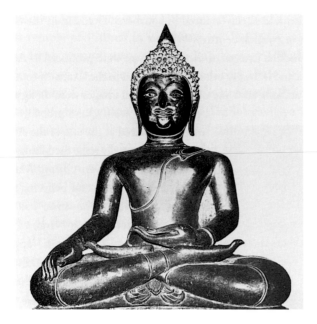

Fig. 41. "Sihing" type Buddha image, 1689, Wat Khok Kham, Samut Sakhon.

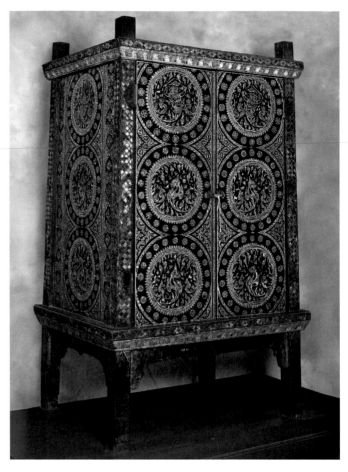

Fig. 42. Manuscript cabinet with decoration of roundels, cat. no. 67.

in a royal procession.⁴⁸ He had, therefore, a kind of inherent right to the throne. Under such circumstances, it was only natural for him to turn, it can be surmised, to a fresh source of support and authority, namely the Sihing Buddha, and away from the standing crowned images that ranked highest for King Narai. Another indication of a symbolic break with the past is that the image halls at Wat Borommaphuttharam face north rather than, as customary, east.⁴⁹

THE PLACE OF FAMOUS IMAGES

This survey of famous Buddha images has covered a broad span of time: 1325/1326 (the Phanaeng Choeng Buddha); 1504 (the Si Sanphet); 1538 (the Mongkhon Bophit); 1658 (King Narai's Buddhas in royal attire); and 1689 (the Sihing-type Buddha). Focusing on well-known and highly venerated images provides important insights into the actual practice of Buddhism in Ayutthaya but only a partial, and somewhat curious, art history. Additional exploration of documentary evidence could lead first to a study of the statues of Hindu gods, which played a role in the court ceremonies at which brahman priests officiated. One important image was the elusive Phra Thep Bidon (*deva pitra*, "god-father"), probably, in form, a Hindu god. As at Angkor, and continuing until the end of the period of the absolute monarchy, officials had to take an oath of allegiance, involving the drinking of water that would prove poisonous to the disloyal. The Phra Thep Bidon, described as if it were a portrait of "King Rama-dhipati U Thong, the first king of the old capital" was kept in the palace precinct in Ayutthaya.⁵⁰ Officials paid homage to

it before proceeding to utter the water oath at Wat Phra Si Sanphet. The Phra Thep Bidon was brought to Bangkok from Ayutthaya in 1783, transformed into a Buddha, and installed in the chapel of the Emerald Buddha. Beginning in 1785, its role in the water oath was taken by the Emerald Buddha itself, an image King Rama I had brought from Laos. Clearly, if a fourteenth-century sculpture commemorating the founder of the city were still in existence today, and if it indeed played a role in ritual throughout the Ayutthaya period, it would be possible to determine the degree to which it was a significant touchstone over the centuries.

A focus on famous images in the context of an exhibition of the art of the Ayutthaya period illuminates the degree to which these four centuries were, in fact, dynamic ones, pulled in different directions by different models. Somewhat similarly, anyone who, contemplating the images deposited at Wat Ratchaburana in the 1420s, supposes that they might provide clear indications of the future development of Ayutthaya art would be mistaken, because in fact the changes in the coming decades were radical ones. As a group of sculptures of particular aesthetic distinction emerges in the coming years,

it may be possible to write more of an art history and to understand the interactions between the images that became famous – whether because of their size, powers, or history, or the circumstances of their foundation – and the decisions made by generation after generation of sculptors, who filled the world with thousands of images of the Enlightened One.

NOTES

1 *Khamhaikan chao krungkao*, 203–204.

2 Pramot, *Phraphuttharup lae anusawari*, iii–iv.

3 Cushman, *Royal Chronicles*, 10.

4 I am grateful to Dr. Franklin E. Huffman for his help. See Guesdon, *Dictionnaire cambodgien-français*, 2:1314: *preah phnen choeng*, "L'Auguste replie les jambes." Michael Vickery raised the question of whether Mon-language cognates might be playing a role in the name. He noted that, in the seventeenth century, Engelbert Kaempfer called the temple "Peguan," that is, Mon. See Vickery, "Review of *A Dictionary of Mon Inscriptions*," 207–208.

5 As cited in *Prawat wat phananchoeng*, 5 n. 2.

6 Digha, ii 292, in *Dialogues of the Buddha*, pt. 2, 328–329.

7 Taranatha, *History of Buddhism*, 42–43. See also Swearer, *Becoming the Buddha*, 27.

8 Woodward, "Monastery, Palace," 30–31. For the four postures elsewhere in Thailand, see Woodward, *Sacred Sculpture*, 160. The inscription mentioned on p. 302 n. 27 of the same publication dates from 1832. On the base of an image of the standing Buddha in Nan, it refers to establishing images in "all four *iriyapatha*," implying that the surviving image was one of a set of four.

9 Cushman, *Royal Chronicles*, 519, modified. For a facsimile of the Thai manuscript text, see *Chronicle of the Kingdom of Ayutthaya*, 525, where the name appears as Wat Chao Phanang Choeng.

10 For Chinese views of Wat Phanan Choeng, see Tobias, "Buddhism, Belonging." I also thank Dr. Hui-Wen Lu.

11 Baker, "Ayutthaya Rising."

12 Woodward, *Sacred Sculpture*, 186–187.

13 Notton, *Legendes*, 65; *Phongsawadan nua*, 51.

14 Cushman, *Royal Chronicles*, 209.

15 Woodward, *Sacred Sculpture*, 232, 303 n. 15.

16 *Prachum phrraratchaputcha*. Vol. 4, *Phrraratchaputcha nai ratchakan thi 3*, 24–27, partly translated in Woodward, *Sacred Sculpture*, 21–22.

17 Swearer, *Becoming the Buddha*.

18 *Prachum sila charuk*, vol. 3, inscr. 54, 99–103. See Woodward, *Sacred Sculpture*, 24–25; and Swearer, *Becoming the Buddha*, 55–56, 190–191, and 286 n. 86.

19 Swearer, *Becoming the Buddha*, provides references to many of these, 16–22.

20 *Khamhaikan chao krungkao*, 114, 125–126.

21 Woodward, "Monastery, Palace," 42.

22 Cushman, *Royal Chronicles*, 19.

23 Woodward, *Sacred Sculpture*, 228.

24 Woodward, *Sacred Sculpture*, 22–23; Swearer, *Becoming the Buddha*, 54–55.

25 Cushman, *Royal Chronicles*, 247.

26 For this identification, see Khaisri, *Les statues du Buddha*, 81.

27 The Thai life of the Buddha, in the Thai-language version of 1844 by Prince Paramanuchit Chinorot, *Phra pathomsomphotkatha*, 271. For a visualization, see Herbert, *Life of the Buddha*, 51; for the narrative, see Spence Hardy, *Manual of Buddhism*, 189–191.

28 *Chotmaihet rawang ratchathut langka*, 128, 146–147.

29 Thai translation: *Ruang thao mahachomphu*. For summaries of the story, see Finot, "Recherches," 66–69; Mya, "Jambupati Image"; and Fickle, "Crowned Buddha Images."

30 Mya, "Jambupati Image."

31 Woodward, "Life"; Woodward, *Sacred Sculpture*, 211–212, 219–220. Crowning procedures found in Theravada ordinations in certain Southeast Asian traditions may be a survival of esoteric ritual coronations. See Bizot, "La place," 523 (Laos) and Holt, *Religious World*, 30 (Siamese ordination, in Sri Lanka).

32 Woodward, *Art and Architecture of Thailand*, 150–151.

33 Iyanaga, "Récits de la soumission de Maheśvara," 3:660–63.

34 Strong, *Legend and Cult of Upagupta*, 201.

35 This grouping of images is illustrated in Hoskin, *Buddha Images in the Grand Palace*, 6–7. See also *Phra phutthapatima nai phraborommaharatchawang*, 26–31. On the Phra Suralaiphiman and Phra That Monthian Chapels in the Royal Palace, see Woodward, "Monastery, Palace," 44–48.

36 Cushman, *Royal Chronicles*, 205.

37 *Phutthasurin*, spelled *Buddhasurindra*, for *surendra*, the god Indra as chief of the gods, therefore, "Buddha chief of the gods."

38 In the earliest known epigraphical occurrence, of 1470, the name appears as *sahinga* – not a word with a known meaning either: Penth, *Khamcharuk*, 58; Woodward, "The Emerald and Sihing Buddhas," 513 n. 31.

39 Swearer, *Becoming the Buddha*, 196.

40 *Khamhaikan chao krungkao*, 114, 126. For the Upagupta legend, see Strong, *Legend and Cult of Upagupta*.

41 Wyatt, *Thailand*, 118–119.

42 Woodward, "The Emerald and Sihing Buddhas"; Phothirangsi, *Nithan phra phutthasihing*.

43 Woodward, "The Emerald and Sihing Buddhas."

44 Text of the inscription, Phothirangsi, *Nithan phra phutthasihing*, opposite p. 33.

45 Cushman's translation, *Royal Chronicles*, 320.

46 *Chotmaihet rawang ratchathut langka*, 27–28, 147.

47 For the text of the monarch's order of 1752, see *Prachum chotmaihet samai ayutthaya*, 57.

48 Cushman, *Royal Chronicles*, 300, 308–309.

49 *Phraratchawang*, 61–64.

50 *Phraratchaphongsawadan chabap phraratchahatthalekha*, 707, for the quote; for the location and practice, Boran, *Ruang krungkao*, 150–151 and n. 75, 145–147, in the section, "On the Layout of Ayutthaya"; also Woodward, "Emerald and Sihing Buddhas," 506. There was also a tradition connecting the Phra Thep Bidon with Wat Phutthaisawan, a monastery said in some chronicles to have been established in 1353 by Ramadhipati himself, the founder of Ayutthaya. See *Phraratchawang lae wat boran*, 41; Cushman, *Royal Chronicles*, 11; Woodward, *Sacred Sculpture*, 300 n. 4.

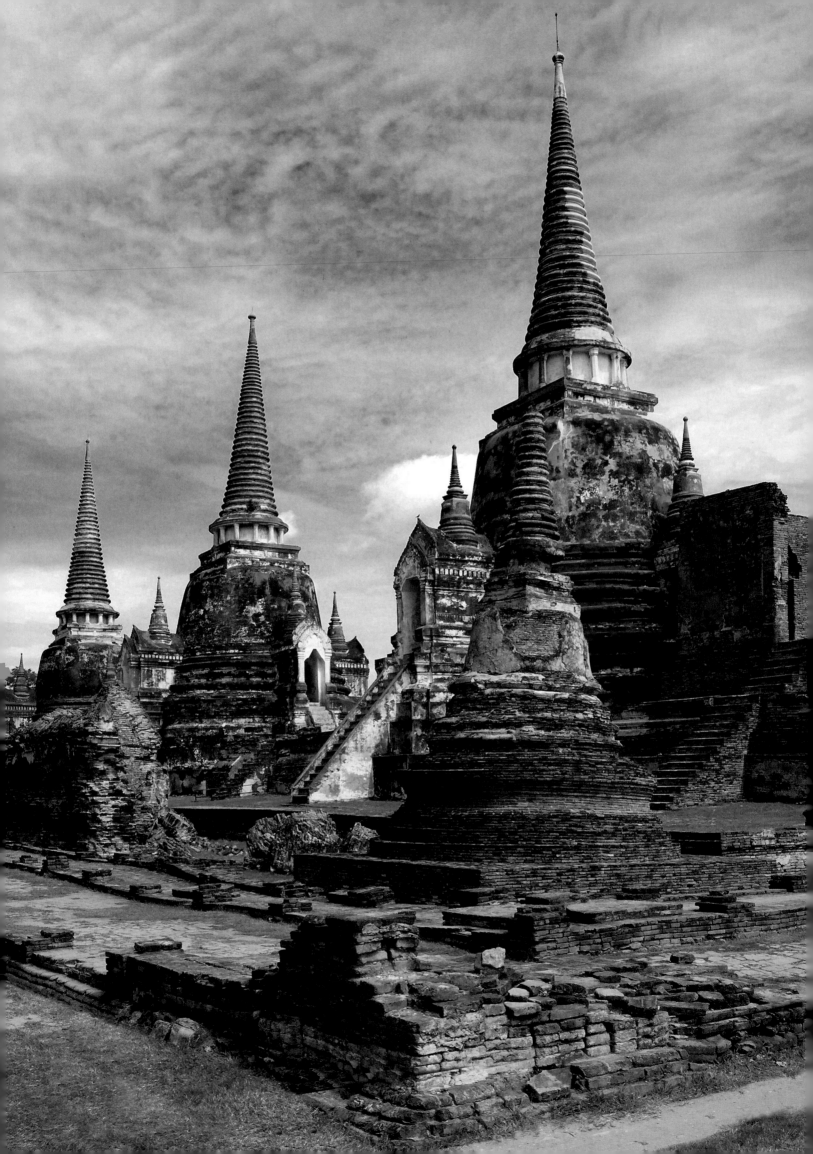

The Evolution of the Memorial Towers of Siamese Temples

Santi Leksukhum

In Thailand stupas and other sorts of memorial towers (in Thai called *chedi*) are symbolic reminders of the Buddha and his teachings; sometimes they enshrine relics of the Buddha. The stupa's role in Buddhism is highlighted in the story of the Buddha's life. After the Buddha was cremated, the god Indra brought to the heaven where the gods dwell a portion of the remains to be enshrined in the great stupa there known as the Chulamani Stupa (in Thai, "Chulamani Chedi"). This was the same stupa in which, years before, Indra had placed the hair that the young prince who was to become the Buddha cut off after he left his father's palace and began his spiritual journey.[1]

There are several Thai terms for relics of the Buddha and the stupas or other memorial towers that house them: *mahathat* ("great relic"), *phra si mahathat* ("holy auspicious great relic"), *phra si rattanamahathat* ("holy auspicious jeweled [or jewel-like] great relic"), and *phra borommathat* ("holy supreme relic").

As early as the Sukhothai period, towers were built as reliquaries. For example, a thirteenth-century inscription describes how King Ram Khamhaeng held a ceremony to commemorate the enshrining of relics of the Buddha in a stupa in the center of Si Satchanalai.[2] Another use of stupas may have begun by the Sukhothai period: Prince Damrong Rajanubhab, the father of Thai archaeology, argued that

during that period stupas housed relics of members of the royal family.[3] In Ayutthaya, in 1492, stupas were erected at Wat Phra Si Sanphet to contain the remains of King Borommatrailokkanat and his son (fig. 43).[4] The tradition of placing relics of royal persons in stupas was based on the belief that the king was a bodhisattva, or potential Buddha. The divine nature of the king extended to royal family members.

THE ARCHITECTURE OF THE MEMORIAL TOWERS OF SIAMESE TEMPLES

Ayutthaya, ceremonially founded in 1351, received architectural influences from Sukhothai and the northern Thai kingdom of Lan Na. Most importantly, it inherited many of the Cambodian-related traditions of Lopburi, which had sometimes been a province of Angkor, and sometimes an autonomous principality. The primary sort of memorial tower in Lopburi was the Cambodian-type tower known in Thai as the *prang*, which developed there in the century before the founding of Ayutthaya. The main tower of Lopburi's Wat Mahathat is a good example of the Angkor-influenced prang (figs. 44a and 44b).[5] This prang, and the layout of Wat Mahathat, Lopburi, as a whole, served as prototypes for Ayutthaya's early temples.[6]

Ayutthaya's art can be divided into

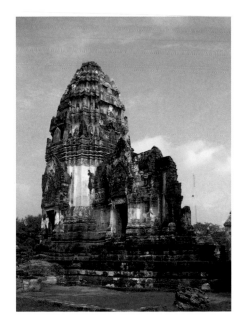

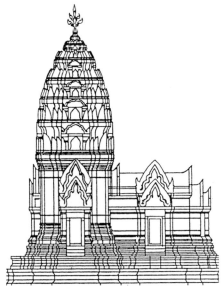

Left: fig. 43. Three main stupas, Wat Phra Si Sanphet, Ayutthaya.

Above: figs. 44a and 44b. The main tower (prang) of Wat Mahathat, Lopburi (approx. early thirteenth century).

 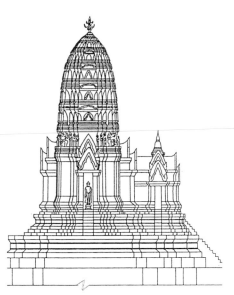 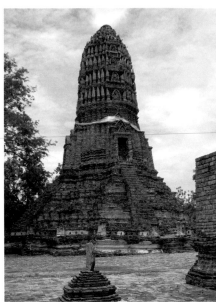

Left and center: figs. 45a and 45b. Main prang of Wat Ratchaburana, Ayutthaya, early period, reign of King Borommaracha II (1424–1448).

Right: fig. 46a. Main prang at Wat Worachet Thepbamrung, Ayutthaya, middle period, reign of King Ekkathotsarot (1605–1611). See also facing page, left.

early, middle, and late periods. Each period spans more than a century. This article discusses the stylistic features of memorial towers erected during all three Ayutthayan periods. Each section addresses a particular type, and discusses first examples in the city of Ayutthaya and then examples elsewhere. Each type evolved along its own particular course, but sometimes one type of tower had a significant influence on another.

THE CAMBODIAN-TYPE TOWER, CALLED PRANG

Early Period
The temple plan of the early period (fig. 4) consisted of (1) the main memorial tower (a stupa or a *prang*), which was the center of the temple, both spiritually and physically; (2) the gallery that surrounded the main tower; (3) the primary preaching hall, located on the eastern side of the main tower and extending into the gallery; and (4) the ordination hall situated

beyond the western wall of the gallery. The ordination hall and preaching hall form the east-west axis of this temple plan, with subsidiary stupas and other buildings located on either side. These other stupas and buildings are smaller in scale and less important than the ordination hall and preaching hall. An example of the early period prang is that of Wat Mahathat in Lopburi, built around the early thirteenth century (see figs. 44a and 44b).

During the middle and late periods, the temple complexes decreased in size. The main tower, a stupa or prang, was made smaller, given different forms, and placed in different locations within the complex. Finally, during the late period, the ordination hall became smaller and was repositioned so that it attached to the main tower.

The prangs of Lopburi are generally less complex than the original Angkorian towers to which they were related. During the Ayutthaya period, this type of tower became even more simplified, as well as more slender in shape. The

main tower of Wat Ratchaburana is a good example of an early Ayutthaya prang (figs. 45a and 45b). It is still in good condition and has required less restoration than any other main tower from this period.

While there are numerous variations of the prang, all have three main parts: base, body, and superstructure (fig. 45b). The base consists of several (often three) tiered sets of moldings. This type of base developed from that of the prang of Lopburi (figs. 44a and 44b). The body has a projecting porch on the eastern side. This porch has three entrances: a front entrance facing east and two side entrances facing north and south. This design was also derived from the prang of Lopburi. At Wat Ratchaburana, a small stupa was placed on the roof of the porch (fig. 45b). This feature is not found on any Angkorian temple. Instead, the idea may have come from Pagan in Burma.[7] The superstructure of the Ayutthaya prang comprises numerous false stories, following the prototypes in Lopburi.

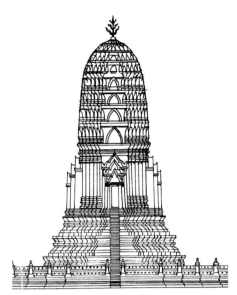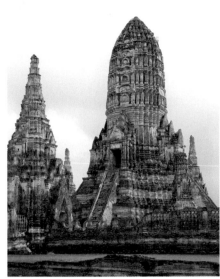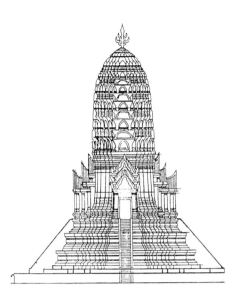

Left: fig. 46b. Main prang at Wat Worachet Thepbamrung, Ayutthaya, middle period, reign of King Ekkathotsarot (1605–1611). See also facing page, right.

Center and right: figs 47a and 47b. Main prang at Wat Chaiwatthanaram, Ayutthaya, late period, reign of King Prasat Thong (1629–1656).

The main prangs of other Ayutthaya temples built before Wat Ratchaburana, such as Wat Phutthaisawan, Wat Phra Ram, and Wat Mahathat, have undergone restoration work in the past and present. The main prang at Wat Mahathat was built of laterite; only its base has survived. The base is cross-shaped and would have supported four projecting porches. This type of base contrasts to that of most early period towers, which have only a single projecting porch on the east. According to some versions of the Royal Chronicles, this prang underwent a major restoration during the reign of King Prasat Thong in 1633.[8] Although there is no mention of whether structural changes were made during this restoration, it is possible that the four porches were added then.

Some of the smaller early period prangs, such as the main prang of Wat Som and the subsidiary prangs at Wat Mahathat and Wat Ratchaburana, have shallow facades without projecting porches. These prangs have undergone numerous restorations over time, most recently by the Thai Fine Arts Department.

Middle Period
Prangs were constructed less frequently during the middle period. The main prang at Wat Worachet Thepbamrung is a good example of a middle period prang (figs. 46a and 46b).[9] Located outside of the city walls, this temple was possibly constructed around 1605 – the first year of the reign of King Ekkathotsarot. The dating of this temple is not conclusive, however, because of confusion with a similarly named temple that may or may not have been constructed around the same time. This other temple is known as Wat Worachettharam,[10] and is located east of Wat Lokkayasuttha and west of the palace. It appears likely, however, that both temples were constructed during the middle period (see the discussion of these dates in the section on stupa shrines of the middle period, below).

The main prang at Wat Worachet

Thepbamrung, built with both medium and small bricks, has a slender shape. It is situated on a wide platform encircled by a balustrade. This platform served as a place for people to worship by performing ritual circumambulation. Despite having undergone numerous restorations, some architectural features of the main prang suggest that it might belong to the middle period.

The base is decorated with tiered sets of cyma-recta moldings with dividing bas-relief strips, as were prangs of the early period. The body has four small projecting porches. On the eastern porch, the doorway was constructed by a special technique. The bricks were arranged in a pointed arch. Such arches are rare in Ayutthaya architecture of this period; generally, they only appear in the late period, as a result of French (or Persian[11]) influence. Here, however, the pointed arch most likely originated from Burmese art. It was adopted into Lan Na art in northern Thailand around the mid-thirteenth to mid-fifteenth centuries;[12]

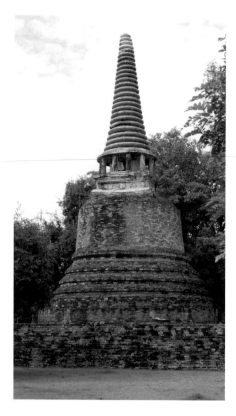

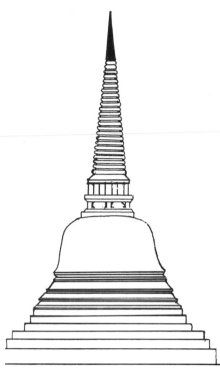

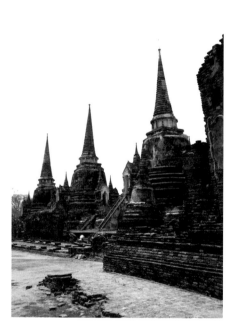

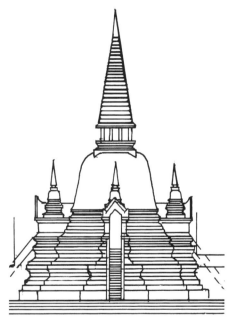

Top left and right: figs 52a and 52b. The main bell-shaped stupa of Wat Samanakot, Ayutthaya, early period, approx. mid-fourteenth to mid-fifteenth century. Moldings with sloped profiles were made by slicing off the edges of bricks and covering them with a coating to make the surface even.

Bottom left and right: figs 53a and 53b. The three large stupas of Wat Phra Si Sanphet, Ayutthaya, middle period, reign of King Ramathibodi II (1491–1529). Important features include the bell-shaped body and the presence of short pillars in the superstructure to support the conical spire.

dominant kingdom in the latter half of the fourteenth century.[23]

There is no concrete evidence that the bell-shaped stupas of Ayutthaya developed from those of Dvaravati. A more probable source is Burma, where bell-shaped stupas began to be built during the Pagan period, perhaps due to influences from Sri Lanka. A significant example is the Sapada Stupa at Minanthu village east of Pagan, erected around the mid-twelfth century.[24] The bell-shaped stupa was briefly popular in Pagan before being adopted into Sukhothai art around the second half of the thirteenth century, and, from Sukhothai, influencing Ayutthaya. This explains why Sukhothai and Ayutthaya bell-shaped stupas share a number of features.[25]

Like prangs, bell-shaped stupas generally have three main parts. The base is a tiered square platform. The body includes the bell-shaped element and the series of torus moldings that support it. The superstructure consists of a square "throne" supporting a cone of graduated rings and, above that, a plain tip.

Early Period

The Royal Chronicles report that King Borommaracha II constructed Wat Maheyong in 1438.[26] The main bell-shaped stupa at this temple is exceptional because of the figures of elephants decorating its base and seeming to support the structure on their backs (figs. 51a and 51b). Each elephant (of which only the front half is shown) stands within a round-arched recess. Both the notion of the elephant-supported stupa and this manner of presenting the elephants within arched niches had previously been used during the Sukhothai period.

On top of the platform were four covered colonnades (of which nothing remains but pillar bases) leading to the stupa. These may have been added or

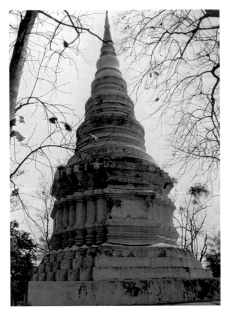

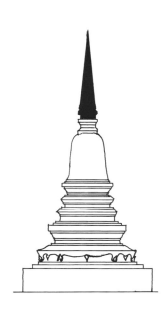

Left: fig. 54. The large Lan Na–style bell-shaped stupa at Wat Bang Kacha, Ayutthaya, middle period, approx. mid-fifteenth to mid-sixteenth century. The tall shape is due to a very high base, which supports a small bell-shaped body and a slender conical super-structure.

Center and right: figs. 55a and 55b. Subsidiary stupas on the platform of the prang of Wat Phra Ram, Ayutthaya. These stupas may have been added during restorations under King Borommakot (1733–1758). The conical spires have disappeared; they were usually the first element to be damaged.

restored during the late period. There may also once have been four small stupas surrounding the main stupa.

While there are no documents of the history of Wat Samanakot, the style of its main stupa, especially the series of moldings with sloped profiles, suggests it belongs to the early period[27] (figs. 52a and 52b). Such moldings had also been used during the Sukhothai period. In the superstructure, the throne element has remnants of stucco decoration of flowers and tendrils that differs from most early Ayutthaya period decoration. It was probably influenced by Sukhothai art.

Middle Period
Good examples of bell-shaped stupas during the middle period are the three identical large stupas of Wat Phra Si Sanphet (figs. 43, 53a, and 53b), built in 1492.[28] Each has four projecting porches with a small stupa on the roof, as did prangs of the early period, such

as that of Wat Ratchaburana (figs. 45a and 45b). On each large stupa, the east porch served as the entrance, while the three other porches sheltered niches that would have held images of the Buddha (of which none remains today).

The subsidiary stupas of Wat Phra Si Sanphet are also bell-shaped, and had, in their superstructure, a square throne element supporting the conical spire.

Bell-shaped stupas of the later part of the middle period include the stupa of Wat Worachettharam inside the walls of Ayutthaya and the badly damaged stupa of Wat Worachet Thepbamrung outside the walls to the west. These stupas have been restored by the Thai Fine Arts Department.

One of the most interesting developments of this period is the appearance in Ayutthaya of bell-shaped stupas in the style of the northern Thai kingdom of Lan Na. These stupas are found at Wat Tha Kae on Sa Bua

Canal north of the city,[29] at Wat Bang Kacha, beyond the city walls to the south (fig. 54), and at Wat Nang Kui, near Wat Bang Kacha. These stupas have redented bases decorated with a set of Lan Na–style bas-relief strips. Above the base, the body consists of three tiers of moldings and a bell-shaped element. It is possible that the parts of the city where these stupas are located served as residential areas for merchants or royalty from the north. Although erected during the Ayutthaya period, these stupas are not classified as Ayutthaya architecture.

Late Period
A few bell-shaped stupas were erected during the late period, but most were additions to temples that already had bell-shaped stupas. Examples include a number of subsidiary stupas that were relatively small, with slender, bell-shaped bodies. These high-based subsidiary stupas were added amid the

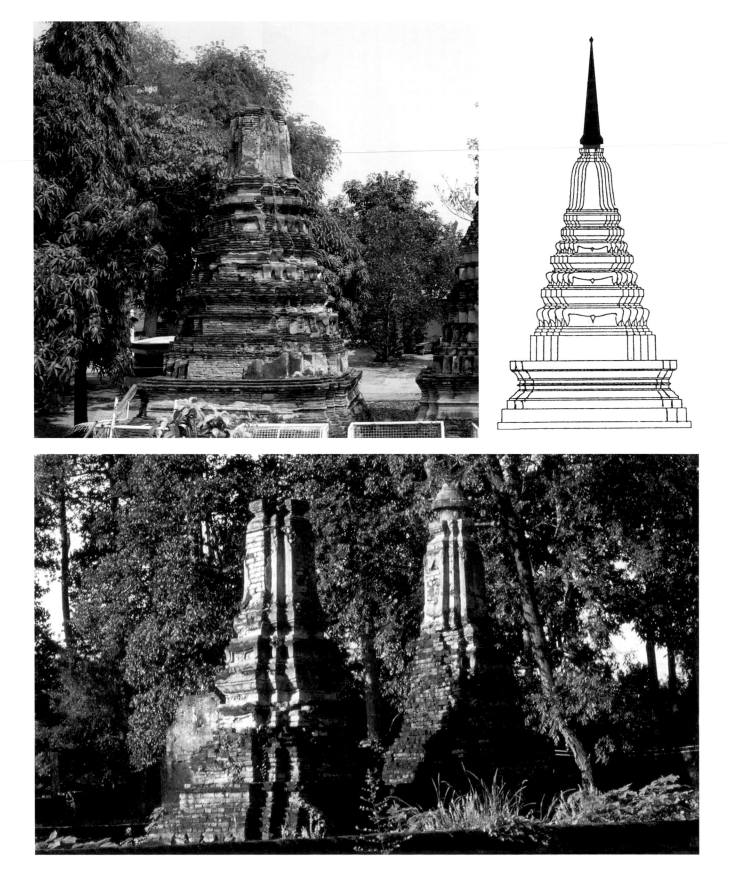

Top: figs. 66a and 66b. Redented stupa no. 6 at Wat Phukhao Thong, Ayutthaya, late period, probably reign of King Borommakot (1733–1758). See also figs. 69a and 69b.

Bottom: fig. 67. The redented stupas at Wat Pho Prathap Chang, Phichit province, late period, reign of King Sua (1703–1709).

ing the reign of King Prasat Thong, but restored during the reign of King Rama IV (1851–1868).[43] These stupas have a tall square base and a single staircase on the east side.

The redented stupas constructed during the reign of King Prasat Thong have their own unique characteristics. After this reign, there were major changes in several features. Not only did the size of stupas decrease, but the size of the redentations became smaller and the tendency continued for all redentations to have the same size. Simple bases were replaced by three-tiered lion-throne molding bases. On top of the lion-throne molding base sat a redented bell-shaped element. A good example is the subsidiary stupa no. 6 at Wat Phukhao Thong, probably erected during the restoration in the reign of King Borommakot (1733–1758) (figs. 66a and 66b).

Redented stupas outside the City of Ayutthaya

Examples of redented stupas outside the city are the paired stupas at Wat Pho Prathap Chang, Phichit province (fig. 67). The Royal Chronicles mention the construction of this temple during the reign of King Sua (1703–1709).[44] During the late period, the popularity of the redented stupa gradually decreased until it disappeared with the proliferation of the new type of decorated stupa described below.

"DECORATED" STUPAS

The decorated stupa type emerged during the middle period. Stupas of this type tend to be small subsidiary stupas. These stupas are called "decorated" (Thai: *song khruang*) because of their relatively large amounts of stucco decoration. Other important characteristics of this stupa type are that it

has a number of similarities with the stupa shrine type and that it is also closely related to the redented stupas, and thus is sometimes referred to as the "decorated redented stupa." The primary parts of the decorated stupa are as follows:

1 The base comprises tiered lion-throne moldings, and is similar to the base of prangs and redented stupas of the same period.

2 The body comprises one or two cushion-shaped elements in the form of open lotuses. These are situated on top of a lion-throne molding and support a bell-shaped element that, in section, is either a circle or a redented square.

3 The superstructure comprises a square throne element, a spire made up of a tapering stack of open lotuses, and a tip.

Middle Period

The typical decorated stupas of the middle period are small to medium-sized. According to the research reported here, the oldest middle-period stupa is stupa no. 13 on the east side of Wat Phutthaisawan, Ayutthaya. This stupa was recently restored by the Thai Fine Arts Department. Prior to the restoration, this stupa was in poor condition and its base was covered by a three-meter-high termite mound. The surviving original features include the upper part of the lion-throne moldings that were not covered by the termite mound, a cushion-shaped element in the form of an open lotus supporting a slender bell-shaped element decorated with vertical strips, and a set of moldings on top of the bell-shaped element. Above these there probably once was a spire of tapering open lotuses and a tip (figs. 68a and 68b).

The legs of the lion-throne mold-

ings of this stupa are short and robust. They are similar to the legs of lion-throne moldings at Wat Phra Si Sanphet, constructed around 1499,[45] but they are more slender. This suggests that the form continued to evolve over the course of the sixteenth century. After this evolution, the lion-throne moldings became even more slender as exemplified by those on the bases of the crowned and bejeweled Buddha images in the eight Meru-towers of Wat Chaiwatthanaram, Ayutthaya, built during the reign of King Prasat Thong (1629–1656).

Late Period

The decorated stupas erected after stupa no. 13 at Wat Phutthaisawan also have tiered lion-throne moldings. An example is stupa no. 7 at Wat Phukhao Thong (figs. 69a and 69b). This stupa must have been erected during the restoration campaign of King Borommakot (1733–1758).[46] Although the bell-shaped element of this stupa is also decorated with vertical strips, it is later than stupa no. 13 at Wat Phutthaisawan (figs. 68a and 68b). The legs of the lion-throne moldings of stupa no. 7 have already evolved in shape.

The decorated stupa at Wat Sam Wihan, Ayutthaya, is in better condition than other stupas of this type (figs. 70a and 70b). It is possible that this stupa and its stucco decoration were restored relatively recently. The lower part of the tall original base has been covered by a recently added cement base. The superstructure of the stupa includes a spire of tapering open lotuses of which only part survives. This type of superstructure was popular during the reign of King Borommakot.[47] During the late period, redented stupas declined in number with the increased popularity of decorated stupas.

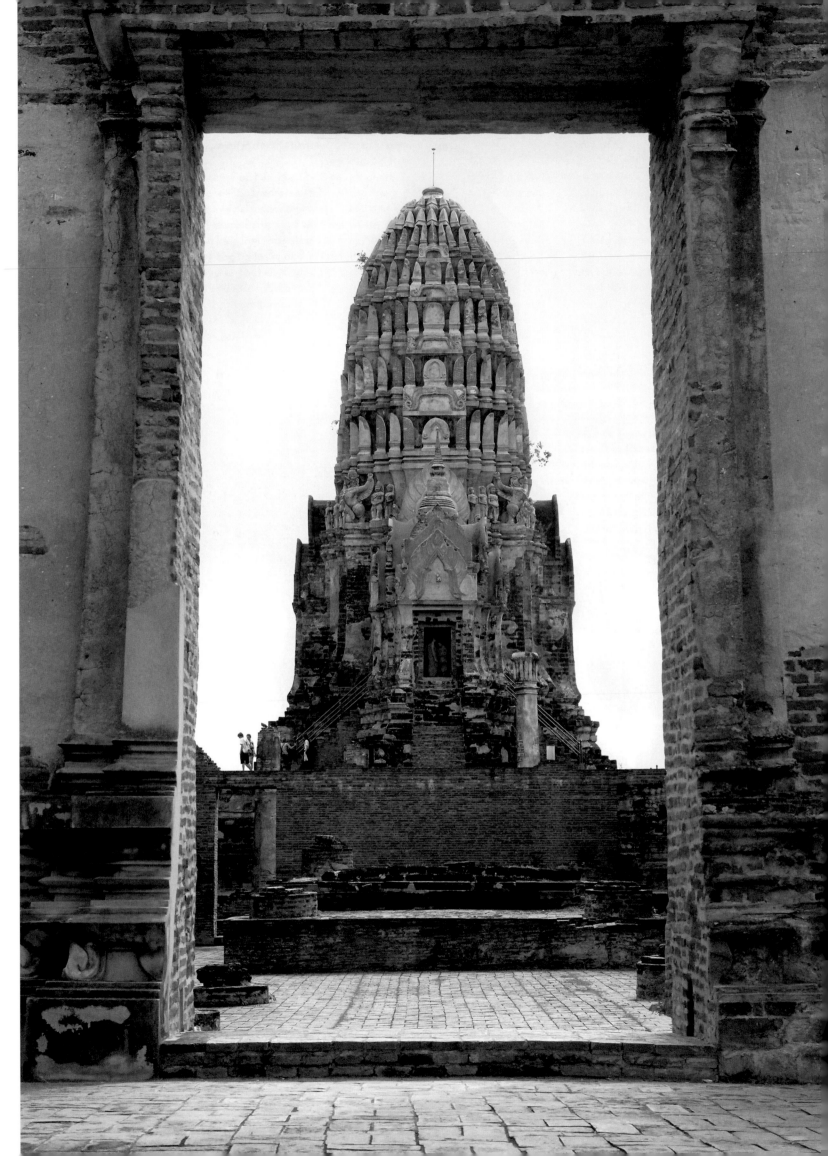

Wat Ratchaburana: Deposits of History, Art, and Culture of the Early Ayutthaya Period

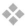

M. L. Pattaratorn Chirapravati

Sealed off from human sight since 1424, magnificent gold royal regalia and vessels, over six hundred Buddha images, and over one hundred thousand votive tablets lay neatly stacked in the main tower of Wat Ratchaburana in Ayutthaya for more than five hundred years (fig. 73). The deposits came to light in 1957 during an excavation of the main tower by the Fine Arts Department of Thailand after looters broke into the second and third levels and stole approximately twenty bags of gold objects. The incident prodded the Fine Arts Department to finish excavating this historic site. In the process, they discovered more deposits of gold and nine previously unknown rooms, including the relic room, considered the most important for its religious significance. The other eight rooms were filled with Buddha images and votive tablets of various styles and types. Most of these Buddha images appear to have been made for the founders of the temple shortly before they were deposited. A small number, however, were antique heirlooms from the old kingdoms of Dvaravati, Srivijaya, and Angkor, while others had been imported from India, Nepal, and Sri Lanka.

It would be hard to overestimate the significance of the artifacts discovered in the tower of Wat Ratchaburana. They comprise not only the largest and most important collection of archeological remains of the early Ayutthaya period, but also the most important source of information regarding the history, culture, and religious practices of Central Thailand in the fifteenth century. Very few artifacts from Ayutthaya can be dated with confidence by the usual methods that make use of inscriptions or historical records. This group of objects, however, sealed away in Wat Ratchaburana, can apparently be attributed to the period when the temple was founded. Thus, the treasure of Wat Ratchaburana can be used like a text to study the history of early Ayutthaya.

Unlike the ancient Cambodians who left a large number of stone inscriptions recording their history, the rulers of Ayutthaya recorded their history on perishable materials,

much of which fell victim to the fires of the 1767 Burmese invasion that destroyed the city and effectively put an end to Ayutthaya's role as a political center. Historical records of this period are very scarce, so we can only speculate about the city's history based on archeological evidence and foreign records from places such as China.

There are not many known written sources of information about Wat Ratchaburana. The oldest is the Luang Prasoet version of the Royal Chronicles, written in 1680, 256 years after the temple was built. According to the chronicle, a temple was built at the cremation site of the two brothers of King Borommaracha II (or Chao Sam Phraya, meaning third governor), who were both killed in a duel for the throne after their father passed away in 1424. To commemorate this event, two stupas were built at the battle site during that year. The temple is called here "Wat Ratchabun."[1]

The second mention of Wat Ratchaburana is in the Phan Chanthanumat version of the Royal Chronicles, written in 1795.[2] The chronicle provides details of the battle between the two brothers of Borommaracha II and the site chosen for their cremations. After the cremations, Borommaracha II had a *mahathat* ("great relic [tower]") and a preaching hall built at the site and named the temple "Wat Ratchaburana."[3] Two stupas were built at Pa Than Bridge, the site where the two brothers fought and died.

The great Thai historian Prince Damrong identified "Wat Ratchabun" with the present-day Wat Ratchaburana.[4] The presence in the crypt of Wat Ratchaburana of several objects with the name of a king or a period (for example, Kashmiri coins[5] and Chinese inscriptions on votive tablets) tends to support a fifteenth-century date for the tower, and thus strengthens the likelihood that Wat Ratchaburana is indeed the early chronicle's "Wat Ratchabun" of 1424.[6]

Despite the significance of Wat Ratchaburana, it has been very little researched. In 1959, the Fine Arts Department of Thailand published three books about the temple

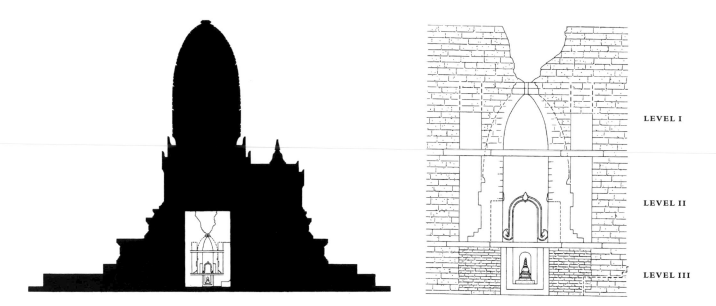

LEVEL I

LEVEL II

LEVEL III

Fig. 74. Crypt, main tower, Wat Ratchaburana, Ayutthaya.

in Thai shortly after the discovery of the crypt.[7] One of the books describes the most significant information about the discovery, the placement of objects in the relic chamber, and the mural paintings. Unfortunately, no photographs were taken when the objects were still in situ. Thus, important data about ritual practices were lost forever.

When the site was first discovered, the objects that attracted the most attention were those crafted from gold. Two books recently published on the gold deposits in the main tower provide important information about the uses of gold, metalworking techniques, and types of jewelry found in the treasure room.[8]

In this article, I first investigate King Borommaracha II, his religious practices, and the status of Wat Ratchaburana. Next, I focus on the Buddhist artifacts recovered from the temple, such as gold votive plaques and Buddha images. Finally, I examine the deposits of gold royal regalia, insignia, and vessels in the second level of the main tower, which I call here the "treasure room."

KING BOROMMARACHA II AND HIS RELIGIOUS PRACTICES

Before he became king, Borommaracha II (reigned 1424–1448) had been only third in line for the throne. He therefore probably needed to make an effort to legitimize his reign and establish his power with the authority to govern. A common and important tool for such empire building was Buddhism, and a major preoccupation of most Ayutthaya kings was the building of Buddhist temples. Thus,

Wat Ratchaburana was probably built as part of an effort to establish the king's legitimacy and his right to claim the title of Universal Monarch (*chakravartin*).[9] In theory, the king held omnipotent and absolute power over his kingdom. The temple was a conspicuous symbol in the center of his kingdom, which included regions that had once been under the suzerainty of the Thai of Sukhothai or the Cambodians of Angkor. Buddhist artifacts that were deposited within the structure, namely sculptures, votive tablets, and mural paintings, were carefully chosen to enhance the prestige of the king and the potency of the kingdom. Religious merit would also be gained to ensure a felicitous future birth for each of the king's deceased brothers, for the king and his family, and for his subjects.

Borommaracha II seems to have chosen the site of his temple carefully. Wat Ratchaburana is situated next to Wat Mahathat, which was built, according to the Royal Chronicles, in 1374. Mahathat, meaning "great relic" (that is, relic of the Buddha), was the name given to the most sacred temple of an ancient Thai city, which was commonly situated in the city center. Thus, Wat Mahathat in Ayutthaya may be considered the symbolic center of the early Ayutthaya kingdom. Historian Charnvit Kasetsiri has suggested that the construction of grand temples in the center of an ancient city often served the practical purpose of supplying convenient manpower. The presence of popular temples helped to guarantee that the center of the kingdom was surrounded by a dense population, which the court could make use of on a permanent basis.[10] This concept may be applied to the reign of Borommaracha II. With the establishment of Wat

Left: fig. 82. P

form with a larg
Four containers
have been placed
looters called "pe

The associat
tant Sri Lankan
the treasure roo
Lanka, is descril
and the late th
vamsa recounts

. . . The King
novice's hand
grant with per
which resemb

Again, accor
piyatissa (reigne
King Ashoka of
was very please
alty and many c
Stupa.[42] In addi
enshrined reser
nuggets of gold
numbers of pea
treasure room o

Peter Skillin
crypt was dicta

Ratchaburana next to Wat Mahathat, the king killed two birds with one stone: he reinforced the center of his state, and with the manpower already assembled, the surrounding area was easy to develop and expand as a community.

Situated next to each other at the heart of the ancient city of Ayutthaya, Wat Mahathat and Wat Ratchaburana both have large Cambodian-type towers in which religious deposits were found. It is quite uncommon to have two extremely important temples built so closely to each other. This might be a further indication that King Borommaracha II intended to use the first temple he built as a way to legitimize his role as a new Universal Monarch. The archeological evidence discussed later also strongly suggests that the king wanted to show his support for a new Buddhist monastic ordination lineage just introduced from Sri Lanka during the first year of his reign (1424).[11]

According to the *Jinakalamalipakaranam*, a sixteenth-century chronicle from the northern Thai kingdom, twenty-five monks from Chiang Mai and eight from Cambodia returned to Ayutthaya in 1424 from Sri Lanka where they had been re-ordained. As a result, they were said to belong to the *Sihalabhikkhu nikaya* (meaning the monastic lineage from Sri Lanka).[12] They brought back with them a relic of the Buddha and two learned Sinhalese monks. This group of monks re-ordained Silavisuddhi, the advisor of King Borommaracha II's wife, and stayed in Ayutthaya for four years. Their presence may explain why new types of artifacts such as gold royal regalia and vessels, commonly found among deposits in Sri Lanka and India, were deposited at the Wat Ratchaburana crypt. It is also possible that the Sinhalese monks donated the three Sri Lankan Buddha images found in the crypt.[13]

In *Culture of Ceylon in Mediaeval Times*, Wilhelm Geiger explains that in ancient Sri Lanka, all meritorious works of the king were registered in the royal annals and were later recorded in a chronicle. Generally, a Sri Lankan king would symbolize his submission to the religion by dedicating his kingdom, or the royal insignia, to an image, temple, or relic. For example, King Parakramabahu II was renowned for his offering of sixty-four royal ornaments to a temple.[14]

BUDDHIST ARTIFACTS

The main tower of Wat Ratchaburana is made of brick on a square laterite base with four subsidiary stupas at the corners. The entrance is through a forechamber accessed by a small, steep staircase on the east side. A miniature bell-shaped stupa, never before used as a decorative element on such a Cambodian-type tower, is placed above the fore-

chamber.[15] This interesting architectural element may also be related to the introduction of the new monastic lineage in Ayutthaya. On the other three sides of the tower, standing Buddha images of stucco were placed in niches.[16]

The three rooms of the main tower that line up one above the other in the center from the level of the stone base down to the laterite base (fig. 74) are the important areas where gold deposits, relic caskets, and mural paintings were placed. The corner rooms were filled with votive tablets and topped with Buddha images. The first level is a room with mural paintings that will hereafter be called the "Celestial beings and Chinese figures mural painting room" (LEVEL I). The next level down is the treasure room where the gold Buddhist artifacts, royal regalia, and insignia were found, and that includes mural paintings of the life of the Buddha and of stories of his previous lives (*jatakas*) (LEVEL II). The lowest level is the relic room, where the relics were placed (LEVEL III).

Precisely 618 Buddha images and more than one hundred thousand tablets were found in the crypt. It is likely that some images were brought in from other important Buddhist centers across Asia, namely Sri Lanka, India, Nepal, Indonesia, and Cambodia. Often these are examples of the most significant types of icons of their regions. For instance, a common type of relief in the style of tenth–eleventh century Buddha images from the Pala kingdom in northeastern India, was among the deposits.[17] It represents the Eight Great Events from the Buddha's life with the so-called "Buddhist creed" (*Ye Dharma …*) inscription on the reverse side.[18]

Why was such a wide variety of Buddhist icons placed among the deposits? The images came not only from regions in which Theravada traditions predominated, such as Sri Lanka, Burma, and other Thai areas, but also from areas in which the Mahayana prevailed: China, Java, and the Pala region of India. It is interesting that there seems to have been no concern about their differences. From the dedicatory inscriptions found on votive tablets in Thai, Cambodian, and Chinese, we know that some votive tablets were donated by monks and lay practitioners who either lived in the region or passed through Ayutthaya.[19] Many include the names of the donors, their professions, and the date of donation, reflecting the common practice of merit making among Buddhist communities. The finest examples are a gold plaque and three metal votive tablets with Chinese dedicatory inscriptions. The inscription on the gold plaque, which reads, "May your life be as long as the Southern Mountain," is most certainly a dedication for merit making.[20] The Chinese characters incised on each of the three votive tablets, which date to the Ming period (1368–1644), refer to a group of Chinese Buddhists who made the tablets

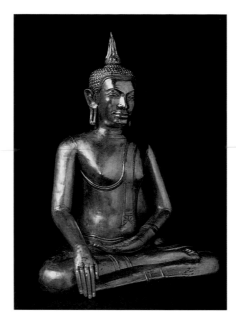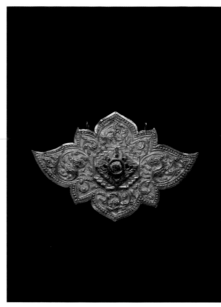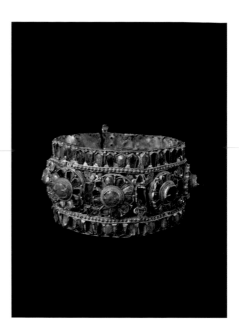

Left: fig. 86. Seated Buddha, cat. no. 1. Center: fig. 87. Chest pendant, cat. no. 17. Right: fig. 88. Bracelet or jeweled band, cat. no. 18.

GOLD DEPOSITS OF ROYAL REGALIA AND ROYAL VESSELS

Some of the deposits found at Wat Ratchaburana, namely the royal regalia, insignia, utensils, and vessels, are extremely rare among temple deposits in Thailand (though few other such deposits have been found undisturbed). This type of dedication, although atypical in earlier Thai kingdoms, was quite common in Sri Lanka and India as a symbol of the king's devotion to the temple, and it is possible that the practice may have been introduced by the two Sri Lankan monks.[63] Although deposits of gold jewelry became more popular after the fifteenth century, none of the archeological finds in Thailand has revealed any other royal regalia. The plenitude of gold deposits uncovered at many stupas in Ayutthaya may indicate both the significant status of gold and a change in religious practice during the late fourteenth to fifteenth centuries. A gold Buddha image in this exhibition (fig. 86) and several gold and silver votive plaques were recovered in the crypt of Wat Mahathat in Ayutthaya.[64]

If the looters can be believed, eighteen crowns and headdresses were deposited in the treasure room.[65] In the end, only two headdresses were retrieved.[66] Chin Youdi, a Thai archaeologist, compared the two headdresses to a detailed description of headdresses in the Palace Laws of Ayutthaya and concluded that one headdress might have belonged to a prince and the other to a princess.[67] A headdress from the collection of the Philadelphia Museum (fig. 89) is related stylistically to the Wat Ratchaburana type, as well as to a small bronze statue of a woman in the collection of the National Museum, Bangkok.[68] According to the list of royal crowns and headdresses in the Palace Laws, the highest ranking queen wore a headdress made completely of gold, while a queen of the second rank wore a more modest headdress with the back cut out in the shape of her chignon.[69] The Philadelphia headdress may have come from Wat Ratchaburana.[70]

According to the looters, the royal costumes were made of gold thread and perishable materials, such as textiles, which turned to dust when touched. Unfortunately, none of these costumes survived. However, various types of necklaces and royal chains, chest ornaments (fig. 87), armlets, bracelets, bangles, anklets,[71] and finger and toe rings were retrieved.[72] They were made with great skill in the techniques of applied filigree, openwork, and beading.[73] Many pieces of royal regalia and jewelry were decorated with some of the auspicious "nine gems" important in Indian and Thai symbolism.[74] One example of a gold bracelet decorated with precious stones is on display in the exhibition (fig. 88).

Several types of royal vessels were deposited in the crypt including ceremonial vessels, cosmetic containers, betel nut sets, and miniature animals, fruits, and a boat. Interestingly, the shapes, styles, and sizes of these royal vessels closely resemble ceramic vessels dated to the fifteenth to sixteenth centuries from Si Satchanalai and Sukhothai (fig. 2).[75] Figure 79 shows two containers, a beaker, and a goose-shaped vessel from among the deposits in the treasure room.

Miniature animals were made in fully three-dimensional form, as well as in thin plaques. Animals represented

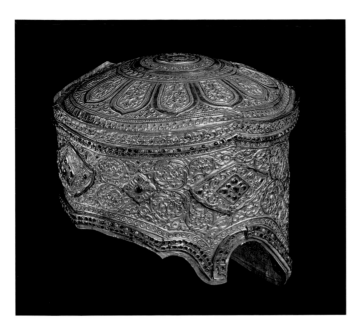

Fig. 89, Crown, cat. no. 16.

in-the-round include both real and mythical animals, such as elephants, geese, fish, and the mythical bird Garuda. Thin plaques cut in animal shapes were deposited around the gold miniature stupa, the most important object in the tower. As mentioned earlier, these gold cut-outs may have represented the Universal Monarch's precious possessions such as horses and elephants.[76]

CONCLUSION

In the treasure of Wat Ratchaburana, we can see diverse sources of Buddhist imagery that came from important Buddhist sites, not only from the kingdoms of Sukhothai and Angkor, but also from other Buddhist regions in Asia such as India, Sri Lanka, and Nepal. The ideology that inspired the deposits may be related to that found in two revered Pali chronicles from Sri Lanka, the *Mahavamsa* and the *Thupavamsa*, which describe stupa deposits in Sri Lanka. In addition, the deposits of Buddhist imagery, the unique iconographic program of the mural paintings, the elaborate royal regalia, and the varieties of gold jewelry suggest that by the fifteenth century, Ayutthaya was a flourishing and cosmopolitan city and port. The deposits from Wat Ratchaburana shed light on our understanding of royal funerary and religious practices, as well as on the art and history of early Ayutthaya. No other archeological discovery in Thailand has so far revealed such a diversity of material culture and religious thought. Thus, Wat Ratchaburana is like a Rosetta stone for the history of the early Ayutthaya period.

NOTES

I have studied various aspects of Wat Ratchaburana since 1999 and have written five papers on the main tower and its deposits and murals. Many people have been generous with advice and help with this research; without their guidance, this project would not have been possible. I thank Forrest McGill for his valuable advice on the Ayutthaya period, Peter Skilling for his counsel regarding aspects of Buddhist religious practice, and Prapod Assavavirunhakan for sharing his knowledge of court ceremonies and for translations of inscriptions. I am indebted to Khun Somchai Na Nakhonphanom, Director of the National Museum, Bangkok, and Khun Patcharee Komolthiti, Retired Director of the Chao Sam Phraya National Museum, Ayutthaya, for supplying photographs and for permission to examine objects for this article. Finally, I thank the Asian Art Museum of San Francisco for supporting the *Kingdom of Siam* project.

1 *Phraphuttharup lae phraphim*, 8. It is not clear whether the temple had already existed and was renovated for the event, or was built during the reign of this king. Also see Cushman, *Royal Chronicles*, 14–15.

2 *Phraratchaphongsawadan krung si ayutthaya chabap phan chanthanumat*, 11; Cushman, *Royal Chronicles*, 15; British Museum Version, 22–23.

3 The name can be pronounced two ways: Ratchabuna and Ratchaburana. In the same way, there are Thai provinces that can be pronounced with or without the "ra" syllable, such as Chantharaburi or Chanthaburi.

4 Damrong, *Tamnan phutthachedi*, 187.

5 Two Kashmiri coins dated to the reign of King Zaib-ul-Abidin (or al-Sultan al-adil), who ruled from 1420–1470, were recovered in the main room. This shows that the trove cannot be dated to earlier than 1420. See *Kru mahasombat*, 35–37. A Dutch scholar, L. M. Bruyn, recently attributed these coins to the reign of a king from Samudra (Indonesia) whose name is the same as the Kashmiri king (Prathum, *Khruang thong*, 54–55). It is important that the dates of these coins be investigated further.

6 Piriya Krairiksh, an important Thai art historian, does not accept the date (1424) given by the Luang Prasoet version of the chronicles. Based on a drawing of one European map of Ayutthaya, he attributes the date of Wat Ratchaburana to 1687 or later. In his *Sinlapa sukhothai lae ayutthaya*, he does not take into consideration any objects, with or without dates, nor does he examine the entire structure. He only compares the mural paintings in the treasure room to the murals of Suriyagoda, dated to 1757, and in the Temple of the Tooth, both in Kandy, Sri Lanka. If Wat Ratchaburana indeed dates to the seventeenth or eighteenth century, why are most of the Buddha images, votive tablets, and coins that were found there from the early part of the fifteenth century, and why are there no objects that can be dated to the seventeenth century? The deposits in the main tower certainly suggest its date more reliably than a European map.

7 These are: 1. *Phraphuttharup lae phraphim nai kru phraprang wat ratchaburana changwat phra nakhon si ayutthaya*. This book

was published in commemoration of the opening of the Chao Sam Phraya National Museum by the Fine Arts Department in 1959. Funding for the museum came from donations and the sale of Buddha images and votive tablets from the crypt of Wat Ratchaburana. 2. *Chittrakam lae sinlapawatthu nai kru phraprang wat ratchaburana changwat phranakhon si ayutthaya.* 3. *Kru mahasombat phraprang wat ratchaburana, changwat phra nakhon si ayutthaya.* This is a cremation volume published in memory of Mrs. Wat Siriseuy. Most of the articles in this third book were drawn from the first book listed here. The author added an introduction to the first chapter.

8 Prathum, *Khruang thong*; Sunait, *Ayutthaya Gold.*

9 On the idea of the chakravartin see McGill, "Jatakas, Universal Monarchs," 430–439 and references cited there.

10 Charnvit, *Rise of Ayudhya*, 101–103.

11 Peter Skilling explains that this new ordination lineage was significant because it probably was believed to enhance the purity of the monastic line. Private communication.

12 The monks went to Chiang Mai in 1430. Ratanapanna, *Epochs of the Conqueror*, 129–131.

13 Based on style, the three images can be dated to the Late Polonnaruva period (twelfth–thirteenth centuries). The decorations on the stylized structure, as well as the appearance of bodhi leaves and a pair of birds above the Buddha, clearly indicate the stylistic source of these motifs in the mural painting in the treasure room. The images are now on display in the Chao Sam Phraya National Museum, Ayutthaya. For pictures of these images, see figs. 3 and 4 in *Phraphuttharup lae phraphim*. Also see Schroeder, *Buddhist Sculptures*, 113–114.

14 Geiger, *Culture of Ceylon*, 204.

15 For further study of the architectural structure of Wat Ratchaburana, see Santi, *Chedi rai song prasat yot.*

16 At present, although these three images are badly damaged, some decorative motifs are still partially visible. Each Buddha was once flanked by a pair of vases with long-stemmed flowers. This motif is closely related to those depicted on the walking Buddha type of votive tablets deposited in the main crypt (see fig. 77).

17 *Phraphuttharup lae phraphim*, figs. 1, 2. Compare Huntington, "Pala-Sena" Schools, fig. 131.

18 *Ye Dharma* (Pali: *Ye Dhamma*) are the first two words of a Buddhist creed that concisely summarizes the essence of the Buddha's teaching. It was very popular to include the *Ye Dharma* on Buddhist artifacts during the Pala-Sena period in India. In Thailand, it was quite common before the time of Sukhothai kingdom. With the rise of Sri Lankan monastic lineage among Thai kingdoms, the practice of inscribing the *Ye Dharma* declined.

19 Twelve metal votive tablets are inscribed on the back. Nine are written in Thai script and three in Cambodian script. The ones in Thai script give the names of donors with both male and female names. The Cambodian tablets are inscribed only with the word *namo*, which means "homage." *Chittrakam lae sinlapawatthu*, 63.

20 This type of dedication was a common birthday greeting in China. Another common dedication was "Good fortune like the Eastern Ocean."

21 Private communication. The characters are shown in *Phraphuttharup lae phraphim*, 42 and figs. 512–515.

22 Early Ayutthaya Buddha images of the type described used to be called "U Thong C style" or "third period of the U Thong style." See, for example, Bowie, Subhadradis and Griswold, *Sculpture of Thailand*, 108; Subhadradis, *Art in Thailand*, 19.

23 Woodward, *Sacred Sculpture*, 180.

24 For further information on votive tablets, see Pattaratorn, *Votive Tablets* and "Buddhist Votive Tablets."

25 Images of this type were common in Angkor and the provincial regions of Angkor in present-day Thailand by the twelfth century. For further information see Woodward, *Sacred Sculpture*, 80–81.

26 Pattaratorn, *Votive Tablets*, 40–49. Hevajra Mandala tablets have been recovered mainly in Cambodian temples in the northeastern region of Thailand such as Lopburi, and in Cambodia. Metal sculptures of Hevajra and his accompanying yoginis were also popular in this region.

27 It is interesting that these Cambodian tablets were made of pewter, a medium not commonly used prior to the dedication of this temple, but were produced in the style of twelfth century tablets.

28 For further information on the Sukhothai walking Buddha, see Brown, "God on Earth."

29 *Phraphuttharup lae phraphim*, fig. 158. A similar tablet was found in Wat Phra That, Suphanburi. See Manat, *Phra kru muang suphan*, 5. It is interesting that the deposits of votive tablets from this temple are closely related to those in the Wat Ratchaburana. It may indicate that these deposits were made during the reign of Borommaracha II.

30 The Fine Arts Department used the proceeds from the sale of the Ratchaburana images to build the Chao Sam Phraya National Museum in Ayutthaya. Those who donated 200 baht (about US $10 at the time) received this type of tablet.

31 The Sihing type of Buddha image is seated with legs interlocked and hands in the gesture of calling the Earth as a witness during the victory over Mara. The face has distinctively round features, wide-open eyes, and large round hair curls topped with a lotus bud-shaped radiance. For further information, see Woodward's essay in this volume and his *Sacred Sculpture*, 211–215.

32 According to the Chronicles of Nakhon Si Thammarat, a Sihing image was given to the ruler of Tambralinga by the Sinhalese king during the second half of the thirteenth century. It was eventually taken to Sukhothai and then to Chiang Mai in the late fourteenth century. For more information about Sihing images, see Woodward, "Emerald and Sihing Buddhas."

33 Woodward, *Sacred Sculpture*, 115.

34 For further information on the gold deposits of Wat Ratchaburana, see Pattaratorn, "Gold Deposits."

35 For further information, see *Kru mahasombat*, 22.

36 According to the looters' accounts, they first dug into the crypt through the southern wall and the tables were found placed in the north, east, and south niches. However, the Vice Director of the Fine Arts Department at the time, Krit Indralakosai, who directed the archeological investigation immediately following the break-in, stated that they were originally in the north, east, and west niches. *Kru mahasombat*, 20–26.

37 According to the looters' list, twenty images were in the east niche and twenty-five in the south. The west niche reportedly contained three large images and two bags full of votive plaques, one of gold and the other of silver plaques. A large number of these images were retrieved. The looters mentioned a "great crown" on the list. In my opinion the so-called "great crown" referred to King Intharacha's royal regalia rather than those of his two sons or Borommaracha II. Traditionally the king wore a "great crown" (*mahamongkut*) when he was in an important official state ceremony such as a coronation. Because Borommaracha II still needed his royal regalia for such ceremonies, miniature regalia of a gold fly whisk, a shoe, and two types of fans were deposited in the crypt.

38 For examples of this type, see *Phraphuttharup lae phraphim*, 57–58.

39 Some rings, believed to have come from the channel along the perimeter of the raised platform in the treasure room's center, show signs of wear. Since these rings are also simpler in design than the others, they might have been donations from the common people of Ayutthaya.

40 The *Mahavamsa*, written by a monk named Mahanama of the Mahavihara temple, is a valuable source for the early history of Buddhism in Sri Lanka. Bullis, *Mahavamsa*.

41 Vacissara, *Chronicle of the Thupa*, 64.

42 Vacissara, *Chronicle of the Thupa*, 59–60. Although the text does not list the specific kinds of insignia, the reference implies that it was common for kings and other royal persons to deposit insignia of royalty in stupas.

43 Private communication.

44 Geiger, *Culture of Ceylon*, 204.

45 Geiger, ed., *Mahavamsa*; see chapter 30, "Preparation/Decoration of the Relic Chamber."

46 Vacissara, *Chronicle of the Thupa*. The *Thupavamsa* consists of thirty-seven chapters. Chapters 4 and 15 give detailed information about the enshrinement of the relics, and Chapter 14 concerns the figures in the relic chamber. Chapters 29 and 30 deal directly with the beginnings of the Great Stupa – the *Mahathupa* – and the making of the relic chamber, respectively. It lists the thirty-two life episodes, the jatakas, with an emphasis on the Vessantara Jataka in the relic chamber.

47 Vacissara, *Chronicle of the Thupa*, 273–274.

48 In any case, when the looters broke into this room, it was completely packed with gold jewelry and Buddha images, therefore the mural paintings would have been completely covered.

49 Twenty standing figures of the Great Disciples appear on each register of each wall.

50 The lives of the twenty-four Buddhas are related in a Pali text called the *Madharatthavilasini*; see Saeng, "Ruang phra adithaphut," 44–45.

51 Bullis, *Mahavamsa*, 272–274.

52 Bullis, *Mahavamsa*, 275.

53 For information about Wat Si Chum, see Woodward, *Sacred Sculpture*, 148–149 and a forthcoming book entitled *Jataka Reliefs of Wat Si Chum*, edited by Peter Skilling. The reliefs are illustrated in *Prachum sila charuk*, vol. 5.

54 No. Na Paknam, *Chittrakam ayutthaya*, 39–40.

55 I am grateful to He Li, an associate curator specializing in Chi-

nese ceramics at the Asian Art Museum, for helping to identify this type of jar.

56 Prapod Assavavirunhakan, private communication.

57 It was common for a Cambodian king to build a temple to mark the symbolic center of his kingdom. Thus, the center of the kingdom sometimes changed after a reign ended.

58 The *Lilit Yuan Phai*, dated to the fifteenth century, refers to the king as being well versed in the Vedas as well as the three gems of Buddhism. See Griswold and Prasert, "Siamese Historical Poem."

59 Fine Arts Department, *Chittrakam lae sinlapawathu nai kru phraprang wat ratchaburana*, 60

60 This object is on the list of National Treasures of Thailand. Unfortunately, it could not travel outside of Thailand for this exhibition.

61 *Chittrakam lae sinlapawatthu*, 22–28.

62 The great possessions of the Universal Monarch (*chakravartin*) consisted of his minister, wife, general, wheel, jewel, horse, and elephant.

63 Geiger, *Culture of Ceylon*, 204.

64 For further information about the Wat Mahathat deposits, see *Mahathat*.

65 The only information we have about what was in the treasure room comes from the looters' list. For more information, see Prathum, *Khruang thong*, 39.

66 These are on display in the "Gold Room" in the Chao Sam Phraya National Museum, Ayutthaya.

67 *Chittrakam lae sinlapawatthu*, 58.

68 G. Coedès attributed the image to the Ayutthaya period; "Une statue de princesse."

69 Chin Youdi, "Kruang pradap sian."

70 It would be interesting to compare gold analyses of the female headdresses from the collections of the Chao Sam Phraya National Museum and the Philadelphia Museum.

71 These were present in large numbers. Some are plain and others are elaborately embellished with incised decorations. The large ones are hollow, and the small ones are solid gold.

72 Over one hundred toe rings were found.

73 Many long necklaces were made by the loop-in-loop technique, and many still hold the original precious and semiprecious stones. For further information, see Richter, *Jewelry*, 90.

74 The nine gems consist of pearl, ruby, topaz, diamond, emerald, coral, sapphire, cat's eye or moonstone, and sardonyx. The tradition of using nine-colored gems on jewelry such as conical-shaped rings and long necklaces was popular in Thailand until the 1950s. See McGill, *Prasatthong*, 139–140.

75 Ceramic goods were important exports that continued to be produced even after the north central Thai kingdom of Sukhothai lost its sovereignty to Ayutthaya. For further information on the ceramics of Sukhothai and Si Satchanalai, see Brown, *Ceramics*.

76 Similar deposits of gold sheets have been removed from Wat Mahathat in Ayutthaya, as well as from Cambodian temples.

พรพิทูรบรรพ์ยักภูเขาไป ๚

Ayutthaya Painting

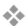

Henry Ginsburg

Many hundreds of Buddhist temples were constructed during the Ayutthaya period, at the capital and throughout the kingdom, over the course of four hundred years. The Ayutthaya kingdom was a wealthy one, with highly developed arts and architecture.

We can presume that fine manuscript painting, banner painting, mural painting, and pictorial lacquer all flourished extensively as adornments to temples. But surviving examples of Ayutthaya painting are extremely few. A handful of temples still have some remains of mural painting, a very small number of banner paintings survive, and a small number of lacquer chests painted in lacquer and gold remain. The survival of paintings found in Buddhist manuscripts of the Ayutthaya period probably comprises the richest resource from which we can try to form a picture of what was clearly a superb painting tradition.

MANUSCRIPTS

Illustrated manuscripts from the Ayutthaya period provide the best source of knowledge about Ayutthaya painting, because a small number of excellent examples of manuscript painting have survived, dating from the seventeenth and eighteenth centuries. The paintings in them are often well preserved, with their original colors intact, enabling us to see the paintings as they were when they were painted, as is generally not possible with mural or banner paintings. The ravages of war, neglect, climate, and damage from insects and rodents worked havoc on old Thai manuscripts, but the actual paintings in them are rarely tampered with or altered by later generations. The finest artists of the time must have worked on the illustrated manuscripts, and we are fortunate indeed to have them as partial witness to the art of painting in Ayutthaya.

The scale of manuscript paintings is small. Individual paintings are placed at the two ends of a page, separated by the text in the middle, and are only a few centimeters in height and width. In all perhaps fewer than fifty illustrated folding book manuscripts are known today. During the final Burmese invasion of the capital at Ayutthaya in 1767 nearly all temples and their libraries were burned and sacked. The manuscripts that survive reveal an art of exceptional delicacy of drawing and use of color, and a vivacity not matched in the painting of the Bangkok period, although high-quality painting was produced until the early twentieth century. Happily, many of the finest surviving manuscripts have now been published in Bangkok, by the Fine Arts Department of the Ministry of Education, by the Office of the Prime Minister, and by Muang Boran Publishing House.

Illustrated Thai manuscripts are mainly of the "folding book" type. The folding books are made from long sheets of sturdy Thai paper, which are folded back and forth accordion style and then joined to other sections folded in the same way to a required length. The locally produced Thai paper provides an excellent ground for the text and paintings, though it is not nearly as fine as the higher quality papers produced in India and western Asia. The folding book format was used in Burma, Cambodia, and Laos, and in Nepal, Tibet, China, and southern India.

We can only guess at what date the Thai folding book was first introduced, since the oldest surviving Thai example dates back just to the seventeenth century. It is quite possible, however, that such books may have been made in the early Ayutthaya period.

The format of the Thai folding book derives from that of books made of palm leaf, which date back in Indian and Himalayan usage perhaps two thousand years. Such palm leaf manuscripts are made of long, narrow leaves that offer a limited area for painting. Exquisitely painted palm leaf manuscripts were produced in Nepal and eastern India in the ninth and tenth centuries. Thai palm leaf manuscripts also were also occasionally painted, and some examples have survived.[1]

Fig. 90. The sage Vidhura is carried through the air holding the tail of a demon's flying horse; a scene from one of the last ten previous lives of the Buddha, cat. no. 72.

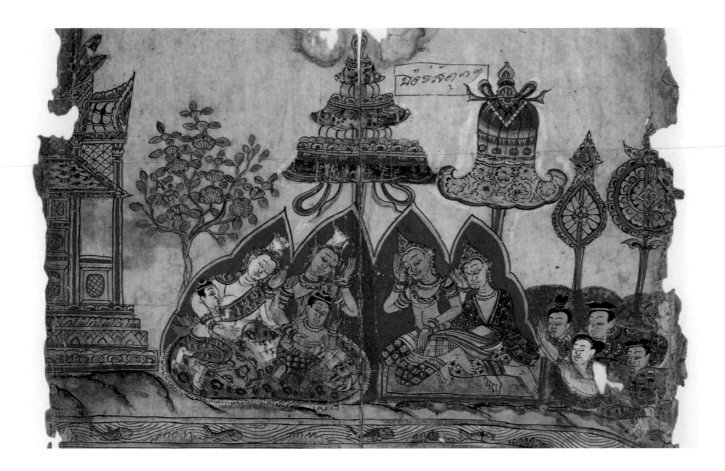

Fig. 91. Prince Vessantara and his family weep for joy at their reunion, from a manuscript with paintings of the Three Worlds, National Library, Bangkok.

Facing page, top: fig. 92. The sage Mahosadha, from a manuscript with paintings of the last ten previous lives of the Buddha, cat. no. 73. Bottom: fig. 93. Jujaka drives Prince Vessantara's children along, from a manuscript with paintings of the last ten previous lives of the Buddha, cat. no. 73.

While no specific illustrated examples can be dated to the Ayutthaya period, they were probably also made then.

The changing format of one particular type of Thai folding book manuscript during the course of the eighteenth century clearly indicates that the early folding books were based on the palm leaf ones. This was the main type of manuscript produced in this period and contained a text of Buddhist sutras written mainly in the Pali language. Seven texts from the Abhidhamma scriptures of the Buddhist canon are the content of these illustrated manuscripts. The earlier examples are extremely long and narrow (60 to 66 cm wide by 8 to 11 cm high), resembling the format of the palm leaf manuscript. By the late eighteenth cen-

tury, however, this type of folding book was clearly changing in its dimensions, becoming both wider and higher (65 to 68 cm wide by 12 to 15 cm high).

One of the earliest manuscripts is the richly illustrated Three Worlds (Traiphum) manuscript of Buddhist cosmology, most probably of the seventeenth century, now in the National Library in Bangkok (fig. 91).[2] Although many areas are badly worn and frayed, its vibrant colors and superb drawing survive unharmed in many other areas of the manuscript. The drawing style is not highly refined, but the quality of the painting is full of wonderful vitality and exuberance. The text in this manuscript is in the Thai script and in the Thai

language, whereas the Pali language and Cambodian script are typical of many Ayutthaya Buddhist manuscripts. The Three Worlds' subject matter is comprehensive and includes depictions of the world, the heavens and hells, and the life and previous lives of the Buddha. These subjects are all richly illustrated by the artists who created it. Other Thai illustrated cosmology manuscripts dating from the eighteenth century are also preserved in the National Library in Bangkok. They are less free in their painting style[3] and lead on stylistically to three dated cosmology manuscripts that were made in 1776 (including one now in Berlin, cat. no. 79), shortly after the fall of Ayutthaya, and they represent and important step in the attempt

to reconstruct the main documents of Ayutthaya art during the period closely following the destruction of the old capital and kingdom.

Abhidhamma manuscripts illustrated with ten tales from the previous lives of the Buddha (*jatakas*) contain Buddhist scriptures written in the decorative thick Cambodian script called Mul. The text in the Pali language is drawn from the seven parts of the Abhidhamma scriptures, one of the three main sections of the Buddhist canon. The illustrations are mainly of the ten tales of the previous lives of the Buddha (*sip chat* in Thai), and also of charming nature scenes in the Himavanta forests lying on the lower slopes of Mt. Meru, the cosmic mountain leading up to the Buddhist heaven, regions inhabited by a variety of wondrous creatures. The text does not relate specifically to the illustrations. The Pali texts of the tales of the previous lives of the Buddha in fact come from another part of the Buddhist canon, called the Khuddhaka nikaya section ("Division of small books") of the Suttapitaka. The texts of the tales of the previous lives are generally written on palm leaves rather than on folding books. These palm leaf canonical texts of the tales of the previous lives are not illustrated.

One of the finest of the Abhidhamma manuscripts typical of the late Ayutthaya period is dated to the year 1743. It was preserved at Wat Sisa Krabu in Bangkok. In fact so far it is the only known Ayutthaya-period illustrated manuscript that is dated. Its date, together with its superb quality, make it a crucial document for the study of Ayutthaya manuscript painting.[4]

The sensitivity of color and drawing in this manuscript is unsurpassed. Its gold and lacquer covers are characteristic of many decorated Thai manuscripts, and the illustrations are of deities, heavenly beings, and her-

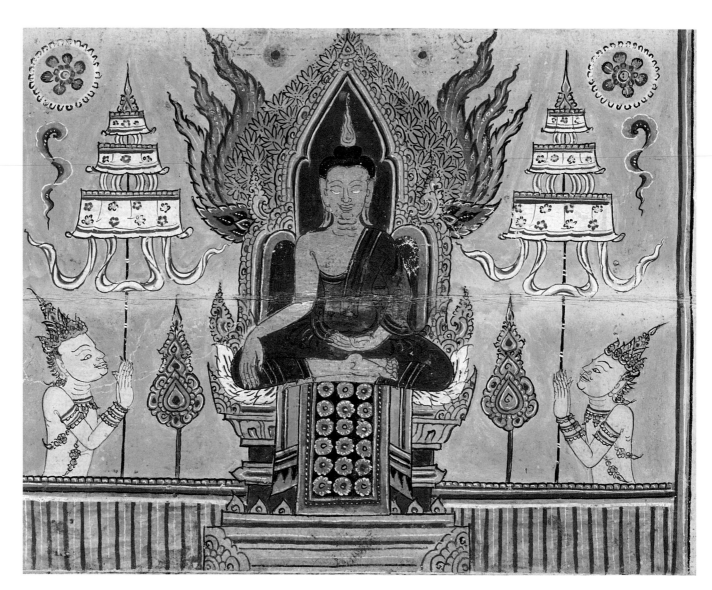

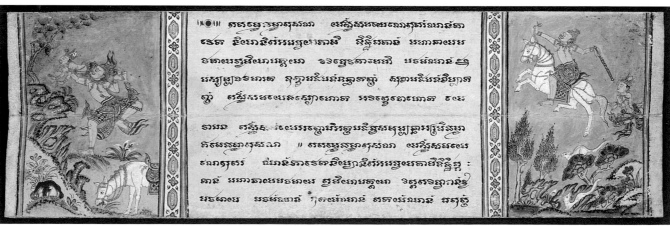

Above, top: fig. 94. The Buddha enthroned, from a manuscript with paintings of the last ten previous lives of the Buddha, cat. no. 77. Bottom: fig. 95. Two scenes from the story of the sage Vidhura, from a manuscript with paintings of the last ten previous lives of the Buddha, cat. no. 77

Facing page, top: fig. 96. Mahosadha tests his prospective wife, from a manuscript with paintings of the last ten previous lives of the Buddha, cat. no. 75. Bottom: fig. 97. Indra, invoked by Chandakumara, prevents the monstrous sacrifice, from a manuscript with paintings of the last ten previous lives of the Buddha, cat. no. 75.

mits. Their clothing is lavishly depicted and the color range is particularly subtle and varied. The forest settings depict many wondrous animals.

Several other Abhidhamma manuscripts with illustrations from the tales of the previous lives of the Buddha are comparable in style to the Sisa Krabu manuscript, and presumably comparable in date as well. Most of them are also of superb quality. (Five such manuscripts are included in this exhibition.)

The manuscript of tales of the previous lives of the Buddha in the Hofer Collection of the Arts of Asia in the Harvard University Art Museums (figs. 92, 93) also exhibits superb drawing and color. Each scene is composed and drawn in a masterly way. As in the 1743 manuscript the artist's color choices are impressive. Quite dark hues of blue-gray fill most of the backgrounds, where the 1743 backgrounds are more varied, and mainly in light colors. The high ranking or noble figures in both manuscripts are extremely dignified, and dressed in superb garments that represent the finely painted Indian painted cotton textiles made to order for the Thai market in the early eighteenth century (cat. nos. 82–84).

The soldiers and palanquin bearers in the Harvard manuscript wear striped trousers that end below the knee, a garment similar to ones found in the earliest *Three Worlds* (Traiphum) cosmology manuscript mentioned above. Women attendants appear to wear long lower garments with stiffened and pleated end flaps, a feature that may indicate an earlier and archaic style of clothing, although it is also shown in the 1776 Berlin *Three Worlds* manuscript. Hair styles are distinctive, but similar to those in the other manuscripts of tales of the previous lives of the Buddha. The 1743 dated manuscript does not include any figures of common people, so direct comparisons cannot be drawn here. In short, it is difficult at this early stage of our knowledge to determine whether the Harvard manuscript is earlier or later than, or nearly contemporary with, the dated 1743 manuscript.

The artist of the Harvard manuscript includes unexpected touches of humor in his depictions. In the chess game from the story of Vidhura that is shown in the same manuscript, a small child's head appears from above the prince's ceremonial umbrella,[5] Another infant peeps out most incongruously from a little hammock above the hell scene in the Nimi tale.[6] These touches do not form any part of the narrative of the stories. Indeed the facial expressions of the victims of hell's torments are in some instances positively cheerful, or otherwise neutral.

Such humorous elements are an indication of how the Thai artists here, and also in other surviving Ayutthaya

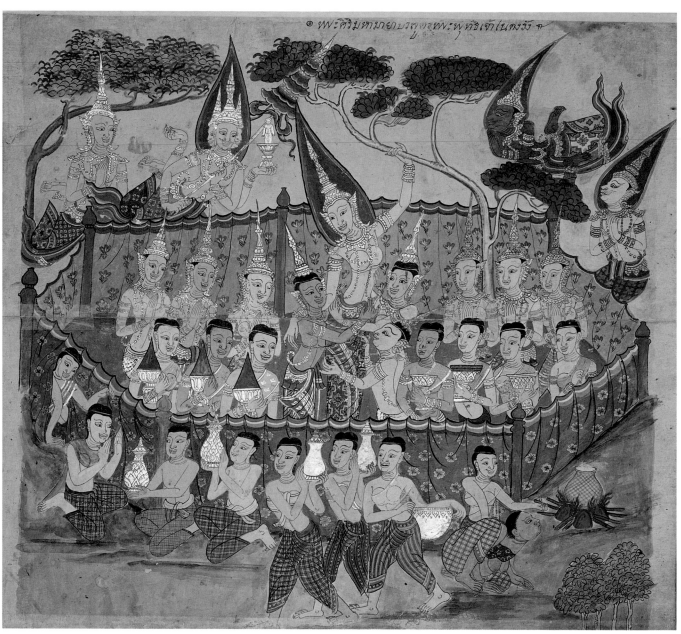

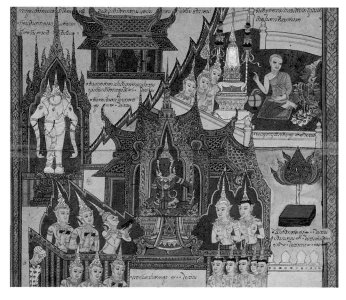

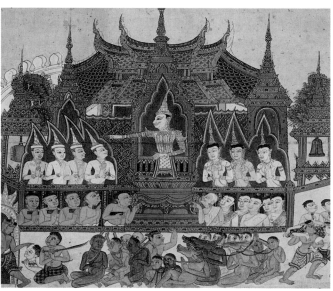

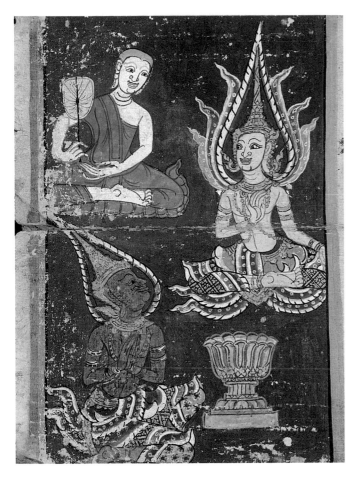

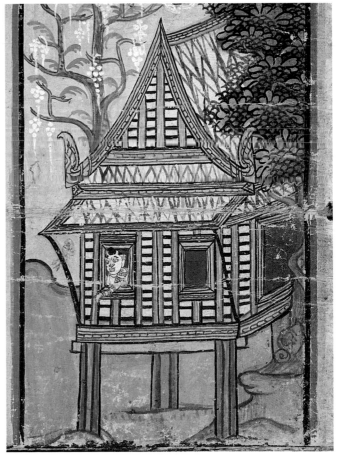

Facing page, top: fig. 102. The birth of the Buddha-to-be, from a manuscript with paintings of the Three Worlds, *cat. no. 79. Bottom left: fig. 103. Indra's heaven, from a manuscript with paintings of the* Three Worlds, *cat. no. 79. Bottom right: fig. 104. The realm of the judge of the dead, from a manuscript with paintings of the* Three Worlds, *cat. no. 79.*

This page, top left: fig. 105. Indra, Phra Malai, and Maitreya, the Buddha of the future, from a manuscript with scenes from the story of the holy monk Phra Malai, cat. no. 80. Atypically, Phra Malai is shown with his left shoulder (viewer's right) instead of his right shoulder uncovered. Top right: fig. 106. Phra Malai flies heavenward, from a manuscript with scenes from the story of the holy monk Phra Malai, cat. no. 80. Bottom right: fig. 107. A rural house, from a manuscript with scenes from the story of the holy monk Phra Malai, cat. no. 80.

Here is a rare glimpse of the working methods of the artist. We can guess that paintings were produced in workshops with several versions produced at one time, and in this case in more than one format. Or an artist may have worked alone, or with a few assistants. The rare survival of these scenes in two forms, on paper and on cloth, suggests a multiple production system, or at least that the artist wanted to duplicate a painting for a second client or usage. The differing expressions on the face of the hero in the two versions may have had a specific implication, or it may simply have been a matter of the artist's inclination.

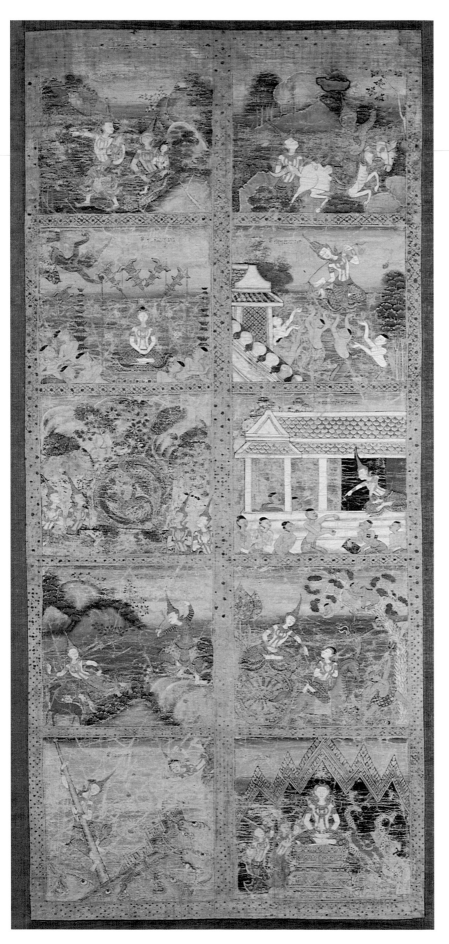

MURAL PAINTING

Murals that survive from earlier Ayutthaya temples are found in inner cells of structures such as stupas or towers, and in crypts lying below them. Remains dating from the fifteenth century can be seen in Ayutthaya itself, at Wat Mahathat (fig. 109), Wat Rajaburana (fig. 110), and Wat Phra Ram, and in the city of Ratburi at Wat Mahathat. They are all in very poor condition. Buddhas of the past were depicted in rows along the walls of the crypts constructed below the central towers of these temples. The scholar No. Na Paknam suggests that in the early Ayutthaya period wall surfaces of enclosed structures were constructed with so many openings that there was not enough space for mural painting.[13] By the seventeenth century, and perhaps earlier, we find that the assembly halls of temples have inner walls covered with murals, but only very few survive. Many more temple murals must have been lost.

Studying the early murals at Wat Ratchaburana, created in the fifteenth century, we find fourteen seated Buddhas of the past adorning a crypt wall, and on the facing wall there are traces of a further fourteen Buddhas. Beside each seated Buddha are figures of disciples. Rows of standing disciples appear below the Buddhas of the past (fig. 110), along with scenes from tales of the previous lives of the Buddha (fig. 84). Most of these murals are either heavily worn or virtually obliterated, and we can only study fairly small areas of painting that are still visible. At Wat Mahathat in Ratburi rows of Buddhas of the past, with disciples between them, still exist on the walls of the crypt, though in very poor condition. These tantalizing glimpses give us at least some notion of early Thai murals. They seem to develop out of the traditions of mural painting at Pagan and elsewhere in Burma, which are earlier in date and yet much better preserved.

Thai murals were not painted on plaster walls while they were wet, as in European fresco painting. The wall surface was carefully prepared with plaster, which was

Facing page: fig. 108. Banner painting with scene from the last ten previous lives of the Buddha, approx. 1825–1875, Asian Art Museum, Gift from Doris Duke Charitable Foundation's Southeast Asian Art Collection, F2002.27.73.

Above left: fig. 109. Frame for a Buddha image, surmounted by the bodhi tree, possibly 1350–1400, northwest subsidiary prang, Wat Mahathat, Ayutthaya. Right: fig. 110. Row of disciples, approx. 1424, crypt, Wat Ratchaburana, Ayutthaya.

allowed to dry completely. Efforts were made to reduce salt content in the wall surface, and a preparation of boiled tamarind seeds served to bind the new surface. Then the murals were painted on it, mixed with water-soluble tempera binding agents such as egg yolk.

Thai mural painting is not long lasting, since the constituent materials are easily damaged by water and excessive humidity, elements that are constantly a problem in Thailand's tropical climate. For this reason the murals deteriorated so rapidly, often within only a few decades, that they were extensively repainted in damaged areas, or else entirely. The repainting and renovation process could occur several times over the years. By this process the original paintings could be completely lost.

This leaves us with the problem of determining which parts of the restored murals (if any) are original and which are repainted. The repainting can be partial, just filling in and altering the background areas, and repainting those figures that have deteriorated. Or entire scenes may be repainted.

In the earlier temples, murals illustrated the Buddhas of the past, the disciples, and some tales from the previous lives of the Buddha. But later on, perhaps in the sixteenth century, and more surely in the seventeenth, the world and heavens according to Thai Buddhist cosmology were graphically illustrated, usually on one of the end walls of the ordination hall. These illustrations were combined with scenes from the life of the Buddha on the longer side walls, and scenes from his ten previous lives. At the top of the side walls above these narrative scenes stretched a row of Buddhas of the past, or of heavenly beings, called *prachum thewa* (assembly of divinities).

Today we know of the former role of mural paintings in the temple from the evidence of a very small number of temples that survive with their murals intact, or at least partly intact. In a few instances we find that there was no repainting of the murals. The condition of such murals can range from adequate to very poor.

Two temples in the city of Phetburi, to the west and south of Bangkok, retain Ayutthaya-period mural paintings that have not been significantly altered. The first of these, Wat Yai Suwannaram, preserves painting along an entire wall of the ordination hall that is not broken up by any windows. The wall is filled with rows of divinities, including devas, demons, garudas, and hermits (fig. 111). The space between the figures is filled in with exquisite floral decorations.

The backgrounds at Wat Yai Suwannaram are the light color of the priming of the wall, although red is a ground color in some areas.

Another temple at Phetburi, Wat Ko Kaeo Suttharam, preserves in its ordination hall further precious examples of Ayutthaya mural painting that are dated in an inscription on the wall to the year 1734, during the reign of King Borommakot (1733–1758) (fig. 112). On the wall behind the Buddha images in the ordination hall is depicted the victory over Mara, as at Wat Yai Suwannaram, while the side walls incorporate scenes of the Buddha's life (fig. 113). These scenes are set into vertical triangular panels, each scene surmounted by a five-tiered ceremonial umbrella. These panels alternate with other panels containing stupas, each with a standing Buddha in a niche in the body of the stupa.

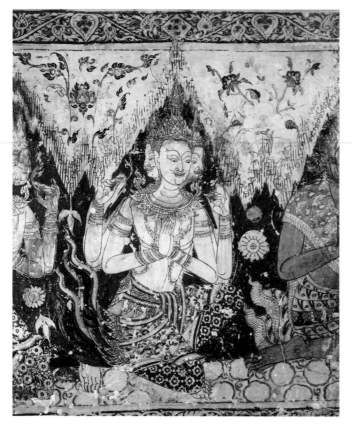

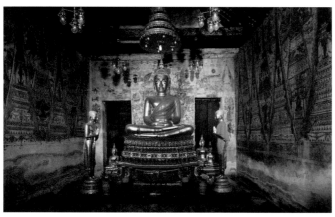

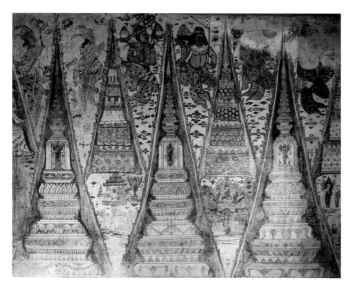

The color range is quite limited, comprising red, ochre, black, white, and green, with the addition of gold leaf. Other colors may have been available to the artists at wealthier temples. As Ayutthaya was the center of an extensive international trade, imported pigments would certainly have been available there. At Phetburi, however (and at Wat Chong Nonsi in Bangkok, discussed below), the palette is limited to colors readily available from local materials.

Certain other temples should also be studied in trying to identify Ayutthaya mural painting. These are temples in which the murals have been heavily reworked, perhaps more than once, yet they can still reflect the composition of the original scenes, and some of the figures may also be largely as they were originally painted. The background is often dramatically altered by the addition of sombre ground colors and natural features such as rockery, plants, and trees. An unattractive dark green color is a feature of backgrounds in the nineteenth century, and in repainted murals from earlier periods. An example is Wat Khian at Ang Thong. Determining which elements of the murals are older and which newer is often extremely difficult, so we should focus on the very few temples where the murals have not been extensively repainted. Of these, some have deteriorated to the point where it is difficult to see anything remaining, such as those in Wat Prasat in Nonthaburi, and Wat Mai Prachumphon near Ayutthaya.

A notable exception occurs in Wat Chong Nonsi in Bangkok where the small ordination hall retains its murals in fair condition and largely unaltered. Chong Nonsi is familiar today as a station on the Bangkok Sky Train located north of Silom Road. The temple itself lies about two kilometers to the south of the station. When first built, Wat Chong Nonsi was a rural temple beside a small canal close to the Chaophraya River, about seven kilometers downriver from the original settlement of Bangkok, an area that grew much later into the modern city. The ordination hall (*ubosot*) at Wat Chong Nonsi, which is the only main structure to survive from the Ayutthaya period, is simple in form and small in scale, a rectangular building containing a single chamber with small windows on each side wall, and a porch with a single door for entry. The windows and the door are surmounted by a pointed arch, typical of the late Ayutthaya style. Pilasters and columns on the porch end of the building terminate in lotus-decorated capitals. The base of the structure has a pronounced bowed curve, creating a boatlike shape.

The surviving murals in the ordination hall at Wat Chong Nonsi have apparently not been subject to changes or revision over the years. Consequently they accurately illustrate mural painting of their period, which is probably the late seven-

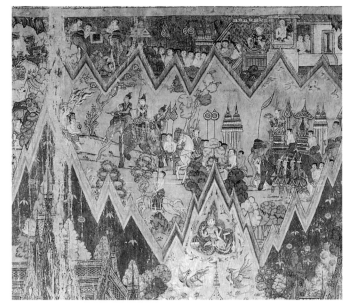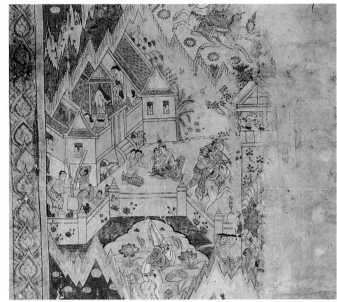

Facing page, top: fig. 111. A Brahma deity, approx. late 1600s–early 1700s, ordination hall, Wat Yai Suwannaram, Phetburi. Middle: fig. 112. Interior of the ordination hall, 1734, Wat Ko Kaeo Suttharam, Phetburi. Bottom: fig. 113. Scenes from the life of the Buddha and stupas, 1734, Wat Ko Kaeo Suttharam, Phetburi.

This page, left: fig. 114. Scenes from the story of Narada, approx. late 1600s–early 1700s, ordination hall, Wat Chong Nonsi, Bangkok. Right: fig. 115. Scenes from the story of the sage Vidhura, approx. late 1600s–early 1700s, ordination hall, Wat Chong Nonsi, Bangkok.

teenth or early eighteenth century. Although all the paintings on the lower sections of the walls have been completely lost, leaving no traces of the original work, most upper parts of the murals survive in a fairly good state, enough to give us quite a good idea of their original appearance. The murals on the side walls at Wat Chong Nonsi depict the tales of the ten previous lives of the Buddha (figs. 114, 115). On the wall on the entrance side appears the victory over Mara, with the flood created by the earth goddess Nang Thorani to drown the forces of evil.

Due to the total deterioration of the wall surface on the last wall, which is located behind the altar with its assembled Buddha images, only a fragmentary scene of the great departure of the Buddha-to-be from his father's palace can be identified.

These murals display several obvious characteristics of Ayutthaya mural painting – first, that the background is not colored but usually white. (Red is also sometimes used as a ground color.) Sections of the narrative parts of the murals are characteristically divided by zigzag bands, called *sinthao* in Thai. These stylized divisions are not found in other types of Asian painting. Their use in Thai painting continues throughout the eighteenth and nineteenth centuries. We can only conjecture when they first came into use, and whether they were introduced from elsewhere or invented by the Thai. Faces and figures are drawn with distinct characteristics of their period. When we compare them with figures painted

in the Bangkok period (1782–present) we find that although the basic elements and conventions of Thai figural drawing continue to be used in a similar way, the effect is different. The Ayutthaya artist generally draws with a free hand where the Bangkok artist's hand is more controlled, tighter, and less expressive. Color is another area where there were many changes, as well as details of clothing, hair style, and architecture. By the end of the nineteenth century Thai painting tends to be quite formulaic and dry, although the best artists were still capable of exquisite workmanship.

NOTES

1 Ginsburg, *Thai Manuscript Painting*, pl. 20.
2 *Samutphap traiphum chabap krung si ayutthaya – chabap krung thonburi*, vol I.
3 *Samutphap traiphum chabap krung si ayutthaya – chabap krung thonburi*, vol I.
4 *Chittrakam samai ayutthaya chak samut khoi*, 62–79, and *Samut khoi*, 322–355.
5 Ginsburg, *Thai Manuscript Painting*, 63
6 Ginsburg, *Thai Manuscript Painting*, 55
7 Ginsburg, *Thai Manuscript Painting*, 62.
8 Ginsburg, *Thai Art and Culture*, 54–57.
9 Ginsburg, *Thai Art and Culture*, 58.
10 Ginsburg, *Thai Art and Culture*, 72–73.
11 Ginsburg, *Thai Art and Culture*, 93–97.
12 Boisselier, *Thai Painting*, 126–127.
13 No. Na Paknam, *Chittrakam samai ayutthaya ton klang lae ton plai*, 12.

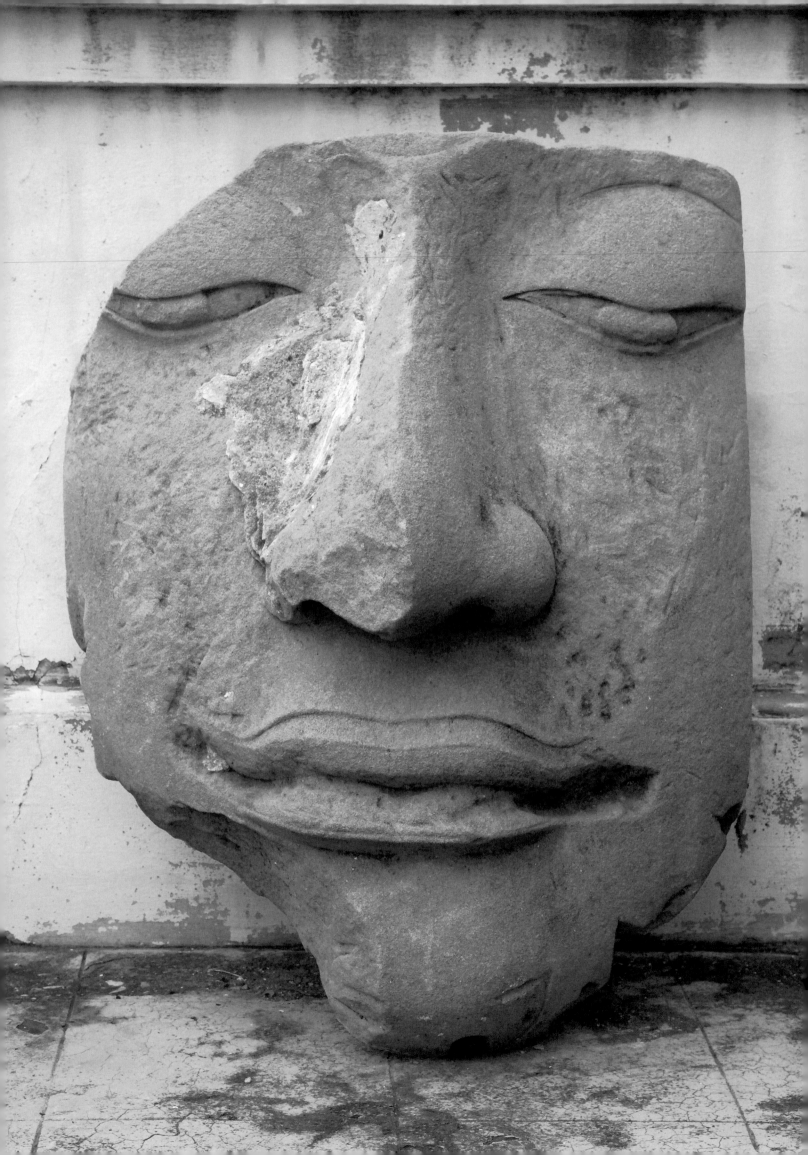

Objects in the Exhibition

Forrest McGill

(unless otherwise noted)

1

SEATED BUDDHA, APPROX.
1350–1400 (FIG. 86)
*Found in the crypt of the main tower
of Wat Mahathat, Ayutthaya*
Gold foil over resin-impregnated
woody material
H: 18 CM; W: 14 CM
Chao Sam Phraya National
Museum, Ayutthaya, M66/1

Ayutthaya's most important temple, Wat Mahathat, is said by the Chronicles to have been founded in 1374 when its great Cambodian-type tower was built.[1] This image was discovered in the crypt of the tower, excavated in 1956, and could well have been made not long before it was deposited. Today, Wat Mahathat's tower has largely disappeared, but old photographs show it before it collapsed.[2]

The square face, eyes cast forward rather than down, wide mouth with what might be a mustache along the upper lip, the band (or here double band) at the hairline, and the robust body – all are characteristics of the sculpture of Ayutthaya's first decades.

1 Cushman, *Royal Chronicles*, 12.
2 A description of the main tower of Wat Mahathat, an account of the excavation of the crypt, and an old photo of the tower intact are found in Sunait, *Ayutthaya Gold*, 41–47.

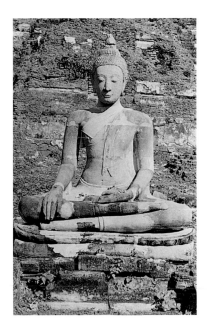

Fig. 117. *Reassembled stone Buddha image, Wat Mahathat, Ayutthaya.*

2,3

LARGE STONE HEADS OF
BUDDHA IMAGES FROM WAT
MAHATHAT, AYUTTHAYA

These stone faces, from seated images that must have been approximately seven meters (twenty-three feet) tall, are said by Woodward to "provide the best evidence for the normative Early Ayutthaya style."[1]

Stone was not plentiful around the city of Ayutthaya, and its temples were usually constructed of brick and stucco. Whether this is entirely due to the scarcity of appropriate stone is not certain, however, because even though stone had been the primary material of Angkor's temples, those of Dvaravati, Sukhothai, Lamphun, Lan Na, and Pagan had generally been (or were being) built of brick. The architects of Ayutthaya may have been responding to cultural preferences as well as to the availability of materials.

Stone was sometimes used for sculpture in early Ayutthaya, but for whatever reasons seems largely to have gone out of use by the mid 1400s (but see cat. no. 36). Large stone sculptures were put together of a number of blocks, and the many surviving stone heads of Buddha images (for example, cat. no. 4) have probably not been sawn off their bodies, but were always separate blocks. Several large stone seated Buddha images constructed of blocks that had fallen apart have been reassembled in recent decades, giving us an idea how they originally looked (fig. 117). They must, however, have been covered with a layer of stucco (and perhaps lacquer) and were probably painted or gilded, so we still have to imagine their appearance when new.[2]

Woodward provides a fascinating, detailed discussion of the relation of these faces to the sculpture of Sukhothai and early Ayutthaya.

Fig. 116. Face of a Buddha image, cat. no. 2.

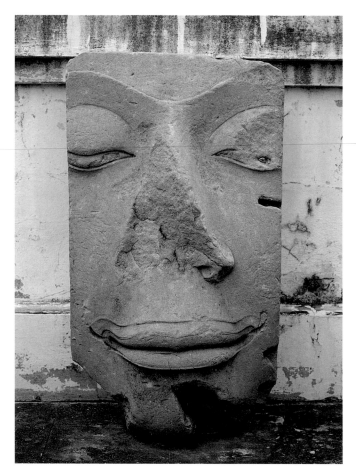 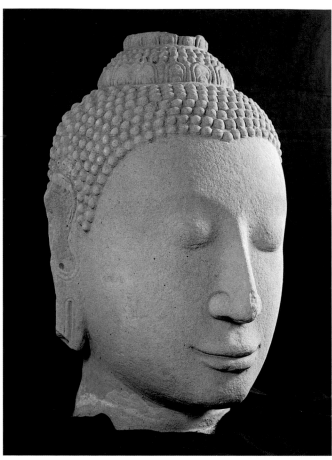

Left: fig. 118. Face of a Buddha image, cat. no. 3. Right: fig. 119. Head of a Buddha image, cat. no. 4.

1 Woodward, *Sacred Sculpture*, 178. In the 1970s these faces were still among the ruins of Wat Mahathat, Ayutthaya, together with fragments that may have been parts of the same statues.

2 Woodward, *Sacred Sculpture*, 178–181. A related, but even larger, and probably somewhat later, head of a Buddha in bronze, now at the National Museum, Bangkok, is illustrated in Boisselier, *Thai Sculpture*, pl. 126 (from the side), and in *Tai bijutsu ten*, fig. 97 (from the front). It would be interesting and useful to know where this huge bronze head came from, but apparently no records exist.

2

FACE OF A BUDDHA IMAGE, APPROX. 1350–1400 (FIG. 116)
From Wat Mahathat, Ayutthaya
Stone
H: 87 CM
Chao Sam Phraya National Museum, Ayutthaya

3

FACE OF A BUDDHA IMAGE, APPROX. 1350–1400 (FIG. 118)
From Wat Mahathat, Ayutthaya
Stone
H: 100 CM
Chao Sam Phraya National Museum, Ayutthaya

4

HEAD OF A BUDDHA IMAGE, APPROX. 1375–1425 (FIG. 119)
Stone
H: 89 CM, W: 53 CM
Chantharakasem National Museum, Ayutthaya, 223WCh/251

This head is similar in size and style to that of a reassembled stone Buddha image at Wat Mahathat, Ayutthaya (see fig. 117).

5

SEATED BUDDHA, APPROX. 1400–1450 (FIG. 76)
Copper alloy
H: 52 CM; W: 31.5 CM
Somdet Phra Narai National Museum, Lopburi, AT.2

Images of this type (though not this particular example) were found in some numbers in the 1424 crypt of Wat Ratchaburana in Ayutthaya.

6

SEATED BUDDHA, APPROX. 1400–1450 (FIG. 121)
Wood with traces of lacquer and gilding
H: 93.2 CM; W: 45 CM
National Museum, Bangkok, RS27

This image, carved from a single piece of wood, is one of the most elaborate and complete wooden sculptures surviving from early Ayutthaya.

The Buddha itself relates to other early Ayutthaya Buddha images of the oval-faced type such as cat. nos. 4 and 5 and fig. 117.[1] Its surrounding, a U-shaped arch above which rises a tree with symmetrically down-curving branches, recalls that of votive tablets like those found in the 1424 crypt of Wat Ratchaburana.[2] Cat. no. 10 is a similar example, although it may not be not from that location.

An unusual feature is the pair of parrotlike birds at either side of the arch. No other examples of Buddha images from Thailand are known with a pair of birds positioned in such a way, and in fact birds are very seldom associated with Buddha images at all. Rather similar pairs of birds do, however, appear in a few other contexts, such as on a ceramic roof ornament from Sukhothai, and a mural painting in the crypt of Wat Ratchaburana.[3]

Given the extreme rarity of pairs of birds being shown on the arch over the head of a Buddha image, it is startling to note their appearance on the U-shaped arch of a Buddha image from Sri Lanka found in the crypt of Wat Ratchaburana.[4] Few other Sri Lankan sculptures seem to have such birds, so

their parentage is not easy to trace. The ultimate source must be the art of the ancient Buddhist kingdom of Gandhara in today's Pakistan (fig. 120).

It appears that the pair of birds (together, perhaps, with the U-shaped arch) are another of the motifs adopted in Ayutthaya from Sri Lanka. (See the discussion in M. L. Pattaratorn's essay of the likely presence in Ayutthaya in about 1424 of Sri Lankan, Thai, and Cambodian Buddhist monks who had recently arrived from Sri Lanka.)

Some of the decorative motifs of this sculpture, such as the row of rosettes with bars in the base and the triangular

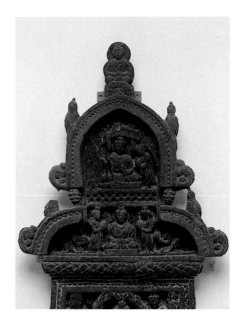

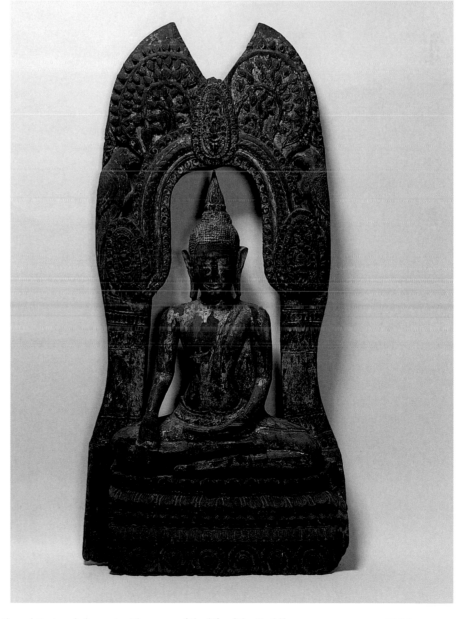

Top: fig. 120. detail, architectural element with scenes of the life of the Buddha, approx. 100–300; Pakistan; ancient region of Gandhara; phyllite; Asian Art Museum of San Francisco, The Avery Brundage Collection, B60S138+. Bottom: fig. 121. Seated Buddha, cat. no. 6.

pendants below the capitals of the pilasters on either side of the Buddha have been discussed by Dr. Santi in the context of the evolution of such motifs in the early Ayutthaya period.[5]

1 See Woodward, *Sacred Sculpture*, 176–177.

2 See also *Phraphuttharup lae phraphim*, figs. 278, 279, 284, 294, 299, 306, 357.

3 Subhadradis, *Sinlapa sukhothai*, fig. 54; Sunait, *Ayutthaya Gold*, 74.

4 Schroeder, *Buddhist Sculptures*, no. 114c.

5 Santi, *Early Ayudhya Period*, figs. 125, 282.

7

HEAD OF A BUDDHA IMAGE, APPROX. 1400–1450 (FIG. 122)
Copper alloy
H: 48 CM
Chao Sam Phraya National Museum, Ayutthaya, 16/14CH

This head, with its sense of gravity and meditative repose, embodies many of the ideals of Ayutthaya's early sculpture.

It would have been part of an image approximately like cat. no. 5. As postulated by Hiram Woodward, generally similar images were made simultaneously in two modes.[1] One mode hearkened back to the Cambodian-related traditions of

Lopburi and had a rather square face and straight hairline; the other, the more oval face and widow's peak common in Sukhothai and later Thai traditions.

1 Woodward, *Sacred Sculpture*, 176–177.

8

WALKING BUDDHA, PERHAPS 1375 (FIGS. 33, 123)
Stone
H: 194 CM; W: 50 CM
Chantharakasem National Museum, Ayutthaya, 6

The walking Buddha is often associated with the kingdom of Sukhothai, where sculptors produced a number of superb examples. Walking Buddhas appear fairly frequently in the arts of Ayutthaya as well, however, though seeming to become rarer century by century. Hiram Woodward has pointed out that the walking Buddha is found in central Thailand by the thirteenth or fourteenth century.[1] The crypt of Wat Ratchaburana in Ayutthaya, sealed in 1424, held dozens of the type – mostly in relief on votive tablets, but also in the round, and even painted on a wall.[2] Also, a number of temple buildings in central Thailand that have been attrib-

uted to the late fourteenth or fifteenth centuries have representations of the walking Buddha in stucco relief.[3]

The representation of the walking Buddha in this exhibition is extremely unusual because it is carved in high relief in stone.[4] Stone sculptures in the round (at least Buddha images)[5] were common in early Ayutthaya, but stone reliefs seem to have been rare; one of the few other examples is cat. no. 36).

The characteristics of this walking Buddha are similar enough to those of a freestanding bronze example from the crypt of Wat Ratchaburana to suggest a fourteenth- or fifteenth-century date.[6] The pointed frame around the head of the Buddha in the stone relief, with its upcurving flourishes at the shoulders, can be compared to related frames in stucco reliefs mentioned earlier.[7]

The nose of the sculpture has been inexpertly restored.

NOTE: Shortly before this publication went to press, important information about this image came to light. The image had long ago been fixed against a wall in one of the museum's storerooms. When the image was removed to be prepared for inclusion in this exhibition, a twenty-line inscription was noticed on the back. In June 2004, the Thai Inscription Survey Department of

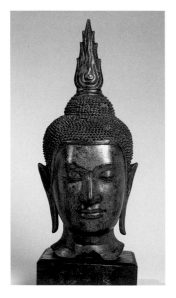

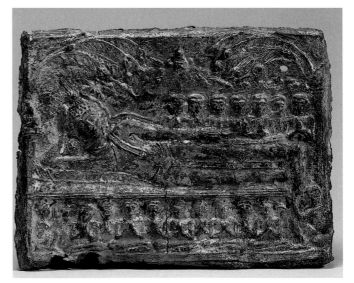

Left: fig. 122. Head of a Buddha image, cat. no. 7 (see p. 178 for a larger image). Center: fig. 123. Inscription on back of cat. no. 8. Right: fig. 124. Votive plaque with the passing away of the Buddha, cat. no. 9.

the National Library of Thailand recorded, deciphered, and registered the inscription. According to Kongkaew Weeraprachak, "the Buddha image and the inscription were likely carved about the same time."

She continues: "The inscription begins with a date: 1918 of the Buddhist Era (1375 CE). Khun Soramut, his wife and children, and others made donations to support the construction of monks' dwellings, a preaching hall, and Buddha images. They also planted bo trees and demarcated the temple grounds. The inscription ends with Buddhist blessings for those who made merit through these donations, and indicates their hope to be reborn in the era of the future Buddha, Maitreya. The inscription notes that those attempting to obstruct these donations are bound for hell with no hope of seeing the Buddha.

"A study of the shapes of the letters in the inscription suggests that they belong to the Thai-Ayutthaya form of the twentieth century of the Buddhist Era (1358–1457 CE) and had evolved out of the Thai-Sukhothai form. . . .

"Knowledge gained from this inscription will shed new light on other Thai inscription studies. Very few inscriptions have been recovered that contain Thai-Ayutthaya letter shapes, especially from the early Ayutthaya period. Thus, the discovery of the dated inscription on the back of the walking Buddha image is an invaluable discovery for historians of this time period. Before this finding, researchers had compiled an incomplete alphabet of the Thai-Ayutthaya letter shapes. Thanks to this finding they now have the complete Thai-Ayutthaya alphabet. This finding also helps to verify the accuracy of the existing identification system of Thai-Ayutthaya letters from the late fourteenth century CE."

(Adapted from a translation by
Chureekamol Onsuwan Eyre)

1 Woodward, *Sacred Sculpture*, 138.

2 For votive tablets, see Bowie, ed., *Sculpture of Thailand*, cat. no. 56; and *Phraphuttharup lae phraphim*, for example, figs. 137–154, 219–237; for images in the round, see Piriya, *Sacred Image*, 196–197; for painting, see *Chittrakam lae sinlapawatthu*, 9.

3 Buildings at Wat Kai Tia, Suphanburi; Wat Mahathat, Lopburi; and Wat Song Phinong, Chinat, all illustrated in Santi, *Early Ayudhya Period*, 192–193; southeast corner stupa at Wat Phra Ram, Ayutthaya, illustrated in No. Na Paknam, *Lai punpan*, fig. 57 (mislabeled Wat Mahathat, Ayutthaya).

4 Only one other large stone relief of the walking Buddha from central or north-central Thailand is known, and its proportions and style are quite different from the example in this exhibition; see Stratton and Scott, *Sukhothai*, fig. 61.

5 For a discussion of the head of this image in relation to a number of other Ayutthaya stone heads, see Prathip, "Baep phraphak," 83–86.

6 See note 2 above. For possible examples of sixteenth-century Ayutthaya representations of the walking Buddha, see Woodward, *Sacred Sculpture*, 244–245.

7 Especially those of Wat Kai Tia, Suphanburi; see note 3 above. Another such frame surrounded the head of a standing Buddha in relief on the prang of Wat Phra Ram, Ayutthaya; No. Na Paknam, *Ha duan*, 170.

9

VOTIVE PLAQUE WITH THE PASSING AWAY OF THE BUDDHA, APPROX. 1350–1425 (FIG. 124)
From Wat Phra Si Sanphet, Ayutthaya
Lead-tin alloy with traces of gilding
H: 16 CM; W: 20.5 CM
National Museum, Bangkok, 52/6

The Buddha spent his last hours lying on a couch in a grove of shala trees, surrounded by his loyal monks. He gave them final words of advice, and offered to answer their questions. Here the monks sit in positions of reverent attention. Above the monks, and beside the Buddha's head, celestial deities hover, having descended to witness his attainment of final nirvana, and to pay homage.

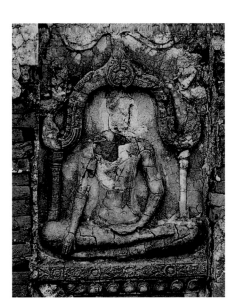

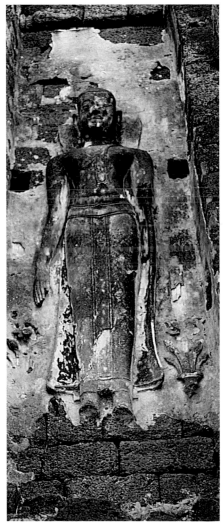

Left: fig. 125. Seated Buddha beneath arch and bodhi tree, northeast corner tower, Wat Phra Ram, Ayutthaya. Right: fig. 126. Standing Buddha with vases, main tower, Wat Ratchaburana, Ayutthaya.

Few Ayutthaya-period representations of the Buddha's passing away survive. One with which this votive plaque may be compared is a wooden relief from Khao No Cave, in Nakhon Sawan in central Thailand.[1] Its representation of the Buddha and a row of seated monks is reminiscent of that on the plaque, as is the odd rendering of the Buddha's feet pointing downward.

A detail of the plaque that may be significant is the raised outline following the contour of the left side of the head, left shoulder, and upper arm of the Buddha. Rather similar outlines, perhaps representing an aureole, are found in a group of stucco reliefs on central Thai temple buildings that have been dated to the second half of the fourteenth century.[2]

1 No. Na Paknam, *Sinlapa kon krung si ayutthaya*, 254–255. In the wooden relief the monks sit on the same level as the Buddha, at his feet. (This relief, and a very similar one from the same site, are illustrated in color in Naengnoi and Somchai, *Wood Carving*, 104.) A relief with a row of reverent monks seated below the Buddha, in front of his cot, can be seen in the thirteenth-century Preah Palilay at Angkor; see Roveda, *Khmer Mythology*, fig. 84. On the date of Preah Palilay, see Woodward, *Art and Architecture in Thailand*, 203. In the Preah Palilay relief, the Buddha's right hand and arm rest beside his head (as they do in the bronze reclining Buddha in this exhibition, cat. no. 46), rather than supporting it. Compare also a relief of the death of the Buddha at Wat Mahathat, Sukhothai, which shares several features with the depiction on this votive plaque, such as the down-pointing feet and – more importantly – the boughs bending over the Buddha from either side; Subhadradis, *Sinlapa sukhothai*, 28–29.

2 Santi, *Early Ayudhya Period*, 102, 192–193.

10

VOTIVE TABLET WITH SEATED
BUDDHA, APPROX. 1400–1450
(FIG. 78)
Gilded tin alloy
H: 18 CM; W: 12 CM.
Philadelphia Museum of Art, 1959-58-1

The Buddha sits beneath an inverted U-shaped arch with ovals of foliate motifs at the sides, above which grows a rounded tree with symmetrically curving branches. Both the arch and the tree recall those sheltering the seated Buddha of cat. no. 6. The Buddha images themselves differ, however; the one on this votive tablet is broader in the proportions of both its body and face, and it lacks a flame-shaped radiance at the top of the head.

The U-shaped arch (and the somewhat similar one in cat. no. 12) may have its ultimate origin in south India or Sri Lanka,[1] but also turns up in the architecture of Ayutthaya, as at Wat Maheyong, Wat Phra Ram (fig. 125), and the niches of the crypt of Wat Ratchaburana.[2] It contrasts with the pointed, sometimes cusped arch of cat. no. 11, which has its origins in ancient Cambodia.

On either side of the throne of the Buddha in this votive tablet are pairs of vases containing flowers, one pair above the other. Flower vases can be seen flanking Buddha images on other votive tablets (cat. no. 12, for example), in stucco on the main tower of Wat Ratchaburana (fig. 126), and in the mural paintings in its crypt.[3] No precedent for these flanking vases has yet been identified in India or Sri Lanka, but they turn up at Borobudur and in East Javanese sculpture.[4]

It is not known where this votive tablet was made or found, but other very similar examples came from Wat Phra Si Sanphet and the crypt of Wat Ratchaburana in Ayutthaya.[5]

1 See, for example, Schroeder, *Buddhist Sculptures*, pl. 17, figs. 39 and 47, and nos. 114c–114f. Compare also the shape and placement of the tree in Schroeder's fig. 40, a well-known bronze Buddha image in the Government Museum, Chennai.

2 Wat Maheyong: Kanita, *Ayutthaya*, fig. 10/3; Wat Phra Ram: Santi, *Early Ayutthaya Period*, fig. 89; Wat Ratchaburana: *Chittrakam lae sinlapawatthu*, 69.

3 Santi and Kamol, *Chittrakam faphanang samai ayutthaya*, fig. 51.

4 Borobudur: Nou and Frédéric, *Borobudur*, 248 no. Ia97 (I thank Natasha Reichle for calling this appearance of flanking flower vases to my attention); East Java: Bernet Kempers, *Ancient Indonesian Art*, pl. 248.

5 From Wat Phra Si Sanphet: example in the Chao Sam Phraya National Museum, Ayutthaya (McGill negative no. 1975-11-6); from the crypt of Wat Ratchaburana: *Phraphuttharup lae phraphim*, fig. 284.

11

PLAQUE WITH SEATED BUDDHA
AND DISCIPLES (FIG. 80)
From the crypt of the main tower of Wat Ratchaburana, Ayutthaya, approx. 1424
Gold
H: 11 CM; W: 7 CM
Chao Sam Phraya National Museum, Ayutthaya, Thailand; K.45(1)

Here, in a reference to the enlightenment, the Buddha is shown seated under the bodhi tree. He is sheltered by an arch similar to that of cat. no. 15. At his sides are his two important followers: Maudgalyayana and Shariputra. Above these two figures are two circles, probably representing the sun and the moon; there are references to the sun and moon in many textual sources.

M. L. Pattaratorn Chirapravati

12

VOTIVE PLAQUE WITH WALKING
BUDDHA (FIG. 77)
*Possibly from the crypt of the
main tower of Wat Ratchaburana,
Ayutthaya, approx. 1400–1425*
Lead-tin alloy with traces of gilding
H: 25.4 CM; W: 13.7 CM
Asian Art Museum, F2000.35

This votive plaque depicts a walking
Buddha, a type that is rare in Bud-
dhist art outside Thailand, but fairly
common in the sculpture and votive
tablets of Sukhothai.[1] Many votive
tablets virtually identical to this one
were deposited in the crypt of Wat
Ratchaburana.[2] Because they were
made of pewter (an alloy of lead and
tin) like most of the votive tablets
deposited there, instead of terra-cotta
like those found in Sukhothai and
Kamphaeng Phet, it is likely that they
were made in Ayutthaya, but in the
style of Sukhothai.

The Wat Ratchaburana walking
Buddha tablets are also larger in
size than those of Sukhothai, and
have some different iconographic ele-
ments, such as fifty seated Buddhas
in rows, and a pair of flower vases.[3]
For a discussion of the flower vases
and the arch over the Buddha, see
cat. no. 10.

A great many tablets from the
crypt of Wat Ratchaburana were sold
to the public in 1958; it is possible that
this tablet was among those sold at
that time.

M. L. Pattaratorn Chirapravati

1 For further information on the
Sukhothai walking Buddha, see Brown,
"God on Earth."
2 For example, *Phraphuttharup lae
phraphim*, fig. 153. This example, like cat.
no. 12, is double-sided.
3. See my essay in this book.

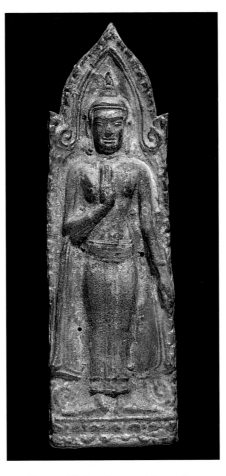

Fig. 127. *Votive plaque with standing
Buddha, cat. no. 13.*

13

VOTIVE PLAQUE WITH
STANDING BUDDHA, APPROX.
1400–1425 (FIG. 127)
*Possibly from the crypt of the main
tower of Wat Ratchaburana, Ayutthaya*
Led-tin alloy
H: 18.4 CM; W: 5.7 CM
Asian Art Museum, Gift of Dr.
Sarah Bekker, F20002.8.12

This votive plaque may have come from
the crypt of Wat Ratchaburana, Ayut-
thaya, sealed in about 1424. Hundreds
of votive tablets and plaques were found
in the crypt. Beginning in 1958, many of
these were sold to the public to raise funds
for building a museum. This plaque was
bought in Ayutthaya in August, 1967.

Virtually identical plaques are

known to have been found not only in
the Wat Ratchaburana crypt[1] but also
in other crypts in central Thailand.[2]

The standing Buddha image on this
plaque, with its right hand held palm-
forward in front of the chest, belongs to
a lineage that has been traced by Hiram
Woodward.[3] The hand position is found
in the art of Pagan in Burma in the elev-
enth century and in the art of central
Thailand in the thirteenth. Other features
of this standing Buddha, such as the way
its robe is represented and the curving left
arm that hangs beyond the border of the
robe, can be seen in fourteenth-century
Buddha images from central Thailand,
both in high relief and in the round. A
related example is a well-known standing
Buddha in gold repoussé that was found
in the Wat Ratchaburana crypt.[4]

1 *Phraphuttharup lae phraphim*, fig. 165
2 Manat, *Phra kru muang suphan*, p. 16
of unnumbered pages of illustrations.
3 Woodward, *Sacred Sculpture*, 115–117,
124, 139.
4 Bowie, Subhadradis, and Griswold,
Sculpture of Thailand, 24, cat. no. 54.

14

PEDIMENT FROM A MINIATURE
TOWER (FIG. 82)
*From the crypt of the main tower of Wat
Ratchaburana, Ayutthaya, approx. 1424*
Gold alloy with traces of glass and
stone
H: 14 CM; W: 16 CM
Chao Sam Phraya National Mu-
seum, Ayutthaya, Thailand, Kh137

This gold pediment was originally part
of the miniature replica of the main
tower of Wat Ratchaburana that was
placed in the center of the treasure
room of the crypt (fig. 81).[1]

The sides of the pediment are the styl-
ized serpentlike bodies of a pair of mythi-
cal creatures. From their mouths emerge

multiple serpent heads (compare cat. no. 26) decorated with green and red stones.

In Hindu mythology, serpents (*nagas*) are step-brothers of the heroic bird Garuda. Because their mothers did not get along, serpents and Garuda are often shown in combat. Figures of both serpents and garudas decorated the main tower of Wat Ratchaburana, and the miniature tower in its crypt as well.[2]

M. L. Pattaratorn Chirapravati

1 See my essay in this book.
2 The garudas on both the main tower and the miniature tower can be seen in Sunait, *Ayutthaya Gold*, 96.

15

ARCH FROM A FRAME FOR A BUDDHA IMAGE, APPROX. 1424 (FIG. 83)
From the crypt of the main tower of Wat Ratchaburana, Ayutthaya
Gold alloy with traces of glass and stone
H: 14; W: 15.5 CM
Chao Sam Phraya National Museum, Ayutthaya, Thailand; 900/2543 K.40.(12)

This arch is thought to have come from the sort of elaborate frame that sometimes surrounds or stands behind a Buddha image. A well-known example is that of the fourteenth- or fifteenth-century Sukhothai-style Chinnarat Buddha at Wat Mahathat, Phitsanulok.[1]

1 Woodward, *Sacred Sculpture*, fig. 146. The image's name is the Thai version of the Indic *jinaraja*, "victorious king."

16

CROWN, APPROX. 1424 (FIG. 89)
Probably from the crypt of the main tower of Wat Ratchaburana, Ayutthaya
Gold, rubies, and pearls
H: 19 CM; W: 21.6 CM
Philadelphia Museum of Art, 1982-105-1

Several gold headdresses were found in the crypt of the main tower of Wat Ratchaburana, thought to have been built in 1424. No other ritual deposit so far discovered has included such headdresses, so it is likely that this crown also came from the Wat Ratchaburana crypt.[1] Furthermore, the lozenge-shaped motifs on this crown, the arrangement of eight gems within them, and the style of the swirling vines covering much of the surface strongly recall those on the gold chest pendant from Wat Ratchaburana included in the exhibition (cat. no. 17).

Because a well-known statuette of a queen or princess wears a crown of rather similar type – also more-or-less flat on top, and lacking a finial – this crown has sometimes been thought to be that of a female member of the royal family.[2] That may be the case, but it is worth noting that some of the heads of male figures from the set of sculptures cast in 1458 of the Buddha in his previous lives wear crowns of comparable shape, and without finials.[3]

1 See M. L. Pattaratorn's essay in this book for information on the discovery and emptying of the crypt in 1957–1958. The headdresses are illustrated in Sunait, *Ayutthaya Gold*, 110–111.
2 The statuette is illustrated and discussed in Coedès, "Une Statue de princesse."
3 McGill, "Jatakas, Universal Monarchs," figs. 27, 28.

17

CHEST PENDANT, APPROX. 1424 (FIG. 87)
From the crypt of the main tower of Wat Ratchaburana, Ayutthaya
Gold alloy with rubies and glass gems
H: 8.9 CM, W: 13.2 CM
National Museum, Bangkok, 71-73/2503

In a variety of reliefs and free-standing sculptures figures appear wearing pendants similar to this one on their chests, hung by a pair of chains from a necklace or jeweled collar. (This piece has along its upper edge two loops from which it may have been suspended.) Madeleine Giteau has discussed the appearance of such pendants in the mid-sixteenth-century bas-reliefs of Angkor Wat, and notes their earlier occurrence in reliefs at Sukhothai.[1] In the Ayutthaya kingdom, they are common on crowned and bejeweled Buddha images of the 1500s (cat. no. 35), and are seen occasionally on sculptures of the mid 1400s,[2] but until now have not been noted in sculptures as early as the 1424 date of the crypt of Wat Ratchaburana, from which this piece came.

In the middle of this pendant is a gem surrounded by eight smaller gems- the "nine-gems" (Sanskrit: *navaratna*) of Hindu-Buddhist lore. The king of Siam was said to be adorned with the nine gems, as was his capital.[3]

These gems are placed on the petals of an eight-petaled flower that is contained within a square with stepped indentations at its corners. That a quite similar arrangement is seen in the border of an eighteenth-century Indian textile made for the Siamese market (cat. no. 82) suggests how long some decorative motifs could retain their popularity.

1 Giteau, *Iconographie*, 106–107; Roveda, *Sacred Angkor*, fig. 52. The bronze footprint from Kamphaeng Phet that Giteau mentions is illustrated in fig. 143 and Bowie, Subhadradis, and Griswold, *Sculpture of Thailand*, fig. 53 (p. 14). Its date is far from certain.
2 Woodward, *Sacred Sculpture*, 188, 202. Elements of a similar "winged lozenge" shape can be seen in necklaces on much earlier sculptures from central Thailand, such as Woodward's fig. 82 (approx. late

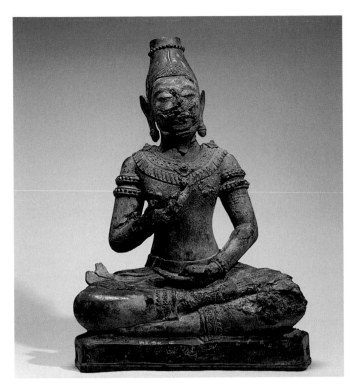

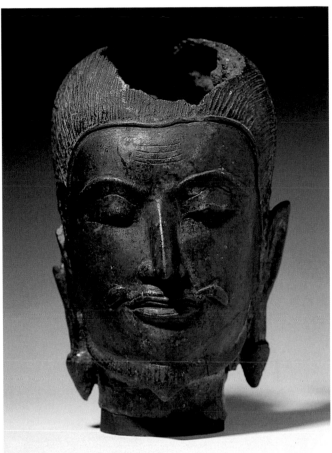

Above: Fig. 128. Hermit from a set of figures representing the Buddha's previous lives, cat. no. 19. Right: fig. 129. Head of a hermit from a set of figures representing the Buddha's previous lives, cat. no. 20.

twelfth century), but not as a pendant hanging on a pair of chains.

3 Cushman, *Royal Chronicles*, 195. See also the references in McGill, *Prasatthong*, 139, 158, where the subject of the nine gems, and one-surrounded-by-eight symbolism in Siam in general is discussed at some length.

18

BRACELET OR JEWELED BAND, APPROX. 1424 (FIG. 88)

From the crypt of the main tower of Wat Ratchaburana, Ayutthaya
Gold alloy and glass gems
H: 5.5 CM, W: 8.5 CM
Chao Sam Phraya National Museum, Ayutthaya, KH32

It is not clear whether jeweled gold bands such as this found in the crypt of Wat Ratchaburana were used as bracelets or as some other sort of ornament.

19–24

IMAGES OF THE BUDDHA-TO-BE IN HIS PREVIOUS LIVES

The stories of the five hundred or more previous lives of the Buddha-to-be – the *jatakas* – were well known and important in much of the Buddhist world. In 1458 Ayutthaya's King Borommatrailokkanat ("Supreme Lord of the Three Worlds") commissioned a set of bronze figures to represent them, showing the Buddha-to-be in such guises as a hermit, a prince, or a deer. The king's motivation probably had to do with the arrival of the year 2000 of the Buddhist era. Old prophecies suggested that humankind's understanding of the Buddha's teachings would decay over time, and the arrival of a millennial anniversary would bring further grievous losses. A great Buddhist king would take steps to halt or

reverse the decay by building temples, supporting the monkhood, commissioning didactic artworks such as the jataka statues, and perhaps even entering the monkhood himself – all of which Borommatrailokkanat is said to have done.[1]

Several whole figures and more than thirty heads almost surely from the king's jataka set have survived.[2] One figure and five heads are included in the exhibition. What strikes the eye immediately is how varied in style they are. Three representative crowned heads, cat. nos. 21, 22, and 24, are so different in their modeling, their proportions, and the treatment of their crowns, that it may be difficult to imagine their being made for the same project. It nevertheless seems likely that they were. The best explanation seems to be that casting five hundred or more bronze figures was a big task, and must have been

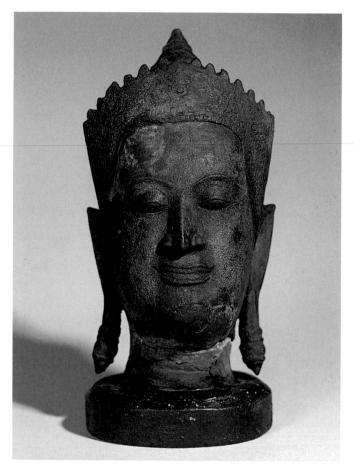 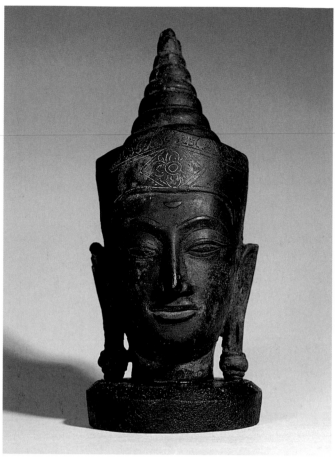

Left: fig. 130. Crowned head from a set of figures representing the Buddha's previous lives, cat. no. 21. Right: fig. 131. Crowned head from a set of figures representing the Buddha's previous lives, cat. no. 22.

divided among workshops in various cities of the kingdom. If this is the case, no so-called national style had developed (as used to be suggested) in Siam in the mid-fifteenth century, and various regional traditions continued strong. Some workshops would have worked in styles recalling those of Angkor (cat. nos. 23 and 24), and others in styles recalling those of Sukhothai (cat. no. 22). This variation in styles must not have been unacceptable to the king.

1 The history of Borommatrailokkanat's period, his possible motivations, the significance of the jatakas in Ayutthaya, and the sculptures representing them are discussed at length in McGill, "Jatakas, Universal Monarchs."

2 In addition to the article mentioned in note 1, see Woodward, *Sacred Sculpture*, 186.

19

HERMIT FROM A SET OF FIGURES REPRESENTING THE BUDDHA'S PREVIOUS LIVES, PROBABLY 1458 (FIG. 128)
Found at Wat Phra Si Sanphet, Ayutthaya
Copper alloy with traces of gilding
H: 16 CM; W: 43 CM
National Museum, Bangkok, AY34

The inscription, in Cambodian, identifies the figure as a *brahma rishi* (an ascetic or hermit).[1] It has been

observed that "the early kingdom of Ayutthaya reserved an important place for the Khmer [Cambodian] language which appears in the majority of original Ayutthayan documents preserved from before the seventeenth century."[2]

1 Vickery, review of *Thai Titles*, 164 n. 8.
2 Vickery, review of *Thai Titles*, 164.

20

HEAD OF A HERMIT FROM A SET OF FIGURES REPRESENTING THE BUDDHA'S PREVIOUS LIVES, PROBABLY 1458 (FIG. 129)
Bronze
H: 18 CM
National Museum, Bangkok, 18/168

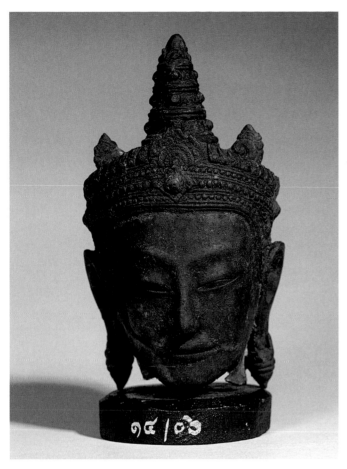 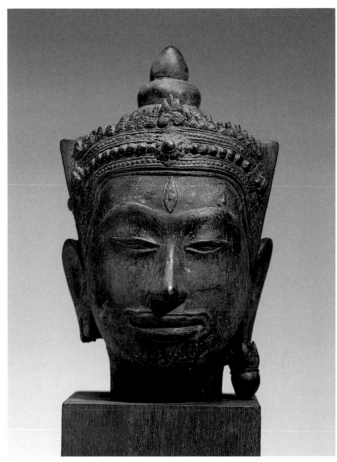

Left: fig. 132. Crowned head from a set of figures representing the Buddha's previous lives, cat. no. 23. Right: fig. 133. Crowned head from a set of figures representing the Buddha's previous lives, cat. no. 24.

21

CROWNED HEAD FROM A SET OF
FIGURES REPRESENTING THE
BUDDHA'S PREVIOUS LIVES,
PROBABLY 1458 (FIG. 130)
Copper alloy
H: 22 CM; W: 23.5
Chao Sam Phraya National Museum, Ayutthaya, 11/06

22

CROWNED HEAD FROM A SET OF
FIGURES REPRESENTING THE
BUDDHA'S PREVIOUS LIVES,
PROBABLY 1458 (FIG. 131)
Copper alloy
H: 21.5 CM
Chao Sam Phraya National Museum, Ayutthaya, 9/06

23

CROWNED HEAD FROM A SET OF
FIGURES REPRESENTING THE
BUDDHA'S PREVIOUS LIVES,
PROBABLY 1458 (FIG. 132)
Copper alloy
H: 23 CM; W: 23 CM
Chao Sam Phraya National Museum, Ayutthaya, 14/06

24

CROWNED HEAD FROM A SET OF
FIGURES REPRESENTING THE
BUDDHA'S PREVIOUS LIVES,
PROBABLY 1458 (FIG. 133)
Found at Wat Phra Si Sanphet, Ayutthaya
Copper alloy
H: 19 CM; W: 12 CM
National Museum, Bangkok, AY57

25

ELEPHANT WITH RIDERS AND
ATTENDANTS, APPROX. 1400–
1550 (FIG. 134)
Glazed stoneware
H: 38.7 CM; L: 35.6 CM
Asian Art Museum, The James and
Elaine Connell Collection of Thai
Ceramics, F1991.97.1

The kilns near Sawankhalok and
Sukhothai in north-central Thailand produced, in addition to huge
numbers of useful dishes and vessels,
decorative architectural fixtures and
figurines of various sorts. A number
of stoneware elephants rather similar
to this one are known, some found
as far away as Borneo.[1] A related
example, from northern Thailand,

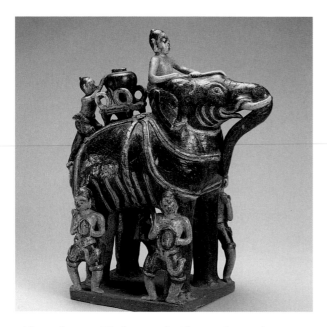

Above: fig. 134. Elephant with riders and attendants, cat. no. 25. Right: fig. 135. Balustrade terminal in the form of a multiheaded mythical serpent, cat. no. 26.

is of bronze, and is inscribed with a date equivalent to 1575.[2]

The purpose of these sculptures of elephants, if they had any other than delight, is unknown. The elephant often carries a jar on a small platform lashed to its back, and has several riders and attendants. Possibly the jar was understood to contain holy water for rituals or perhaps a relic. Piriya Krairiksh believes that the dated bronze elephant was "made as a stand for offerings to an image of the Buddha."[3]

This stoneware elephant, like many of the type, has suffered extensive damage and restoration. It has been carefully examined and x-rayed by conservators at the Asian Art Museum. They have concluded that the figures of the two riders are entirely of new material above their waist level, and that the heads of the four soldiers, one of the elephant's legs, and the whole base are also new. Parts of the platform for the jar are original, but there is uncertainty about the jar itself. It is possible that a genuine old jarlet has been used to replace the missing original.

In general, enough of the original figures remains to suggest that the restorations are approximately correct. For example, though the upper torso and head of the figure on the elephant's neck are new, the figure's proper left arm and hand, grasping an elephant goad, survive intact. Thermoluminescence testing of a sample taken from the elephant's right shoulder yielded an approximate date – between 1395 and 1645.

1 Asian Art Museum, *Thai Ceramics*, 13.
2 Hong Kong Museum of Art, *Sculptures from Thailand*, 164–165. The bronze elephant is more elaborately caparisoned than is the stoneware example here, is shown raising its trunk in a salute, and has a single rider and no other attendants.
3 Hong Kong Museum of Art, *Sculptures from Thailand*, 164. Of course real elephants would have had a variety of roles in royal ceremonies. For instance, the Royal Chronicles tell of a ceremony during which the king scatters coins to the populace from a gold pedestal

tray placed on the back of a royal elephant; Cushman, *Royal Chronicles*, 223; *Phraratchaphongsawadan chabap phraratchahatthalekha*, 435.

26

BALUSTRADE TERMINAL IN THE FORM OF A MULTIHEADED MYTHICAL SERPENT, APPROX. 1460–1490 (FIG. 135)
Said to have come from Wat Mahathat, Phitsanulok
Copper alloy with traces of gilding
H: 89 CM; W: 51 CM
The British Museum, Gift of Sir Ernest Satow, 1887.7-14.1

In Siam, stairways on or leading to religious buildings sometimes had the body of a mythical serpent running along the upper edge of each side wall or balustrade. At the foot of the stair the serpent reared up so that its multiple heads faced the visitor preparing to ascend. Old traditions associated serpents with the rainbow, and the rainbow was the ladder or bridge that

Left: fig. 136. Balustrade terminal in the form of a multiheaded mythical serpent, in storage, Wat Mahathat, Phitsanulok. Above: fig. 137. Serpent-bordered balustrades, Shrine of the Buddha's Footprint, Saraburi.

allowed passage between the earth and the heavens.[1] Intact examples of stairways with serpent-bordered balustrades and rearing serpent heads of bronze may still be seen at the Shrine of the Buddha's Footprint in Saraburi (fig. 137),[2] and the tradition can be traced back to Angkor, where serpent balustrades were common.[3]

This bronze serpent-head terminal from the balustrade of such a staircase was donated to the British Museum in 1887. According to the museum's records, the donor, a British diplomat stationed in Bangkok, reported that it came from Wat Mahathat in Phitsanulok, Siam's second city for much of its history.[4] Old photos show a matching terminal, presumably the mate of this one, in storage at Wat Mahathat in Phitsanulok (fig. 136).[5] These serpent balustrade terminals might originally have been installed on the main stairway of Wat Mahathat's Cambodian-type tower, which has been extensively restored and has little of its original decoration left (fig. 11). A less likely alternative is that they were made for Wat Chulamani in Phitsanulok,

which has a ruined Cambodian-type tower (fig. 49) and the foundations of an ordination hall and preaching hall. Both of these towers are likely to have been built by King Borommatrailokkanat (reigned 1448–1488) during the extended period he lived in Phitsanulok (approx. 1463–1488).[6]

What this balustrade terminal represents is more complicated than indicated so far. The five serpent heads rise not directly from a serpent body, but out of the mouth of another creature. This creature has an upturning snout, rows of frightening teeth, bulging eyes, ears like those of a pig, a scaled or feathered frill at the neck, and, behind that, little forelimbs. In Indic mythology, in which Siam was steeped, such creatures are called *makara*. They are aquatic and sometimes associated with crocodiles, though they often have features of various animals. Other creatures, and sometimes human figures, may be seen springing from their mouths.

Multiheaded serpents have been shown rising from the mouths of such

crocodilelike creatures in the arts of Thailand and Cambodia for many centuries. Examples can be seen in architectural decoration in both stone and stucco.[7] The motif turns up in stucco architectural decoration in the city of Ayutthaya on the Cambodian-type tower of Wat Som (dated by Santi Leksukhum to the last decades of the fourteenth century)[8] and on the remains of the tower of Wat Chulamani itself,[9] as well as on the miniature gold gable in this exhibition (cat. no. 14). Comparison with these examples makes a date for the British Museum balustrade terminal in the later part of the fifteenth century seem plausible.

1 Mus, "Angkor," 70–71.

2 The Royal Chronicles mention King Phetracha (reigned 1688–1703) ascending one of the serpent staircases (*bandai nak*) at the Shrine of the Buddha's Footprint; Cushman, *Royal Chronicles*, 372; *Phraratchaphongsawadan krung si ayutthaya chabap phan chanthanumat*, 423. The Sri Lankan

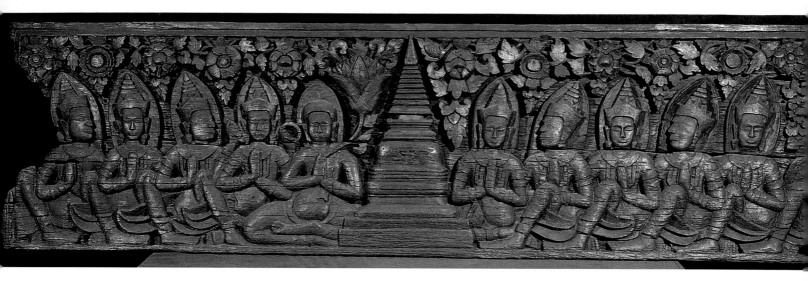

Fig. 138. Relief of stupa and worshippers, cat. no. 27.

delegation visiting Ayutthaya in 1750 mentions a serpent staircase in their description of a temple they visited; McGill, *Prasatthong*, 125.

3 For examples, see Jacques, *Angkor*, 131 (Preah Vihear), 154–155, 160–161 (Angkor Wat), 191 (Phnom Rung in northeastern Thailand), and 232–233 (Srah Srang).

4 The entry in an old register at the British Museum reads: "From the temple Wat Phra Chinarat at Pitsanulok, Siam. Presented by Ernest Satow CMG, H[er] B[ritannic] M[ajesty's] Minister, Bangkok." (This information was kindly provided by T. Richard Blurton of the British Museum.) Wat Mahathat houses the famous Buddha image known as the Phra Chinnarat (Sanskrit *jinaraja*, "victorious king"); hence the name reported by Satow. The existence of this important artwork was drawn to my attention by Hiram Woodward. The issue of where it may originally have been placed (see below) was discussed privately some years ago by Woodward and Santi Leksukhum. Both have been generous in sharing their thoughts with me, answering questions, and supplying relevant photos and building plans.

5 A photo of this object in storage was kindly supplied to me by Vichai Poshyachinda, to whom I am indebted for many superb photos over many years.

6 McGill, "Jatakas, Universal Monarchs," 413–427, 447–448 and references there. Plans and detailed photos of the remains of Wat Chulamani can be found in *Wat chulamani*; general photos can be found in Moore, Stott, and Suriyavudh, *Ancient Capitals*, 228–233; plans of Wat Mahathat, Phitsanulok, can be found in *Mahathat*, and in Woodward, "Monastery, Palace."

7 Smitthi and Mayurie, *Lintels*, figs. 69, 97, 100 (at the corners of a pediment frame), etc.; Roveda, *Sacred Angkor*, figs. 195, 217 (Angkor Wat); Thida, *Prawattisat sukhothai*, 41 (Wat Phra Phai Luang, Sukhothai), 72 (Wat Chedi Chet Thaeo, Si Satchanalai); Woodward, *Art and Architecture of Thailand*, figs. 49A and B (Phra Prang Sam Yot and Wat Nakhon Kosa, Lopburi); No. Na Paknam, *Lai punpan*, fig. 51 (aureole of a Buddha image at Wat Chom Khiri Nak Phrot, Nakhon Sawan).

8 Santi, *Early Ayudhya Period*, 102. A very clear close-up photo is found in No.

Na Paknam, *Lai punpan*, fig. 25.

9 *Wat chulamani*, figs. 155–156, 175, 183. Neither set of bronze serpent balustrade terminals at the Shrine of the Buddha's Footprint in Saraburi has the crocodilelike creatures. Both sets are several centuries later than the terminals from Phitsanulok; see McGill, *Prasatthong*, 183–185, 253–256; Listopad, *Phra Narai*, 436 n. 48.

27

RELIEF OF STUPA AND WOR-
SHIPPERS, APPROX. 1500–1575
(FIG. 138)
Wood
H: 68.2 CM; W: 237 CM
Suan Pakkad Palace Museum, Bangkok

As in cat. no. 28, rows of worshippers flank a stupa. Next to the stupa on one side sits a monk holding a lotus; next to him, unexpectedly, is the Hindu god Vishnu, identified by his four arms, two of which hold a conch shell and a war discus.[1] The other worshippers appear to be crowned celestials. None can be identified further. In eighteenth- and nineteenth-century Thai art a scene of

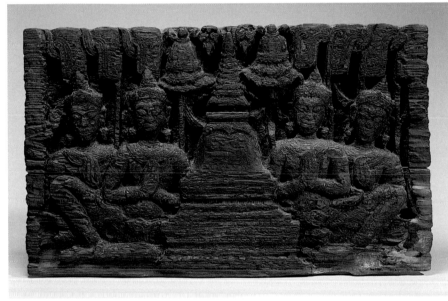

Top: fig. 139. detail of bas relief, 1546–1564, Angkor Wat. Immediately above: fig. 140. Relief of stupa and worshippers, cat. no. 28.

influences" deserve further study. The arrangement, postures, and costumes of the row of celestials on the right are strikingly reminiscent of those of a row of celestials in one of the late bas reliefs of Angkor Wat, added to the monument in 1546–1564 (fig. 139).[3]

1 Prince Subhadradis's caption in *Suan Pakkad Palace Collection*, 125, no. 49.

2 See discussion of cat. no. 80; also, see Ginsburg, *Thai Manuscript Painting*, 72–82; McGill and Pattaratorn, "Art of the Bangkok Period," 31; and Brereton, *Phra Malai*.

3 The date of these reliefs is discussed in Roveda, *Sacred Angkor*, 56–57; the specific relief referred to is pictured in *Temple d'Angkor Vat*, pl. 424.

28

RELIEF OF STUPA AND WOR-
SHIPPERS, PERHAPS 1400–1500
(FIG. 140)
Wood
H: 37 CM; W: 61 CM
National Museum, Bangkok, AY11

Pairs of crowned worshippers flank a stupa; behind them is a row of honorific parasols and flapping pennants. The worshippers' crowns and jeweled collars are of types usually attributed to the 1400s (see cat. nos. 16, 22, and 24), but are too abraded for detailed study. The general shape and proportions of the stupa (not so different from those of a gold stupa found in the 1424 deposit at Wat Ratchaburana) are in keeping with such a date.[1] Other features, however, such as the bell shape of the parasols and their ruffled lower edge,[2] would usually be thought to be later. An archaizing force may be at work, leaving the date uncertain.

This panel, which is said to have come from Tha Manao in Suphanburi province,[3] may have decorated the pedi-

a monk and crowned celestials paying homage to a stupa would be interpreted as the monk Phra Malai visiting the heaven of the gods and joining them in worshipping the famous stupa containing hair relics of the Buddha (before he attained buddhahood) located there.[2] Whether a similar interpretation is appropriate here is uncertain. If it is eventually found to be correct, this would be the earliest representation of Phra Malai yet recognized.

A further complicating factor is that this relief might have been carved in Cambodia. The noted Thai art historian Prince Subhadradis Diskul, in describing the relief, remarked that "the carving shows some Khmer [Cambodian] influences such as the rather square faces and the seated posture but it was probably sculpted by Thai artists in the late seventeenth or eighteenth century A.D." Prince Subhadradis's dating now seems much too late, but the "Khmer

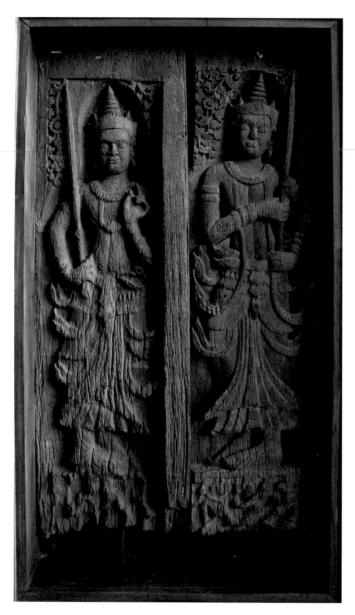

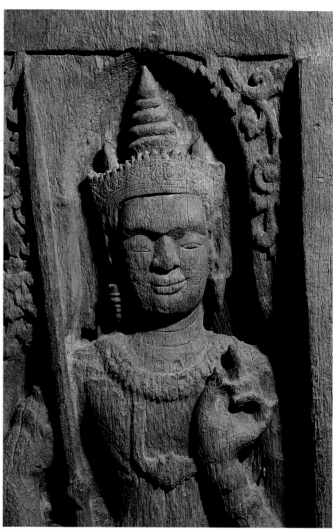

Left: fig. 141. Doors with carved guardians, cat. no. 29.
Above: fig. 142. Detail of cat. no. 29.

ment of a temple building. A similar wooden relief, of the same subject, can be seen in the pediment of the ordination hall of Wat Phayap in Nakhon Ratchasima in northeastern Thailand.[4]

1 Sunait, *Ayutthaya Gold*, 82.

2 Compare the parasols in the upper part of a relief at Wat Lai, Lopburi, also of uncertain, and much contested, date; visible in Wray, Rosenfield, and Bailey, *Ten Lives*, fig. 5.

3 *Sinlapawatthu krung rattanakosin, Sinlapa watthanatham thai*, vol. 5, 143.

4 No. Na Paknam, *Sinlapa samai krung si ayutthaya*, 47.

29

DOORS WITH CARVED GUARDIANS, PERHAPS 1490S (FIGS. 141, 142)
From one of the stupas of Wat Phra Si Sanphet, Ayutthaya
Wood
H: 167 CM; W: 96 CM
Chao Sam Phraya National Museum, Ayutthaya, 89/2543

Placing figures of guardians at the entrances of temples and palaces to protect them was an ancient tradition in the Hindu-Buddhist world. In Siam, such guardians were often carved or painted directly on the doors. They were usually decked in the elaborate garments and crowns of nobles, and may have been associated with the guardian kings of the four directions mentioned in cosmological texts. Whereas in ancient Angkor and Indonesia such door guardians were sometimes depicted as muscle-bound grotesques, in Siam they usually – though not always – had the features and physiques associated with heroes and demigods.[1] The guardians on these doors in the exhibition are slightly heavier of face and limb than usual.

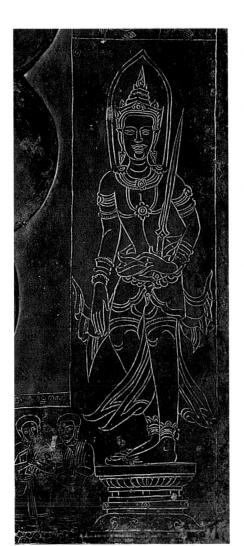

Fig. 143. Detail of bronze footprint from Kamphaeng Phet, National Museum, Bangkok.

These doors came from one of the three large stupas at Wat Phra Si Sanphet, the Temple of the Omniscient One, adjacent to the royal palace area in Ayutthaya. The Royal Chronicles record that in 1492 the king built stupas to enshrine the ashes of the two previous kings, and it is possible that these doors were carved at that time.[2] Though weathering has obscured the details of their jewelry and dress, nothing that remains would preclude such a date. Their crowns, with the band encircling the head having little teeth along the upper edge and slightly higher points above the middle of the forehead and

the ears, and topped by a rather tall cone of rings flanked by two shorter cones, are not very different in type from the crowns of some of the jataka figures cast in 1458 (cat. no. 21 and others not included in the exhibition).[3] The necklace with a medallion hanging from a U-shaped loop over the chest is also paralleled in other sculptures of the 1400s.[4]

Very close to these figures in the design and proportions of the crowns, jewelry, and other features are figures of sword-bearing guardians on a probably fifteenth-century bronze footprint of the Buddha from Kamphaeng Phet in north-central Thailand (fig. 143).[5]

Two other pairs of doors from Wat Phra Si Sanphet have been preserved, one from one of the main stupas and one from the ordination hall.[6] Both would seem to be variations on the themes set out in the pair exhibited here. For instance, the figures on the stupa doors, like the ones in the exhibition, have flowering branches arching over their heads, but they hold the end of the stem, as the figures on our doors do not. The figures on the ordination hall doors hold the ends of the branches, but there the branches move gracefully upward without arching over. Many other distinctions of detail, both of configuration and of style, could, of course, be described. In general, it would seem that the doors in the exhibition are the earliest; the second set, from one of the main stupas, probably some decades later, and the third set conceivably as late as the eighteenth century. This set seems to have a mixture of what are usually considered older and more recent features, and may manifest a tendency of archaizing noticeable in other probably eighteenth-century works. The difficulty of sorting out what is archaic from what is archaizing has bedeviled the study of Ayutthaya's arts, and accounts for

the widely differing dates assigned to such works as the important narrative scenes in stucco at Wat Lai near Lopburi.[7]

1 In the 1700s and 1800s door guardians in Thailand were sometimes represented as demons or giants, or as long-bearded Chinese warriors; for example, Naengnoi and Somchai, *Wood Carving*, 74, 78, 117, 177.

2 Cushman, *Royal Chronicles*, 18. The text does not specify how many stupas were built – whether one or more then one; Luang Prasoet version, entry for the year Ch. S. 854.

3 McGill, "Jatakas, Universal Monarchs," figs. 7, 24, 30.

4 For instance, Woodward, *Sacred Sculpture*, 188, 202. See also a celestial incised on an inscription from Wat Sorasak, *Sukhothai*, apparently from the 1410s, illustrated in Stratton and Scott, *Sukhothai*, pl. 25.

5 Bowie, Subhadradis, and Griswold, *Sculpture of Thailand*, 14, 94; dated by these scholars to the fourteenth century.

6 Bowie, Subhadradis, and Griswold, *Sculpture of Thailand*, 126–127; and Boisselier, *Heritage*, 178.

7. Illustrated in Boisselier, *Heritage*, 168 (detail); and Wray, Rosenfield, and Bailey, *Ten Lives*, 130.

30

FINIAL OF A TEMPLE TOWER, 1400–1700 (FIG. 144)
Found at Wat Phra Ram, Ayutthaya
Iron, lead
H: 177 CM (NOT INCLUDING TANG);
W: 117 CM
Chantharakasem National Museum, Ayutthaya, 26WCh/2524

The temple towers of Siam were usually topped with a multipronged finial similar to this one. In Angkor such towers apparently often had related

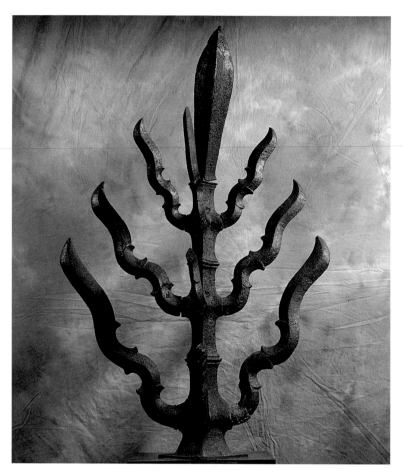

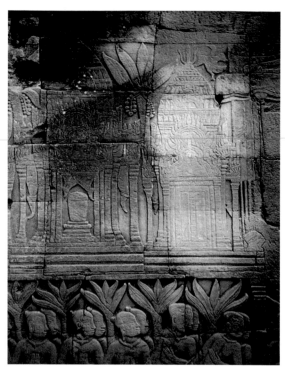

Left: fig. 144. Finial of a temple tower, cat. no. 30.
Above: fig. 145. Relief of temple tower showing
finial, Bayon, Angkor

finials, but simpler and with fewer prongs, as can be seen in reliefs at the Bayon (approx. 1190–1230; fig. 145).[1] In the Cambodian context these finials are usually called *trishula*, "three spike," and are associated with the trident that is a frequent attribute of the Hindu god Shiva, even when they appear on Buddhist buildings.[2] In Thailand they are called *nopphasun*, a word that can be spelled two ways. One spelling means "sky spike;" the other "nine spike." Some finials of this type have, in fact, nine spikes ("branches" would be a more apt descriptive term). On others, such as this example, another tier of branches has been added, making a total of thirteen.[3]

The description of the founding of the tower of Wat Mahathat in Ayutthaya (supposedly in 1374) in some versions of the Royal Chronicles mentions the tower's nopphasun.[4] This example was found at the nearby Wat Phra Ram,

but whether it dates from the founding of that temple in 1369 is not known.

This finial is made of cast iron with lead, perhaps as a sort of solder, at the joins in the branches. Near the joins are Thai numbers cast in relief. Conceivably these numbers were to guide workers in assembling the pieces.

The history of iron casting in the Ayutthaya period is somewhat uncertain, but the size and complexity of this finial, and of a large section of a temple tower of cast iron covered with stucco (preserved at the Chao Sam Phraya National Museum in Ayutthaya) suggest that at least by the later part of the period sophisticated iron casting was common.[5]

Another multipronged finial – an actual "nine spike" – was recovered at Wat Chaiwatthanaram, founded in the 1630s (though the finial could, of course, be later). Though considerably smaller and simpler than the example

in the exhibition, it otherwise resembles it in shape.[6]

1 Barely visible in an illustration in Freeman and Jacques, *Ancient Angkor*, 87.

2 Boisselier, *Le Cambodge*, 69, 185. Boisselier notes that some finials may have had five prongs. He mentions that a prong of a trident large enough to have been a tower finial is in the collection of the National Museum in Phnom Penh. A bronze trident that presumably served as an attribute of a large statue is illustrated in Bunker and Latchford, *Adoration*, 367.

3 The two Thai spellings reflect the Sanskrit *nabhashula*, "sky spike," and *navashula*, "nine spike." Both Thai spellings produce the pronunciation *nopphasun*.

4 Cushman, *Royal Chronicles*, 12; *Phraratchaphongsawadan krung si ayutthaya chabap phan chanthanumat.*

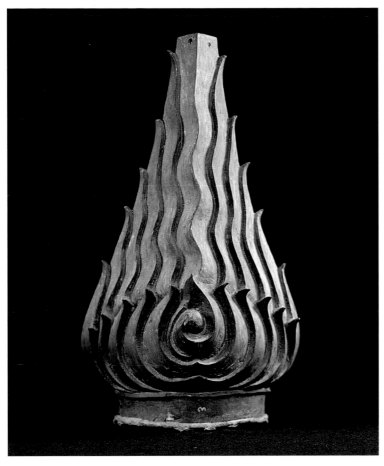

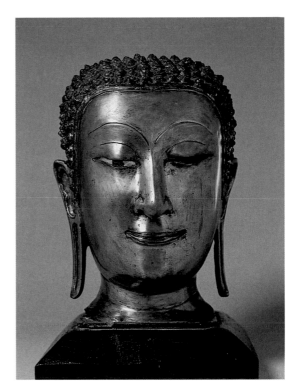

Left: fig. 146. Flame of the head of a Buddha image, cat. no. 31. Above: fig. 147. Head of a Buddha image, cat. no. 32.

5 This finial and the section of a temple tower have not, to my knowledge, been noticed in discussions of the history of iron casting in Siam. What is known of this history is summarized in Bronson, "Iron in Thailand." One wonders how many other architectural components of cast iron remain undiscovered under layers of stucco.

6 Prathip, Sathapattayakam, 42.

31

FLAME FROM THE HEAD OF A BUDDHA IMAGE, PERHAPS 1400–1600 (FIG. 146)
Copper alloy
H: 58.5 CM, W: 32CM
Chantharakasem National Museum, Ayutthaya, 3

Most Ayutthaya Buddha images had a flame springing from the protuberance on top of the head. Sometimes, as here, the flame was cast separately from the rest of the sculpture. The flame (called in Thai *ketumala* or *ratsami*),[1] like the gilding that once covered most Buddha images, suggested the fiery radiance of the Buddha's person. An unusual feature of this flame is the opening at the top, to which, presumably, a tip made separately was once attached. Perhaps this tip was of a shining, reflective material such as gold alloy or even crystal.

The image to which this flame once belonged must have been quite large, perhaps four or five meters high (between thirteen and sixteen and a half feet) if in seated position, or seven or eight meters high (between twenty-three and twenty-six and a quarter feet) if standing.[2] A head from a large Buddha image found at Wat Phra Si Sanphet in Ayutthaya and now preserved in the National Museum in Bangkok is of approximately the size, and perhaps the style, of the one to which this flame once belonged (cat. no. 88).[3]

A systematic study of the shapes of flame radiances on Thai Buddha images has yet to be undertaken, and assigning a date to examples separated from their images is difficult.

1 Woodward, "Buddha's Radiance."

2 Measurements taken of a number of intact images to compare the size of the flame to the overall size of the image show a large range of proportions of flame to whole.

3 Boisselier, *Heritage*, fig. 20; also illustrated in Fontein, *Bouddhas du Siam*, cat. no. 11.

32

HEAD OF A BUDDHA IMAGE, APPROX. 1500 (FIG. 147)
Copper alloy
H: 24 CM
Chao Sam Phraya National Museum, Ayutthaya, 33/10Ch

This head shares some of the qualities of the heads of a group of Buddha images thought to have been made for Wat Phra Si Sanphet in Ayutthaya in about 1500, and several other heads related to them.[1] Though less stylized and severe than they, this head is similarly elongated, and has a similar wide mouth with thin, "recessed" lips, taut upper lip, long nose, and high arching brow ridges marked with incised lines along both lower and upper edges.

1 Woodward, *Sacred Sculpture*, 228, 240, and figs. 224, 238; McGill and Pattaratorn, "Art of the Bangkok Period," 28–29; Matics, *Wat Phra Chetuphon*, fig. 15.

33

SEATED BUDDHA, APPROX. 1500–1550 (FIG. 35)
Found in the colossal Buddha image called the Phra Mongkhon Bophit, Ayutthaya
Bronze
H: 37.5 CM; W: 23.5 CM
Chantharakasem National Museum, Ayutthaya, M54/99

If the huge Buddha image known as the Phra Mongkhon Bophit was founded in 1538, as seems likely, many of the smaller images found in its shoulder were probably more-or-less new at that time. This beautiful image is among those. Its unusual base type (discussed in the entry for cat. no. 40) is found on at least one other image from the Phra Mongkhon Bophit,[1] and its egg-shaped head and smooth, rather flat face recall those of the crowned Buddha image dated 1541 (cat. no. 42).

1 Chao Sam Phraya National Museum, *Ayutthaya*, no. 16/99.

34

STANDING BUDDHA, PERHAPS 1500–1550 (FIG. 36)
Found in the colossal Buddha image called the Phra Mongkhon Bophit, Ayutthaya
Copper alloy with traces of lacquer and gilding
H: 70 CM
Chao Sam Phraya National Museum, Ayutthaya, 7/43

An appealing gentleness pervades this image, and makes us wish to know more about it. The image is unusual, however, and is not easy to place.

Bronze images of the Buddha standing with both arms raised and palms facing outward – images of a "modest gracefulness" – were made in north-central Thailand in the 1200s.[1] The type is not very common subsequently, especially for uncrowned images.

This image was found, along with cat. nos. 33, 35, and a number of other images,[2] in the shoulder of the huge Buddha image in Ayutthaya called the Phra Mongkhon Bophit, which may have been cast in 1538. Which of these were antiques when they were deposited, and which were new, has not been worked out.

While this image may date to the decades before 1538, in several of its features it recalls images from Ayutthaya's earlier days. Comparing it with an early fifteenth-century head such as cat. no. 7, for example, shows certain resemblances: relatively wide-set eyes and full cheeks, eyebrows less arched than in many images, a band separating the hair from the upper forehead, and very small hair curls. Numerous differences could also be pointed out – the flaring nostrils of cat. no. 7 are more strongly articulated – and the issue remains unresolved.

1 Woodward, *Sacred Sculpture*, 136–137.
2 Most of the images from the Phra Mongkhon Bophit are in the collections of the Chao Sam Phraya National Museum and the Chantharakasem National Museum in Ayutthaya. A group of standing images from the Phra Mongkhon Bophit is illustrated in *Namchom phiphitthaphan sathan haeng chat chao sam phraya*, 85.

35

STANDING CROWNED AND BEJEWELED BUDDHA, APPROX. 1500–1550 (FIG. 37)
Found in the colossal Buddha image called the Phra Mongkhon Bophit, Ayutthaya
Copper alloy
H: 58 CM
Chao Sam Phraya National Museum, Ayutthaya, M2/99

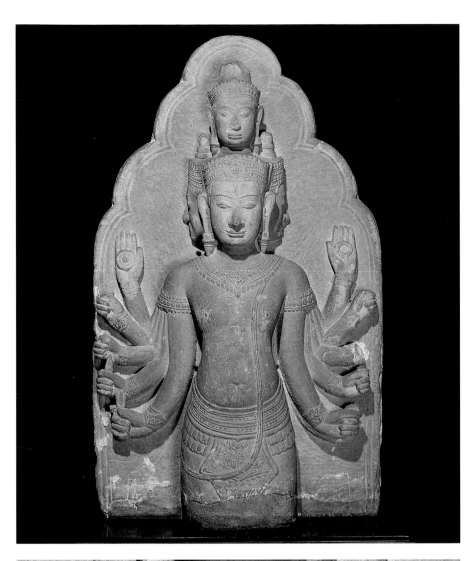

36

FIVE-HEADED SHIVA, APPROX.
1450–1550 (FIGS. 148, 149, 150)
Found at Wat Na Phra Men, Ayutthaya
Sandstone
H: 113 CM; W: 69 CM
National Museum, Bangkok, AY1

The subject, style, and material of this image are all unusual. There seems little doubt that it was made in the Ayutthaya kingdom in its earlier centuries, but it would be difficult to suggest more precisely where and when – and why.

Though it is identifiable as the Hindu god Shiva by the third eye in the forehead and the brahmanical cord across the body, in fact, five-headed, ten-armed representations of Shiva are not common in the arts of India or Southeast Asia.¹ A number of bronze statuettes of Shiva in this form were cast in the twelfth or thirteenth centuries by artists of the Angkor kingdom (or artists influenced by them),² but the only known Angkorian stone relief of a five-headed, ten-armed Shiva is at Wat Phu, in what is now southern Laos.³ This Wat Phu Shiva has been identified as Sadashiva, Shiva in his "supreme aspect," as have the bronze statuettes.⁴

The stone relief in the exhibition is the only example of a five-headed, ten-armed Shiva known from the Ayutthaya kingdom, and no precisely similar deity – and none with a name resembling "Sadashiva" – appears in the Bangkok-period manuals of Hindu iconography.⁵

Although there is no reason to think that Hinduism was practiced among the people of Ayutthaya (except, of course, by Indian traders), Hindu deities played an important role in court ceremonies, and a so-called Shiva-Vishnu Shrine was maintained in the capital.⁶ In royal ceremonies the names of Hindu deities

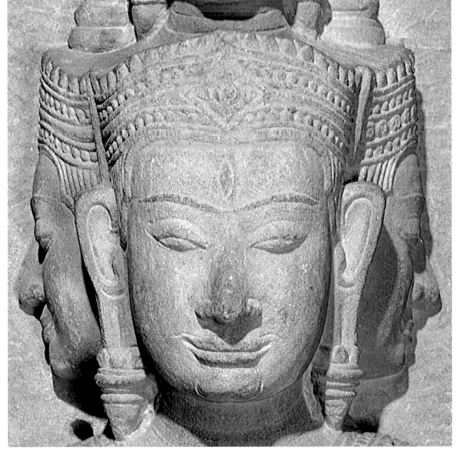

Top: fig. 148. Five-headed Shiva, cat. no. 36. Bottom: fig. 149. Detail of cat. no. 36. Facing page: fig. 150. Detail of back of cat. no. 36.

armed Avalokiteshvara in the Walters Art Museum.[5]

With dated artworks from Siam so extremely rare, the images in this group have always seemed particularly important for what they might tell us about artistic trends in the early sixteenth century. So far, however, their unusual and archaizing features and their seeming isolation have prevented much progress from being made.

1 Griswold and Prasert translate and discuss the inscription in "Inscription of the Śiva," and lay out possible interpretations of the dedication to "Their Majesties the two kings." Vickery doubts that Kamphaeng Phet was under the suzerainty of Ayutthaya at this time, and that the dedication refers to kings of Ayutthaya at all, "Cambodia and Its Neighbors," 32. The 1510 Shiva is pictured and discussed in Subhadradis, *Hindu Gods*, 111–115; and Listopad, *Phra Narai*, 385–389. Listopad also discusses this image of Vishnu, 389–391.

2 Listopad rightly notes, however, that the superiority of modeling and casting of the Shiva, and its greater originality and force as a work of art, set it apart. He concludes, "It is difficult to determine without metallurgical studies, whether the image of Phra Narai [Vishnu] was cast shortly after the image of Phra Isuan [Shiva], or whether it was cast at the same time and by the same patron, with a different less prestigious workshop chosen for its production" (*Phra Narai*, 391). The incomplete female figure is pictured in Subhadradis, *Hindu Gods*, 113, and the male torso in Subhadradis, *Sinlapa sukhothai*, 288–289.

3 Illustrated and discussed in Woodward, *Sacred Sculpture*, 155; and Subhadradis, *Hindu Gods*, fig. 54A. The 1510 Shiva is 280 cm in height, the Sukhothai Shiva, 308 cm.

4 Woodward, *Sacred Sculpture*, figs. 69, 94.

5 Woodward, *Sacred Sculpture*, fig. 100.

38

A HINDU DEITY, PROBABLY UMA, APPROX. 1500–1600 (FIGS. 154, 155, 156)
Copper alloy with gilding
H: 171 CM; W: 52 CM
National Museum, Bangkok, 969Kh

Jean Boisselier, the renowned French scholar of Southeast Asian art, proclaimed this bronze image of Uma (Parvati), wife of the Hindu god Shiva, the finest of its kind: "a work of genuine artistry" that "stands out distinctly from the rest of Ayutthaya sculpture."[1]

The remarkably South Indian appearance of this sculpture – reflected in the swaying posture, style of dress, tall rounded headdress, and large circular ear ornaments, for example – is what makes it unique among Ayutthaya's bronzes. That there must have been an Indian model, whether directly or indirectly available to the artist, seems to be beyond doubt. The gentle outward thrust of Uma's right hip, her relaxed left leg, and her extended right arm are all features associated with the classic posture known in India as the *tribhanga*, or triple-bend, pose. Few other bronze sculptures from the Ayutthaya period, or earlier, make use of this particular stance.[2] Instead, most depict the deities standing or sitting in a rigidly frontal pose, with arms – frequently holding attributes – extended in front of the body or to the sides.[3]

The Indian bronze traditions among which this image finds its closest parallels are those associated with the late Chola and Vijayanagara empires, which effectively encompassed much of southern India from the eleventh through the mid-sixteenth centuries.[4] That no more precise identification of the stylistic source can be made indicates the long duration of certain iconographic types in South Indian ritual bronze

traditions as well as the transformative abilities of, in this case, Siamese artists. The process by which Southeast Asian artists received and translated foreign forms into ones uniquely their own is a vexing one. Of the numerous sculptures found in Southeast Asia that indicate some contact with Indian artistic and architectural forms, many appear so thoroughly localized in appearance that their exact Indian sources remain speculative.

South Indian images were known in the peninsular area of Thailand from perhaps as early as the fifth century.[5] A long history of contact with South Indian artistic forms is indicated by such finds as the three eighth- to ninth-century Hindu sculptures from Takua Pa,[6] two tenth- to eleventh-century sculptures, one of Vishnu and one of Shiva, discovered at Wiang Sa,[7] and, as late as the seventeenth to eighteenth century, a small bronze statue, identified as Uma, which was found at a Hindu shrine in Nakhon Si Thammarat.[8]

The group of images from Takua Pa are stylistically close to South Indian images of the Pallava dynasty (early fourth to late ninth century), whose power was centered in the region of South India now known as Tamil Nadu state. So close is it, in fact, that Stanley O'Connor suggested "we may assume either that it was made in India, or that it was made at Takuapa by an Indian artist."[9] Whether the Wiang Sa sculptures were made in India, or in Thailand by an Indian or Southeast Asian artist, is equally unclear. The bronze Uma, now in the Nakhon Si Thammarat Museum, is thought to have been made in Thailand though it is virtually indistinguishable from contemporary South Indian bronzes.[10] Was an earlier image of this type – imported into the Ayutthaya kingdom from India or produced in

Thailand by an Indian artist – used as a model for the National Museum's South Indian-style bronze goddess?

The sheer size of this sculpture, which stands over five feet tall, indicates that it was made for an important – probably royal – patron. That it should depict a Hindu deity is not surprising as Hindu-derived rituals played a vital role in Thai royal ceremonies and continue to do so today. Historical records of various dates indicate the presence at the Thai court of Hindu brahmans able to perform these important services.[11] A family that became prominent among Ayutthaya's nobility in the late seventeenth century traced its lineage to an Indian brahman who had arrived in Siam during the reign of King Prasat Thong (reigned 1629–1656).[12] It is not known if he came from South India, but other Hindu ritual specialists did. In the early nineteenth century, a priest at the so-called Brahman Temple in Bangkok is reported to have informed a member of the British embassy that he was the fifth-generation descendent of a brahman who originally came from the pilgrimage center of Rameshvaram, in the present-day Indian state of Tamil Nadu.[13]

No large bronzes comparable to

Right: figs. 154. A Hindu deity, probably Uma, cat. no. 38. Top: fig. 155. Detail of cat. no. 38. Bottom: fig. 156. Back of cat. no. 38.

this one, with its numerous South Indian-style features, are known from the Ayutthaya period. However, a bronze Buddha image cat. no. 42, dedicated in the year 1541, is stylistically similar in the treatment of the facial features and may provide an approximate date for its manufacture.[14] Other large Hindu bronzes were certainly made in the Ayutthaya kingdom, as indicated by an impressive group of fourteen images from the Brahman Temple in Bangkok that have been documented by Prince Subhadradis. None – especially the single goddess image in the group – is close to this sculpture in appearance.[15]

The goddess in the exhibition has a curvaceous shape – accentuated by a small waist and full, rounded breasts – that recall late Chola and Vijayanagara period bronzes (fig. 157).[16] The sensuous figure of the image is quite different from the Brahman Temple Uma, which is thicker through the waist and has smaller, flatter breasts. Clothing and ornament are also dramatically different. The lower garment clings to the legs of this goddess in a fashion quite unlike that of the heavy flared skirt worn by the Brahman Temple Uma and, indeed, by most other Ayutthaya Hindu bronzes.[17] This clinging drapery, with the fluttering panels along the sides of the skirt, again finds parallels in South Indian bronzes of the Chola period and later. The sweeping tiered panels along the front length of the skirt seem to be an Ayutthaya innovation, encountered in various permutations across a range of sculptures. The ornamental designs on the waistband, headband, necklace, and skirt are found on several other Ayutthaya-period bronzes.[18]

The wheel-like attachment behind the head of the goddess is certainly derived from South India, where these halo devices also served an ornamental function, concealing the knot of the headband.[19] No other Hindu bronzes of the Ayutthaya period have this disk. Other features that appear in South Indian sources include the large round earrings, which are unlike the heavy pendants typically encountered in the Ayutthaya period.[20] The wavy extensions of hair indicated along the shoulders and upper arm are also found on several Chola- and Vijayanagara-period bronzes, as is the tall, rounded headdress. The latter is a marked departure from the flaring diadem and peaked crown of the Angkor-related headdress more commonly encountered on Ayutthaya images.

Nothing is known about the origins of this image and very little is known of its history. Even its identification is not certain; the image has been thought by some to represent Lakshmi, consort of the Hindu god Vishnu.[21] In Chola- and Vijayanagara-period bronzes, which provide the closest models, long-established visual conventions were used to distinguish among deities. When depicted individually, Lakshmi and Uma can appear rather similar in appearance. Lakshmi, however, almost always wears a breastband and is thus differentiated from her Shaivite counterpart. Uma is not the only Hindu goddess to be depicted without a breastband in South Indian bronzes, but of these goddesses – including Bhudevi and Sita – she was the one most frequently depicted in Thailand. For lack of an identifying inscription or companion image, and due to the fact that specific Indian iconographic features may not always have been followed in Southeast Asia, the identification of this sculpture remains tentative.[22] Nonetheless, within the corpus of known Ayutthaya-period bronzes, it is another remarkable reminder of the diverse sources that were brought to bear on the art of the Ayutthaya kingdom.

Tushara Bindu Gude

1 Boisselier, *Heritage*, 178.

2 Two bronze images of the Hindu goddess Lakshmi that were published in the nineteenth century by Lucien Fournereau stand in the swaying posture with their right arms similarly extended along the sides of their bodies. They differ, however, in several details from this bronze image. (Fournereau, *Le Siam ancien*, pls. XVIII, XXIX.)

3 Some bronze sculptures of Hindu goddesses, while adhering to such frontality, are depicted with one arm extended downward in a manner similar to this image. Perhaps the most well-known of these is the large Uma in the National Museum, Bangkok (SK 17), discussed later in this entry as part of the so-called Brahman Temple group.

4 The Chola empire was founded in the ninth century and ended in 1279. After a period during which competing groups claimed power, the Vijayanagara empire was established and lasted from approximately 1350 to 1565.

5 Stanley J. O'Connor was the first to suggest that a well-known image of the Hindu god Vishnu, found in Chaiya in peninsular Thailand, has its closest parallels in third- to fourth-century sculptures from the region of South India corresponding to present-day Andhra Pradesh state. Previously thought to be an eighth-century work, the South Indian material suggested to O'Connor that the Chaiya Vishnu dated from as early as 400 CE (*Hindu Gods of Peninsular Siam*, 37–39, fig. 1). Although several scholars have questioned O'Connor's dating, the Chaiya Vishnu and other sculptures clearly indicate a long pattern of contact between South India and Thailand. (For an alternate opinion about the dating of the Chaiya image, see Woodward, *Review*, 210–211.) The artistic and cultural links between

India and Southeast Asia have been a subject of academic interest for the past several decades. For a consideration of early artistic relationships between Cambodia and India, including South India, see Bénisti's *Rapports*. Studies investigating the connections between early mainland Southeast Asia and South India, specifically, include Filliozat's *Kailasaparampara* and Wright's *Sacred Gable*.

6 O'Connor, *Hindu Gods of Peninsular Siam*, 52–55, figs. 28–31.

7 O'Connor, *Hindu Gods of Peninsular Siam*, 60–63, figs. 32–33.

8 Natthapatra and Saengchan, eds., *Nakhon Si Thammarat National Museum*, 95. As discussed later in this entry, the fact that this image wears a breastband indicates that it may not, in fact, represent the goddess Uma, who is conventionally depicted without a breastband in South Indian bronzes.

9 O'Connor, *Hindu Gods of Peninsular Siam*, 55.

10 Piriya Krairiksh identifies this Uma (13/2515) as a product of peninsular Thailand showing southern Indian influence (*Baep sinlapa*, 188). The Nakhon Si Thammarat National Museum Visitor's Guide credits it to the "Southern school of art under Southern Indian influence" (Natthapatra and Saengchan, eds., *Nakhon Si Thammarat National Museum*, 95).

11 For example, mention of brahman participation in various ceremonies is scattered throughout the Ayutthayan Royal Chronicles; see, to highlight only a few references to brahmans performing ritual and ceremonial functions, Cushman, *Royal Chronicles*, 6, 8, 10, 21, 26, 59, 92–93, 101–102.

12 Wyatt, *Thailand*, 129; see also, Wyatt, "Family Politics in Nineteenth-Century Thailand," in *Studies in Thai History*, 106–130.

13 Crawfurd, *Journal of an Embassy*, 119.

14 This Buddha image was discussed by

Prince Subhadradis in his *Hindu Gods*, 104–106, figs. 57A–57B; and his "Dated Crowned Buddha Image." The bronze Uma was not considered in either work.

15 Most of the fourteen sculptures

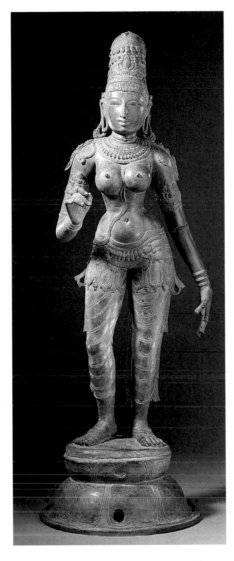

Fig. 157. The Hindu Goddess Satyabhama, approx. 1150-1300; India, Tamil Nadu state; copper alloy; Los Angeles county Museum of Art, gift of Mr. and Mrs. Hal B. Wallis, M.70.69a.

are close in size to this bronze Uma. Four are larger, and of those, two are considerably larger (Subhadradis, *Hindu Gods*, figs. 1–14, illustrated on a foldout between pp. 5 and 6). Subhadradis first published his study of these bronzes in a Thai publication of 1966.

16 Identifying a narrower range of possible source imagery is difficult. A number of innovations were steadily introduced into the South Indian bronze tradition, though many images show a conscious continuation of earlier types. Compare, for instance, a pre-Chola period image of the Hindu goddess Durga (Sivaramamurti, *South Indian Bronzes*, fig. 11b) with examples of the tenth century and thirteenth century (Dehejia, *The Sensuous and the Sacred*, 134–137, cat. nos. 19–20). With respect to Uma images, which are more pertinent to this discussion, compare the following bronzes: tenth century (Sivaramamurti, *South Indian Bronzes*, fig. 17a), twelfth century (Sivaramamurti, *South Indian Bronzes*, fig. 26), fourteenth century (Pal, *Indian Subcontinent*, 233, cat. no. 170d), and sixteenth century (Sivaramamurti, *South Indian Bronzes*, fig. 80a).

17 Compare, for instance, the clinging drapery of this figure to the dress of the Hindu bronzes illustrated in Subhadradis's *Hindu Gods* and Fournerou's *Le Siam Ancien*.

18 Listopad, *Phra Narai*, 428–429.

19 Dehejia, *The Sensuous and the Sacred*, 92.

20 The image of Satyabhama, wife of the Hindu god Krishna, in fig. 157, does not wear rounded earrings of this type. However, heavy round earrings are documented in numerous surviving male and female bronzes of the Chola and Vijayanagara periods.

21 The National Museum identifies the goddess as Lakshmi, as did Boisselier, who used the goddess's alternate appellation, Shri (*Heritage*, 178).

22 The bronze image of Satyabhama (fig. 157) is part of a group of images that were intended to form a set. Had the bronze been found without these accompanying figures, it could easily be misidentified as an image of another female – such as Uma or Bhudevi – for whom the same figural, clothing, and headdress conventions are used.

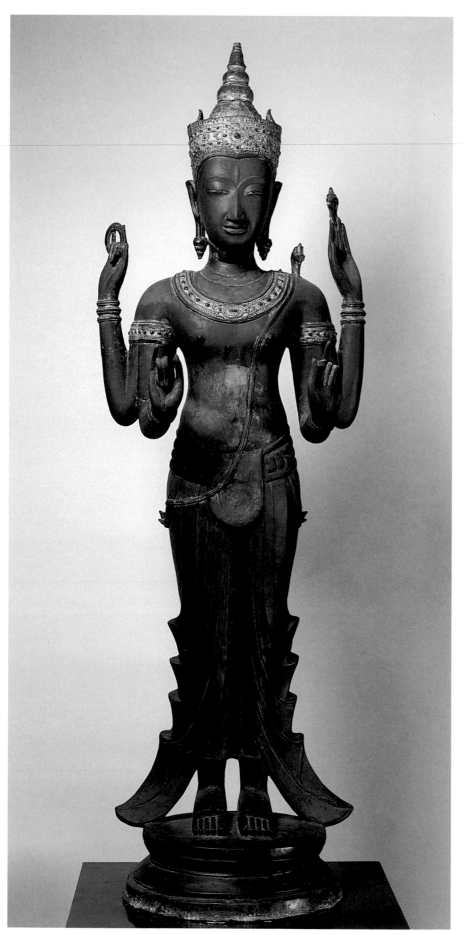

Fig. 158, The Hindu deity Harihara, cat. no. 39.

39

THE HINDU DEITY HARIHARA,
APPROX. 1500–1600 (FIG. 158)
Copper alloy with mother-of-pearl
inlay and gilding
H: 136 CM; W: 42 CM
National Museum, Bangkok, SKh 18

This image has attributes associated
with two Hindu deities, Vishnu (the
circular weapon and the conch shell
held in the upper hands) and Shiva
(the third eye in the forehead and
the brahman's cord with snake clasp).
Therefore it has long been identified
as Harihara, who combines aspects
of both.[1]

Except among the related group of
large bronze images of Hindu deities
to which this image belongs,[2] repre-
sentations of Harihara in Thailand are
extremely rare. In ancient Cambodia
they were numerous enough until the
early tenth century, but then more
or less disappeared except for a few
small bronzes.[3] Woodward has noted,
however, that in the decades after the
death in the early thirteenth century
of the great Buddhist king of Angkor
Jayavarman VII, as part of the efforts
to convert the Bayon, his central Bud-
dhist temple, into a Hindu temple, its
principal Buddha image was replaced
with an image of Harihara.[4] Unfor-
tunately, this period of Cambodian
history is obscure; it would be helpful
to know more about the meanings and
implications of this image of Harihara
to the people who erected it.

On the place of Hindu deities in
Ayutthaya's religion and ceremonial,
see cat. no. 36. On the controversy over
the date and place of manufacture of
large bronze Hindu images such as
this, see cat. no. 41.

1 See, however, Wibke Lobo's discussion
in Jessup and Zéphir, *Sculpture of*

Angkor, 260–261, 340–341.

2 Discussed and illustrated in Subhadradis, *Hindu Gods*.

3 Dalsheimer, *Collections*, 14 and no. 133. Dalsheimer notes that Harihara continues to be mentioned occasionally in inscriptions. Also, Bhattacharya, *Religions brahmaniques*, 157–159.

4 Woodward, *Art and Architecture of Thailand*, 202.

40

GANESHA, 1500–1600 (FIG. 159)
Copper alloy
H: 32.4 CM; W: 18.1 CM
Metropolitan Museum of Art, New York, Gift of the Kronos Collection, 1983.512

Surviving images of the elephant-headed Hindu god Ganesha are rare in the arts of Ayutthaya, even though such images are mentioned more than once in the Royal Chronicles. In 1656 King Narai ordered the casting of several images of Hindu gods, including "Mahawikhanesuan" (Sanskrit: Mahavighneshvara), a form of Ganesha. In 1657 he ordered the casting of two images of "Thewakam" (Sanskrit: Devakarma), a different form of Ganesha, apparently in conjunction with royal ceremonies including the "ceremony of elephant training."[1] Small bronzes of Ganesha were carried in processions for various royal ceremonies in the early twentieth century, perhaps reflecting practices passed down from the Ayutthaya period.[2]

Images of Ganesha were fairly common in Angkor, and, "having maintained a substantial popularity in the post-Angkorian period, bronzes of Ganesha continued to be cast up to our own day."[3] The bronze Ganesha in this exhibition is ultimately based on Angkorian prototypes, such as one in the National Museum of Cambo-

dia.[1] But given how poorly the development of post-Angkorian sculpture, and of the sculpture of Hindu deities in Thailand after the twelfth century, are understood, tracing the intermediaries is difficult. A number of bronzes of Ganesha related closely or more distantly to Angkorian models are preserved in Thailand's museums and shrines, but most are of very uncertain date and place of manufacture, and they are largely unstudied.[5] Part

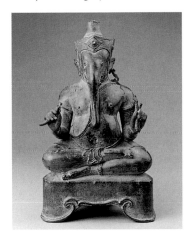

Fig. 159. Ganesha, cat. no. 40.

of the problem, no doubt, is that sculptors in Thailand chose, or were asked, to emulate earlier images of Ganesha, or to follow drawings in iconographical manuals that were based on prestigious ancient or foreign styles, and so the art historical picture is obscured by layers of archaism and foreign influence.[6]

The crown of this image of Ganesha, with its decorative lozenges at the front and sides, is a simplified version of common fifteenth- and sixteenth-century types. Only the base of the image may provide a somewhat more precise chronological clue. It is relatively high, and has, at its corners, broad feet with spirals at the heel, bordered by a raised line (or pair of lines). A quite similar base can be seen on cat. no. 33, a Buddha image found in the shoulder of the huge Buddha image of Wat Mongkhon

Bophit, Ayutthaya, which may have been constructed in about 1538.[7] Similarly decorated legs can be seen in stucco architectural decoration that may date from about 1500, and elaborated versions can be seen on a northern Thai bronze elephant bearing an inscribed date equivalent to 1575.[8]

1 *Phraratchaphongsawadan krung si ayutthaya chabap phanchanthanumat*, 383, 386; Chiratsa, *Phra phikkhanet*, 69–70; Listopad, *Phra Narai*, 37, 39, 62–63. Cushman's translation in *Royal Chronicles*, 243, 245 is misleading, as he did not recognize the unusual names of Ganesha. For these names, see *Tamra phap thewarup*, for instance 27, 28, 52, 53; Sarma, "Un Album thailandais," fig. 12a; Chiratsa, *Phra phikkhanet*, 129–131; and Fournereau, *Le Siam ancien*, part 1, 64. Bhattacharya notes that "Vighneshvara" is attested as a name for Ganesha in an eleventh-century Angkorian inscription; *Les Religions brahmaniques*, 133. "Thewakam (Devakarma)" is said to be the "great teacher of elephants;" *Phra khanet thepphachao*, 98.

2 Wales, *State Ceremonies*, 77, 251; Chiratsa, *Phra phikkhanet*, 129–131, includes a photo of a statuette of Ganesha being carried in such a procession. See also Mongkol, "Phithikam," 25.

3 Boisselier, *Le Cambodge*, 290.

4 Jessup and Zephir, *Sculpture of Angkor*, cat. no. 109. Only in Thailand and Cambodia, it seems, was Ganesha shown seated with legs folded one atop the other. Earlier discussions of the Ganesha in this exhibition can be found in Lerner, *The Flame and the Lotus*, 140–141, and Brown, "Images of Ganesh," 24 and fig. 4.

5 Fournereau, *Le Siam ancien*, part 1, pls. 18, 24; Coedès, *Bronzes Khmers*, pl. 15; Chiratsa, *Phra phikkhanet*, 82, 84, 86, 87, 105–111, etc.; *Phra khanet thepphachao*, cat. nos. 6-8, 11–14, 18.

6 Archaism and foreign influence are also evident in other Ayutthaya-period sculptures of Hindu deities, such as the Vishnu and goddess in this exhibition, cat. nos. 37 and 38.

7 Woodward, *Sacred Sculpture*, 233, 249, 303 (n. 15), 304 (n. 53). The date of the huge image is uncertain, as is whether the Buddha images found in its shoulder were deposited at the time the huge image was made. Further, of course, some of the images found in the shoulder may not have been new – in fact, probably were not – when deposited.

8 Cat. no. 46, n. 5. Another small bronze Ganesha has a fancier – and somewhat later? – version of this base type; see Chiratsa, *Phra phikkhanet*, 87.

41

HEAD OF AN IMAGE OF SHIVA,
APPROX. 1500–1600 (FIG. 160)
Said to have been excavated in the city of Ayutthaya
Leaded bronze with mother-of-pearl inlay and gilding
H: 29.2 CM; W: 15.9 CM
Asian Art Museum, The Avery Brundage Collection, B60S18

The third eye in the forehead and the headdress with crescent moon and associated symbols on the upper part identify this head as coming from an image of the Hindu deity Shiva.

A group of bronze images of Hindu deities, most of which are now in the National Museum, Bangkok, have been the object of scholarly controversy for many years. Regarding neither their dates nor their place of manufacture has any consensus been reached.[1] Part of the difficulty is that several of these images probably date to the 1300s and the rest to the 1500s, and that the latter have certain archaizing features – references to the

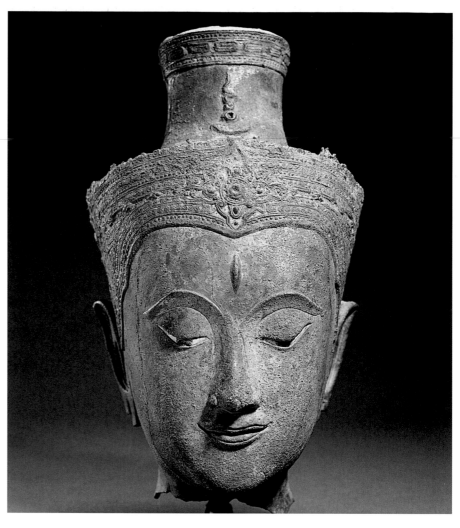

Fig. 160. Head of an image of Shiva, cat. no. 41.

tradition of the earlier images – that have caused confusion.[2]

The group of Hindu deities has usually been thought to have been cast in the Sukhothai area, and this may be so, but this head is said to have been excavated the city of Ayutthaya.[3] Of course, it may have been transported to Ayutthaya from elsewhere. It shares a number of qualities, such as the egg-shaped head with rather pointed chin, relatively flat face, narrow nose, and small, thin-lipped mouth, with the crowned Buddha (1541, cat. no. 42), which may also be a product of a north-central workshop.[4]

1 The hundred-year history of the controversy is recounted in Listopad, *Phra Narai*,

396–409. The images are described and illustrated in Subhadradis, *Hindu Gods.*

2 I agree with Woodward, who believes that two of the figures (S. Kh 14 and 26) may well be ones mentioned in a Sukhothai inscription of 1349 or 1361, see *Sacred Sculpture*, 155. Listopad takes a different view, assigning them to the seventeenth century, see *Phra Narai*, 426–427.

3 According to an invoice from the New York dealer William Wolff, dated May 16, 1960, this head was "excavated in early 1959, in Ayuthia; this head with a multitude of other relics of previous dynasties were burried [*sic*] under and within the base of the large bronze Buddha of Ayuthia. These relics were discovered in 1959 when the large bronze

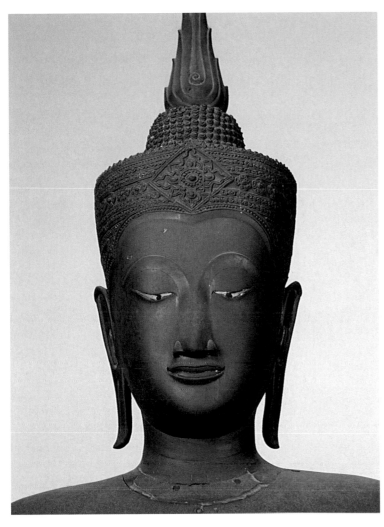

Fig. 161. Detail of cat. no. 42.

until the end of the religion."[2] Unfortunately, neither the town named, nor the temple, can be identified with certainty today,[3] but the fact that this image was formerly in the collection of Wat Ratchathani in New Sukhothai suggests that they were in the north-central region.[4]

The implications of the donor's calling this crowned Buddha image a "king of kings" are important. The reference is probably to the Southeast Asian legend of Jambupati, an arrogant king who boasted of his supremacy. The Buddha commanded him to appear and pay homage to the "king of kings." The Buddha then manifested himself in a great palace, clad in royal adornments of incomparable brilliance, and Jambupati was humbled.[5]

A very unusual feature of this image is that, while most crowns on Buddha images of this period and later are closed at the top and have an integral finial (cat. nos. 35, 43), this one is open, allowing the *ushnisha* and flame to be seen. One other example – similar to this image in a number of ways – is known.[6]

Buddha was moved to a newly errected [*sic*] temple." Also, several bronze hands like those of the later group of Hindu deities were excavated at the so-called Hindu Shrine of Ayutthaya, see Subhadradis, "Boranwatthu sung khutkhonphop," 59 and figs. 35–37.
4 A thermoluminescence test in 1998 suggested that this head was cast between 1400 and 1650.

42

STANDING CROWNED BUDDHA, 1541 (FIGS. 40, 161)
Copper alloy
H: 187 CM; W: 45 CM
National Museum, Bangkok, lent by Wat Benchamabophit, Bangkok

Because it bears an inscribed date (which is rare) equivalent to 1541, this impressive image is exceptionally important to our understanding of the history of sculpture in Siam. Before the inscription was noticed in 1960, the image had been tentatively assigned to periods ranging from the 1400s to the 1600s.[1] Having it now fixed in time helps in trying to date a large number of other works by comparison with it, for example, cat. nos. 38 and 41.

According to the inscription, a merchant from "Chanthabun" founded this "*ratchathirat*" (king of kings) to be set up in "Wat Burapharam." He donated four persons (presumably as slaves) "to maintain the Lord Buddha

1 Subhadradis, "Dated Crowned Buddha," 409.
2 Subhadradis, "Dated Crowned Buddha," 410.
3 The inscription, and the style and importance of this image are discussed thoroughly in Listopad, *Phra Narai*, 391–396 and notes.
4 Subhadradis, *Hindu Gods*, 105, 121 n. 7.
5 Woodward, *Sacred Sculpture*, 76, 79, 116, 212, 219, 232–233, 294 nn. 6, 7; Griswold, "Conversion of Jambupati," 259; and Fickle, "Crowned Buddha Images," which is now rather out of date.
6 National Museum, Bangkok, acc. no. AY11, unpublished, to the best of my knowledge.

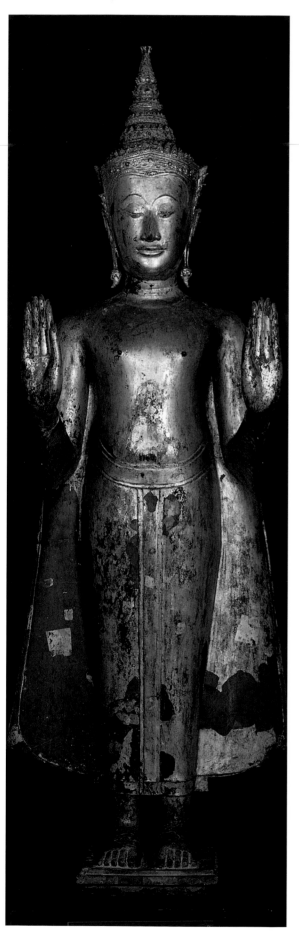

43

STANDING CROWNED BUDDHA,
APPROX. 1550–1600 (FIG. 162)
Copper alloy
H: 156 CM
Chao Sam Phraya National Museum, Ayutthaya, 29/12Ch

44

SEATED BUDDHA WITH MARA'S
ARMY, APPROX. 1450–1600
(FIGS. 163, 164)
Copper alloy
H: 33 CM; W: 19.6 CM
Chao Sam Phraya National Museum, Ayutthaya, 17/1Ch

The Buddha is shown conquering the army of Mara, the personification of evil and death. Mara's demonic warriors – including one at the back with a goat-like head – seem to be running clockwise around the base of the sculpture. They carry no weapons; their upraised arms may suggest that they are lifting the Buddha's throne. If so, what is represented is not the battle but its aftermath, when the chastened warriors submit to the Buddha.

Some other similar images from Ayutthaya show Mara's warriors in the humble role of supporters of the Buddha's throne, and others also show, as here, a figure directly below the Buddha apparently being carried on the shoulders of another warrior.[1]

As Hiram Woodward has pointed out, a related representation of the Buddha's throne supported by conquered warriors can be seen in a stucco relief on a tower at a temple in Singburi province in central Thailand.[2]

1 Woodward, *Sacred Sculpture*, figs. 226, 227, 228. On the sculpture in his fig. 227, at least some of the warriors

appear to be actively attacking. (A larger photo of this image is found in Hong Kong Museum of Art, *Sculptures from Thailand*, no. 42.) See also Woodward's discussion on 231–232.

2 Woodward, *Sacred Sculpture*, 231–232; illustrated in No. Na Paknam, *Sinlapa samai krung si ayutthaya*, 96–97. No. Na Paknam attributes the tower to the pre-Ayutthaya or early Ayutthaya period.

45

HEAD OF A BUDDHA IMAGE,
PERHAPS 1500–1600 (FIG. 165)
Copper alloy
H: 28 CM; W: 19 CM
Chantharakasem National Museum, Ayutthaya, 7/14Ch

This head is rather unusual in the delicacy of its features and the very small size of its hair curls. These, together with the narrow, slightly pursed mouth, give a sense of quietude and intense concentration.

Several important scholars have assigned this head a date in the fifteenth or sixteenth century,[1] and certainly it has similarities with presumed sixteenth-century sculptures such as cat. nos. 33 and 35, both found in the shoulder of the huge image called the Phra Mongkhon Bophit, probably cast 1538. But it also has similarities with what Woodward has called a "late-Ayutthaya plain style" of the eighteenth century.[2] It is a symptom of the weakness of our understanding of many aspects of Siam's sculpture that a work like this one is so hard to place.

1 "Fifteenth–sixteenth century," Woodward, *Sacred Sculpture*, 241; "about sixteenth-century," Boisselier, *Heritage*, fig. 159.

2. Woodward, *Sacred Sculpture*,

Fig. 162. Standing crowned Buddha, cat. no. 43.

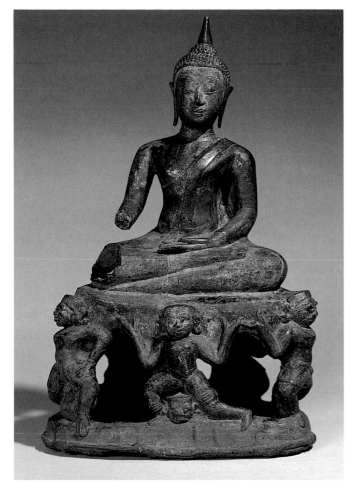

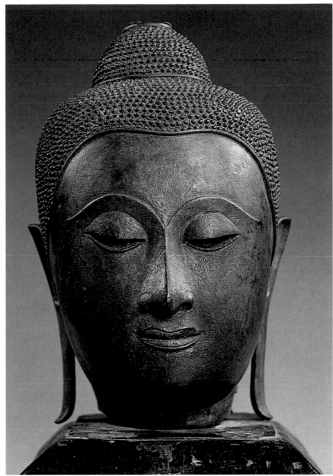

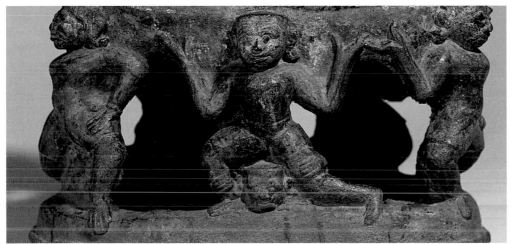

Above left: fig. 163. Seated Buddha with Mara's Army, cat. no. 44.

Below left: fig. 164. Detail of cat. no. 44.

Above right: fig. 165. Head of a Buddha image, cat. no. 45.

239 and fig. 236. The notion of a "late-Ayutthaya plain style" is still ill defined. Certainly a number of late Ayutthaya and early Bangkok Buddha images have a subdued, often somewhat archaizing, quality but it is difficult to agree with Woodward in dating the face of the huge reclining at Wat Pa Mok to the eighteenth century, and the similarities between his fig. 236 ("eighteenth century") and fig. 249 ("sixteenth century") require more study.

46

RECLINING BUDDHA, APPROX. 1550–1625 (FIG. 32)
Copper alloy
L: 63 CM
U Thong National Museum, Suphanburi, 98/09

The Buddha in the position of reclining is usually thought of as attaining final nirvana, but in Thailand is sometimes considered to be resting.[1]

There are several very large old reclining Buddhas in the Ayutthaya area, including the well-known ones at Wat Lokkayasuttha in the city of Ayutthaya and Wat Pa Mok eighteen kilometers to the northeast.[2] This bronze resembles neither of these, however, either in the disposition of its head and arms or in its style. In this case, the head is tilted to face slightly upward rather than straight forward horizontally, and the right arm and hand are lying beside the head rather than supporting it.

These rare features are shared by an image of the reclining Buddha at Wat Ko in Lampang in northern Thailand, which is inscribed with a date equivalent to 1602.³ On the one hand, certain of the facial features of the image in the exhibition – its close-set eyes, high-arching brows connected to the nose bridge, rather puckered mouth, and articulated chin – also recall those of some northern Buddha images,⁴ and it might be concluded that it was, after all, made outside the Ayutthaya realm.

On the other hand, the lower part of its base is of a type known in Ayutthaya as well as in the north⁵ (though the zigzag edge of the Buddha's cot is hard to match), and most of the features of its face and body have parallels in Ayutthaya sculpture.⁶ The patterns on the upper part of the base, such as the band of alternating plus-sign shapes and winged lozenges, turn up in Ayutthaya-period stucco, ceramics, and other decorative arts, and in Indian textiles made for the Siamese market.⁷

1 Somphon, *Phraphuttharup pang tangtang*, 140–141; Phiset, "Phraphuttharup pang parinipphan," 106–114.

2 The image at Wat Lokkayasuttha is illustrated in Tri, *Official Guide*, 37; the Wat Pa Mok image is illustrated and discussed in Griswold, "Eighteenth-Century Monastery," and Griswold and Prasert, "Devices and Expedients." The Thai scholar No. Na Paknam compares the image in the exhibition with the very large one at Wat Phra Rup, Suphanburi, and gives it a date before the Ayutthaya period; see No. Na Paknam, *Samutphap prawattisat sinlapa*, 66–69. In fact, the similarities to the reclining Buddha at Wat Phra Rup do not seem at all close, and the image in the exhibition must, for reasons discussed below, be later.

3 Woodward, *Sacred Sculpture*, 222–223;

Griswold, *Dated Buddha Images*, 94 and pl. 52.

4 For instance, various of the images with sixteenth-century dates in Griswold, *Dated Buddha Images*, and Woodward, *Sacred Sculpture*, cat. no. 80.

5 See, for example, stucco decoration on the main image hall of Wat Phra Si Sanphet, Ayutthaya, which Santi (*Late Ayutthaya Period*, 105, 215) dates to 1499; in sculpture, the bronze goddess in this exhibition, cat. no. 38; several unpublished Buddha images from the shoulder of the huge bronze Buddha image of Wat Mongkhon Bophit, Ayutthaya, which may possibly date to about 1538 (Chantharakasem National Museum, Ayutthaya, M50/99, 59/99); and Somkiat, *Phra phuttharup sinlapa samai ayutthaya*, fig. 150 (it is unclear to what extent the base has been repaired; see p. 406). But perhaps more similar is the base of a bronze elephant from the north inscribed with a date equivalent to 1575; Fontein, *Bouddhas du Siam*, cat. no. 45. For further discussion of this base type, see the entry for cat. no. 40.

6 Cat. nos. 93 and 94 in Woodward, *Sacred Sculpture*, are at least distantly related, as are the facial features of his

cat. no. 55, a Sukhothai-style seated Buddha that he suggests may have been made in Phitsanulok in the mid-fifteenth century, or as late as the early sixteenth.

7 Section of a stuccoed wall from Wat Phukhao Thong, Ayutthaya, now at the Chao Sam Phraya National Museum, Ayutthaya, usually dated to the mid-eighteenth century; lidded bowl, Sawankhalok ware, fifteenth–sixteenth century, see Brown, *Legend and Reality*, cat. no. 161; bronze nagas at the Shrine of the Buddha's Footprint, Saraburi, seventeenth or eighteenth century, see McGill, *Prasatthong*, fig. 159; and textile, cat. no. 82, in this catalogue.

35, 47, 48, 63

CROWNED AND BEJEWELED BUDDHA IMAGES

The meanings of the crowned and bejeweled Buddha image in Siam have often been discussed, but remain elusive. (See Hiram Woodward's discussion in this volume.) There is the Southeast Asian fable of the Buddha's manifesting himself in incomparable royal glory to overawe the arrogant king Jambupati, but, as has

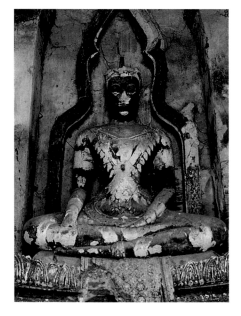
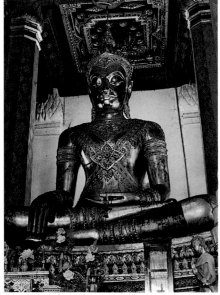

Left: fig. 166. Ruined Buddha image, Wat Chaiwatthanaram, Ayutthaya. Right: fig. 167. Main Buddha image, Wat Na Phra Men, Ayutthaya.

been pointed out, it has the quality of something made up by a learned monk to satisfy the questions of the faithful about an already-existing form.[1] Part of the problem is that even in Siam in the 1500s through 1800s the meanings are likely to have been different in different periods and for different groups – monks, layfolk, and royalty. Also, crowned and bejeweled Buddhas in different positions, whether standing or seated, and with various hand gestures, may well have had different associations. Certainly the twelve large, identical crowned and bejeweled Buddhas at Wat Chaiwatthanaram (fig. 166), founded by King Prasat Thong in the 1630s, had different meanings for the king and court from those they had for townspeople, and other royally commissioned crowned Buddha images probably had associations with the worship of royal ancestors and suggestions of the

special status of the king's forebears, and therefore himself, that were not fully known to ordinary people. Also, as Woodward has pointed out, a crowned Buddha probably from Wat Phra Si Sanphet in Ayutthaya may represent Maitreya, the buddha-to-come.[2] My suspicion, based in part on the popularity of the Phra Malai story,[3] is that in the period from the sixteenth through the nineteenth centuries Maitreya was far more important, and more frequently represented, than is usually recognized.

The evolution of the forms of crowned and bejeweled Buddha images is only roughly understood. The crowned Buddha, having been common in the twelfth and thirteenth centuries, seldom appeared again until around 1500, and then became increasingly common in succeeding decades.[4] It seems in general that the elements of royal jewelry and fin-

ery become more numerous and elaborate as the decades passed.[5] What seem to be the earlier examples often have only a crown; later, jeweled collars appear; still later, jeweled loops or medallions hang from the collar (cat. no. 35). Then jeweled bands cross the chest in both directions like bandoliers, and bracelets, armlets, and anklets appear (cat. nos. 47 and 48). Later yet, flamelike decorations sprout from jeweled bands hanging in front of the legs, every finger bears a ring, and the Buddha begins to wear royal slippers (cat. no. 63). There are numerous exceptions to this suggested development. For example, cat. no. 43 wears a crown but no other royal adornments (except earrings). It might then be thought to be earlier than cat. no. 35, which wears a jeweled collar with hanging loop. However, the type of crown worn by cat. no. 43 falls between that of cat. no. 35

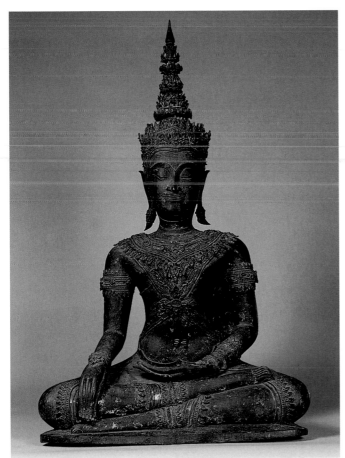
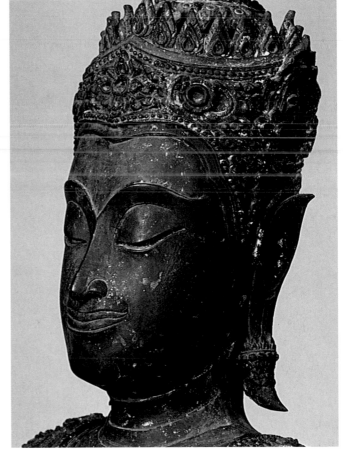

Left: fig. 168, Seated crowned and bejeweled Buddha, cat. no. 47. Right: fig. 169. detail of cat. no. 47.

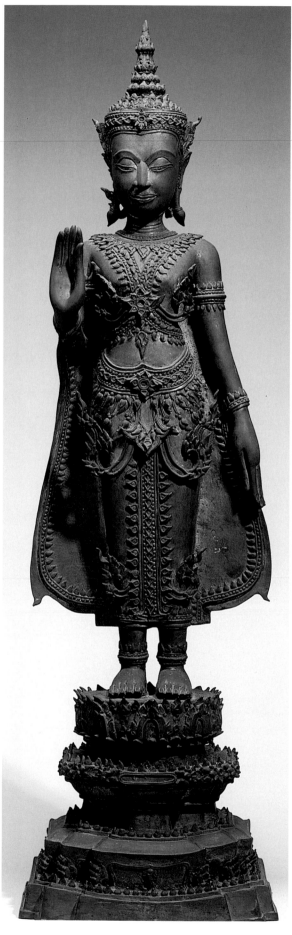

and the clearly later cat. no. 47, so in fact cat. no. 43 must be later than cat. no. 35.[6]

1 Fickle, "Crowned Buddha Images," 88; more complex readings of the Jambupati story have been proposed by Woodward in *Sacred Sculpture*, 79, 212, 219, 233; and in *Art and Architecture of Thailand*, 152. See also the entry for cat. no. 44.

2 Woodward, *Sacred Sculpture*, 228, 233.

3 See the entry for cat. no. 80.

4 We cannot, however, rule out that in the intervening centuries Buddha images were sometimes decked with separately made crowns and jewels.

5 Out of the hundreds surviving, only two Ayutthaya-period crowned and bejeweled Buddha images bear inscribed dates. These are cat. no. 42, dated equivalent to 1541, and an image in Nakhon Si Thammarat dated equivalent to 1671 (Woodward, *Sacred Sculpture*, fig. 232). Both are from important but distant provincial cities rather than the city of Ayutthaya itself, and so reflect traditions related to, but distinct from, those of the capital.

6 A detailed overview of the development of the crowned and bejeweled Buddha in Siam is attempted in McGill, *Prasatthong*, 238–247. See also, Woodward, *Sacred Sculpture*, 236–237.

47

SEATED CROWNED AND BEJEWELED BUDDHA, PROBABLY 1630–1650 (FIGS. 168, 169)
Copper alloy
H: 87 CM; W: 50 CM
Chao Sam Phraya National Museum, Ayutthaya, 4/33 9711

This image is one of relatively few that resemble in many details the twelve crowned and bejeweled images of Wat Chaiwatthanaram in Ayutthaya (fig. 166), the important temple founded by King Prasat Thong in the 1630s.[1] Those images survive only in quite damaged condition, but the well-known main Buddha image of Wat Na Phra Men in Ayutthaya (fig. 167), thought to be of the same period, shows what they must have looked like when new.[2]

According to the museum's records, this image was donated by a person from Ayutthaya. Strangely, a very similar image is said to have come from a temple in Sawankhalok, near Sukhothai in north-central Thailand.[3]

1 See the introductory essay in this catalogue, p. 15.

2 The Wat Chaiwatthanaram and Wat Na Phra Men images are discussed at length in McGill, *Prasatthong*, 112–117, 232–236.

3 *Namchom phiphitthaphan sathan haeng chat sawankhaworanayok*, 142–143.

48

STANDING CROWNED AND BEJEWELED BUDDHA, APPROX. 1650–1700 (FIG. 170)
Found in Nakhon Ratchasima province
Copper alloy with inlaid eyes
H: 77.5 CM; W: 21.5 CM
National Museum, Bangkok, AY10

49

TEMPLE BOUNDARY STONE, APPROX. 1625–1650 (FIG. 171)
Probably from Wat Chaiwatthanaram, Ayutthaya
Stone
H: 71 CM
Chantharakasem National Museum, Ayutthaya, 217WCH/2519/18

Fig. 170. Standing crowned and bejeweled Buddha, cat. no. 48.

 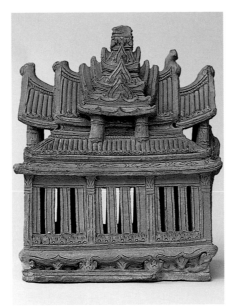

Left: fig. 171. Temple boundary stone, cat. no. 49. Center: fig. 172. Miniature temple or palace building, cat. no. 50. Right: fig. 173. Spirit houses, central Thailand.

The ordination halls of temples were surrounded by eight boundary stones, placed at their corners and midpoints, to mark the consecrated area within which ordinations could take place (fig. 8).[1] Boundary stones are usually large stone slabs with carved decoration, set into a brick and stucco base. Sometimes they are covered by domed or tiered enclosures with large openings at the sides.

This boundary stone probably came from Wat Chaiwatthanaram, Ayutthaya, which was founded in the 1630s (fig. 14). Large fragments of virtually identical boundary stones could still be seen there in the mid 1970s.[2] This design, with its multiple recesses at the borders and its "flying lozenge" in the middle of a midrib, is thought to be characteristic of the reign of King Prasat Thong (reigned 1629–1656), but the development of the boundary stone through the Ayutthaya period is still rather speculative.[3]

1 For a discussion of the symbolism of boundary stones in Cambodia, and the ceremonies attending their establishment, see Giteau, *Bornage rituel*. More than two hundred boundary stones from Thailand are illustrated in

No. Na Paknam, *Buddhist Boundary Markers.*

2 McGill, *Prasatthong*, fig. 102.

3 McGill, *Prasatthong*, 120–121, 210–212. For a partially contrasting view, see Listopad, *Phra Narai*, 464. No. Na Paknam has made the most thorough study of boundary stones in Thailand. For his outline of their development in the Ayutthaya period, see *Buddhist Boundary Markers*, 73–79.

50

MINIATURE TEMPLE OR PALACE
BUILDING, APPROX. 1500–1675
(FIG. 172)
Terra-cotta
H: 46 CM; W: 35.5 CM
Wat Mahathat, Phitsanulok, 989
24/37

Several beautifully made terra-cotta miniature temple or palace building have survived from the Ayutthaya period, but their purpose is something of a mystery. Perhaps they served, like the spirit houses commonly seen in Thailand today, as little shrines for offerings to propitiate spirits of the land (fig. 173).[1]

Large rectangular windows are usually thought to have become common in Siamese architecture during the reign of King Narai (reigned 1656–1688), probably due to Western influence. Buildings with the older treatment of wall openings, a series of relatively narrow slits, as seen on this miniature building, are therefore usually thought to date from before this period, though how long the old tradition was still sometimes followed is not known.

The unusual projecting gables at the ends of the miniature building, which are supported by pillars extending up through the lower roof, are seen in such buildings as the preaching hall of Wat Khwit in Lopburi (which also has slit-type windows) and a wooden building at Wat Yai Suwannaram in Phetburi.[2] The four-sided tiered roof complex rising above the middle of the main roof, and also supported on pillars extending up through the lower roof, seems to be an early version of the tiered pyramidal roof complex that rises above the main roof of several palace buildings in Bangkok, a feature that, likewise, is supported on pillars extending up through the lower roof, but the pillars may be

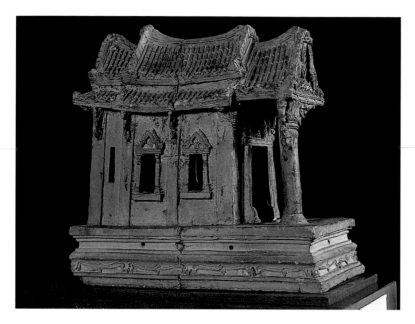 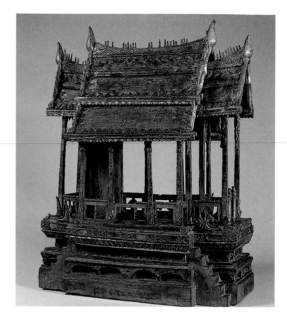

Left: fig. 174. Miniature temple building, cat. no. 51. Right: fig. 175. Miniature pavilion, cat. no. 52.

partly masked by large figures of mythical eagles (garudas).[3]

1 Kingkeo, *Folk Religion*, 40; Tambiah, *Spirit Cults*, ch. 15, "The Cult of Guardian Spirits."
2 Illustrated in *The Siam of King Narai*, 35; and *Samut phap sinlapakam wat yai suwannaram*, figs. 24–26.
3 On the Dusit Maha Prasat Palace, for example. The pillars behind the garuda can be seen in the illustrations on pp. 114–115 of Naengnoi, *Grand Palace*.

51

MINIATURE TEMPLE BUILDING, APPROX. 1700–1800 (FIG. 174)
Said to have been found at Wat Bua, Ayutthaya
Terra-cotta
H: 58 CM; W: 32 CM
Chao Sam Phraya National Museum, Ayutthaya, 16/15Ch

This miniature building might have served as a spirit house (see the entry on cat. no. 50).

Its large rectangular windows suggest a date later than that of cat. no. 50.

Details such as its half-cylindrical tiles covering the roof and the brackets projecting from the side walls to support the eaves (which would be of elaborately carved wood on a real building) are painstakingly represented.

52

MINIATURE PAVILION, APPROX. 1700–1800 (FIG. 175)
Wood with paint, lacquer, gilding, and mirror inlay
H: 64 CM; W: 47.5 CM
Chao Sam Phraya National Museum, Ayutthaya, 243/2542

53

RELIQUARY IN THE SHAPE OF A STUPA, APPROX. 1600–1700 (FIG. 176)
Bronze
H: 85.5 CM, INCLUDING RESTORED SPIRE; W: 29 CM
The Walters Art Museum, Baltimore, Gift of A. B. Griswold, 54.2556

In 1548 Queen Suriyothai of Ayutthaya was killed in battle after taking up arms to join her husband King Chakkraphat in defending the country against Burmese invaders. This episode is recounted in most versions of the Royal Chronicles,[1] and has become familiar to international audiences because of the success of a recent movie.

A large stupa at Wat Suan Luang Sop Sawan in Ayutthaya, which this bronze reliquary rather resembles, may be the one that was erected at the time to enshrine the remains of Queen Suriyothai (figs. 63a and 63b).[2] It may also be the earliest major stupa of an unusual type. Like the bronze reliquary, it is basically square in cross section, rather than circular, as are most stupas, and it has multiple indentations at the corners.[3]

Forms with a cross section in the shape of a square with multiple indentations at the corners are very common in the architecture of the Ayutthaya kingdom. Temple towers of the type called *prang* (for instance, cat. no. 55), follow this form; sometimes pillars, the corner turrets of walls, and other architectural components do too.

A rather uncommon feature of this stupa-shaped reliquary is the pierced decoration on the corners of the cen-

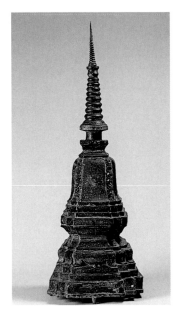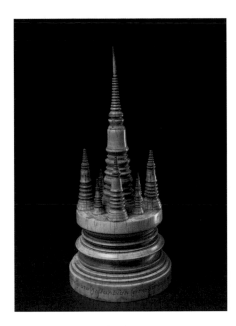

Left: fig. 176. Reliquary in the shape of a stupa, cat. no. 53. Right: fig. 177. Miniature stupa complex, cat. no. 54.

tral bell-shaped element. Something similar can be seen on the stupas painted on the walls of the ordination hall of Wat Ko Kaeo Suttharam, Phetburi, dated 1743.[4] These painted stupas, however, are much more elaborate and elongated than the reliquary is, and have "epaulets" at the shoulders of the bell-shaped element – all of which suggest a considerably earlier date for the reliquary. The architectural stupas the reliquary perhaps most resembles are those at Wat Chaiwatthanaram, Ayutthaya, thought to date from the 1630s (figs. 65a and 65b).[5]

1 Cushman, *Royal Chronicles*, 32–43; Santi, *Redented Added-angled Chedis*, 6, and passim.
2 Or the association of this stupa with Queen Suriyothai's memorial stupa may be mistaken; McGill, *Prasatthong*, 216–217; Woodward, *Sacred Sculpture*, 254, 304 n. 60.
3 It may be better to imagine the shape not as a square with indented corners, but as a square to which rectangular projections have been added on the sides, producing the same effect. See McGill, *Prasatthong*, 218–219; and Santi,

Redented Added-angled Chedis, passim.
4 No. Na Paknam, *Wat Ko Kaeo Suttharam*, 23–26.
5 McGill, *Prasatthong*, 121; and Santi, *Redented Added-angled Chedis*, figs. 47–49.

54

MINIATURE STUPA COMPLEX, 1711 (FIG. 177)
Ivory
H: 25 CM; W: 11 CM
Lent by the family of Prince Dhani Nivat, Bangkok

A grouping of nine stupas, the largest in the center surrounded by eight others, alternating medium-sized and small, stands on a high base. The stupas, as well as the base, are decorated with moldings; one can imagine them being turned on a lathe.

An incised inscription rings the lowest level of the base. In Thai written in Cambodian letters, the inscription ascribes to the year 2254 of the Buddhist era (1711 CE) the commissioning, by the king or deputy king, of this "nine-spired great stupa, or great

memorial" (the Thai term *mahachedi* can mean either).[1]

A.B. Griswold pointed out many years ago that the small nine-spired great stupa was probably "a miniature copy of a large monument founded by the same donor or donors at the same time," but that he had not been able to identify the original among the ruins of Ayutthaya. "On the other hand," he continued, "it might be a copy of some model elsewhere."[2]

It has still not been possible to find an architectural equivalent in Ayutthaya. Monuments in the form of a large stupa surrounded by eight smaller ones might be expected to be fairly common, given the pervasiveness of one-surrounded-by-eight configurations in Buddhist symbolism,[3] but in fact they are quite rare. The only known examples are in Arakan in Burma, and in Yunnan in China. Neither would seem likely to be the model for this miniature complex. Also, in both of those examples the eight surrounding stupas are all the same size.[4]

1 Griswold, "Eighteenth-Century Ivory Cetiya," 6–11.
2 Griswold, "Eighteenth-Century Ivory Cetiya," 11.
3 The center of a lotus surrounded by eight petals, a gem surrounded by eight other gems, a representation of a Buddha surrounded by eight other deities or eight episodes of his life, the Mahabodhi temple surrounded by the eight sites of these episodes, and so on.
4 In Arakan, the sixteenth-century Andaw-thein; Gutman, *Burma's Lost Kingdoms*, 112–117. In Yunnan, the supposedly thirteenth-century Manfeilong Ta; Cummings, *Buddhist Stupas*, 58–59. Related in concept are impressed terracotta tablets from Nalanda showing a stupa surrounded by eight smaller stupas; Zwalf, *Buddhism*, no. 146. Also related are

the small terracotta votive stupas from Borobudur and elsewhere that have eight half-stupas attached around the main stupa; Stuterheim, *Tjandi Baraboedoer*, fig. 32; Klimburg-Salter, *Silk Route*, pl. 116.

55

MINIATURE TEMPLE TOWER,
APPROX. 1650–1750 (FIG. 178)
Stucco
H: 78 CM; W: 23 CM
Chantharakasem National Museum, Ayutthaya, 2WCh2519

As was discussed in the introductory essay, the Siamese version of the Cambodian-type temple tower was one of the most characteristic features of the architecture of the Ayutthaya kingdom. Such towers ranged in size from the huge ones at the center of temple complexes to small ones only five or six meters tall placed in subsidiary positions.

The purpose of this miniature tower is not known. As it appears to have no interior space, it must not have served as a reliquary. It is also not known what would have been placed in its false doors; a possibility would be votive tablets showing standing Buddhas.

In its general appearance, proportions, and rather straight sides, this miniature tower resembles the four subsidiary towers of Wat Chaiwatthanaram in Ayutthaya, built in the 1630s.[1] However, unlike them, this miniature has plain bands separating the false stories of its superstructure. In this respect it is more similar to the towers of Wat Choeng Tha in Ayutthaya (fig. 179), possibly of the reign of King Narai (1656–1688),[2] and Wat Arun in Thonburi (early 1800s).[3]

1 McGill, *Prasatthong*, figs. 12, 13.

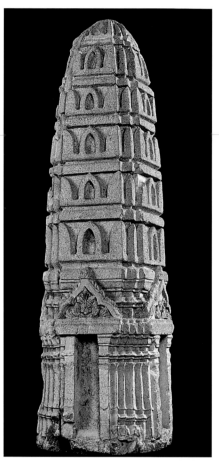

2 Listopad, *Phra Narai*, 199.
3 Good photos are found in *Namchom krung rattanakosin*, 134–140.

56

SEATED CROWNED AND
BEJEWELED BUDDHA, APPROX.
1650–1750 (FIGS. 180, 181)
Copper alloy with mother-of-pearl inlay
H: 99 CM; W: 64.5
National Museum, Bangkok, Th69

57

HEAD OF A CROWNED BUDDHA
IMAGE, 1650–1725 (FIG. 182)[1]
Leaded tin brass
H: 15 CM
Walters Art Museum, Baltimore, Gift of A. B. Griswold, 54.2542

1 See Woodward, *Sacred Sculpture*, 237.

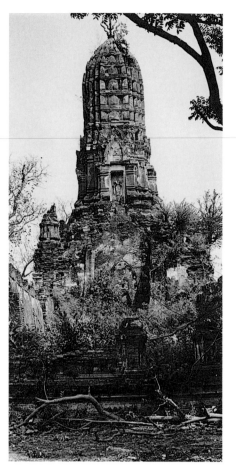

58, 59, 60, 68

LACQUERED AND GILDED
MANUSCRIPT CABINETS

The palaces and monasteries of Siam, like the houses, had relatively little furniture. The item of furniture of which the most examples survive is the tall cabinet for storing documents or religious texts. These cabinets were often of wood covered with black lacquer, which provided a beautiful smooth surface and helped protect the wood from rot and insect damage. The lacquer was usually decorated with elaborate figures, scenes, and designs in gold leaf.

The scenes on these cabinets must be thought of not just as ornamentation for pieces of furniture but as paintings in their own right. The quality of the painting is sometimes extremely high, and because relatively

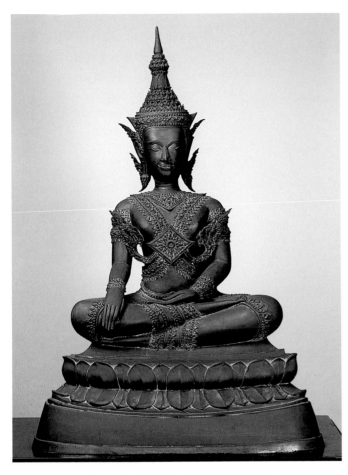

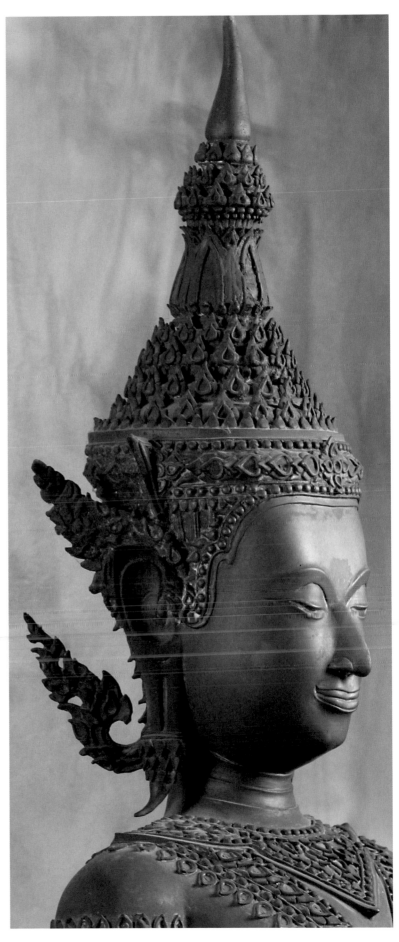

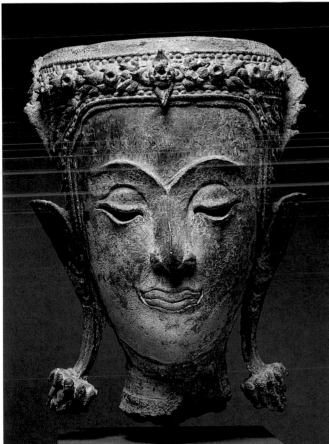

Facing page left: fig. 178. Miniature temple tower, cat. no. 55. Facing page right: fig. 179. Main tower, Wat Choeng Tha, Ayutthaya. This page top: fig. 180. Seated crowned and bejeweled Buddha, cat. no. 56. Right: fig. 181. Detail of cat. no. 56. Bottom: fig. 182, Head of a crowned Buddha image, cat. no. 57.

little Thai painting in other mediums survives from before 1800, the oldest of the cabinets are important documents of the painting of the seventeenth and eighteenth centuries.

The technique of decoration, called "splashed-water pattern (*lai rot nam*)," has been summarized by Michael Wright in this way:

A negative image of the design is painted on the finely prepared black (or, very rarely, red) lacquer surface using a water-soluble pigment. When the watercolour is dry, gold leaf is applied to the whole surface. The gold leaf becomes bonded to the bare areas of slightly tacky lacquer, but the watercolour acts as a resist, preventing adherence from occurring in the areas that it covers. Later, when all is judged perfectly dry, quantities of water are splashed against the panel, dissolving the watercolour which carries away with it all unwanted gold leaf. In this way a "positive" image in gold, with black background, is developed from the black-and-watercolour negative.[1]

1 Wright, "Siamese Gilt-Lacquer Painting," 19; also, Wright, "Gilt lacquer Cabinets of Siam" and Silpa, *Thai Lacquer Works*. Scores of cabinets are illustrated and described in Kongkaeo, *Tu lai thong*.

58

MANUSCRIPT CABINET, APPROX. 1650–1750 (FIGS. 183, 184)
Lacquered and gilded wood with mirror inlay
H: 207.5 CM; W: 99 CM
Somdet Phra Narai National Museum, Lopburi, KTh89

This cabinet is highly unusual in being decorated not with figures, scenes, or flamelike foliage, but with an overall trellis pattern derived from textiles.[1] The diagonal trellis itself is adorned with foliage designs, and at each intersection is a notched diamond-shape enclosing an eight-petaled flower. In each opening between bands of the trellis is a half-length celestial with arms angled out from the body at the elbow, and holding what appears to be a flower or bouquet in each hand.

Indian cottons made to Thai designs for the Thai market are often decorated with quite similar diagonal trellis patterns. Sometimes these patterns have diamond shapes at the intersections of the bands. Half-length celestials – even holding their arms in the same position as those on the

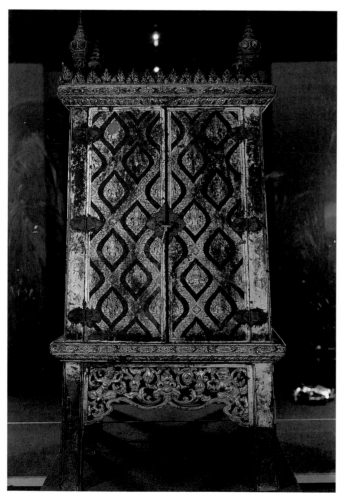

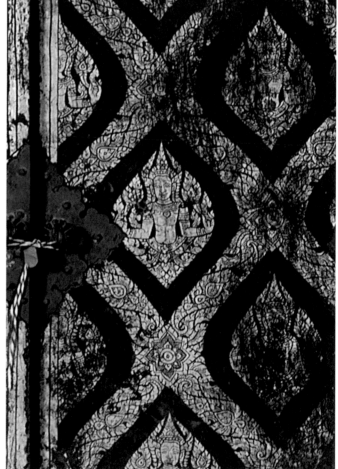

Left: fig. 183. Manuscript cabinet, cat. no. 58. Right: fig. 184, detail of cat. no. 58.

cabinet – may appear in the openings between the bands (fig. 185).[2] Many of these patterned Indian cottons are attributed to the eighteenth century.[3]

The feature of this cabinet that has sometimes led to its being associated with the reign of King Narai (1656–1688) is the skirting around its lower part, carved with European-looking foliate scrolls and pairs of odd cherubs with Western-style hairdos. In recent years scholars have repeatedly pointed out that though Western motifs, and depictions of Westerners, began to appear in Thai art in the mid- and later-seventeenth century, they continued to be popular for two centuries, and can be used as dating devices only with great caution.[4]

Nevertheless, the foliate scrolls on the skirting of the cabinet seem to relate to the European-derived stucco

ornament of Wat Tawet in Ayutthaya, credibly attributed to the mid- or later-seventeenth century,[5] and no features of the cabinet would seem to preclude assigning it a similar date.

1 Listopad notes that on this cabinet "the gilt lacquer designs have all been refurbished, none are original." He suspects the refurbishment took place in the Bangkok period – that is, after 1782 – and that what we now see "may or may not have reproduced the original designs" (Phra Narai, 310). Listopad's warnings are apposite, but it will be assumed here that the designs are not far from their original appearance. As will be seen, they are not inconsistent with a date in the 1650 to 1750 range, and their rarity would appear to argue against their being a Bangkok-period creation. Many early Bangkok-period cabinets survive, only one known example of which is decorated with a trellis pattern, and even there only on its back (cabinet Kth 245 in Kongkaeo, Tu lai thong 2/3, 219). Would restorers starting more or less from scratch not be expected to follow the more common gilt cabinet designs of their own day? But again, Listopad's admonitions underline the necessity of thorough technical examinations of cabinets by conservation scientists. Not only do some appear to have been refurbished, but observation suggests that at least a fair number of cabinets (such as cat. no. 67) were originally assembled – partly or completely – from sections of older doors or shutters, and so their components could be decades or even a century apart in age. See McGill and Pattaratorn, "Art of the Bangkok Period," 31–32.

2 Guy, Woven Cargoes, 124–136, particularly figs. 169, 174; Gittinger, Textiles and the Thai Experience, 152–153, 185. As Guy points out, related patterns sometimes adorn the walls or columns

of Thai temples. A pattern quite similar to the one on this cabinet can be seen on a column in the ordination hall of Wat Yai Suwannaram, Phetburi (No. Na Paknam, Wiwatthanakan lai thai, first ed., fig. 238.) Presumably these patterns too derive from textiles. The trellis patterns on the cabinet and some of the Indian cottons are not made up of straight bands with straight-edged openings between them. The bands curve slightly, and the spaces between them are not shaped like an elongated diamond, but more like a teardrop with points on both ends, or perhaps a leaf. It is hard not to imagine some sort of connection with the lattice designs on sixteenth- and seventeenth-century Ottoman textiles. See Rogers, Empire of the Sultans, 222; King, Imperial Ottoman Textiles, 40; Atil, Süleyman, 209. (A Persian envoy encountered an Ottoman Turk living near Ayutthaya in the 1680s; O'Kane, Ship of Sulaimân, 50–51.) But see also Guy's comparison to designs painted on the walls of a temple in Pagan, Woven Cargoes, 57.

3 Though it seems possible that some might be earlier. Note that on another cabinet attributed here to 1650–1750 (cat. no. 60), both "Aurangzeb" on the front and Brahma on the back wear garments decorated with a diagonal trellis pattern.

4 Listopad, Phra Narai, 308–311 and passim; Phuthorn, "Pièces remarquables," 68. For many illustrations of Thai works depicting Westerners or incorporating Western motifs, see No. Na Paknam, Farang.

5 Listopad, "Phra Narai" 231–237; Woodward, Sacred Sculpture, 258. Listopad's suggestion that Dutch influences were as important as French in the arts of seventeenth-century Ayutthaya is valuable and thought-provoking. So too is his discussion of the possible importance of the carvings and other decorations of European ships as models for Thai artisans.

Fig. 185. Indian textile for the Siamese market, approx. 1800–1900; Victoria and Albert Museum, London, IS 52-1991.

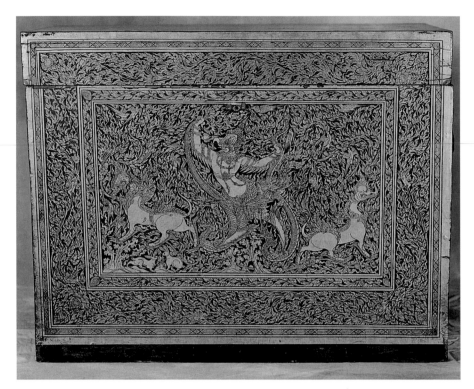

59

MANUSCRIPT CHEST WITH
MYTHICAL ANIMALS, APPROX.
1650–1700 (FIGS. 186, 187, 188)
Lacquered and gilded wood with
iron handle
H: 57 CM; W: 74.5
National Museum, Bangkok,
NCH709

Chests such as this are usually thought
to have been used to hold manuscripts.
Some are decorated with scenes from
Buddhist stories, and so were probably
used for religious texts. Others, such as
this one, have no specifically Buddhist
motif in their decoration, and may
have been used in the palace.

On the front of the chest a garuda
grasping snakes in its talons strides
between a dragon-lion and an ele-
phant-lion. Amusing rabbits cavort
amid bushes (or stylized rocks) that
resemble seaweed, and in the sky, filled
with flamelike foliage patterns, birds
dart back and forth. Forms interlock;
every space is taken up; the sense of
barely contained fiery energy and
whiplashing movement is exhilarating.

On one side a pair of lions play;
on the other, a pair of cloven-hoofed
beasts that seem cousins to the Chinese

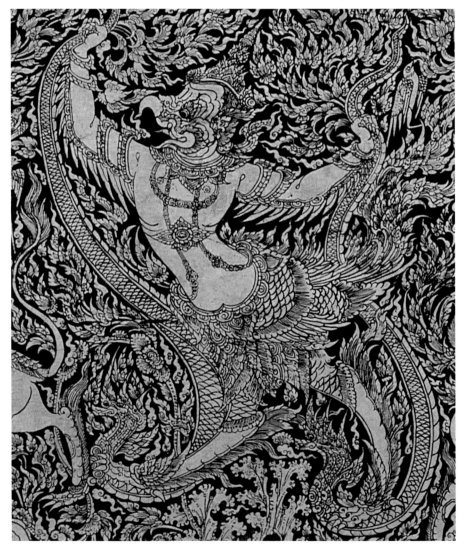

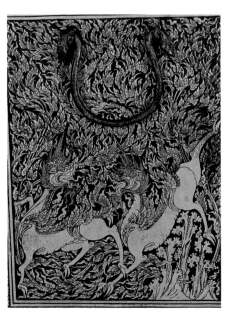

Top: fig. 186. Manuscript cabinet with mythical animals, cat. no. 59. Below: fig. 187. Detail of cat. no. 59. Right: fig. 188. Detail of side of cat. no. 59.

qilin. On the back writhes a fish-tailed dragon, the arch of its back marked by a monster face. This face calls to mind the rather similar faces that sometimes appear on Thai military tunics and armor, in imitation of a centuries-old Chinese tradition of decorating breast-plates with grimacing monster faces.[1]

All four sides have a wide border of curving and recurving flamelike foliage with occasional bird's heads biting the stems. The special prickliness and intensity of the drawing of these forms recall the treatment of the flamelike foliage on a manuscript cover with an inscribed date equivalent to 1688.[2] Other features of the chest, such as the jewelry and crown of the garuda, are not inconsistent with such a date.

Several related chests have been published. Two are in temples in Thonburi, and another is in the collection of the Musée National des Arts Asiatiques-Guimet in Paris.[3] A less closely related example is in the collection of the Asian Art Museum of San Francisco.

1 For Thai tunics and armor, see Guy, *Woven Cargoes*, 141; for Chinese breastplates with monster faces see, for example, Paludan, *Ming Tombs*, 30. The monster faces on the Chinese and Thai armor are presumably apotropaic. The meaning of the one on the dragon is not clear, nor is that of the vaguely similar monster face shown beneath the Earth Goddess in the scene of the Buddha's victory over Mara in the 1776 manuscript in the exhibition (cat. no. 79; see Wenk, *Miniaturmalereien*, pl. 10). Other fish-tailed dragons, similarly posed with their backs arched upwards, can be seen in the ceiling decorations of Wat Sa Bua in Phetburi, probably of the eighteenth century (unpublished, as far as is known), and on the cover of a manuscript with a date equivalent to 1743 in Wat Sisa Krabu, Thonburi (*Chittrakam samai ayutthaya chak samut khoi*, 80).

2 Woodward, *Sacred Sculpture*, 258; No. Na Paknam, description of cover, 2, and "Masterpieces of Mon Art," 29.

3 No. na Paknam, *Wiwatthanakan lai thai* (first ed.), figs. 224–226; Béguin, *L'Inde et le monde indianisé*, 91.

60

CABINET DECORATED WITH A EUROPEAN AND AN INDIAN OR PERSIAN, PERHAPS LOUIS XIV AND AURANGZEB, APPROX. 1650–1750 (FIGS. 189, 190, 191, P.12)
Lacquered and gilded wood
H: 164.5 CM; W: 118 CM
National Museum Bangkok, 115 (T. 101)

This well-known cabinet has conventionally been thought to represent Louis XIV (reigned 1643–1715) and the Mughal emperor Aurangzeb (reigned 1658–1707), and to date from the reign of King Narai (1656–1688), who exchanged ambassadors with both.[1]

Western scholars are divided in their opinions. One has recently accepted the attribution to Narai's reign. Another thinks it possible that while the woodcarving may date from that period, the figures and designs in gold must be later.[2] Neither believes the identifications of the two figures have been established convincingly; one suggests that "if the European figure really is Louis XIV … his companion could well be Shah Sulaiman of Persia (reigned 1666–1694) … rather than Aurangzeb."[3]

Leaving aside the date of the cabinet and its designs in gold for the moment, a few additional observations can be offered on the identifications of the figures. The European wears what looks like a Thai interpretation of seventeenth-century European armor, complete with surface decoration of foliate scrolls (some of which seem to have escaped to swirl around the

figure's elbows[4]). Then, the pose of the figure – with proper right foot pulled back and left foot forward, left hand at waist and right holding a vertical weapon – recalls that of Louis XIV in court portraits by such artists as Hyacinthe Rigaud.[5] A full-length portrait of the Sun King is known to have been present in Narai's secondary capital of Lopburi[6] (together with large numbers of French luxury goods bought by the Thais or given by the French as gifts to the king and court) and presumably the French ambassadors and missionaries had with them illustrated books or engravings that might have depicted their monarch.

As for "Aurangzeb," no doubt a portrait of him – either a Mughal miniature or a European copy of one – might have reached the eyes of a Thai artist. But the features of the figure do not resemble those of Aurangzeb in his Mughal portraits. In them he is shown having a rather long, straight nose and a full beard tapering to a point.[7] Perhaps, though, the question is whether, for the Thais, this exotic figure *stood for* Aurangzeb (or the shah of Persia), not whether it resembled him.

Can we clarify further whether the figure was supposed to be an Indian or a Persian? Merchants and envoys of both nationalities were present in Siam to be looked at, and King Narai is said to have dressed in Persian style, so there must have been aspects of clothing that for Thais signaled "Indian" (or "Mughal") as opposed to "Persian." The robe of the figure on the cabinet could be a Thai rendition of either Indian or Persian dress. A puzzling feature is that on the lower body the sides of the robe seem to meet in the middle at the front, rather than one side wrapping all the way over the other as is shown on the upper body. The trousers seem too short for either Indians or Persians, both of whom are usually depicted in their own paintings

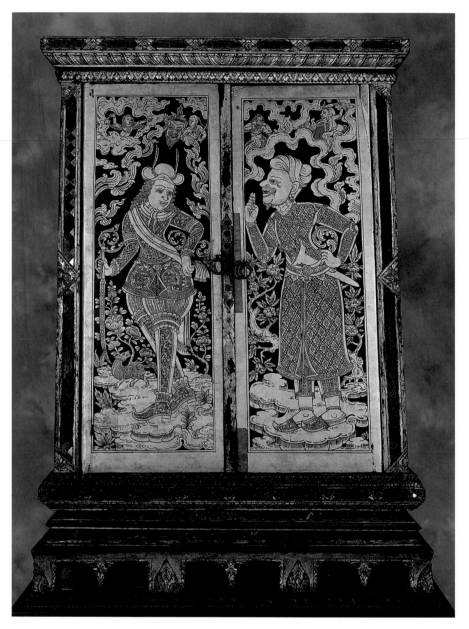

with tight trousers long enough to gather at the top of the foot. The belt looks suspiciously Thai, and does not resemble the sash worn by both Persians or Indians in the seventeenth century – usually wound around and tucked into itself by Persians or knotted in front with long ends hanging down by Indians. The turban, by comparison with those shown in Persian and Mughal paintings of the second half of the seventeenth century, seems closer to Indian types, but if an Indian monarch is represented, where are the necklaces one would expect? And why would either a Persian or an Indian wear an Indonesian kris?[8]

The gesture made by the Indian or Persian figure calls attention to itself, and may reward further study. In Indonesian art a related gesture seems to be associated with admonishing or berating; the gesture may have similar associations in South Asian Muslim contexts.[9] The possibility that here "Aurangzeb" is scolding "Louis XIV" is tantalizing.

Hiram Woodward has proposed a thought-provoking interpretation of the small figures in the sky above the main figures. He associates them deities of thunder and lightning, as well as the planet Rahu, who causes eclipses by swallowing the sun and moon. In Thai cosmology, such sky deities hover near the summit of Mt. Meru, the central mountain of the universe. Below them, on the upper slopes of Mt. Meru, reside the four guardian kings of the directions – two of whom may be represented here as the French and Indian or Persian monarchs.[10]

European and Indian or Persian figures similar in type to those on this cabinet are found on the lacquered and gilded window shutters of a building at Wat Saket, Bangkok, that is thought to date from the reign of Rama I (1782–1809).[11] These shutters could have been reused from an older building (as seems to have been fairly common). If they were indeed made in the reign of Rama I, however, then showing how the related figures on the cabinet could be more than 100 years earlier will require much more detailed analysis of the evolution of painting in Siam from 1650 to 1800 than has so far been undertaken.

On the back of the cabinet are two more figures painted in a style that appears unrelated to that of the figures on the front. The figure on the right has three (visible) heads, and so may represent Brahma; the figure on the left has no attributes that would identify him clearly, but the deity usually paired with Brahma in Thailand is Indra, the king of the gods, and this may well be who the left-hand figure represents.

The "Brahma," however, stands on a short pedestal supported on the back of a crouching animal that seems to be a bear, and the "Indra's" pedestal is supported by a monkey. Monkeys and bears figure prominently in the epic Ramayana (known in Thai as the Rammakian), and if the "Indra" were not paired with a three-headed figure, we might have identified it as Rama, the hero of the Ramayana, who is sometimes shown supported by the monkey hero Hanuman.

Paired guardians standing on short pedestals supported by giants, demons, or other creatures are found fairly commonly on window shutters, doors, and the backs of manuscript cabinets, but they usually have few distinguishing features, and seldom can be identified by name.[12]

If the figures on the back of the cabinet are indeed Brahma and Indra, then they, together with the two figures on the front, might conceivably be construed as the four guardian kings of the directions. Brahma is not usually thought of as a king, however, and Indra resides not on the slopes of Mt. Meru but in the Heaven of the Thirty-Three Gods at its summit. Only one other cabinet is known to bear four large princely figures, and it does not aid in identifying the figures here.[13]

Michael Wright has suggested that the panels decorated by the figures on the back of the cabinet – so different in style and treatment from those on the front – may have been rescued from an older cabinet (or other context) and reused. He also points out their resemblance to figures painted on the back of the doors of the ordination hall of Wat Yai Suwannaram, Phetburi, the date of which is, unfortunately, quite uncertain.[14] Also comparable in their stances and elongation are standing celestials in the murals of Wat Prasat, Nonthaburi, which have been assigned dates ranging from the mid-1600s to the mid-1700s.[15]

Both sides of the cabinet are decorated with landscapes filled with real and fantastic creatures such as deer, phoenixes, a tiger, and a Chinese lion. Through the foliage-filled sky on one side fly a male celestial and a garuda grappling with serpents.[16]

1 This view is expressed, for instance, in *Somdet phra narai lae phra chao lui thi*

14, 61. See also Wright, "Gilt-lacquer Painting," 32–34. Wright is cautious, but "can find nothing about the cabinet to contradict the tradition."

2 Woodward, "Structures," 3; Listopad, "Phra Narai," 311–312.

3 Woodward, "Structures," 3.

4 Calling to mind Woodward's discussion of the playful element in the cabinet painter's approach, "Structures," 5.

5 Two well-known portraits by Rigaud of Louis XIV in a similar pose date from 1701 (in regal robes) and about 1702 (in armor); Burke, *Fabrication*, fig. 1; Maumené and d'Harcourt, *Iconographie*, 98–99 and pl. 14. The pose was established as appropriate for royal portraits by Van Dyke in his *Charles I Dismounted* of approx. 1635. An anonymous French portrait from about 1670 shows Louis XIV in armor, standing in a related pose (but reversed); Maumené and d'Harcourt, *Iconographie*, 57–59 and pl. 8. To make

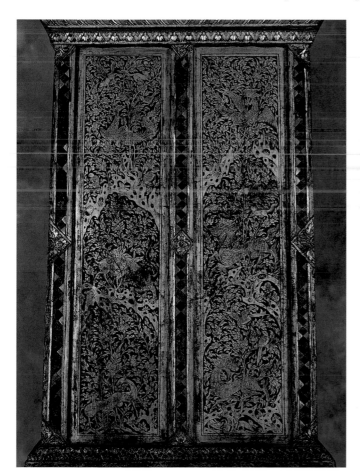

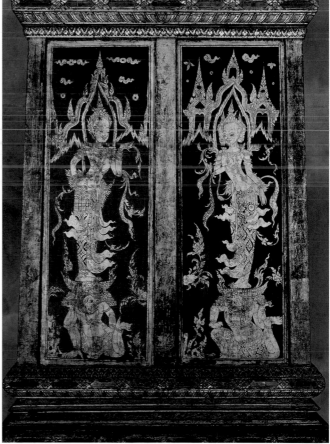

Facing page: Fig. 189. Cabinet decorated with a European and an Indian or Persian, perhaps Louis XIV and Aurangzeb, cat. no. 60. Left: fig. 190, cat. no. 60, side view. Right: fig. 191, cat. no. 60, back view.

progress in identifying other possible models for the "Louis XIV" on the cabinet will require checking portraits of the monarch by such artists as Pierre Mignard, Henri Testelin, and Robert Nanteuil. Early copies of such portraits will also need to be checked, as will engravings after them. The odd hat with two feathers worn by the figure on the cabinet remains puzzling. Louis XIV is sometimes shown wearing a vaguely similar hat, but decorated with floppy plumes rather than two erect feathers; Burke, *Fabrication*, figs. 18, 24. The little dog also does not seem to appear in portraits of Louis XIV, though it was an accessory in other aristocratic portraits.

6 Van Der Cruysse, *Siam and the West*, 340; also 265.

7 Gascoigne, *Great Mughals*, 214, 239.

8 The answer to this question may be simply that krises were fairly frequent attributes of door guardians. Krises are brandished by the Chinese-Thai guardians on the doors of a late-Ayutthaya cabinet in the National Museum Bangkok, for instance. See No. na Paknam, *Wiwatthanakan lai thai* (1st ed.), figs. 248–249. On the other hand, wearing a kris seems to have been the style for Thai courtiers in Narai's period. See Jacq-Hergoulac'h, "Dessins de Charles LeBrun," 30–35.

9 Natasha Reichle proposed this interesting possibility, citing the use of gesture as a warning by door guardians and other protective figures in East Javanese art, and in East Javanese narrative reliefs. See Fontein, *Sculpture of Indonesia*, 130; Kinney, *Worshipping Siva*, figs. 127, 146, 154, 247, 258, 259. Information on the implications of this gesture in present-day Pakistan was provided by Altaf Bhatti.

10 Woodward, "Structures, Names," typescript, 3–6. I appreciate Hiram Woodward's kindly sharing this unpublished paper.

11 Wannipha, *Chittrakam samai rattanakosin*, 65, 73–74.

12 For example, Wannipha, *Chittrakam samai rattanakosin*, 21 (Phutthaisawan Chapel); 29 (ordination hall of Wat Dusitdaram); 55 (ordination hall of Wat Ratchasittharam). For such figures on cabinets, see Kongkaeo, *Tu lai thong*, Part One, 32-34, 100, 156–158 and Part 2, Vol. 3, 216–218 (a cabinet with an inscribed date equivalent to 1784).

13 Kongkaeo, *Tu lai thong*, Part One, 70–75. Two of the figures on this cabinet are fairly easy to identify: one is carried by Garuda, and is Vishnu or perhaps Rama; another, carried by a monkey warrior – probably Hanuman – would seem to be Rama again. The other two figures are carried by a demon and a lion.

14 Wright, "Siamese Gilt Lacquer Painting," 33. The painted doors are illustrated in *Samut phap sinlapakam wat yai suwannaram*, fig. 16.

15 Santi and Kamol, *Chittrakam faphanang samai ayutthaya*, 99, fig. 74; *Chittrakam faphanang sakun chang nonthaburi*, 15 (English text) and fig. 12.

16 The sides are illustrated in Kongkaeo, *Tu lai thong*, Part One, 248, 250.

61

FRAGMENT OF STUCCO ARCHITECTURAL DECORATION, APPROX. 1500–1700 (FIG. 192)
Stucco over brick
H: 50 cm; W: 51 cm
Chantharakasem National Museum, Ayutthaya, 88/178

The temples of Siam were usually of brick (or sometimes laterite) covered with elaborately decorated stucco. Certain standard motifs – bands of rosettes alternating with lozenges, stylized lotus petals, foliate scrolls, overlapping triangular or leaf-shaped pendants – tended to be popular for centuries, evolving only slowly.[1] The difficulties of dating stucco ornamentation are increased by the tendency of the stucco to break off and require replacing.

Museum records suggest that this fragment of stucco came from Wat Mahathat in Ayutthaya, but from which of its more than eighty

Fig. 192. Fragment of stucco architectural decoration, cat. no. 61.

buildings and monuments – erected or repaired over nearly four hundred years – has not been determined.

1 For painstaking analyses of Ayutthaya's stucco architectural decoration (and many excellent photographs), see Santi, *Early Ayudhya Period*, and his *Stucco Motifs*. For a technical description of stucco as a material, see Strahan's discussion in Woodward, *Sacred Sculpture*, 59–60.

62

GABLE DECORATION WITH VISHNU (OR RAMA) MOUNTED ON THE MYTHICAL BIRD GARUDA, SURROUNDED BY DEMONS, APPROX. 1650–1750 (FIG. 193)
Found at Wat Mae Nang Plum, Ayutthaya
Wood with traces of lacquer, gilding, and mirror inlay
H: 300 CM; W: 317 CM
Chao Sam Phraya National Museum, Ayutthaya, IK

The main gables of Thai temple (and palace) buildings were elaborately decorated. Sometimes the decoration included figures, though seldom as many, as densely arranged, as in this example.

In the center, the deity Vishnu stands on the outstretched arms of his usual mount, the brave half-man, half-bird Garuda. Garuda, in turn, stands on the arms of a kneeling demon. Sixteen similar demons, brandishing clubs and glowering, surround the central figures. At either lower corner is an animal-headed demon holding a short sword; behind each of these demons is an owl.

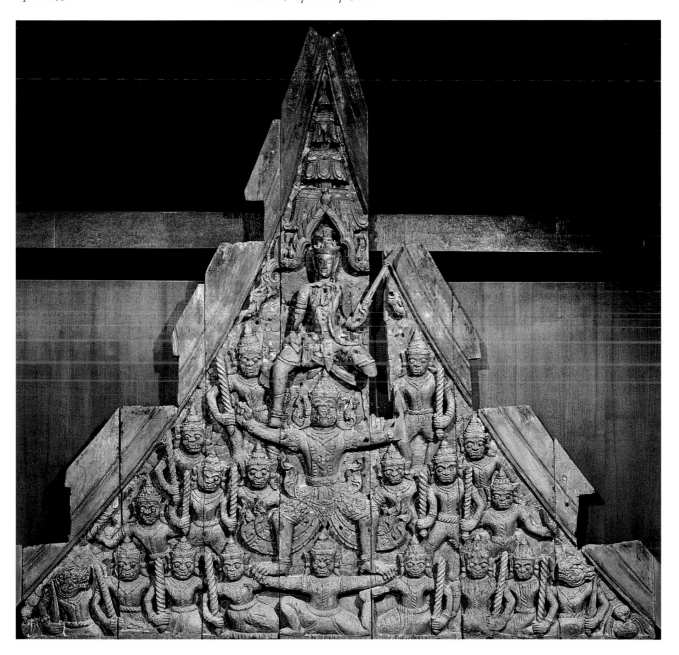

Fig. 193. Gable decoration with Vishnu (or Rama) mounted on the mythical bird Garuda, surrounded by demons, cat. no. 62.

Certain Hindu gods, especially Brahma and Indra, had from the earliest centuries of Buddhist literature and art been incorporated into Buddhist stories as attendants and helpers of the Buddha. Vishnu, however, seldom appears in Buddhist contexts outside mainland Southeast Asia and Sri Lanka.[1] In Thailand and Cambodia, though, in certain periods, scenes from the Ramayana or other legends involving Vishnu in one of his incarnations decorated Buddhist temples. Two of the best known examples are the twelfth-century Tantric Buddhist temple of Phimai in northeastern Thailand, and the late eighteenth- and nineteenth-century Wat Phra Chettuphon (Wat Pho) in Bangkok.[2]

From perhaps the seventeenth century on, sculptures of Vishnu, usually mounted on Garuda, have occasionally formed the centerpiece of the decoration of gables. Usually, though, if there is a host of surrounding figures they are celestials, not demons, as on the seventeenth- or eighteenth-century gable of Wat Na Phra Men, Ayutthaya.[3] Who the demons in this gable decoration are and what myth is represented are not entirely clear. It would not at first seem likely to be a scene from the Thai version of the Ramayana, because in it Garuda seldom appears. He is called upon once, however, to free Rama's troops from magical snakes. This episode is shown in the "Lacquer Pavilion" at Suan Pakkad Palace in Bangkok. The depiction there of Rama borne on the arms of Garuda is very close, in details such as the stance of Rama, the arrow he carries, and the tiered parasol over his head, to the depiction on this gable, so that perhaps it is indeed correct to identify the main figure of the gable as Rama, and the demons as the demon army he combats in the Ramayana.[4]

The ultimate source of this configuration of Vishnu (or one of his incarnations) standing on the shoulders or arms of Garuda is in the art of the Angkorian kingdom of Cambodia and northeastern Thailand. Vishnu is shown in this way in a number of reliefs at Angkor Wat itself, both those carved during the original twelfth-century construction and during the effort to complete the reliefs carried out in 1546–1564.[5] Also, Vishnu is shown standing on Garuda's arms in many Cambodian, or Cambodian-related, bronzes of the twelfth century, found in both Cambodia and Thailand.[6]

In many kingdoms of India and Southeast Asia Vishnu, the righteous preserver of order, especially in his incarnation as Rama, was a model and exemplar for kings. In Siam (as elsewhere), many kings had elements in their names and titles that associated them with Vishnu, from the founding king, Ramathibodi (Sanskrit: Ramadhipati), to the seventeenth-century king Narai (Sanskrit, Narayana, an epithet of Vishnu) to the present king, Rama IX. When the Royal Chronicles tell of King Narai going out in a royal barge known as *The Garuda*, which no doubt had a large garuda as figurehead (as do some of the royal barges in use today), the parallels are evident.[7]

This gable decoration with Vishnu and Garuda cannot be dated precisely. The crowns of the demons are of a type that seems to appear first in the early seventeenth century, and because such crowns seem to grow taller and slimmer with the passage of time, the squat proportions of these would suggest they are early in the sequence. However, both Vishnu and Garuda wear heavy jeweled chains that fall along either side of their chests rather than crossing in an X shape. Chains shown crossed seem to have been popular at least into the latter part of the seventeenth century. In the paintings in Wat Ko Kaeo Suttharam, dated 1734, however, the chains hang straight, as on this Vishnu and Garuda.[8]

Wat Mae Nang Plum, from which this gable decoration came, is near the northeast corner of the city of Ayutthaya, just across the river. It is off the beaten track, and known, if at all, for its stupa surrounded by stucco lions.[9] By the mid-1970s there was no building in the temple compound of which this gable might have been a part. Perhaps the gable had been saved when an old building was torn down, or perhaps it had been brought from elsewhere for safekeeping at Wat Mae Nang Plum.

1 Gutman, "Vishnu in Burma," 36 n. 2; Geiger, *Culture of Ceylon*, 170.

2 Woodward, *Art and Architecture of Thailand*, 146–155; Matics, *Wat Phra Chetuphon*, 24–33. For photos of gables decorated with Ramayana scenes at Phimai (and at the Hindu temple of Phnom Rung, also in northeastern Thailand), see Smitthi and Moore, *Palaces of the Gods*. Some scholars have raised the possibility that "Siam's King Narai may have sent scholars to examine reliefs at Cambodian ruins and collect stories" (Wright, review of *Tamra phap thewarup*, 124).

3 Anuvit, *Elements*, 104, n. 10; ills. 7–11.

4 Santi, *Temples of Gold*, 94–95. For other depictions of this scene in art of the Bangkok period, see Cadet, *Ramakien*, fig. 123 and *Nang Yai*, fig. 26.

5 Roveda, *Sacred Angkor*, 54–73 and frontispiece. Certain details of the sixteenth-century reliefs call to mind those of the Ayutthaya gable, such as the large arrow carried by Vishnu, the nearby tiered parasol, and the sashes hanging from Vishnu's waist and fluttering behind his legs in Roveda's fig. 43. Many other details, however, are completely dissimilar.

6 Lee, *Ancient Cambodian Sculpture,*
fig. 35; Coedès, *Bronzes khmèrs,* pls. 42,
43. According to the Royal Chronicles,
a metal image of Vishnu was dug up
in Ayutthaya around 1518–1519, and
was enshrined by the king. In the mid
1570s this same image was stolen by
the invading king of Cambodia. See
Cushman, *Royal Chronicles,* 19, 79.
7 Cushman, *Royal Chronicles,* 244;
*Phraratchaphongsawadan krung si
ayutthaya chabap phan chanthanumat,*
384. See Natthaphat, *Royal Barges* and
Sirinand, "Khrut."
8 Boisselier, *Thai Painting,* fig. 52.
See also No. Na Paknam, *Wat ko*

kaeo suttharam. A large wooden boat
figurehead in the shape of a garuda,
in the Chao Sam Phraya National
Museum, Ayutthaya, has its chest
chains crossed, and is probably
earlier than this gable decoration.
See *Namchom phiphitthaphan sathan
haeng chat chao sam phraya,* 98. The
crown worn by the Vishnu is of a very
unusual type, and distantly recalls
some of those worn by Vishnu in
nineteenth-century iconographical
manuals. See *Tamra phap thewarup,*
for instance 46, 130.
9 See No. Na Paknam, *Ha duan,* 114–
115; Sumali, "Wat mae nang plum."

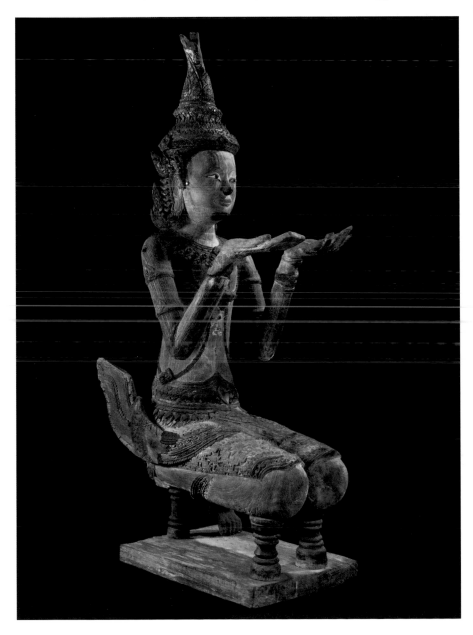

Fig. 194. Kneeling crowned figure, possibly Prince Vessantara, offering a pious donation, cat. no. 64.

63

STANDING CROWNED AND
BEJEWELED BUDDHA, APPROX.
1700–1775 (FIG. 39)
Bronze
H: 104 CM
National Museum, Bangkok, AY130

64

KNEELING CROWNED FIGURE,
POSSIBLY PRINCE VESSANTARA,
OFFERING A PIOUS DONATION,
1750–1800 (FIG. 194)
Wood with traces of lacquer and
gilding
H: 111 CM
Chantharakasem National Museum,
Ayutthaya, 52

Such figures were probably used
for the ceremonial presentation of
new robes to high-ranking Buddhist
monks.[1]

The headdress has features of a
standard Thai royal crown, but the
unusual shape of its finial identifies the
figure as a hermit or ascetic.[2] The prime
example of a royal hermit in Buddhist
lore is Prince Vessantara, the Buddha
in his next-to-last life before achieving
buddhahood. Prince Vessantara, ever
charitable, gives away his kingdom's
magical rain-bringing elephant and is
sent into exile in the forest, where he
lives as a hermit. Earlier, he has made
a famous seven-hundredfold donation,
and is, in fact, the model of boundless
generosity. Perhaps, therefore, a Sia-
mese king or prince might commission
a statue of Vessantara for presenting
his own donations.[3]

The garments and jewelry of this
figure resemble, in their configura-
tion, those of celestials in the 1734
paintings of Wat Ko Kaeo Susthar-
am in Phetburi, but the body of its
crown is closer to those of celestials

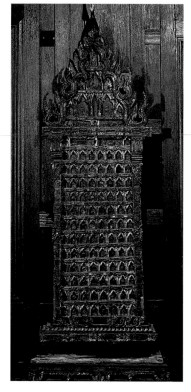

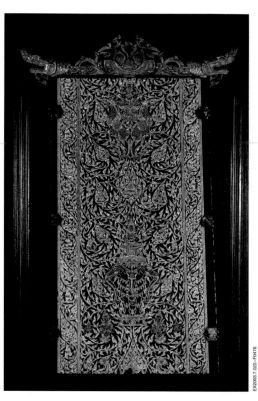

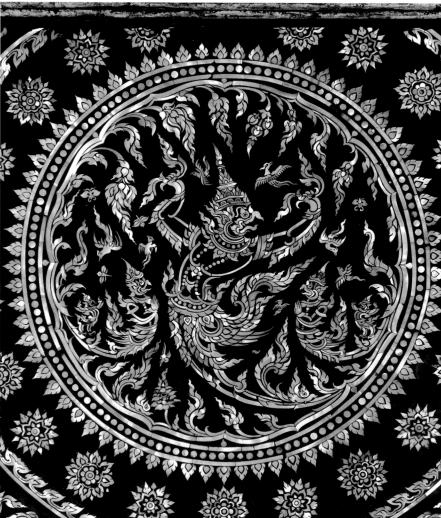

in the late eighteenth-century paintings of the Phutthaisawan Chapel in Bangkok.[4] The pattern on the figure's lower garment suggests those of Indian cottons made for the Siamese market.[5]

Another such wooden figure, kneeling in a similar position of presenting an offering, probably dates from 1650–1700. It lacks features that would associate it with Prince Vessantara.[6] Yet another, of uncertain date, also wears the crown of a royal hermit.[7] A possible distant prototype for these sorts of figures are small bronze figures from ancient Angkor posed kneeling and holding their upturned hands forward in a gesture of offering.[8]

1 Boisselier, *Heritage*, fig. 31 and p. 224.
2 The crown with the finial of a hermit's headdress is frequently seen in painting, for example fig. 16 and Ginsburg, *Thai Art and Culture*, 62, 70, 71, 73, 75, 76, 78, 84.
3 Several kings of Ayutthaya imitated Vessantara in making the great seven-hundredfold donation; Cushman, *Royal Chronicles*, 31, 224. See also McGill, "Jatakas, Universal Monarchs," 431 and n. 39. On the story of Vessantara and its place in Thai art, see McGill, "Painting the 'Great Life.'"
4 Santi, *Temples of Gold*, 49, 78–79.
5 For example, Guy, *Woven Cargoes*, fig. 194.
6 Bowie, Subhadradis, and Griswold, *Sculpture of Thailand*, 122–123. But the upper part of its crown, which could conceivably have had the finial of a hermit's headdress, is damaged. A close-up photo can be seen in Suraphon, *Moradok changsin thai*, 168.
7 Naengnoi and Somchai, *Woodcarving*, 139.
8 For example, Giteau and Guéret, *Khmer Art*, 104–105.

Top left: fig. 195. Votive tablet stand, cat. no. 65. Top right: fig. 196. Section of a door with the deity Indra and foliate design, cat. no. 66 (see also p. 12). Bottom: fig. 197, detail of cat. no. 67.

65

VOTIVE TABLET STAND,
APPROX. 1700–1800
(FIG. 195)
*From Wat Kasattrathirat,
Ayutthaya*
Lacquered and gilded wood with
mirrored glass inlay
H: 224 CM; W: 86 CM
Suan Pakkad Palace Museum,
Bangkok

The many small niches in stands of
this sort were filled with terra-cotta
amulets and votive tablets stamped
with Buddha images. This stand seems
to have accommodated amulets and
votive tablets totaling 108 – an auspi-
cious number.[1]

The form of the stand follows that
of the gabled windows (and related
architectural components) of Sia-
mese buildings of the late Ayutthaya
period.[2] The shape of the gable itself,
and its decoration of fins and rearing
serpents, can be traced back through
cat. no. 14 to the architecture of ancient
Angkor.

This votive tablet stand is said to
have come from Wat Kasattrathirat,
just across the river to the west of
Ayutthaya.[3]

1 Prince Subhadradis's caption in *Suan
Pakkad Palace Collection*, 125, no. 48.
By my count there are spaces for 109
amulets and votive tablets: 96 in 12
rows of 8, then (moving upward) rows
of 4, 2, 5, 1, and 1. Perhaps, however,
one of these spaces held some other
sort of sacred object. On votive tablets
and amulets, see Pattaratorn, *Votive
Tablets.*
2 Pitya, "Gabled Doors and
Windows."
3 Illustrated and described briefly in
Kanita, *Ayutthaya*, 122–123.

66

SECTION OF A DOOR WITH THE
DEITIES BRAHMA AND INDRA
AND FOLIATE DESIGNS, APPROX.
1750S (FIG. 196, P. 12)
Lacquered and gilded wood with
inlay of mother-of-pearl
H: 158 CM; W: 85 CM
Suan Pakkad Palace Museum, Bang-
kok, PT 2353/2539

At the upper end of this section of
a door sits the four-headed deity
Brahma on a throne supported by his
associated animal, the wild goose; in
the middle sits Indra, the king of the
gods, on his three-headed elephant
Airavata (Thai: Erawan). The figures
are seemingly enmeshed in spirals of
flamelike foliage.

Not at first noticeable are the comi-
cally leering monster faces hidden with-
in leaf-shaped bunches of foliage. One
scholar has written that they are raised
to "almost the provoking level, through
their position in the context of the
ornament and the figures, and through
their spirited bursting out from the ara-
besques in a rampant, evidently mock-
ing, attitude."[1] Another amusing motif is
hidden here and there: bird heads biting
the foliage stems. Often they are made
up of little more than an eye, an upper
beak, and a crest.

At the level of the elephant's feet are
two larger and two smaller figures of
celestials in gestures of respect. Their
faces are unusually animated, given
the painstaking nature of the medium
of mother-of-pearl inlay. They call to
mind, in the configuration of their
crowns and ornaments, and in the
depiction of their facial features, a pair
of celestials in the 1734 murals of Wat
Ko Kaeo Suttharam, Phetburi.[2]

This panel is probably a section of
a temple door that may have been cut
down to remove a damaged part. Very

similar doors, inscribed with dates in
the 1750s, are preserved in a building in
Wat Phra Si Rattanasatsadaram (Wat
Phra Kaeo, the "Temple of the Emerald
Buddha") in Bangkok and the preaching
hall of Wat Mahathat in Phitsanulok.[3]

1 Wenk, *Art of Mother-of-Pearl*, 100.
2 Compare Wenk, *Art of Mother-of-
Pearl*, 103, with No. Na Paknam, *Wat ko
kaeo suttharam*, 41, or Boisselier, *Thai
Painting*, 83.
3 Wenk, *Art of Mother-of-Pearl*, 21–22;
Julathusana, *Mother-of-Pearl Inlay*,
12–14, 16–17. See the entry and notes
for cat. no. 67. Most similar to this panel
are the doors of the building called
the *ho monthian tham* at Wat Phra Si
Rattanasatsadaram, which have very
much the same arrangement of Brahma,
Indra, and secondary figures among
foliage, in a related style. Excellent photo
details may be see in Suraphon, *Moradok
changsin thai*, 362–367.

67

MANUSCRIPT CABINET WITH
DECORATION OF ROUNDELS,
APPROX. 1750S AND LATER
(FIGS. 42, 197)
Lacquered and gilded wood with in-
lay of mother-of-pearl and mirrored
glass
H: 220 CM; W: 160 CM
National Museum, Bangkok, 113B

The mother-of-pearl inlaid panels of
this cabinet are usually said to have
come from Wat Borommaphuttharam
in Ayutthaya. This temple was estab-
lished, according to the Royal Chron-
icles, about 1689.[1] New doors, elabo-
rately inlaid with mother-of-pearl,
were added decades later. One pair
of these doors, presumably removed
after the destruction of Ayutthaya
in 1767, was installed in a building in
Wat Phra Si Rattanasatsadaram (Wat

Phra Kaeo, the Temple of the Emerald Buddha) in Bangkok in 1939. These doors bear an inscription describing their commissioning for Wat Borommaphuttharam in 1751.[2] Another set of doors also thought to have come from Wat Borommaphuttharam was cut down to remove damaged parts and made into this cabinet.[3]

The evidence that the panels of the cabinet came from Wat Borommaphuttharam is not entirely clear. However, two other pairs of doors with inscriptions dating them to the 1750s are close enough to the cabinet panels in style, and in their design of a column of roundels, to make a similar date seem likely.[4]

The inlaid designs on the cabinet panels repay close attention. In the center of each roundel is a legendary serpent or bird, monkey warrior, celestial maiden, or other figure from myth surrounded by infinitely varied flame-

like foliate motifs. The way these figures are shown only from the waist up, while below the waist they narrow and merge into long stems of foliage, makes them resemble the figureheads of the long narrow royal barges that played such an important role in Ayutthaya's riverborne royal ceremonies, and that continue to fascinate crowds on the rare occasions they are used today.[5]

The Siamese artists' sense of playfulness is shown in the many tiny animals that gambol in the foliage: monkeys swagger and taunt, a dog wags its tail at a serpent, a squirrel swoops down like a bird. A viewer can hardly help being amazed by so much graceful silliness and so much exuberance in such a costly and time-consuming medium as mother-of-pearl inlay, for such a seemingly solemn use as a temple door.

1 The several versions of the Chronicles

are confusing regarding this period. Listopad discusses the issues and provides translations of the relevant passages from several versions; Listopad, *Phra Narai*, 335–339 and 372–373 n. 15.

2 Julathusana, *Mother-of-Pearl Inlay*, 12–13; Wenk, *Art of Mother-of-Pearl*, 21–22. The inscription can be found in *Prachum chotmaihet samai ayutthaya*, 57. Another datable example of Thai mother-of-pearl inlay, which seems not to have come to the attention of scholars of Thai art, is a box containing a letter incised on a sheet of gold, sent by the Thai king to Emperor Qianlong of China in 1781, illustrated in Guo li gu gong bo wu yuan, *Qianlong huang di de wen hua da ye*, no. IV-27. Terese Bartholomew noticed the box in this catalogue and kindly showed it to me.

3 Julathusana, *Mother-of-Pearl Inlay*, 12–13; Wenk, *Art of Mother-of-Pearl*, 21–22; Wisansinlapakam, *Tamra wicha chang pradap muk*, 18–19, 75–77. For more on

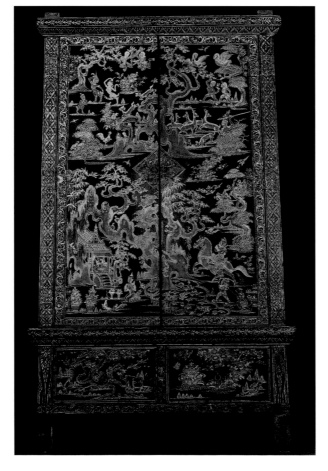 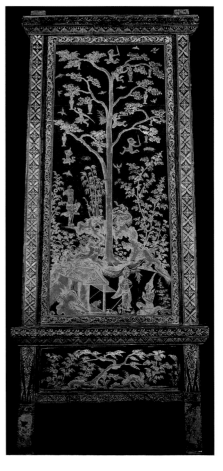

Left: fig. 198, Cabinet with scenes of the Himavanta Forest and the Ramayana, and a pair of celestials, cat. no. 68. Right: fig. 199, side of cat. no. 68, side view.

mother-of-pearl inlay in Thailand in general, see Wenk, "Doors on the Ubosot of Wat Phra Chetuphon."

4 The other pairs of dated doors are from Wat Phra Phutthasaiyat Pa Mok, Ang Thong province (now on a building at Wat Phra Si Rattanasatsadaram, Bangkok), and Wat Mahathat, Phitsanulok (still in situ); Julathusana, *Mother-of-Pearl Inlay*, 15–17; Wenk, *Art of Mother-of-Pearl*, 21. For additional photos, see *Sinlapakam krung rattanakosin*, Sinlapa watthnatham thai, vol. 6, between pp. 52 and 53. Their inscriptions are in *Prachum chotmaihet samai ayutthaya*, 74, 76. Photos of the inscription on the

doors of Wat Mahathat, Phitsanulok, and a hand copy can be found in *Mahathat*, 130–131.

5 Many are pictured in Natthaphat, *Royal Barges*.

68

CABINET WITH SCENES OF THE
HIMAVANTA FOREST AND THE
RAMAYANA, AND A PAIR OF
CELESTIALS, APPROX. 1750–1825
(FIGS. 198, 199, 200)
Lacquered and gilded wood
H: 179 CM; W: 108.5 CM

Fig. 200, back of cat. no. 68.

National Museum, Bangkok, 121

The front and sides of this cabinet are decorated in colors on black, rather than the usual gold on black.[1] Both the color scheme and some aspects of the style recall Chinese lacquer decoration.

In the sacred geography of Thai Buddhism, from the continent upon which people dwell rise the great Himavanta Mountains, on the slopes of which is an idyllic forest. The forest, depicted on three sides of this cabinet, is filled with mythical creatures such as half-human, half-bird folk, and fantastic plants such as magical trees, including a type from whose branches grow fruits in the shape of beautiful maidens.[2]

On the front doors of the cabinet, below the landscape of the Himavanta forest are two scenes from the latter part of the Thai version of the Ramayana. The scene on the left probably shows King Rama's pregnant wife Sita, who has been sent into exile, appealing to a forest hermit for shelter. The scene on the right takes place some years later when Sita's twin sons have become young men. In their adventures they have caused huge noises that have been heard far away in Rama's capital. The king is concerned that the noises are those of an enemy, and sends out a horse, with the monkey hero Hanuman following behind, to find the troublemakers. A message attached to the horse commands those who have caused the noise to signal their submission. If anyone dares to ride the horse he will be caught and executed. The elder of Sita's sons (whose father is Rama, though Rama is unaware of his existence) is undaunted, and jumps on the horse's back. Hanuman tries to capture the princes, but is defeated and bound up with vines.[3]

The placement on this cabinet of scenes from the Thai version of

the Ramayana – the story of one of the incarnations of the Hindu deity Vishnu – within a landscape described in Buddhist texts may seem odd. But in Siam (and Cambodia, Laos, and Burma) the legends of Rama could be interpreted in Buddhist terms and seen as occurring in a Buddhist context, and so they were depicted on Buddhist temples with no sense of incongruity.[4]

Many manuscript cabinets are decorated with scenes from the Thai version of the Ramayana, sometimes mixed with scenes of the life of the Buddha or of his former lives. Little research has yet been devoted to the questions of which scenes are chosen and why, and what might be the relationship of Ramayana and Buddhist scenes.

On the back of the cabinet stand two handsome celestial guardians in gold on black, wearing eighteenth-century garments and jewelry.

1 This cabinet is described and illustrated in Kongkaeo, *Tu lai thong,* Part One, 252–259.
2 *Three Worlds,* 289–292; the trees with maiden-shaped fruits are mentioned on 291.
3 Kongkaeo, *Tu lai thong,* Part One, 255. Also, Olsson, *Thai Ramayana,* 382–391; Jacob, *Cambodian Version of the Ramayana,* 208–231.
4 Boisselier, *Thai Painting,* 186. See also Jacob, *Traditional Literature,* 4, 32.

69

JAR WITH LID, PERHAPS 1700–1800 (FIG. 201)
Brass
H: II CM; W: 17 CM
Philadelphia Museum of Art, The Louis E. Stern Collection, 1963–181–196 a, b

Few utilitarian vessels of metal are known to survive from the Ayutthaya period. They must have been common, but presumably were melted down when damaged or outmoded. Jars of a distantly related shape are sometimes seen in eighteenth-century paintings, and similar tiered finials appear on eighteenth- and nineteenth-century Chinese porcelain made for the Siamese market.[1]

1 Ginsburg, *Thai Manuscript Painting,* 62; Wenk, *Miniaturmalereien,* pl. 8; Robinson, *Sino-Thai Ceramics,* figs. 84, 158.

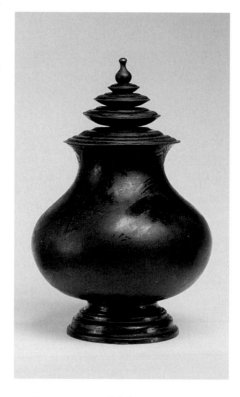

Fig. 201. Jar with lid, cat. no. 69.

70

LONG-HANDLED SWORD WITH DUTCH BLADE, 1757 AND LATER (FIGS. 202, 204)
Steel, brass, wood
L: 179.1 CM
Asian Art Museum, Gift from Doris Duke Charitable Foundation's Southeast Asian Art Collection, F2002.27.110

Long-handled swords such as this were used for fighting on elephant back. The blade of this sword is inscribed on both sides with the date 1757 and a variation of the familiar monogram of the Dutch East India Company. To the initials VOC (Vereenigde Oostindische Compagnie) have been added two strokes to transform the lower part of the V into an M, for Middelberg, one of the offices of the company.

By 1757 the Dutch had been active as traders in Siam for more than 150 years. They provided to the court in Ayutthaya luxury goods from India, China, and Japan, which they had acquired by exchange, as well as goods manufactured in Holland, such as ceramic tiles and weapons.

The handle, collar, and blade of this sword do not fit together perfectly, and the sword in its present condition would been sturdy enough for parade use, but not for combat. When its components were assembled is not known. Its guard closely resembles a Japanese sword guard (*tsuba*) in shape and decoration, but was not made by Japanese techniques, and is presumably a local copy of a Japanese model (see also entry for cat. no. 71). The tang of the sword blade broke at some point, and a rather crude replacement was welded on.

71

LONG-HANDLED SWORD WITH THAI AND JAPANESE-TYPE COMPONENTS, 1850S–1860S OR EARLIER (FIGS. 203, 205)
Steel, brass, wood
L: 172.5 CM
Asian Art Museum, Gift from Doris Duke Charitable Foundation's Southeast Asian Art Collection, F2002.27.111

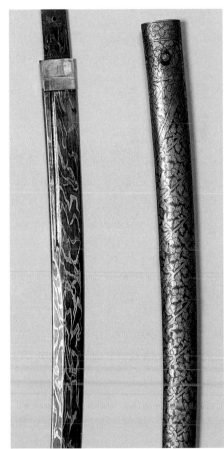

The shape of the blade of this sword calls to mind Japanese sword blades, but its details, and the prominent water pattern, indicate that it is not Japanese-made. The water pattern resembles the *pamor* of Indonesian blades. The guard, decorated with a diagonal trellis pattern with overlaid flowers also resembles Japanese sword guards (*tsuba*), but again, the manufacture is not Japanese.[1] The long handle is in two pieces that may be unscrewed, presumably for ease of carrying.

Japanese traders and adventurers were active in Siam by the late 1500s. In 1606 Shogun Ieyasu wrote to the Siamese king asking for firearms and a species of fragrant wood, and in return offering "as a token of my sincere regard, three suits of Japanese armour, each consisting of three pieces, and ten long swords."[2] In 1688 the French missionary Nicholas Gervaise reported that the Siamese king had warehouses "filled with fine Japanese swords, which are so well tempered that with a single blow they can easily cut through a large iron bar."[3] Some years later, an elaborate royal procession included forty Japanese "volunteers" carrying over their shoulders long-handled swords, presumably similar in type to this one and cat. no. 70.[4]

With Japanese swords known and sought after, it is not surprising

Top: fig. 202. Long-handled sword with Dutch blade, cat. no. 70. Middle: fig. 203. Long-handled sword with Thai and Japanese-type components, cat. no. 71. Bottom left: fig. 204, detail of cat. no. 70. Bottom right: fig. 205, detail of cat. no. 71.

that local artisans would try to copy them. Though there is no documentary evidence of this practice in the Ayutthaya period, much later, in 1861, King Mongkut included among his state gifts to the American president what he described in English as "a sword manufactured in Siam after the Japanese model."[5] The beautiful niello patterns on the scabbard and handle fittings of this sword resemble those on decorative objects from King Mongkut's period (1851–1868).[6] They, and perhaps all the other components of the sword, including the blade, may have been made then.

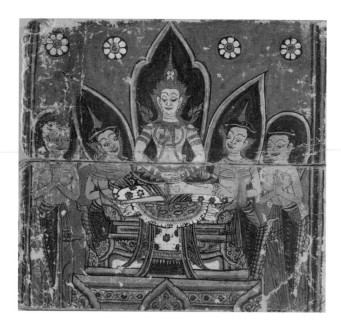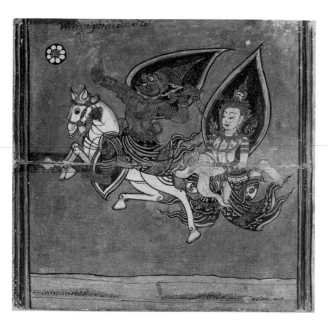

Left: fig. 206. Prince Temiya remains steadfast, from a manuscript with paintings of the last ten previous lives of the Buddha, cat. no. 73. Right: fig. 207. The sage Vidhura is carried through the air holding the tail of a demon's flying horse, from a manuscript with paintings of the last ten previous lives of the Buddha, cat. no. 73.

1 Thanks are due Mark Fenn, objects conservator at the Asian Art Museum, and Richard Mantegani, collector of Japanese swords and related art, for advice.

2 Ieyasu's letter is translated in Satow, "Japan and Siam," 144.

3 Gervaise, *Natural and Political History*, 218.

4 *Phraratchaphongsawadan krung si ayutthaya chabap phan chanthanumat*, 421; Cushman, *Royal Chronicles*, 371. The term for "Japanese volunteers" is *āsā yīpun.* The term that I have translated "long-handled swords," *ngāo*, is translated by Cushman as "halberds." However, *ngāo* seems to be the term used for weapons such as this one and cat. no. 70, as in *Sinlapawatthu krung rattanakosin.* Sinlapa wattanatham thai, vol. 5, 455.

5 McQuail, *Treasures*, 85.

6 McQuail, *Treasures*, 56–61. The development of such Thai decorative patterns during the course of the nineteenth century has not, however, been studied in detail, and it is far from certain that a pattern used in 1820 can be distinguished from one used in 1870.

72

THE SAGE VIDHURA IS CARRIED THROUGH THE AIR HOLDING THE TAIL OF A DEMON'S FLYING HORSE; A SCENE FROM ONE OF THE LAST TEN PREVIOUS LIVES OF THE BUDDHA, APPROX. 1700–1750 (FIG. 90)
Pigments and gold on cloth
H: 31.4 CM; W: 24.8 CM
Asian Art Museum, Gift of Dr. Sarah Bekker, F2002.8.3

Ayutthaya-period banner paintings have rarely survived. This small painting is one of the earliest known fragments of such a banner. It is virtually identical to the comparable scene of a tale of one of the Buddha's previous lives in a manuscript from Harvard University included in the exhibition (fig. 207).

Another fragment almost certainly from the same banner is at the Los Angeles County Museum of Art. It is the same size as the Asian Art Museum fragment, and it also closely matches the equivalent scene in the Harvard manuscript.

The banner, when complete, probably included one episode from each of the last ten previous lives of the Buddha. They may have been arranged in five rows of two. Some later banners (and related artworks) are arranged in this way (fig. 108).[1]

In the story of Vidhura, the Buddha-to-be in one of his previous lives is a great sage. The wife of the king of the serpent folk, desiring to hear him teach, expresses her wish that someone bring her his heart. Her husband takes her request literally, and manipulates the demon Punnaka into agreeing to obtain Vidhura's heart. Punnaka wins custody of the sage in a dice game, and flies back to the land of the serpents with Vidhura clinging to his magic horse's tail. Eventually everyone realizes that the serpent queen wanted not the beating heart from Vidhura's chest but the heart of Vidhura's wisdom, which he willingly imparts.

The short inscription in Thai is oddly spelled but appears to mean "Vidhura and Punnaka depart [or fly off]." The longer inscription in Pali is a common Buddhist formula about taking refuge in the Buddha, the doctrine, and the monkhood.[2]

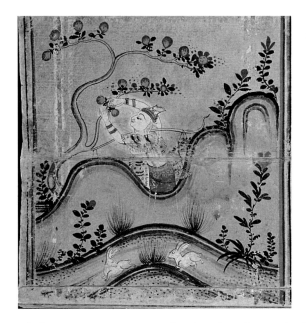 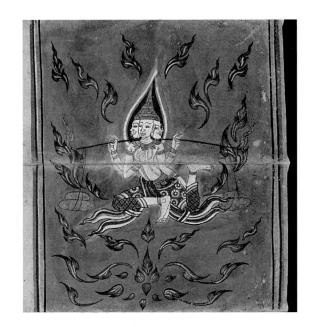

Left: fig. 208. Prince Vessantara's wife gathers fruit in the forest, from a manuscript with paintings of the last ten previous lives of the Buddha, cat. no. 76. Right: fig. 209. Narada descends from the heavens, from a manuscript with paintings of the last ten previous lives of the Buddha, cat. no. 76.

1 Asian Art Museum F2002.27.73 (Gift from Doris Duke Charitable Foundation's Southeast Asian Art Collection); see also a gilded lacquer cabinet with scenes (not of the Buddha's previous lives) arranged in five rows of two, Boisselier, *Thai Painting,* fig. 133.

2 Thanks are due Henry Ginsburg and M. L. Pattaratorn Chirapravati for help in reading the inscriptions.

73

MANUSCRIPT WITH PAINTINGS
OF THE LAST TEN PREVIOUS
LIVES OF THE BUDDHA,
APPROX. 1700–1750
(FIGS. 92, 93, 206, 207)[1]
Pigments on paper
H: 18.8 CM; W: 63.5 CM
Harvard University Art Museums,
Cambridge, 1984.511

For a discussion of a painting on cloth apparently by the same artist or workshop as this manuscript, see the entry on cat. no. 72.

1 Ginsburg, Thai Manuscript Painting, 47, 50, 51, 55, 57, 59, 61, 63.

74

MANUSCRIPT WITH PAINTINGS
OF THE LAST TEN PREVIOUS
LIVES OF THE BUDDHA,[1] APPROX.
1750–1800 (FIGS. 98, 99)
Pigments on paper
W: 62 CM
Spencer Collection, New York
Public Library, Astor Lenox Tilden
Foundations, Thai ms. 6

1 Ginsburg, *Thai Art and Culture,* 59–62, *Thai Manuscript Painting,* 51, 60, 104.

75

MANUSCRIPT WITH PAINTINGS
OF THE LAST TEN PREVIOUS
LIVES OF THE BUDDHA,[1] APPROX.
1700–1725 (FIGS. 96, 97)
Pigments on paper
W: 61.5 CM
Spencer Collection, New York
Public Library, Astor Lenox Tilden
Foundations, Thai ms. 7

1 Ginsburg, *Thai Art and Culture,* 55–58, *Thai Manuscript Painting,* 57, 62, 69, 70, 104.

76

MANUSCRIPT WITH PAINTINGS
OF THE LAST TEN PREVIOUS
LIVES OF THE BUDDHA,[1] APPROX.
1775–1800 (FIGS. 208, 209)
Pigments on paper
W: 64 CM
British Library, London, Or. 14255

1 Ginsburg, *Thai Manuscript Painting,* 9, 45, 46, 67, 69, 103

77

MANUSCRIPT WITH PAINTINGS
OF THE LAST TEN PREVIOUS
LIVES OF THE BUDDHA,[1] APPROX.
1725–1775 (FIGS. 94, 95)
Pigments on paper
W: 60 CM
British Library, London, Or. 14068

1 Ginsburg, *Thai Manuscript Painting,* 46–48, 49, 53, 54, 57, 58, 65, 66, 69, 102.

78

MANUSCRIPT WITH PAINTINGS
OF THE LIFE OF THE BUDDHA
AND OF THE LAST TEN PREVIOUS
LIVES, APPROX. 1750–1780 (FIGS.
100, 101, COVER, P.2)
Pigments on paper
W: 66.5 CM
Bodleian Library, Oxford University,
ms. Pali a.27

This exceptionally rich manuscript
was found in a monastery in Kandy,
Sri Lanka.[1] How it reached Sri Lanka
is not known, but conceivably it was
brought back by an embassy sent to
Siam by the king of Kandy in 1750–
1751.[2]

1 Ginsburg, *Thai Art and Culture*,
65–71.
2 Pieris, "Account." Busakorn, in "Ban
Phlu Luang Dynasty," 280–281, notes
that another Buddhist mission was
sent by the king of Siam to Kandy in
1755.

79

MANUSCRIPT WITH PAINTINGS
OF THE *THREE WORLDS*, 1776
(FIGS. 16, 17, 102, 103, 104)
Pigments and gold on paper
H: 23.5 CM; W: 52 CM
Museum für Indische Kunst,
Staatliche Museen zu Berlin,
Berlin

This famous manuscript with illustra-
tions of the Three Worlds cosmol-
ogy (Thai: *traiphum*) is one of the
most important monuments of Thai
painting, as both a work of art and
a historical document.[1] According to
its inscription, it was commissioned
in 1776 by the king usually known
as Taksin, to assure that accurate

knowledge of traditional Thai Bud-
dhist cosmology would be preserved.
The king ordered careful research to
be carried out "so that the work will be
trustworthy."[2]

It was King Taksin who succeeded
in resisting the Burmese and pulling
the Siamese kingdom back together
after the annihilation of Ayutthaya in
1767. By 1771 he had established a new
capital at Thonburi on the west bank
of the Chao Phraya River across from
Bangkok.[3]

The manuscript has more than
250 pages, with many rich paintings.
Almost half the paintings pertain to
the Three Worlds cosmology; others
include maps of South and Southeast
Asia; still others depict episodes of the
life of the Buddha and his last ten pre-
vious lives.

The nature of the "Three Worlds" is
encapsulated by Henry Ginsburg: they
are "three realms of existence according
to Buddhist philosophy. The first realm
is that of sensual desire which includes
all of hell, the earth, and the lower lev-
els of heaven; it contains eleven differ-
ent levels The second world comprises
sixteen middle levels of heaven where
material elements barely exist. And the
third world contains the four highest
heavens where material elements no
longer exist at all. These are the high-
est reaches, in which the ultimate goal
of nirvana or extinction is virtually
achieved."[4]

1 The manuscript is discussed in detail
and beautifully illustrated in Wenk,
Thailändische Miniaturmalereien. Briefer,
but very useful, descriptive information
is found in Boisselier, *Thai Painting*,
90–94.
2 Thanks go to Daniela Yew for
translating parts of Wenk's text.
Another *Three Worlds* painted
manuscript, now in the National
Library in Bangkok, was also

commissioned in 1776. It is the subject
of *Samutphap traiphum buran chabap
krung Thonburi / Buddhist Cosmology
Thonburi Version*. Several illustrations
from it are also included in Boisselier,
Thai Painting, figs. 60, 61.
3 For an overview of Taksin's reign
and of his conflicts with Catholic
missionaries, in which the public
dedication of the new *Three Worlds*
played a part, see Terwiel, *Modern
Thailand*, 39–65.
4 Ginsburg, *Thai Manuscript Painting*,
13. See also, Boisellier, *Thai Painting*,
139–150, 153, 179–186. An important
Three Worlds text is translated and
discussed by Frank E. Reynolds and
Mani B. Reynolds in *Three Worlds*, and
by Coedès and Archaimbault in *Les
Trois Mondes*.

80

MANUSCRIPT WITH SCENES
FROM THE STORY OF THE HOLY
MONK PHRA MALAI, 1791 (FIGS.
105, 106, 107)
Pigments and gold leaf on paper
H: 12.7 CM; W: 61 CM
Asian Art Museum, Gift from Do-
ris Duke Charitable Foundation's
Southeast Asian Art Collection,
F2002.27.85

Manuscripts with paintings of the sto-
ry of the holy monk Phra Malai do not
seem to have been created before the
late 1700s but were very popular in the
succeeding century. This manuscript,
with an inscribed date of 1791, is the
earliest securely datable manuscript of
this type known.

Though it was known in neigh-
boring countries, the story of Phra
Malai achieved its greatest popularity
and influence in Siam. In the story a
specially pious and compassionate
monk descends to hell to give comfort
to sufferers there. After returning

to earth he is presented a bunch of lotuses collected by a poor man. Phra Malai ascends to Indra's heaven to pay homage and offer the lotuses to the stupa in which is enshrined the hair that the Buddha-to-be cut off after leaving his princely life in his father's palace centuries before. In this heaven Phra Malai and Indra converse on how merit is accumulated, and Phra Malai eventually has the chance to meet Maitreya, the Buddha of the Future. Maitreya gives him messages for the inhabitants of earth on how they may progress spiritually, make merit, and benefit further from his teaching when Maitreya eventually comes to earth for his last existence, during which he will achieve buddha-hood.[1]

This manuscript includes paintings of Phra Malai in hell, speaking with a pious family, receiving the lotuses, conversing with Indra at the stupa of the hair relic, and apparently – though the scene is not commonly depicted – meeting Maitreya. Other paintings show celestials hovering in the air or listening respectfully to the conversations of the great religious figures. A last painting is unusual because it spans the entire width of the book rather than being confined to one third of a page flanking a block of text, as are the other paintings. It is incomplete because one cover of the book, and perhaps a few pages, have been torn away, but it presumably continued onto one of these pages. What remains (in poor condition) shows the lower part of a throne with figures in respectful attitudes arrayed on either side. At the far right a woman presenting an offering is having her breast fondled by the figure next to her.

All the paintings are in a rather spontaneous style, and are less formulaic in composition and treatment than standard Phra Malai paintings of a

later generation. Particularly striking is the vigorous, expressionistic depiction of clouds in certain paintings, sharply contrasting with the usual restrained handling in other paintings. The most similar effect is seen in clouds in a manuscript from Harvard included in the exhibition, attributed to 1700–1750 (cat. no. 73).[2]

Our understanding of the history of Thai manuscript painting is not yet sufficient for us to decide whether the unusual features of the paintings in this manuscript are due to the period in which they were made, or the region, or perhaps to the vision of a particular artist.

An inscription on the manuscript reads:

> This Phra Malai volume has been commissioned for merit making by Grandmother Thong and her child [or children] in support of the holy religion, at the cost of [?], in the hope of happiness in future existences. May we be spared from misery! May [this donation] be a cause of reaching nirvana! This book was dedicated in the year of the rat, fourth of the decade, after 2334 years of the Buddhist era had elapsed.[3]

1 An important version of the Phra Malai story is translated, summarized, and discussed in Brereton, *Phra Malai*. See also, Ginsburg, *Thai Manuscript Painting*, chapter 5 and Ginsburg, *Thai Art and Culture*, 92–III.

2 Ginsburg, *Thai Manuscript Painting*, pl. 14.

3 Henry Ginsburg, M. L. Pattara-torn Chirapravati, and Sakulrat Worathumrong provided a great deal of help in translating the inscription. The cost of the manuscript is indicated in symbols, the meaning of which has not yet been worked out.

81, 82, 83, 84
INDIAN AND IRANIAN TEXTILES FOR THE SIAMESE MARKET

For centuries, towns and villages along the southeastern coast of India produced painted and printed cotton textiles that were in demand all over Southeast Asia as well as in Persia and Europe. The Indian artisans were fully aware of the sorts of designs favored in different places, and must have had access to pattern books brought, for instance, from Java and Siam. The textiles produced for the Siamese market were often of very high quality, and must have been expensive in their day. Their designs and patterns echo those found in Siamese decorative painting, woodwork, stuccowork, gilded lacquer (see cat. no. 58), and other mediums, and quite often painted or sculptured figures in Siamese artworks wear garments that seem to be made of these colorful Indian cottons (for example, cat. nos. 64 and 68).[1]

1 On Indian textiles for the Siamese market, see Gittinger, *Master Dyers*; Gittinger and Lefferts, *Textiles and the Thai Experience*; and Guy, *Woven Cargoes*.

81

PERSIAN TEXTILE FOR THE SIAMESE MARKET, APPROX. 1700–1750 (FIG. 210)
Silk and metallic yarns
TWO PANELS, EACH L: 158 CM; W: 86 CM
Textile Museum, Washington, DC, 3.313.a, b, acquired by George Hewitt Myers in 1952

It has been proposed that this two-paneled textile served to cover a platform on which a throne was

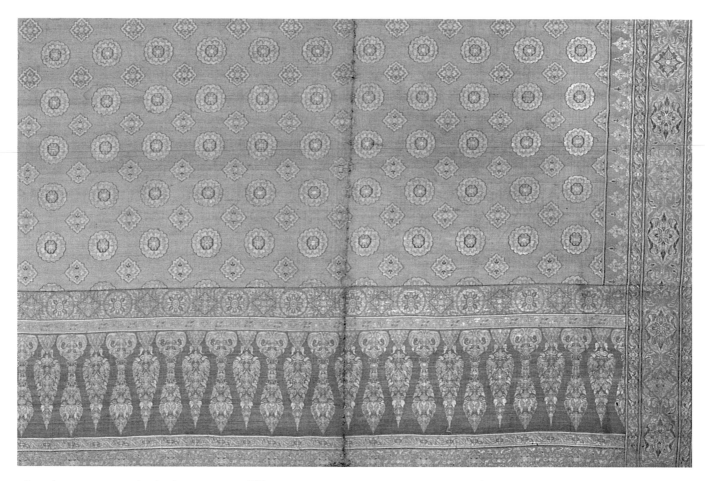

placed. Its extremely high quality suggests it must have been for use by royalty.[1] Records of the Dutch East India Company's representative in Persia in 1713 mention high-quality textiles being ordered by the king of Siam.[2]

1 Gittinger and Lefferts, *Textiles and the Thai Experience*, 168.
2 *Woven from the Soul*, 228.

82

INDIAN TEXTILE WITH
ALTERNATING ROUNDELS AND
EIGHT-POINTED MOTIFS, FOR
THE SIAMESE MARKET, APPROX.
1700–1800 (FIG. 28)
Dyed cotton with gold
L: 245.2 CM; W: 120.6 CM
The Asian Art Museum, Gift of
Mr. and Mrs. M. Glenn Vinson, Jr.,
1988.46

83

INDIAN TEXTILE WITH
ALTERNATING MOTIFS OF
CELESTIALS AND BIRD-WOMEN,
FOR THE SIAMESE MARKET,
APPROX. 1750–1800 (FIG. 211)
Dyed cotton
H: 57.5 CM; W: 109.9 CM
Asian Art Museum, Acquisition made
possible by Mr. and Mrs. David Brom-
well, F2002.38

Half-bird half-human creatures inhab-
it the Himavanta Forest of Buddhist
legend, and are frequently represented
in Siamese painting and sculpture. An
old story recounts the separation and
reunion of a bird maiden and a prince
who have fallen in love.[1]

1 Ginsburg, *Thai Art and Culture*, 62;
Ginsburg, *Thai Manuscript Painting*, 69,
71; Boisselier, *Heritage*, 177, 180.

84

INDIAN TEXTILE WITH
ALTERNATING DIAMOND- AND
CROSS-SHAPED MOTIFS, FOR
THE SIAMESE MARKET, APPROX.
1750–1800 (FIG. 212)
Dyed cotton
L: 370 CM; W: 195 CM
Cooper-Hewitt, National Design
Museum, Smithsonian Institution.
Gift of Jacques Mohr, 1976-32-7

The design of the central field recalls tile
work such as the interlocking "star and
cross" pattern of Persian tradition. The
leaf-shaped elements in the three bor-
ders at each end incorporate half-length
figures of celestials. Such a textile may
have been used as hanging or curtain in
a palace or aristocratic home.[1]

1 Gittinger and Lefferts, *Textiles and the
Thai Experience*, 154.

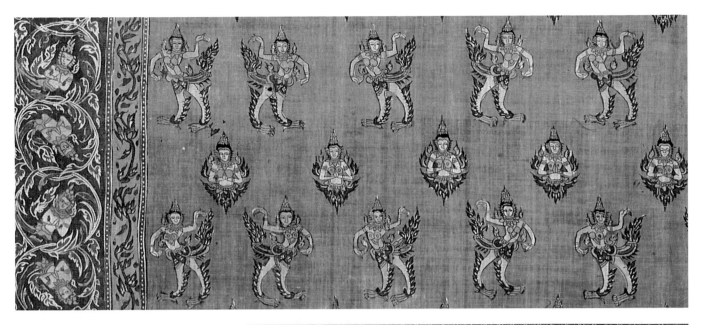

Facing page: fig. 210. Detail of a Persian textile for the Siamese market, cat. no. 81. This page, top: fig. 211. Detail of an Indian textile with alternating motifs of celestials and bird-women, for the Siamese market, cat. no. 83. Right: fig. 212. Detail of an Indian textile with alternating diamond- and cross-shaped motifs, for the Siamese market, cat. no. 84.

85, 86, 87

EARLY EUROPEAN
DESCRIPTIONS OF SIAM

The first substantive European descriptions of the kingdom of Siam were written by the Portuguese in the sixteenth century.[1] After their capture of Malacca on the Malay peninsula in 1511, the Portuguese sent delegations north to explore commercial relations with Ayutthaya. With the founding of the VOC (Dutch East Indies Company) in the early seventeenth century, Dutch traders established commercial relations with Siam, and published reports on the people and their customs.

By the time French missionaries arrived, first in the 1660s, then again in the 1680s, they were impressed by the cosmopolitan nature of the capital, with well-established enclaves of

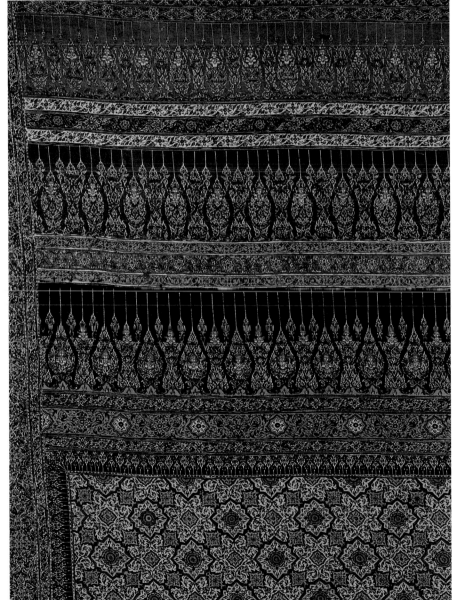

Portuguese, Dutch, and French expatriates, as well as communities from other parts of Southeast Asia, Japan, China, India, and West Asia.

During the second half of the seventeenth century, both the Siamese and French were eager to build diplomatic relations, although for quite different reasons. The Dutch dominance in trade worried the Thai, and they sought to balance political and commercial alliances among foreign powers. The French, on the other hand, had ecclesiastical and military motives. They were sorely misguided in their belief that King Narai could be converted to Christianity, and they proved completely unsuccessful in using religion to advance their position in Siam.

Many of these early envoys and missionaries published accounts of their adventures upon returning to Europe, and their books proved enormously popular. Simon de la Loubère's *Du Royaume de Siam* (cat. no 86) was first published in 1691 in both Paris and Amsterdam, then translated into English, reprinted twice in French, and once again in English.

Some common observations run through many of these European descriptions. They remark on the tolerance of Siamese society toward other peoples and other religions. In fact it was this very tolerance, so unlike the religious climate of western Europe at that time, that inspired the French to attempt conversion of the Siamese. Not surprisingly, most early European descriptions of Siam show very little effort to understand Buddhism as anything other than "idolatry."

Some travelers were keen observers of Thai customs and manners. Visitors were struck by the cleanliness of the Siamese, who bathed several times daily (in marked contrast to European hygienic standards of the day). Exotic

tropical fruits and plants were carefully described, as well as typical Siamese cuisine. La Loubère noted the Siamese predilection for fermented fish, "rotten eggs, locusts, rats, lizards, and most insects," but he was open-minded enough to admit the possibility that "all these things have not such an ill taste as we imagine."[2]

Illustrations accompanying these accounts depicted exotic subjects sure to interest a European audi-

Fig. 213. Title page of Du royaume de Siam, par Monsieur de La Loubère, envoyé extraordinaire du roy auprés du Roy de Siam en 1687. & 1688 ... *by Simon de La Loubère, cat. no. 86.*

ence. Elephants were a subject of endless fascination. Royal barges, court ceremonies, and both secular and religious architecture were also illustrated.

Natasha Reichle

1 Flores, "Portuguese Relationships."

2 La Loubère, *New Historical Relation*, 35.

VOYAGE DE SIAM DES PÈRES JÉSUITES ENVOYEZ PAR LE ROY AUX INDES ET À LA CHINE. AVEC LEURS OBSERVATIONS ET LEURS REMARQUES DE PHYSIQUE, DE GÉOGRAPHIE, D'HYDROGRAPHIE ET D'HISTOIRE, 1686 (FIGS. 22, 24, 26, 27)
By Guy Tachard
Paris: Publisher Chez A. Seneuze et D. Horthemels
Printed book
H: 25 CM
Mandeville Special Collections Library, University of California, San Diego, DS564.T13 1686

The first French embassy to Siam arrived in October of 1685. The mission was led by Chevalier Alexandre de Chaumont, who was accompanied by the Abbé François-Timoléon de Choisy and the Jesuit Guy Tachard, among others. Chaumont was a devout and apparently humorless man, who was determined to covert the Thai king to Catholicism. In contrast, his co-ambassador, the Abbé de Choisy, was a colorful fellow, a priest and well-connected courtier with a reputation for gambling and cross-dressing. A third member of the party, Father Guy Tachard, who returned to Siam in 1687 and again in 1698, assumed many of de Choisy's duties, including negotiating with the Siamese king's minister of trade and foreign relations (the highly influential Greek, Constantine Phaulkon).

Each of these men wrote an account of his journey upon his return to France.[1] Tachard's was by far the most popular; it was published in three French editions, as well as in translations into English, Dutch, and Italian. His descriptions of seventeenth-century Siamese culture served to spark a

European appetite for accounts of the "exotic east."

The French court was not immune to this fascination with Siam. It appears that King Louis XIV had been briefed in detail on the elaborate reception of the French envoys in Siam, and went to great lengths to imitate the reception in Versailles when welcoming the embassy from Siam that arrived in the spring of 1686.[2] In accordance with Thai custom, great effort was made to physically elevate the letter from King Narai: special platforms were made for each house the envoys stayed in, and a shelf for the royal missive was constructed in the carriage they used. Special "Siamese" music, for which there would soon be a vogue, was composed for the reception. The envoys were received in Versailles' great gallery, the Hall of Mirrors. In imitation of King Narai's elevated throne, a platform more than six feet high was constructed on which to place the throne of King Louis XIV. Like King Narai, the French king dressed in gold robes decorated with jewels. This close attention to protocol demonstrates the way that each ruler used ceremony to promote his royal image.

The Thai envoys brought with them two shiploads of gifts for the court. So many objects of gold, silver, and lacquer were sent that the French complained that the list would be as long as a book. The gifts reflect Ayutthaya's position as a bustling international trade center. More than 1500 pieces of porcelain (mostly Chinese), Persian and Indian carpets, and many other objects from Japan and China were given to the French king and his relatives. It is remarkable how few of the items appear to have been made in Siam. Among the gifts were East Asian luxury goods that were immediately valued and treasured; other items, like the chest full of birds' nests (used for making soup in Siam), must have been received with befuddlement. An inventory of the gifts survives, but unfortunately it has proved difficult to match the terse descriptions with surviving objects in French collections.[3]

The Siamese envoys were equally diligent in recording their adventures in Europe.[4] Several French observers noted that the Siamese envoys recorded every detail of their trip and that they "always have their writing tablets in their hands."[5] Sadly, most of these Siamese accounts do not survive today.

Natasha Reichle

1 Alexandre de Chaumont, *Relation de l'ambassade de M* le chevalier de Chaumont à la cour du roi de Siam, avec ce qui est passé de plus remarquable durant son voyage.* Paris, Seneuze & Horthemels, 1686. François-Timoléon de Choisy, *Journal du voyage de Siam fait en 1685 et 1686*, Paris, Mabre-Cramoisy, 1687; Amsterdam, P. Mortier, 1687.
2 Love, "Rituals of Majesty."
3 Smithies, *Discourses at Versailles.*
4 *Diary of Kosa Pan.*
5 Choisy, *Journal*, 272 (May 1686).

86

DU ROYAUME DE SIAM, PAR MONSIEUR DE LA LOUBERE, ENVOYÉ EXTRAORDINAIRE DU ROY AUPRÉS DU ROY DE SIAM EN 1687 & 1688, 1691 (FIG. 213)
By Simon de La Loubère
Paris: Chez la veuve de Jean Baptiste Coignard
Printed books, 2 vols.
H: 16 CM
Department of Special Collections, Stanford University Libraries, DS564.L2 1691

Born in Toulouse, France, in 1642, Simon de La Loubère showed literary and diplomatic talents as a young man. In 1687 he was appointed along with Claude Céberet du Boullay as "extraordinary envoy" in King Louis XIV's second mission to Siam, where he spent almost four months.

La Loubère's diplomatic mission was not successful. By the time he arrived members of the Siamese court were growing suspicious of the increasing influence of foreigners on King Narai, and they did not welcome the arrival of the French envoys, who were accompanied by hundreds of French troops. La Loubère's efforts to negotiate with the Siamese were also hampered by Guy Tachard, who led secret negotiations behind his back. La Loubère returned to France in 1688; before the year was over King Narai had died and his Greek advisor Phaulkon had been executed. In the following years, Siam's trade with Europe decreased, replaced in part by increased commerce with China.

La Loubère's *The Kingdom of Siam* was published three years after his return to France and is considered the most informative European account of Siam in the late 1600s. After a geographical overview, La Loubère discusses "the manners of the Siamese," commenting upon everything from domestic architecture to daily diet. Many of his descriptions about Thai village and monastery life remain apt today.

La Loubère expresses little regard for Thai music, medicine, or military preparedness, but he appreciates Siamese skills in mathematics and astronomy.

Compared to many of his compatriots, La Loubère seemed to have a greater sensitivity to the problems implicit in converting the Siamese to Christianity.

Natasha Reichle

87

*THE HISTORY OF JAPAN …
TOGETHER WITH A DESCRIPTION
OF THE KINGDOM OF SIAM*, 1727
(FIG. 19)
By Engelbert Kaempfer, translated
by J. G. Scheuchzer
London, printed for the translator
Printed book
H: 36 CM
Department of Special Collections, Stanford University Libraries,
DS808. K3 1727 F

Unlike Guy Tachard and Simon de La Loubère, the German scientist Engelbert Kaempfer (1651–1716) did not come to Siam with a political or evangelical agenda. Kaempfer was a physician and botanist who had joined the VOC (Dutch East India Company) as a medical officer. His travels took him far from the small German town where he was born. After studying in Poland, Prussia, and Sweden, Kaempfer joined the Swedish mission to Persia, where he stayed for several years. Highly gifted with languages and clearly fascinated by travel, he then sailed to Batavia (Jakarta). It was there in Indonesia that he joined the 1690 Dutch embassy to Japan, which stopped in Siam en route.

Although Kaempfer stayed only a month and a half in Thailand, his detailed descriptions reflect both keen observational skills and scholarship of past travelers' writings. His account is particularly valuable because it provides a historical report of the fall of King Narai and his advisor Phaulkon. It also provides a detailed description of the city of Ayutthaya, with its palaces and temples. The richly illustrated manuscript includes numerous illustrations of Siamese boats and buildings.

Kaempfer's account of the kingdom

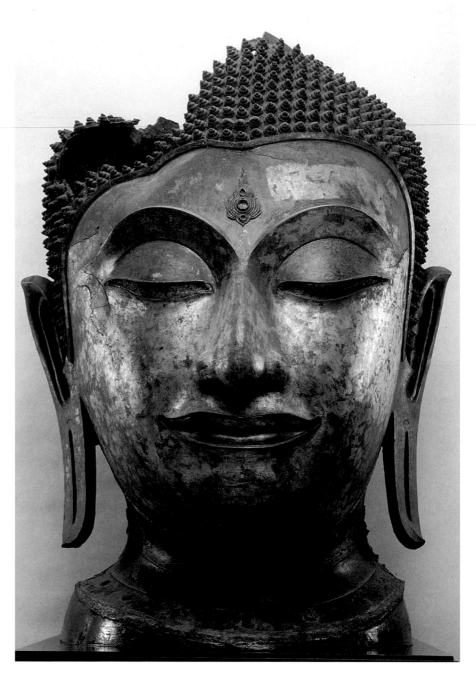

Fig. 214. Head of a Buddha image, cat. no. 88.

of Siam makes up the first of the five sections of his *History of Japan*. The book was published first in English translation eleven years after the author's death. The original German manuscript is in the British Library in London.[1]

Natasha Reichle

1 See Ginsburg, *Thai Art and Culture*, 27.

SUPPLEMENT: *We are pleased to include cat. nos. 88 and 89 as late additions to the exhibition.*

88

HEAD OF A BUDDHA IMAGE,
1500–1600 OR LATER (FIG. 214)
Copper alloy with traces of gilding
H: 173 CM
National Museum, Bangkok, AY 98

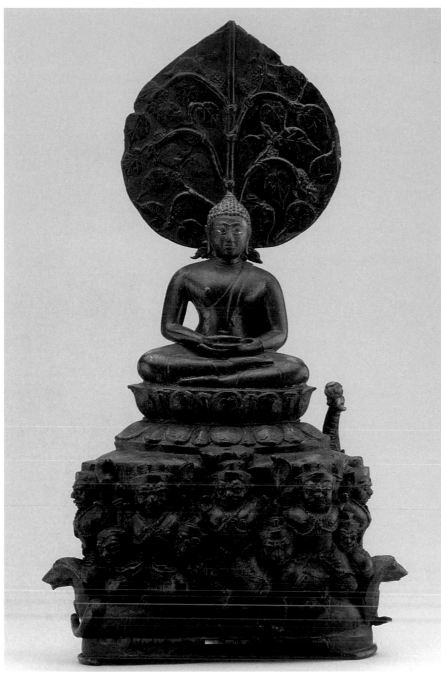

Fig. 215. *The Buddha attacked by Mara's army, cat. no. 89.*

message to author, October 2, 2004. See also Boisselier, *Heritage*, no. 20. See also Fontein, *Bouddhas du Siam*, 44.
2 For example Woodward, *Sacred Sculpture*, figs. 236 and 249.

89

THE BUDDHA ATTACKED BY MARA'S ARMY, APPROX. 1400–1500 (FIG. 215)

Copper alloy
H: 41 CM
National Museum, Bangkok, AY 15

The Buddha-to-be, shortly before attaining enlightenment, sits beneath the bodhi tree in meditation, and is attacked by the army of the demon Mara.[1]

The Buddha image is unusual in its proportions, and would seem to relate to a "big round shoulder" tradition discussed by Woodward. He traces this tradition from the tenth or eleventh century in Thaton in lower Burma to the fourteenth century in Sukhothai.[2] The demons relate to presumably fifteenth-century examples in stucco at Wat Ratchaburana and elsewhere in Ayutthaya, and in ceramics from the Sukhothai region.[3]

1 For a more detailed description, see Bowie, Subhadradis, and Griswold, *Sculpture of Thailand*, 118.
2 Woodward, "Some Buddha Images and the Cultural Developments of the Late Angkorian Period," *Artibus Asiae* 42 (1980): 172–172 and figs. 20–23; also, Woodward, *Sacred Sculpture*, 151, 162.
3 No. Na Paknam, *Wiwatthanakan lai thai*, rev. ed., fig. 139; an important wooden relief of the attack of Mara at Wat Phra Rup, Suphanburi, in No. Na Paknam, *Sinlapa kon krung si ayutthaya*, 72–75; Asian Art Museum, *Thai Ceramics*, 114; McGill, "Jatakas, Universal Monarchs," fig. 45.

According to museum records, this extremely large head was found at the primary preaching hall of Wat Phra Si Sanphet in Ayutthaya, and was moved to the National Museum, Bangkok, in 1927.[1] No other fragments of the image to which it belonged are known. The head has only general similarities to that of the one large Buddha image pre-served from Wat Phra Si Sanphet, the Phra Lokkanat (fig. 38).

It is not easy to compare very large heads with the much more common smaller ones,[2] because the features of very large heads have often been exaggerated to register strongly in their situation far above the viewer's eyes.

1 Somchai Na Nakhonpathom, e-mail

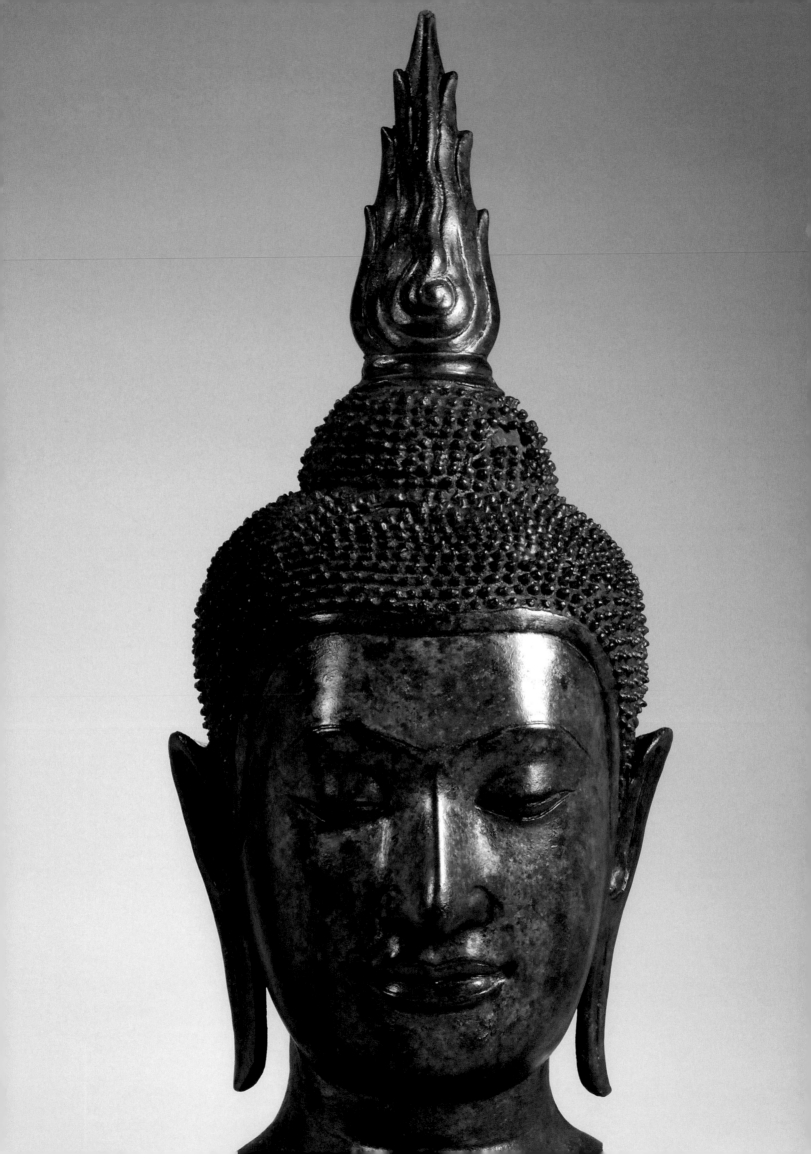

The Kings of Ayutthaya and Thonburi, and the Early Kings of Bangkok

Traditional Designations and Dates

Bibliography

Following Thai custom, Thai authors are listed by their first name.
Important additional resources can be found in the bibliographies
of Woodward, *The Sacred Sculpture of Thailand* and Listopad,
The Art and Architecture of the Reign of Somdet Phra Narai.

Andaya, Leonard Y. "Ayutthaya and the Persian and Indian Muslim Connection." In *From Japan to Arabia: Ayutthaya's Maritime Relations with Asia*, edited by Kennon Breazeale, 119–136. Bangkok: Toyota Foundation and The Foundation for the Promotion of Social Sciences and Humanities Textbook Project, 1999.

Anuvit Charernsukul. *The Elements of Thai Architecture*. Bangkok: Kanphim Satrisan, 1978.

Art and Archaeology in Thailand / Sinlapa lae borannakhadi nai prathet thai. Vol. 1. Bangkok: Fine Arts Department in commemoration of the 100th anniversary of the National Museum, 1974.

Asia Research Institute. "Southeast Asia in the 15th Century: The Ming Factor." Workshop, Singapore, 18–19 July 2003. Abstracts in <http://www.ari.nus.edu.sg/conf2003/ming.htm> (2 November 2003).

Asian Art Museum of San Francisco. *Thai Ceramics: The James and Elaine Connell Collection*. San Francisco: Asian Art Museum, 1993.

The Arts of Islam: Hayward Gallery, 8 April–4 July 1976. [London]: The Arts Council of Great Britain, 1976.

Atil, Esin. *The Age of Sultan Süleyman the Magnificent*. Washington: National Gallery of Art; New York: Harry N. Abrams, 1987.

Baker, Chris. "Ayutthaya Rising: From Land or Sea?" *Journal of Southeast Asian Studies* 34, no. 1 (February 2003): 41–62.

Baker, Chris. Introduction to *The Chronicle of Our Wars with the Burmese: Hostilities between Siamese and Burmese When Ayutthaya Was the Capital of Siam*, by Prince Damrong Rajanubhab. Bangkok: White Lotus, 2001.

Banchop Thiamthat. "Wat worachettharam." In *Phraratchawang lae wat boran nai changwat phra nakhon si ayutthaya*. Bangkok: Fine Arts Department, 1968.

Béguin, Gilles. *L'Inde et le monde Indianisé au Musée national des Arts Asiatiques-Guimet*. Paris: Réunion des Musées Nationaux, 1992.

Bénisti, Mireille. *Rapports entre le premier art Khmer et l'art Indien*. 2 vols. École Française d'Extrême-Orient: Mémoire archéologique, vol. 5. Paris: École Française d'Extrême-Orient, 1970.

Bernet Kempers, August Johan. *Ancient Indonesian Art*. Cambridge, Mass.: Harvard University Press, 1959.

Bèze, Claude de. *1688 Revolution in Siam: The Memoir of Father de Bèze, s.j.* Translated by E.W. Hutchinson. Hong Kong: Hong Kong University Press, 1968.

Bhattacharya, Kamaleswar. *Les Religions bramaniques dans l'ancien Cambodge*. Publications de l'École Française d'Extrême-Orient, vol. 44. Paris: École Française d'Extrême-Orient, 1961.

Bizot, François. *Le Bouddhisme des Thaïs: Brève histoire de ses mouvements et de ses idées des origines à nos jours*. Bangkok: Éditions des Cahiers de France, 1993.

Bizot, François. "La Consécration des statues et le culte des morts." In *Études Thématiques*. Vol. 1, *Recherches nouvelles sur le Cambodge*, 101–135. Paris: École Française d'Extrême-Orient, 1994.

Bizot, François. "La Place des communautés du Nord-Lao dans l'histoire du bouddhisme d'Asie du Sud-Est." *Bulletin de l'École Française d'Extrême-Orient* 87 (2000): 511–528.

Boisselier, Jean. *Le Cambodge*. Manuel d'archéologie d'extrême orient, pt. 1, vol. 1. Paris: Éditions A. et J. Picard, 1966.

Boisselier, Jean. "Evolution du diadème dans la statuaire khmère." *Bulletin de la Societé des Études Indochinoises* 25, no. 2 (1950): 149–170.

Boisselier, Jean. *The Heritage of Thai Sculpture*. New York: Weatherhill, 1975.

Boisselier, Jean. "Notes sur l'art de bronze dans l'ancien Cambodge." *Artibus Asiae* 29, no. 4 (1967): 275–334.

Boisselier, Jean. "Notes sur les bas-reliefs tardifs d'Angkor Vat." *Journal Asiatique* 250 (1962): 244–248.

Boisselier, Jean. "Recherches archeologiques en Thailande, II." *Arts Asiatiques* 20 (1969): 47–98.

Boisselier, Jean. *Thai Painting*. Tokyo and New York: Kodansha, 1976.

Boran Ratchathanin, Phraya. *Ruang krungkao: Prachum phongsawadan*: Vol. 63. Bangkok: Printed for the cremation of Phraya Boran, 1936.

Bowie, Theodore, ed. *The Arts of Thailand: A Handbook of the Architecture, Sculpture and Painting of Thailand (Siam), and a Catalogue of the Exhibition in the United States in 1960–61–62*. Bloomington: Indiana University, 1960.

Bowie, Theodore, M. C. Subhadradis Diskul and A. B. Griswold. *The Sculpture of Thailand*. Edited by Theodore Bowie. New York: Asia Society; distributed by New York Graphic Society, 1972.

Breazeale, Kennon, ed. *From Japan to Arabia: Ayutthaya's Maritime Relations with Asia*. Bangkok: Toyota Foundation and The Foundation for the Promotion of Social Sciences and Humanities Textbook Project, 1999.

Breazeale, Kennon. "Thai Maritime Trade and the Ministry Responsible." In *From Japan to Arabia: Ayutthaya's Maritime Relations with Asia*, edited by Kennon Breazeale, 1–54. Bangkok: Toyota Foundation and The Foundation for the Promotion of Social Sciences and Humanities Textbook Project, 1999.

Brereton, Bonnie Pacala. "Some Comments on a Northern Phra Malai Text Dated C.S. 878 (A.D. 1516)." *Journal of the Siam Society* 81, pt. 1 (1993): 141–145.

Brereton, Bonnie Pacala. *Thai Tellings of Phra Malai: Texts and Rituals Concerning a Popular Buddhist Saint*. Tempe, Ariz.: Arizona State University, 1995.

Bronson, Bennet. "Notes on the History of Iron in Thailand." *Journal of the Siam Society* 73, pts. 1–2 (January, July 1985): 205–225.

Brown, Robert L., ed. *Art from Thailand*. Mumbai: Marg, 1999.

Brown, Robert L. "God on Earth: The Walking Buddha in the Art of South and Southeast Asia." *Artibus Asiae* 50 (1990): 73–107.

Brown, Robert L. "Images of Ganesh from South-East Asia." *Marg* 41, no. 2 (1995): 31–50.

Brown, Robert L. "Narrative as Icon: The *Jataka* Stories in Ancient Indian and Southeast Asian Architecture." In *Sacred Biography in the Buddhist Traditions of South and Southeast Asia*, edited by Julian Schober, 64–109. Honolulu: University of Hawai'i Press, 1997.

Brown, Roxanna M. *The Ceramics of South-East Asia: Their Dating and Identification*. 2nd ed. Singapore and New York: Oxford University Press, 1988.

Brown, Roxanna M. et al. *Legend and Reality: Early Ceramics from South-East Asia*. Cologne: Museen der Stadt Köln, 1977.

Brown, Roxanna M. and Sten Sjostrand. *Turiang: A Fourteenth-century Shipwreck in Southeast Asian Waters*. Pasadena, Calif.: Pacific Asia Museum, 2000.

Brummelhuis, Han ten. *Merchant, Courtier and Diplomat: A History of the Contacts Between the Netherlands and Thailand*. Lochem/Ghent: De Tijdstroom, 1987.

Bullis, Douglas. *The Mahavamsa: The Great Chronicle of Sri Lanka*. Fremont, Calif.: Asian Humanities Press, 1999.

Bunker, Emma C., and Douglas Latchford. *Adoration and Glory: The Golden Age of Khmer Art*. Chicago: Art Media Resources, 2003.

Burckhardt, Titus. *Art of Islam: Language and Meaning*. Translated by J. Peter Hobson. London: World of Islam Festival Pub. Co., 1976.

Burke, Peter. *The Fabrication of Louis XIV*. New Haven and London: Yale University Press, 1992.

Busakorn Lailert. "The Ban Phlu Luang Dynasty 1688–1767: A Study of the Thai Monarchy during the Closing Years of the Ayutthya [sic] Period." Ph.D. diss., University of London, 1972.

Cadet, J. M. *Ramakien: Stone Rubbings of the Thai Epic*. Tokyo and New York: Kodansha, 1971.

Caron, François and Joost Schouten. *A True Description of the Mighty Kingdoms of Japan and Siam*, 1671. Translated by Roger Manley. Facsimile reprint, Bangkok: Siam Society, 1986.

Chandler, David. *A History of Cambodia*. Boulder, Colo.: Westview Press, 2000.

Charnvit Kasetsiri. "Ayudhya: Capital-Port of Siam and its 'Chinese Connection' in the Fourteenth and Fifteenth Centuries." *Journal of the Siam Society* 80, pt. 1 (1992): 75–79.

Charnvit Kasetsiri, ed. *Ayutthaya*. Bangkok: Toyota Foundation, 2003.

Charnvit Kasetsiri. *Ayutthaya: Prawattisat lae kanmuang / Ayutthaya: History and Politics*. Edited by Thamrongsak Petchlert-anan. Bangkok: Munnithi Khrongkan Tamra Sangkhommasat lae Manutsayasat, 1999.

Charnvit Kasetsiri. "Origins of a Capital and Seaport: The Early Settlement of Ayutthaya and Its East Asian Trade." In *From Japan to Arabia: Ayutthaya's Maritime Relations with Asia*, edited by Kennon Breazeale, 55–79. Bangkok: Toyota Foundation and The Foundation for the Promotion of Social Sciences and Humanities Textbook Project, 1999.

Charnvit Kasetsiri. *The Rise of Ayudhya: A History of Siam in the Fourteenth and Fifteenth Centuries*. Kuala Lumpur and New York: Oxford University Press, 1976.

Charuk samai sukhothai. Bangkok: Fine Arts Department, 1983.

Chaudhuri, K. N. *Trade and Civilisation in the Indian Ocean: An Economic History from the Rise of Islam to 1750*. Cambridge and New York: Cambridge University Press, 1986.

Chawingam Macharoen. *Butsabok thammat*. Bangkok: Fine Arts Department, 1977.

Chevalier de Chaumont, The, and the Abbé de Choisy. *Aspects of the Embassy to Siam 1685*. Edited and in part translated by Michael Smithies. Chiang Mai: Silkworm, 1997.

Chihara, Daigoro. *Hindu-Buddhist Architecture in Southeast Asia*. Translated by Rolf W. Giebel. Studies in Asian Art and Archaeology, vol. XIX. Leiden, New York, Cologne: E. J. Brill, 1996.

Chin Youdi. "Kruang pradap sian." In *Chittrakam lae sinlapawatthu nai kru phraprang wat ratchaburana changwat phranakhon si ayutthaya*, 54–59. Bangkok: Fine Arts Department, 1958.

Chirapravati, Pattaratorn, M.L. "Buddhist Votive Tablets and Amulets from Thailand." In *Art from Thailand*, edited by Robert L. Brown, 79–92. Mumbai: Marg, 1999.

Chirapravati, Pattaratorn, M.L. "Gold Deposits in the Main Tower of Wat Ratchaburana, Ayutthaya." In *Suvarnadvipa, Land of Gold: Studies on Gold in Early Southeast Asia*, edited by John Guy. Forthcoming.

Chirapravati, Pattaratorn, M.L. *Votive Tablets in Thailand: Origins, Styles, and Uses*. Images of Asia series. Kuala Lumpur and New York: Oxford University Press, 1997.

Chirasak Dechawongya. *Phrachedi muang chiang saen*. Chiang Mai: Suriwong Buk Sentoe, 1996.

Chiratsa Khachachiwa. *Phra phikkhanet: Khati khwamchua lae rupbaep khong phra phikkhanet thi phop nai phrathet thai*. Bangkok: Fine Arts Department, 1988.

Chittrakam faphanang sakun chang nonthaburi / Murals of Nondburi School. Bangkok: Faculty of Painting and Sculpture, Silpakorn University, 1963.

Chittrakam lae sinlapawatthu nai kru phraprang wat ratchaburana changwat phranakhon si ayutthaya. Bangkok: Fine Arts Department, 1958.

Chittrakam samai ayutthaya chak samut khoi / Khoi manuscript paintings of the Ayutthaya period. Bangkok: Muang Boran, 1985.

Choisy, François-Timoléon, Abbé de. *Journal of a Voyage to Siam, 1685–1686*. Translated by Michael Smithies. Kuala Lumpur: Oxford University Press, 1993.

Chotmaihet rawang ratchathut langka lae sayam khrang krung si ayutthaya. Bangkok: Rongphim Sophon Phiphatthanakon, 1930.

Chronicle of the Kingdom of Ayutthaya: The British Museum Version, Preserved in the British Library. Bibliotheca Codicum Asiaticorum 14. Tokyo: The Centre for East Asian Cultural Studies for Unesco, The Toyo Bunko, 1999.

Coedès, George. *Bronzes khmers*. Ars Asiatica, no. 5. Paris and Brussels: G. van Oest, 1923.

Coedès, George. *Les Collections archéologiques du Musée National de Bangkok*. Ars Asiatica, no. 12. Paris and Brussels: G. van Oest, 1928.

Coedès, George. "Note sur une statue de princesse Siamoise de l'époque d'Ayudhya." *Journal of the Siam Society* 16, no. 1 (1922): 36–38.

Coedès, George and Charles Archaimbault, trans. *Les Trois Mondes (Traibhumi Brah Rvan)*. Publications de l'École Française d'Extrême-Orient, vol. 89. Paris: École Française d'Extrême-Orient, 1973.

Collins, Steven. *Nirvana and Other Buddhist Felicities*. Cambridge Studies in Religious Traditions 12. Cambridge, New York, and Melbourne: Cambridge University Press, 1998.

Coutre, Jacques de. *Aziatische Omzwervingen: Het levensverhaal van Jaques de Coutre, een Brugs diamanthandelaar, 1591–1627*. Edited by Johan Verberckmoes and Eddy Stols. Antwerp: EPO, 1988.

Crawfurd, John. *Journal of an Embassy from the Governor-General of India to the Courts of Siam and Cochin China Exhibiting a View of the Actual State of Those Kingdoms*, 1828. Reprint, New Delhi, Madras: Asian Educational Services, 2000.

Cummings, Joe. *Buddhist Stupas in Asia: The Shape of Perfection*. Melbourne, Oakland, London, Paris: Lonely Planet Publications, 2001.

Cushman, Richard D., trans. *The Royal Chronicles of Ayutthaya*. Edited by David K. Wyatt. Bangkok: The Siam Society, 2000.

Dalsheimer, Nadine. *Les Collections du musée national de Phnom Penh: L'Art du Cambodge ancient*. Paris: École Française d'Extrême-Orient and Magellan, 2001.

Damrong Rajanubhab, Prince. *Tamnan phutthachedi Sayam*. Bangkok: Sophon Phiphatthanakon, 1926.

Dehejia, Vidya. *The Sensuous and the Sacred: Chola Bronzes from South India*. New York: American Federation of Art; Seattle: University of Washington Press, 2002.

Descriptions of Old Siam. Compiled and introduced by Michael Smithies. Kuala Lumpur: Oxford University Press, 1995.

Dhani Nivat, Prince. "The Old Siamese Conception of the Monarchy." In *Collected Articles by H. H. Prince Dhani Nivat Reprinted from the Journal of the Siam Society*, 90–104. Bangkok: The Siam Society, 1969.

Dhani Nivat, Prince. "The Reconstruction of Rama I of the Chakri Dynasty." In *Collected Articles by H. H. Prince Dhani Nivat Reprinted from the Journal of the Siam Society*, 144–168. Bangkok: The Siam Society, 1969.

Dhiravat na Pombejra. "Ayutthaya at the End of the Seventeenth Century: Was There a Shift to Isolation?" In *Southeast Asia in the Early Modern Era: Trade, Power, and Belief*, edited by Anthony Reid, 250–272. Ithaca and London: Cornell University Press, 1993.

Dhiravat na Pombejra. *Court, Company, and Campong*. Bangkok: Ayutthaya Historical Study Centre, 1992.

Dhiravat na Pombejra. "A Political History of Siam under the Prasatthong Dynasty, 1629–1688." Ph.D. diss., University of London, 1984.

Dhiravat na Pombejra. "Princes, Pretenders, and the Chinese Phrakhlang: An Analysis of the Dutch Evidence Concerning Siamese Court Politics, 1699–1734." In *On the Eighteenth Century as a Category of Asian History: Van Leur in Retrospect*, edited by Leonard Blussé and Femme Gaastra, 106–130. Aldershot: Ashgate, 1998.

Dhiravat na Pombejra. *Siamese Court Life in the Seventeenth Century as Depicted in European Sources*. Faculty of Arts Chulalongkorn University International Series, no. 1. Bangkok: Chulalongkorn University, 2001.

Dhiravat na Pombejra. "Towards a History of Seventeenth-Century Phuket." In *Recalling Local Pasts: Autonomous History in Southeast Asia*, edited by Sunait Chutintaranond and Chris Baker, 89–126. Chiang Mai: Silkworm, 2002.

Dhiravat na Pombejra. "VOC Employees and their Relationships with Mon and Siamese Women: A Case Study of Osoet Pegua." In *Other Pasts: Women, Gender and History in Early Modern Southeast Asia*, edited by Barbara Watson Andaya, 195–214 and 310–313. Honolulu: Center for Southeast Asian Studies, University of Hawai'i at Manoa, 2000.

Dialogues of the Buddha. Translation of the *Digha Nikaya* by T.W. and C.A.F. Rhys Davids. Pt. 2, 1910. Reprint, London: Pali Text Society, 1977.

The Diary of Kosa Pan: Thai Ambassador to France, June–July 1686. Edited by Dirk van der Crysse and Michael Smithies, translated by Visudh Busyakul. Chiang Mai: Silkworm, 2002.

Donneau de Visé, Jean. *Voyage des Ambassadeurs de Siam en France*. 4 vols. Paris, 1686.

Duncan, James S. *The City as Text: The Politics of Landscape Interpretation in the Kandyan Kingdom*, Cambridge Human Geography. Cambridge: Cambridge University Press, 1990.

Fickle, Dorothy H. "Crowned Buddha Images in Southeast Asia." In *Sinlapa lae Borannakhadi nai prathet thai / Art and Archaeology in Thailand*, vol. 1, 85–119. Bangkok: Fine Arts Department in commemoration of the 100th anniversary of the National Museum, 1974.

Fickle, Dorothy H. *The Life of the Buddha Murals in the Buddhaisawan Chapel*. Bangkok: Fine Arts Department, 1972.

Filliozat, Jean. "Kailasaparampara." In *Felicitation Volumes of Southeast-Asian Studies: Presented to His Highness Prince Dhaninivat Kromamun Gidyalabh Bridhyakorn on the Occasion of His Eightieth Birthday*, vol. 2, 241–247. Bangkok: Siam Society, 1965.

Finot, Louis. "Recherches sur la literature laotienne." *Bulletin de l'École Française d'Extrême-Orient* 17, no. 5 (1917).

Flores, Maria da Conceição. "Portuguese Relationships with Siam in the Sixteenth and Seventeenth Centuries." In *Proceedings of the International Colloquium on the Portuguese and the Pacific: University of California, Santa Barbara, October 1993*, edited by Francis A. Dutra and João Camilo dos Santos, 64–76. Santa Barbara, Calif.: Center for Portuguese Studies, University of California, Santa Barbara, 1995.

Fontein, Jan. *Bouddhas du Siam. Trésors du Royaume de Thaïlande*. Brussels: Musées royaux d'art et d'histoire, 1996.

Fontein, Jan. *The Sculpture of Indonesia*. Washington, D.C.: National Gallery of Art and New York: Harry N. Abrams, 1990.

Forbin, Comte Claude de. *The Siamese Memoirs of Count Claude de Forbin, 1685–1688*. Introduced and edited by Michael Smithies. Chiang Mai: Silkworm, 1997.

Forest, Alain. "L'Asie du sud-est continentale vue de la mer." In *Commerce et Navigation en Asie du Sud-Est (XIVe–XIXe siècle): Trade and Navigation in Southeast Asia (14th-19th centuries)*, edited by Nguyên Thê Anh and Yoshiaki Ishizawa, 7–29. Tokyo: Sophia University and Montreal, Paris: L'Harmattan, 1999.

Fournereau, Lucien. *Le Siam ancien*. 2 vols. Annales du Musée Guimet, vol. 27 and 31. Paris: Ministère de l'instruction publique, 1895–1908.

Freeman, Michael, and Claude Jacques. *Ancient Angkor*. River Books Guides. Bangkok: Asia Books, 1999.

Gascoigne, Bamber. *The Great Moghuls*. London: Jonathan Cape, 1971.

Geiger, Wilhelm. *Culture of Ceylon in Mediaeval Times*. Wiesbaden: Otto Harrassowitz, 1960.

Geiger, Wilhelm, ed. *The Mahavamsa*. 1912. Reprint, Oxford: Published for the Pali Text Society by Luzac.

Gervaise, Nicolas. *The Natural and Political History of the Kingdom of Siam*. Translated and edited by John Villiers. Bangkok: White Lotus, 1989.

Ginsburg, Henry. *Thai Art and Culture: Historic Manuscripts from Western Collections*. London: The British Library, 2000.

Ginsburg, Henry. *Thai Manuscript Painting*. Honolulu: University of Hawaii Press, 1989.

Giteau, Madeleine. *Le Bornage rituel des temples bouddhiques au Cambodge*. Publications de l'École Française d'Extrême-Orient, vol. 68. Paris: École Française d'Extrême-Orient, 1969.

Giteau, Madeleine. *Iconographie du Cambodge post-angkorien*. Publications de l École Française d Extrême-Orient, vol. 100. Paris: École Française d Extrême-Orient, 1975.

Giteau, Madeleine, and Danielle Guimet. *Khmer Art. The Civilization of Angkor*. Paris: ASA Editions / Somogy Editions d'Art, 1997.

Gittinger, Mattiebelle. *Master Dyers to the World: Technique and Trade in Early Indian Dyed Cotton Textiles*. Washington, D.C.: The Textile Museum, 1982.

Gittinger, Mattiebelle, and H. Leedom Lefferts, Jr. *Textiles and the Thai Experience in Southeast Asia*. Washington, D.C.: The Textile Museum, 1992.

Gommans, Jos, and Jacques Leider, ed. *The Maritime Frontier of Burma: Exploring Political, Cultural and Commercial Interaction in the Indian Ocean World, 1200–1800*. Verhandelinge, Afd. Letterkunde, n.s., vol. 185. Amsterdam: Koninklijke Nederlandse Akademie van Wetenschappen; Leiden: KITLV Press, 2002.

Gosling, Betty. *A Chronology of Religious Architecture at Sukhothai: Late Thirteenth to Early Fifteenth Century*. Association for Asian Studies Monograph and Occasional Paper Series, no. 52. Ann Arbor, 1996.

Gosling, Betty. *Sukhothai: Its History, Culture, and Art*. Singapore: Oxford University Press, 1991.

Green, Alexandra, and T. Richard Blurton, ed. *Burma: Art and Archaeology*. London: The British Museum, 2002, distributed in U.S. by Art Media Resources.

Griswold, Alexander B. *Dated Buddha Images of Northern Siam*. Artibus Asiae, Supplementum 16. Ascona: Artibus Asiae, 1957.

Griswold, Alexander B. "History of Art and Architecture in Siam." In *The Arts of Thailand*, edited by Theodore Bowie, 25–165. Bloomington, Ind.: Indiana University, 1960.

Griswold, Alexander B. "Medieval Siamese Images in the Bo Tree Monastery." *Artibus Asiae* 18 (1955): 46–50.

Griswold, Alexander B. "Notes on the Art of Siam, 2: An Eighteenth-century Ivory Cetiya." *Artibus Asiae* 23 (1960): 6–11.

Griswold, Alexander B. "Notes on the Art of Siam, 5: The Conversion of Jambupati." *Artibus Asiae* 24 (1961): 295–298.

Griswold, Alexander B. "Notes on the Art of Siam, 6: Prince Yudhisthira." *Artibus Asiae* 26 (1963): 215–229.

Griswold, Alexander B. "Notes on the Art of Siam, 7: An Eighteenth-Century Monastery, Its Colossal Statue, and Its Benefactors." *Artibus Asiae* 35 (1973): 179–224.

Griswold, Alexander B. *Towards a History of Sukhodaya Art*. 2nd ed. Bangkok: Fine Arts Department, 1968.

Griswold, Alexander B., and Prasert na Nagara. "Devices and Expedients: Vat Pa Mok, 1727 A.D." In *In Memoriam Phya Anuman Rajadhon*, edited by Tej Bunnag and Michael Smithies, 147–220. Bangkok: The Siam Society, 1970.

Griswold, Alexander B., and Prasert na Nagara. "Epigraphic and Historical Studies, no. 14: Inscription of the Śiva of Kamben Bejra." *Journal of the Siam Society* 62, pt. 2 (July 1974): 223–238.

Griswold, Alexander B., and Prasert na Nagara. "Epigraphic and Historical Studies, no. 24: An Inscription of 1563 A.D. Regarding a Treaty Between Laos and Ayodhya in 1560." *Journal of the Siam Society* 67, pt. 2 (July 1979): 54–69.

Griswold, Alexander B., and Prasert na Nagara. "A Fifteenth-Century Siamese Historical Poem." In *Southeast Asian History and Historiography: Essays Presented to D. G. E. Hall*, edited by C. D. Cowan and O. W. Wolters, 123–163. Ithaca and London: Cornell University Press, 1976.

Griswold, Alexander B., and Prasert na Nagara. "A Pali Inscription from Vat Sriratnamahadhatu, Subarnapuri." In *Sinlapa lae borannakhadi nai prathet thai / Art and Archaeology in Thailand*, vol. 1, 1–6. Bangkok: Fine Arts Department in commemoration of the 100th anniversary of the National Museum, 1974.

Guesdon, Joseph. *Dictionnaire cambodgien-français*. 2 vols. Paris: Les Petits-fils de Plon et Nourrit, 1930.

Guillon, Emmanuel. *The Mons: A Civilization of Southeast Asia*. Edited and translated by James V. Di Crocco. Bangkok: The Siam Society, 1999.

Guo li gu gong bo wu yuan. *Qianlong huang di de wen hua da ye / Emperor Ch'ien-lung's grand cultural enterprise*. Taibei: Guo li gu gong bo wu yuan, 2002.

Gutman, Pamela. *Burma's Lost Kingdoms: Splendours of Arakan*. Trumbull, Conn.: Weatherhill / Bangkok: Orchid Press, 2001.

Gutman, Pamela. "Vishnu in Burma." In *The Art of Burma: New Studies*, edited by Donald M. Stadtner, 29–36. Mumbai: Marg Publications, 1999.

Guy, John. *Woven Cargoes: Indian Textiles in the East*. London: Thames and Hudson, 1998.

Hardy, Robert Spence. *A Manual of Buddhism, in its Modern Development*. Chowkhamba Sanskrit Series, vol. 56. Varanasi: Chowkhamba Sanskrit Series Office, 1967.

He Ping. "Yunnanese in Thailand: Past and Present." *Journal of the Siam Society* 89, pts. 1–2 (2001): 40–45.

Heecq, Gijsbert. "Derde Voyagie van Gijsbert Heecq Naer Oost-Indijen." Edited by S.P. l'Honor Naber. *Marineblad* 25 (1910–1911): 422–450.

Herbert, Patricia M. *The Life of the Buddha*. London: British Library, 1993.

Hill, Ann Maxwell. *Merchants and Migrants: Ethnicity and Trade among Yunnanese Chinese in Southeast Asia*. Monograph 47 / Yale Southeast Asia Studies. New Haven, Conn.: Yale University Southeast Asia Studies, 1998.

Holt, John Clifford. *The Religious World of Kirti Sri: Buddhism, Art, and Politics in Late Medieval Sri Lanka*. New York and Oxford: Oxford University Press, 1996.

Hong Kong Museum of Art. *Sculptures from Thailand*. Hong Kong: Urban Council, 1982.

Hoskin, John. *Buddha Images in the Grand Palace*. Bangkok: Office of His Majesty's Principal Private Secretary, 1994.

Huntington, Susan Lubin. *The Pala-Sena Schools of Sculpture*. Leiden: E. J. Brill, 1984.

Hutchinson, E. W. *Adventurers in Siam in the Seventeenth Century*. London: Royal Asiatic Society, 1940.

Ishii, Yoneo, ed. *The Junk Trade from Southeast Asia: Translations from the Tosen Fusetsu-gaki, 1674–1723*. Singapore: Institute of Southeast Asian Studies, 1998.

Ishii, Yoneo. "Religious Patterns and Economic Change in Siam in the Sixteenth and Seventeenth Centuries." In *Southeast Asia in the Early Modern Era: Trade, Power, and Belief*, edited by Anthony Reid, 180–194. Ithaca and London: Cornell University Press, 1993.

Ishii, Yoneo. "Seventeenth Century Japanese Documents about Siam." *Journal of the Siam Society* 59, pt. 2 (July 1971): 161–174.

Ishii, Yoneo, and Toshiharu Yoshikawa. *Khwam samphan thai-yipun 600 pi.* Bangkok: Thammasat University, 1987.

Iyanaga, Nobumi. "Récits de la soumission de Maheśvara par Trailokyavijaya–d'après les sources chinoises et japonaises." In *Tantric and Taoist Studies in Honour of R. A. Stein.* Edited by Michael Strickmann, vol. 3, 633–745. Brussels: Institut Belge des Hautes Études Chinoises, 1985.

Jacob, Judith M. *The Traditional Literature of Cambodia: A Preliminary Guide.* London Oriental Series, vol. 40. Oxford: Oxford University Press, 1996.

Jacob, Judith M., trans. with the assistance of Kuoch Haksrea. *Reamker (Ramakerti): The Cambodian Version of the Ramayana.* Oriental Translation Fund, n.s., vol. 45. London: Royal Asiatic Society, 1986.

Jacq-Hergoualc'h, Michael. "À propos de dessins de Charles le Brun liés à la venue d'ambassadeurs Siamois à Paris en 1686." *Journal of the Siam Society* 78, pt. 2 (1990): 30–35.

Jacq-Hergoualc'h, Michael. *L'Europe et le Siam du XVIe au XVIIIe siècle: Apports culturels.* Paris: L'Harmattan, 1993.

Jacques, Claude. *Angkor: Cities and Temples.* Translated by Tom White. Bangkok: River Books, 1997; distributed in the U.S. by Weatherhill.

Jessup, Helen Ibbitson, and Thierry Zephir, ed. *Sculpture of Angkor and Ancient Cambodia: Millennium of Glory.* Washington, D.C.: National Gallery of Art, 1997.

Julathusana Byachrananda (Chunlathat Phayakharanon). *Thai Mother-of-Pearl Inlay.* Bangkok: River Books, 2001.

Julispong Chularatana. *Khunnang krom tha khwa: Kan suksa botbat lae nathi nai samai ayutthaya thung ratanakosin ph. s. 2153–2435.* Bangkok: Chulalongkorn University, 2003.

Kaempfer, Engelbert. *A Description of the Kingdom of Siam, 1690.* Translated by J. G. Scheuchzer, 3 vols., 1727. Reprint, Glasgow: J. MacLehose and Sons; New York: Macmillan, 1906.

Kanita Lekhakula, Khunying, ed. *Ayutthaya: A World Heritage.* Bangkok: Tourism Authority of Thailand, 2000.

Kemp, Jeremy. *Aspects of Siamese Kingship in the Seventeenth Century.* Bangkok: Social Science Review, Social Science Association Press of Thailand, 1969.

Khaisri Sri-Aroon. *Les statues du Buddha de la galerie de Phra Pathom Chedi, Nakhon Pathom, Thailande / Phraphuttharup thi rabiang rop ong phra-pathommachedi.* Bangkok: Prince of Songkhla University, 1996.

Khamhaikan chao krungkao; khamhaikan khunluang hawat; lae phraratcha-phongsawadan krungkao, chabap luang prasoetaksonnit. Bangkok: Khlangwitthaya, 1972.

Khongdet Praphanthong. "Thewasathan doem thi changwat phranakhon si ayutthaya nai dan prawattisat." *Borannakhadi* 3, no. 2 (1969): 10–25.

King, Donald. *Imperial Ottoman Textiles.* London: Colnaghi, 1980.

Kingkeo Attagara. *The Folk Religion of Ban Nai: A Hamlet in Central Thailand.* Bangkok: Kurusapha Press, 1968.

Kinney, Ann R. *Worshiping Śiva and Buddha: The Temple Art of East Java.* Hololulu: University of Hawai'i Press, 2003.

Klimburg-Salter, Deborah E. *The Silk Route and The Diamond Path: Esoteric Buddhist Art on the Trans-Himalayan Trade Routes.* Los Angeles: Published under the sponsorship of the UCLA Art Council, 1982.

Kongkaeo Wiraprachak. *Tu lai thong / Thai Lacquer and Gilt Bookcases: Part One (Ayudhya and Dhonburi Periods).* Bangkok: National Library; Fine Arts Department, 1980.

Kongkaeo Wiraprachak. *Tu lai thong / Thai Lacquer and Gilt Bookcases: Part Two, Volume III (Bangkok Period BKK. 191–285).* Bangkok: National Library; Fine Arts Department, 1988.

Kramrisch, Stella. *Manifestations of Shiva.* Philadelphia: Philadelphia Museum of Art, 1981.

Kru mahasombat phraprang wat ratchaburana, changwat phra nakhon si ayutthaya. Bangkok: Rongphim Kanphim Phanit, 1959.

La Loubère, Simon de. *A New Historical Relation of the Kingdom of Siam, 1693.* Translated by A.P. Reprint, Kuala Lumpur: Oxford University Press, 1969.

Launay, Adrien. *Histoire de la mission de Siam, 1662–1811.* 3 vols. Paris: Anciennes Maisons Charles Douniol et Retaux, 1920.

Le Bonheur, Albert, ed. *Phra Narai roi de Siam et Louis XIV.* Paris: Musée Guimet, 1986.

Lee, Sherman E. *Ancient Cambodian Sculpture.* New York: Asia Society, 1969.

Lerner, Martin. *The Flame and the Lotus: Indian and Southeast Asian Art from The Kronos Collections.* New York: Metropolitan Museum of Art and Harry N. Abrams, 1985.

Lieberman, Victor B. *Burmese Administrative Cycles: Anarchy and Conquest, c. 1580–1760.* Princeton: Princeton University Press, 1984.

Lieberman, Victor B. *Strange Parallels: Southeast Asia in Global Context, c. 800–1830.* Vol. 1, *Integration on the Mainland.* Cambridge: Cambridge University Press, 2003.

Listopad, John A. *The Art and Architecture of the Reign of Somdet Phra Narai.* 2 vols. Ann Arbor, Mich.: University Microfilms, 1995.

Listopad, John A. "Early Thai Sculpture Reappraised: Thirteenth–Sixteenth Century." In *Art from Thailand,* edited by Robert L. Brown, 49–64. Mumbai: Marg, 1999.

Lo, Kai-yin, and Puay-peng Ho, ed. *Living Heritage: Vernacular Environment in China / Gu cheng jin xi: Zhongguo min jian sheng huo fang shi.* Hong Kong: Yong ming tang, 1999.

Love, Ronald S. "Rituals of Majesty: France, Siam, and Court Spectacle in Royal Image-Building at Versailles in 1685 and 1686." *Canadian Journal of History* 31 (August 1996): 171–198.

Luang Boribal Buribhand. *The Buddha's Footprint in Saraburi Province.* Translated by Luang Suriyabongs. Bangkok: Chetanadhara Chakrabandhu, 1955.

Mahathat. Bangkok: Chulalongkorn University, 1991.

Manat Ophakun. *Phra kru muang suphan.* Bangkok: Sinlapa Bannakhan, 1969.

Manit Wanliphodom, et al. *Sinlapa samai uthong; sinlapa samai ayutthaya; sinlapa samai rattanakosin.* Bangkok: Fine Arts Department, 1967.

Manop Thaworawatsakun. *Khunnang ayutthaya.* Bangkok: Thammasat University, 1993.

Marcinkowski, Muhammad Ismail. "Persian Religious and Cultural Influences in Siam/Thailand and Maritime Southeast Asia in Historical Perspective: A Plea for a Concerted Interdisciplinary Approach." *Journal of the Siam Society* 88, pts. 1–2 (2000): 186–194.

Matics, Kathleen Isabelle. "An Historical Analysis of the Fine Arts at Wat Phra Chetuphon, a Repository of Ratanakosin Artistic Heritage." Ph.D. diss., New York University, 1978.

Matics, Kathleen Isabelle. *A History of Wat Phra Chetuphon and Its Buddha Images.* Bangkok: The Siam Society, 1979.

Maumené, Ch., and Louis d'Harcourt. *Iconographie des Rois de France.* Vol. 2, *Louis XIV, Louis XV, Louis XVI.* Archives de l'art Français, n.s., vol. 16. Paris: Librairie Armand Colin, 1931.

McGill, Forrest. *The Art and Architecture of the Reign of King Prasatthong of Ayutthaya (1629–1656).* 2 vols. Ann Arbor, Mich.: University Microfilms, 1977.

McGill, Forrest. "Jatakas, Universal Monarchs, and the Year 2000." *Artibus Asiae* 53 (1993): 412–448.

McGill, Forrest. "Painting the 'Great Life.'" In *Sacred Biography in the Buddhist Traditions of South and Southeast Asia,* edited by Julian Schober, 195–217. Honolulu: University of Hawai'i Press, 1997.

McGill, Forrest and M.L. Pattaratorn Chirapravati. "Thai Art of the Bangkok Period at the Asian Art Museum." *Orientations* 34, no. 1 (Jan. 2003): 28–34.

McQuail, Lisa. *Treasures of Two Nations: Thai Royal Gifts to the United States of America.* Washington, D.C.: Smithsonian Institution, Asian Cultural History Program, 1997.

Miksic, John. *Borobudur: Golden Tales of the Buddhas.* Boston: Shambhala, 1990.

Mongkol Samransuk. "Phithikam lae khwamchua kieo kap phra khanet nai patchuban." In Somchai na Nakhonphanom et al., *Phra khanet thepphachao haeng sinlapa witthaya,* 25–29. Bangkok: National Museum, 2002.

Moore, Elizabeth, Philip Stott, and Suriyavudh Sukhasvasti. *Ancient Capitals of Thailand.* London: Thames and Hudson, 1996.

Muhammad Rabi ibn Muhammad Ibrahim. *The Ship of Sulaimān.* Translated by John O'Kane. Persian Heritage Series, no. 11. London: Routledge & Kegan Paul, 1972.

Mus, Paul. "Angkor in the Time of Jayavarman VII." *Indian Art and Letters,* n.s., 11 (1937): 65–75.

Mya, Thiripyanchi U. "The Origin of the Jambupati Image." In *Report of the Director, Archaeological Survey Burma for the Year Ending 30th September 1959,* 28–37. Rangoon, Burma, 1960. Privately circulated English translation by K.J. Whitbread.

Naengnoi Panchaphan, and Somchai na Nakhonphanom. *The Art of Thai Wood Carving: Sukhothai, Ayutthaya, Ratanakosin.* Bangkok: Rerngrom, 1992.

Naengnoi Suksri. *The Grand Palace.* River Books Guides. Bangkok: River Books, 1998.

Namchom krung rattanakosin. Bangkok: Fine Arts Department, 1982.

Namchom phiphitthaphan sathan haeng chat chao sam phraya. Bangkok: Fine Arts Department, 2000.

Namchom phiphitthaphan sathan haeng chat sawankhaworanayok. Bangkok: Fine Arts Department, 1984.

Nang yai: Chut phra nakhon wai. Bangkok: Muang Boran, 1983.

Napat Sirisambhand and Alec Gordon. "Thai Women in Late Ayutthaya Style Paintings." *Journal of the Siam Society* 81, pts. 1–2 (1999): 1–16.

Natthapatra Chandavij, and Saengchan Traikasem, ed. *Visitors Guide to the Nakhon Si Thammarat National Museum.* 2nd ed. Bangkok: Fine Arts Department, 2000.

Natthaphat Chanthawit. *Rua phraratchaphithi / Royal Barges.* Bangkok: Fine Arts Department, 1996.

Neijenrode, Cornelis van. "Vertoog van de gelegenheid des koningrijks van Siam." *Kroniek van het Historisch Genootschap Gevestigd te Utrecht* 27 (1871): 279–318.

Nidhi Aeusrivongse. *Kanmuang thai samai phra narai.* Bangkok: Thai Khadi Institute, Thammasat University, 1984.

No. Na Paknam. "Art of Funan and Chenla." *Muang Boran* 3, no. 1 (October–December 1976): 23–32 and 49–56.

No. Na Pakam. *Chittrakam ayutthaya.* Bangkok: Muang Boran, 2000.

No. Na Paknam. *Chittrakam samai ayutthaya ton klang lae ton plai raya raek: Sakun chang nonthaburi na wat chomphuwek lae wat prasat / Mural Paintings of the Middle and Late Ayutthaya periods, Nonthaburi School at Wat Chompuweg and Wat Prasat.* Bangkok: Muang Boran, 1987.

No. Na Paknam. *Farang nai sinlapa thai.* Bangkok: Muang Boran, 1986.

No. Na Paknam. *Ha duan klang sak it pun thi ayutthaya.* Bangkok: Muang Boran, 1986.

No. Na Paknam. *Khwampenma khong sathup chedi nai sayam prathet.* Bangkok: Muang Boran, 1986.

No. Na Paknam. *Lai punpan: Matthanasin an loet haeng sayam.* Bangkok: Muang Boran, 1989.

No. Na Paknam. "Masterpieces of Mon Art." *Muang Boran* 10, no. 3 (July–September 1984): 2 and 29–36.

No. Na Paknam. *Ngan chamlak mai: Sinlapa lae sathapattayakam thai.* Bangkok: Muang Boran, 1994.

No. Na Paknam. *Samutphap prawattisat sinlapa sayam prathet: Sinlapa kon krung si ayutthaya.* Bangkok: Muang Boran, 1998.

No. Na Paknam. *Samutphap prawattisat sinlapa sayam prathet: Sinlapa samai krung si ayutthaya.* Bangkok: Muang Boran, 2000.

No. Na Paknam. *Sinlapa bon bai sema / The Buddhist Boundary Markers of Thailand.* Bangkok: Muang Boran, 1981.

No. Na Paknam. *Thammat: Sak lae si haeng sinlapa thai.* Pakinnaka sinlapa thai nai saita, vol. 3. Bangkok: Muang Boran, 2000.

No. Na Paknam. *Wat ko kaeo suttharam.* Mural Paintings of Thailand Series No. 2. Bangkok: Muang Boran, 1986.

No. Na Paknam. *Wat pradu song tham.* Mural Paintings of Thailand Series No. 2. Bangkok: Muang Boran, 1985.

No. Na Paknam. *Wiwatthanakan lai thai / Evolution of Thai Ornament.* 1st ed. (In Thai and English). Bangkok: Muang Boran, 1981.

No. Na Paknam. *Wiwatthanakan lai thai.* Rev. ed. (Thai only). Bangkok: Muang Boran, 1986.

Notton, Camille. *Legendes sur le Siam et le Cambodge.* Bangkok: L'Assomption, 1939.

Nou, Jean Louis and Louis Frédéric. *Borobudur.* New York: Abbeville Press, 1996.

O'Connor, Stanley J., Jr. *Hindu Gods of Peninsular Siam.* Ascona: Artibus Asiae, 1972.

Olsson, Ray A., trans. *The Ramakien: A Prose Translation of the Thai Ramayana.* Bangkok: Preapittaya Co., 1968.

Pal, Pratapaditya. *Art from the Indian Subcontinent.* Asian Art at the Norton Simon Museum, vol. 1. New Haven, Conn.: Yale University Press; Pasadena: Norton Simon Art Foundation, 2003.

Paludan, Ann. *The Imperial Ming Tombs.* New Haven and London: Yale University Press, 1981.

Paramanuchit Chinorot, Prince. *Petite chronique d'Ayutthaya: Ancien royaume de Siam (1350–1767).* Translated by Jean Claude Brodbeck. Bangkok: Chalermnit, 1974.

Paramanuchit Chinorot, Prince. *Phrapathomsomphothikatha.* Bangkok: Department of Religious Affairs, 1962.

Pattaratorn Chirapravati: See Chirapravati, Pattaratorn.

Penth, Hans. *Khamcharuk thi than phraphuttharup nai nakhon chiang mai.* Bangkok: Office of the Prime Minister, 1976.

Phiset Chiachanphong. "Phraphuttharup pang parinipphan kap phraphuttha saiyat." *Silpakorn Journal* 46, no. 3 (May–June 2003): 106–114.

"Phongsawadan nua." In *Prachum phongsawadan,* vol. 1. Bangkok: Khurusapha, 1963.

Phonnarat, Somdet Phra. *Phraratchaphongsawadan krung si ayutthaya: chabap somdet phra phonnarat wat phrachettuphon.* 5th ed. Bangkok: Bannakhan Publishing, 1972.

Photchananukrom sathapattayakam lae sinlapa kieo nuang. Compiled by Chot Kanlayanamit. Bangkok Kanfaifa Fai Phalit, 1975.

Phothirangsi. *Nithan phra phutthasihing: Waduai tamnan phra phutthasihing.* Edited and translated by Saeng Monwithun. Bangkok: Fine Arts Department, 1963.

Phra khanet theppachao haeng sinlapa witthaya / Ganesha: God of Arts. Bangkok: Fine Arts Department, 2002.

Phraphutthapatima nai phraborommamaharatchawang. Bangkok: Samnak Ratchalekhathikan, 1992.

Phraphuttharup lae phraphim nai kru phraprang wat ratchaburana changwat phra nakhon si ayutthaya. Bangkok: Fine Arts Department, 1959.

Phraratchaphongsawadan chabap phraratchahatthalekha. Bangkok: Borisat Tang Thong Huat, 1968.

Phraratchaphongsawadan krung si ayutthaya chabap phan chanthanumat (choem). In *Prachum phongsawadan.* Bangkok: Khurusapha, 1969.

Phraratchaphongsawadan krung si ayutthaya chabap phan chanthanumat (choem) kap phra chakkraphatdiphong (chat). Bangkok: Khlang Witthaya, 1964.

Phraratchawang lae wat boran nai changwat phra nakhon si ayutthaya. Bangkok: Fine Arts Department, 1968.

Phuthorn Bhumadhorn. "Pièces remarquables de l'art mobilier religieux au temps du roi Narai." In *Phra Narai roi de Siam et Louis XIV,* 67–68. Paris: Musée Guimet, 1986.

Pictorial Guide to Pagan. Rangoon, Burma: Printing and Publishing Corporation, 1979.

Pieris, P. E., trans. "An Account of King Kirti Sri's Embassy to Siam in 1672 Saka (1750 A.D.)." *Journal of the Royal Asiatic Society, Ceylon Branch* 18, 54 (1903): 17–44.

Piriya Krairiksh. *Baep sinlapa nai prathet thai / Art Styles in Thailand: A Selection from National Provincial Museums.* Bangkok: Fine Arts Department, 1977.

Piriya Krairiksh. *Das heilige Bildnis: Skulpturen aus Thailand / The Sacred Image: Sculptures from Thailand.* Cologne: Museen für Ostasiatische Kunst, Museen der Stadt Köln, 1979.

Piriya Krairiksh. *Prawattisat sinlapa nai prathet thai chabap khumu naksuksa.* Bangkok: Amarin Kanphim, 1985.

Piriya Krairiksh. "A Reassessment of Thai Art of the Ayutthaya Period." *Oriental Art* 53, no. 4 (Winter 1997/8): 14–22.

Piriya Krairiksh. "A Revised Dating of Ayudhya Architecture." Parts 1 and 2. *Journal of the Siam Society* 80, pt. 1 (1992): 36–55; pt. 2 (1992): 11–26.

Piriya Krairiksh. "Sculptures from Thailand." In *Sculptures from Thailand,* 16–39. Hong Kong: Urban Council, 1982.

Piriya Krairiksh. *Sinlapa sukhothai lae ayutthaya: Phap laksana thi tong plian plaeng.* Bangkok: Amarin, 2002.

Pisit Charenwongsa, and M.C. Subhadradis Diskul. *Thailand.* Archaeologia Mundi. Geneva: Nagel, 1978.

Pirya Bunnag. "Thai Traditional Gabled Doors and Windows." *Journal of the Siam Society* 83, pts. 1–2 (1995): 6–24.

Pollock, Sheldon. "The Cosmopolitan Vernacular." *Journal of Asian Studies* 56, no. 1 (February 1998): 6–37.

Prachum chotmaihet sam. i ayutthaya. Vol. 1. Bangkok: Office of the Prime Minister, 1967.

Prachum phraratchaputcha. Vol. 4, *Phraratchaputcha nai ratchakan thi 3.* Bangkok, 1922.

Prachum sila charuk. Vol. 3. Bangkok: Office of the Prime Minister, 1970.

Prachum sila charuk. Vol. 5, *Prachum sila charuk akson thai phap laisen chamlak bon phaen hin kieokap ruang chadok tang tang nai chadok ha roi chat thi pradap wai nai chedi wat sichum, sukhothai.* Bangkok: Office of the Prime Minister, 1972.

Pramot Thatsanasuwan. *Phraphuttharup lae anusawari samkhan thua prathet thai.* Bangkok: Kiat Sayam, 1982.

Prathip Phengtako. "Baep phraphak phraphuttharup hinsai samai ayutthaya." In *Ruam botkhwam thang wichakan: 72 phansa than achan satsatrachan momchao suphatthradit ditsakun / Studies and Reflections on Asian Art History and Archaeology: Essays in Honour of H.S.H. Professor Subhadradis Diskul,* 73–90. Bangkok: Silpakorn University, 1995.

Prathip Phengtako. "Sathapattayakam thi wat chaiwatthanaram." *Muang Boran* 20, no. 3 (July–September 1994): 35–54.

Prathip Phengtako. *Wat Chaiwatthanaram.* Bangkok: Fine Arts Department, 1994.

Prathum Chumphengphan, ed. *Boranwatthusathan nai phak tai ton nua ruam 7 changwat.* Bangkok: Fine Arts Department, 1974.

Prathum Chumphengphan. *Khruang thong krung si ayutthaya / Gold Treasures of the Ayutthaya Period.* Bangkok: Fine Arts Department, 1990.

Prawat wat phananchoeng. Ayutthaya, 1957.

Prawat wat phananchoeng, amphoe phra nakhon si ayutthaya (krung kao) changwat phra nakhon si ayutthaya. Bangkok: Khana Song Wat Phananchoeng, 1971.

Raben, Remco and Dhiravat na Pombejra, ed. *In the King's Trail: An 18th Century Dutch Journey to the Buddha's Footprint.* Bangkok: The Royal Netherlands Embassy, 1997.

Ratanapanna Thera. *The Sheaf of Garlands of the Epochs of the Conqueror: Being a Translation of Jinakalamalipakaranam of Ratanapanna Thera of Thailand.* Translated by N.A. Jayawickrama. Pali Text Society Translation Series, no. 36. London: Published for the Pali Text Society by Luzak, 1968.

Reid, Anthony. *Charting the Shape of Early Modern Southeast Asia.* Chiang Mai: Silkworm, 1999.

Reid, Anthony. *Southeast Asia in the Age of Commerce 1450–1680.* Vol. 1, *The Land Below the Winds.* Vol. 2, *Expansion and Crisis.* New Haven and London: Yale University Press, 1988 and 1993.

Reid, Anthony, ed. *Southeast Asia in the Early Modern Era: Trade, Power, and Belief.* Ithaca and London: Cornell University Press, 1993.

Reid, Anthony, and David Marr, eds. *Perceptions of the Past in Southeast Asia.* Asian Studies Association of Australia, Southeast Asia Publications Series, no. 4. Singapore: Heinemann Educational Books (Asia), 1979.

"The Rekidai Hoan: An Introduction to Documents of the Ryukyu Kingdom." *Kyoto Review of Southeast Asia* 3 (March 2003). Accessed from http://kyotoreview.cseas.kyoto-u.ac.jp/issue/issue2/index.html.

Reynolds, Craig J. "Buddhist Cosmology in Thai History, with Special Reference to Nineteenth-Century Culture Change." *Journal of Asian Studies,* 35, vol. 2 (February 1976): 203–220.

Reynolds, Craig J. "Religious Historical Writing and the Legitimation of the First Bangkok Reign." In *Perceptions of the Past in Southeast Asia,* edited by Anthony Reid and David Marr, 90–107. Singapore: Heinemann Educational Books (Asia), 1979.

Richter, Anne. *Jewelry of Southeast Asia.* New York: Harry N. Abrams, 2000.

Robinson, Natalie V. *Sino-Thai Ceramics in the National Museum, Bangkok, Thailand, and in Private Museums.* Bangkok: Fine Arts Department, 1982.

Rodao Garcia, Florentino. *Españoles en Siam, 1540–1939. Una aportación al estudio de la presencia hispana en Asia Oriental.* Biblioteca de historia, vol. 32. Madrid: Consejo Superior de Investigaciones Científicas, 1997.

Rogers, J.M. *Empire of the Sultans: Ottoman Art from the Khalili Collection.* Alexandria, Va.: Art Services International; London: Nour Foundation: 2000.

Roveda, Vittorio. *Khmer Mythology: Secrets of Angkor.* 4th ed. Bangkok: River Books, 2003; distributed in the U.S. and Canada by Weatherhill.

Roveda, Vittorio. *Sacred Angkor: The Carved Reliefs of Angkor Wat.* Bangkok: River Books, 2002.

Ruang kotmai tra sam duang. Bangkok: Fine Arts Department, 1978.

Ruang thao mahachomphu. Bangkok: Nai Rongkhan, 1921. Microfiche, Washington, Library of Congress, 1989.

Saeng Monwithun, "Ruang phra adithaphut" In *Chittrakam lae sinlapawatthu nai kru phraprang wat ratchaburana changwat phranakhon si ayutthaya,* 42–53. Bangkok: Fine Arts Department, 1958.

Sakamaki Shunzō. "Ryukyu and Southeast Asia." *Journal of Asian Studies* 23, no. 3 (May 1964): 383–389.

Samut khoi. Bangkok: Khrongkan Supsan Moradok Watthanatham Thai, 1999.

Samutphap sinlapakam wat yai suwannaram changwat phetburi / Art Album on Wat Yai Suwannaram, Phetchaburi. Bangkok: Office of the Prime Minister, 1982.

Samutphap traiphum buran chabap krung thonburi / Buddhist Cosmology Thonburi Version. Bangkok: Office of the Prime Minister, 1982.

Samutphap traiphum chabap krung si Ayutthaya – chabap krung thonburi. 2 vols. Bangkok: Fine Arts Department, 1999.

Samutphap wat phrachettuphonwimonmangkhalaram / Pictorial Book of Wat Phra Chetuphon. Bangkok: Fine Arts Department, 1992.

Santi Leksukhum. *Chedi phoem mum chedi yo mum samai ayutthaya / The Redented Added-angled Chedis and the Rabbeted-angled Chedis of the Ayutthaya Period.* Bangkok, 1986.

Santi Leksukhum. *Chedi rai song prasat yot wat ratchaburana, changwat phra nakhon si ayutthaya / The Subsidiary Spire-topped Prasat-type Chedi, Wat Ratchaburana, Ayutthaya.* Bangkok: Amarin Wichakan, 1998.

Santi Leksukhum. "Chedi song rakhang khong lan na, chedi song yot dok bua tum khong sukhothai, lae chedi song prang khong krung si ayutthaya ma chak nai? yangrai?" *Sinlapa Watthanatham* 11, no. 11 (September 1990): 86–92.

Santi Leksukhum. "Chedi wat phra rup, amphoe muang changwat suphan-

buri: lakthan mai thi khon phop." *Muang Boran* 17, pt. 3 (July–September 1990): 86–92.

Santi Leksukhum. "Lai krop samliam prakop chak wongkhong: Itthiphon sinlapa chin nai ratchakan somdet phra borommatrailokkanat." In *Ruam botkhwam thang wichakan: 72 phansa than achan satsatrachan momchao suphatthradit ditsakun / Studies and Reflections on Asian Art History and Archaeology: Essays in Honour of H.S.H. Professor Subhadradis Diskul,* 91–97. Bangkok: Silpakorn University, 1995.

Santi Leksukhum. "Lakthan khong adit (ching ching)." In *Lila Thai* by Santi Leksukhum, 156–161. Bangkok: Matichon, 2003.

Santi Leksukhum. *Luatlai punpan baep ayutthaya ton plai (ph.s. 2172–2310) / The Stucco Motifs of Late Ayutthaya Period (1629–1767 A.D.).* Bangkok: Jim Thompson Foundation, 1989.

Santi Leksukhum. *Prang lae lai punpan pradap wat chulamani, phitsanulok / Prang and Stucco Decorations at Wat Chulamani, Phitsanulok.* Bangkok: Silpakorn University, 1996.

Santi Leksukhum. "Prang prathan samai ayutthaya ton ton." *Muang Boran* 6, pt. 2 (December 1979–January 1980): 97–107.

Santi Leksukhum. *Sinlapa ayutthaya: Ngan changluang haeng phaendin.* Bangkok: Muang Boran, 1999.

Santi Leksukhum. *Sinlapa phak nua: Hariphumchai-lanna.* Bangkok: Muang Boran, 1995.

Santi Leksukhum. *Sinlapa sukhothai.* Bangkok: Muang Boran, 1997.

Santi Leksukhum. *Temples of Gold: Seven Centuries of Thai Buddhist Paintings.* New York: George Braziller, 2000.

Santi Leksukhum. *Wiwatthanakan khong chan pradap luatlai lae luatlai samai ayutthaya ton ton / The Evolution of Stucco Decorative Motifs of Early Ayudhya Period.* Bangkok: Amarin Kanphim, 1979.

Santi Leksukhum and Kamol Chayawatana. *Chittrakam faphanang samai ayutthaya / Mural Paintings of the Ayudhya Period.* Bangkok: Jim Thompson Foundation, 1981.

Sarasin Viraphol. *Tribute and Profit: Sino-Siamese Trade, 1652–1853.* Cambridge, Mass. and London: Harvard University Press, 1977.

Sarma, P. Neelakanta. "Un Album Thailandais d'iconographie Indienne." *Arts Asiatiques* 26 (1973): 157–189.

Satow, E.M. "Notes on the Intercourse Between Japan and Siam in the Seventeenth Century." *Transactions of the Asiatic Society of Japan* XIII (1885): 139–210.

Schroeder, Ulrich von. *Buddhist Sculptures of Sri Lanka.* Hong Kong: Visual Dharma Publications, 1990.

Sharma, Brijendra Nath. *Iconography of Sadāśiva.* New Delhi: Abhinav, 1976.

The Siam of King Narai: A Western View: Handbook of the Special Exhibition at the Lopburi National Museum in Honour of the King's Birthday, 5 December 1975. Bangkok: Department of Fine Arts, 1975.

Silpa Bhirasri. *Thai Lacquer Works.* Thai Culture, n.s., vol. 5. Bangkok: Fine Arts Department, 1969.

Sinlapakam krung rattanakosin. Sinlapa watthanatham thai, vol. 6. Bangkok: Fine Arts Department, 1982.

Sinlapawatthu krung rattanakosin. Sinlapa watthanatham thai, vol. 5. Bangkok: Fine Arts Department, 1982.

Sirinand Boonsiri, "Khrut." *Sinlapakon* 44, no. 5 (September–October 2001): 10–33.

Sivaramamurti, Calambur. *South Indian Bronzes.* Lalit Kalā Series of Indian Art, vol. 9. New Delhi: Lalit Kalā Akademi, 1963.

Skilling, Peter. "Female Renunciants (*nang chi*) in Siam: According to Early Travellers' Accounts." *Journal of the Siam Society* 83, pts. 1–2 (1995): 55–61.

Skilling, Peter, ed. *Jataka Reliefs of Wat Si Chum.* Bangkok: River Books, forthcoming.

Smith, Bardwell L., ed. *Religion and Legitimation of Power in Thailand, Laos, and Burma.* Chambersburg, Pa.: Anima Books, 1978.

Smith, George Vinal. *The Dutch East India Company in the Kingdom of Ayutthaya, 1604–1694.* Ann Arbor, Mich.: University Microfilms, 1974.

Smith, George Vinal. *The Dutch in Seventeenth-Century Thailand.* De Kalb: Center for Southeast Asian Studies, Northern Illinois University, 1977.

Smithies, Michael, ed. and trans. *The Discourses at Versailles of the First Siamese Ambassadors to France 1686–7 Together with the List of Their Presents to the Court.* Bangkok, The Siam Society, 1986.

Smithies, Michael. "Seventeenth Century Siam: Its Extent and Urban Centres According to Dutch and French Observers." *Journal of the Siam Society* 83, pts. 1–2 (1995): 63–78.

Smithies, Michael. "A Stormy Relationship: Phaulkon and Forbin, 1685 1687." *Journal of the Siam Society* 82, pt. 2 (1994): 147–154.

Smitthi Siribhadra, and Elizabeth Moore. *Palaces of the Gods: Khmer Art and Architecture in Thailand.* Bangkok: River Books, 1992.

Smitthi Siribhradra, and Mayurie Veraprasert. *Lintels: A Comparative Study of Khmer Lintels in Thailand and Cambodia / Thaplang: Kansuksa priapthiap thaplang thi phop nai prathet thai lae prathet kamphucha.* Bangkok: Fine Arts Department and Thai Commercial Bank, 1990.

Snellgrove, David L., ed. *The Image of the Buddha.* Paris and Tokyo: Kodansha/Unesco, 1978.

Somchai na Nakhonphanom, ed. *Thawaraban: Phuraksa satsanasathan.* Bangkok: Fine Arts Department, 2003.

Somdet phra narai lae phrachao lui thi 14. Bangkok: Fine Arts Department, 1986.

Somkiat Lophetcharat. *Phraphuttharup sinlapa samai ayutthaya.* Bangkok: Borisat Watthuboran, 1996.

Somphon Yupho, comp. *Phraphuttharup pang tangtang.* Bangkok: Fine Arts Department, 1971.

Stadtner, Donald M., ed. *The Art of Burma: New Studies.* Mumbai: Marg, 1999.

Stratton, Carol. *Buddhist Sculpture of Northern Thailand.* Chiang Mai: Silkworm; Chicago: Buppha Press, 2004.

Stratton, Carol, and Miriam McNair Scott. *The Art of Sukhothai: Thailand's Golden Age: From the Mid-Thirteenth to the Mid-Fifteenth Centuries.* Kuala Lumpur: Oxford University Press, 1981.

Strong, John S. *The Legend and Cult of Upagupta: Sanskrit Buddhism in North India and Southeast Asia.* Princeton, N.J.: Princeton University Press, 1992.

Stutterheim, Willem Frederik. *Tjandi Baraboedoer: Naam, Vorm en Beteekenis.* Weltevreden: G. Kolff & Co., 1929.

The Suan Pakkad Palace Collection. Bangkok: Princess Chumbhot of Nagara Svarga, 1982.

Subhadradis Diskul, M.C. *Art in Thailand: A Brief History.* 2nd rev. ed. Bangkok: Faculty of Archaeology, Silpakorn University, 1971.

Subhadradis Diskul, M.C. "Boranwatthu sung khutkhonphop thi thewasathan changwat phra nakhon si ayutthaya." *Borannakhadi* 3, no. 2 (1969): 56–65.

Subhadradis Diskul, M.C. "A Dated Crowned Buddha Image from Thailand." *Artibus Asiae* 24, nos. 3–4 (1961): 409–416 and "Corrigendum." *Artibus Asiae* 25, nos. 2–3 (1962): 198.

Subhadradis Diskul, M.C. *Hindu Gods at Sukhodaya.* Bangkok: White Lotus, 1990.

Subhadradis Diskul, M.C. *Sinlapa nai prathet thai.* 10th ed. Bangkok: Thammasat University, 1995.

Subhadradis Diskul, M.C. *Sinlapa samai lopburi.* Bangkok: Fine Arts Department, 1967.

Subhadradis Diskul, M.C. *Sinlapa sukhothai / Sukhothai Art / L'Art de Sukhothai.* Bangkok: Cultural Committee of the Thailand National Commission for UNESCO, 1979.

Sumali Sirirat. "Kananurak pratimakam: Chedi sing lom wat mae nang plum changwat phra nakhon si ayutthaya." *Muang Boran* 27, no. 4 (October–December 2001): 80–88.

Sunan Chutintaranond. "The Image of the Burmese Enemy in Thai Perceptions and Historical Writings." *Journal of the Siam Society* 80, pt. 1 (1992): 89–103.

Sunait Chutintaranond. *Khruangthong hrung si ayutthaya. Amata sin phaendin sayam. / The Immortal Art of Ayutthaya Gold.* 2nd ed. Bangkok: Plan Motif, 2003.

Sunait Chutintaranond. "'Mandala,' 'Segmentary State' and Politics of Centralization in Medieval Ayudhya." *Journal of the Siam Society* 78, pt. 1 (1990): 88–100.

Sunait Chutintaranond, and Chris Baker, ed. *Recalling Local Pasts: Autonomous History in Southeast Asia.* Chiang Mai: Silkworm, 2002.

Suraphon Damrikun. *Moradok changsin thai.* Bangkok: Khrongkan supsan moradok watthanatham thai: Chatchamnai doi ongkankha khong khurusapha, 1999.

Suthachai Yimprasert. "Portuguese Lançados in Asia in the Sixteenth and Seventeenth Centuries." Ph.D. diss., Bristol University, 1998.

Swearer, Donald K. *Becoming the Buddha: The Ritual of Image Consecration in Thailand.* Princeton, N.J.: Princeton University Press, 2004.

Tachard, Guy. *A Relation of the Voyage to Siam Performed by Six Jesuits sent by the French King, to the Indies and China in the Year 1685, 1688.* Reprint, Bangkok: White Orchid Press, 1981.

Tachard, Guy. *Second Voyage du Père Tachard et des Jesuites envoyez par le Roy au Royaume de Siam.* Paris: D. Horthemels, 1689.

Tai bijutsu ten: Nichi-Tai shūkō 100-shūnen kinen / Art Treasures of Thailand. Tokyo: Asahi Shinbunsha, 1987.

Tambiah, S.J. *Buddhism and the Spirit Cults in North-east Thailand.* Cambridge Studies in Social Anthropology, no. 2. Cambridge: Cambridge University Press, 1970.

Tambiah, S.J. *World Conqueror and World Renouncer: A Study of Buddhism*

and Polity in Thailand against a Historical Background. Cambridge: Cambridge University Press, 1976.

Tamra phap thewarup lae thewada nopphakhro. Bangkok: Fine Arts Department, 1992.

Taranatha. *Taranatha's History of Buddhism in India.* Translated by Lama Chimpa and Alaka Chittopadhyaya. Edited by Debiprasad Chattopadhyaya. Calcutta: K.P. Bagchi, 1980.

Teeuw, A. and David K. Wyatt. *Hikayat Patani / The Story of Patani.* 2 vols. The Hague: Martinus Nijhoff, 1970.

Tej Bunnag and Michael Smithies. *In Memoriam Phya Anuman Rajadhon: Contributions in Memory of the Late President of The Siam Society.* Bangkok: The Siam Society, 1970.

Le Temple d'Angkor Vat. Pt. 2, *La Galerie des bas-reliefs.* Vol. 2. Mémoires archéologiques publiés par l'École Française d'Extrême-Orient, vol. 2. Paris: G. van Oest, 1932.

Terwiel, Barend J. "Early Ayutthaya and Foreign Trade, Some Questions." In *Commerce et Navigation en Asie du Sud-Est (XIVe–XIXe siècle): Trade and Navigation in Southeast Asia (14th–19th centuries),* edited by Nguyên Thê Anh and Yoshiaki Ishizawa, 77–90. Tokyo: Sophia University and Montreal, Paris: L'Harmattan, 1999.

Terwiel, Barend J. *A History of Modern Thailand, 1767–1942.* The University of Queensland Press' Histories of Southeast Asia Series. St. Lucia, London, New York: University of Queensland Press, 1983.

Thida Saraya. *Prawattisat sukhothai: Phalang khon, amnat phi, barami phra.* Bangkok: Muang Boran, 2001.

Thongchai Winichakul. *Siam Mapped: A History of the Geo-Body of a Nation.* Honolulu: University of Hawaii Press, 1994.

Three Worlds According to King Ruang: A Thai Buddhist Cosmology. Translation with introduction and notes by Frank E. Reynolds and Mani B. Reynolds. Berkeley Buddhist Studies Series 4. Berkeley: Asian Humanities Press/Motilal Banarsidass, 1982.

Tobias, Stephen F. "Buddhism, Belonging, and Detachment: Some Paradoxes of Chinese Ethnicity in Thailand." *Journal of Asian Studies* 36 (1977): 303–326.

Traiphum chabap phasa khamen. Translated by Amphai Khamtho. Bangkok: Ho Samut haeng Chat, 1987.

Tri Amatayakul. *The Official Guide to the Ayutthaya and Bang Pa-in.* 2nd ed. Bangkok: Fine Arts Department, 1973.

Tri Amatayakul. "Sinlapa samai ayutthaya." In Manit Wanliphodom, et al. *Sinlapa samai uthong; sinlapa samai ayutthaya; sinlapa samai rattanakosin,* 43–67. Bangkok: Fine Arts Department, 1967.

Uang Chumthap. *Chittrakam faphanang changwat phra nakhon si ayutthaya.* Chittrakam thai prapheni, series 1, vol. 6. Bangkok: Fine Arts Department, 1995.

Vacissara, Thera. *The Chronicle of the Thupa and the Thupavamsa: Being a Translation and Edition of Vacissaratthera's Thupavamsa.* Edited by N.A. Jayawickrama. London: Luzac for Pali Text Society, 1971.

Vajiravudh, King of Siam. *Thiev muang phra ruang.* Bangkok: Fine Arts Department, 1983.

van Beek, Steve, and Luca Invernizzi Tettoni. *The Arts of Thailand.* London: Thames and Hudson, 1991.

van der Cruysse, Dirk. *Siam and the West, 1500–1700.* Translated by Michael Smithies. Chiang Mai: Silkworm Books, 2002. Originally published as *Louis XIV et le Siam* (Paris: Fayard, 1991).

van Vliet, Jeremias. "Description of the Kingdom of Siam." Translated by L.F. van Ravenswaay. *Journal of the Siam Society* 7, pt. 1 (1910): 1–108.

van Vliet, Jeremias. *Historiael Verhael der Sieckte ende Doot van Pra Interratsia 22en Coninck in Siam, ende den Regherenden Coninck Pra Ong Srij.* Edited by Seiichi Iwao. 2 vols. Tokyo: Toyo Bunko, 1956–1958.

van Vliet, Jeremias. "Historical Account of Siam in the Seventeenth Century." In *Selected Articles from the Siam Society Journal,* vol. 7. Bangkok, 1959, 31–90. Originally published in *Journal of the Siam Society* 30, pt. 2 (1938).

van Vliet, Jeremias. *A Short History of the Kings of Siam.* Translated by Leonard Andaya. Bangkok: The Siam Society, 1975.

Varunyupha Snidvongs, ed. *Essays in Thai History.* Singapore: Southeast Asian Studies Program, Institute of Southeast Asian Studies, 1991.

Velder, Christian. "Notes on the Saga of Rama in Thailand." *Journal of the Siam Society* 56, pt. 1 (January 1968): 33–46.

Vickery, Michael. "Cambodia and Its Neighbors in the Fifteenth Century." Asia Research Institute Working Paper No. 27, June 2004, www.nus.ari.edu.sg/pub/wps.htm.

Vickery, Michael. "The Composition and Transmission of the Ayudhya and Cambodian Chronicles." In *Perceptions of the Past in Southeast Asia,* edited by Anthony Reid and David Marr, 130–154. Singapore: Heinemann, 1979.

Vickery, Michael. "The Constitution of Ayutthaya: The Three Seals Code."

In *Thai Law, Buddhist Law: Essays on the Legal History of Thailand, Laos and Burma*, edited by Andrew Huxley, 133–210. Bangkok: White Orchid, 1996.

Vickery, Michael. "A Guide Through Some Recent Sukhothai Historiography." *Journal of the Siam Society* 66, pt. 2 (July 1978): 182–246.

Vickery, Michael. "The Khmer Inscriptions of Tennasserim: An Interpretation." *Journal of the Siam Society* 61, pt. 1 (January 1973): 51–70.

Vickery, Michael. "A New Tamnan about Ayudhya." *Journal of the Siam Society* 67, pt. 2 (July 1979): 123–186.

Vickery, Michael. "The Old City of 'Chaliang'–'Sri Satchanalai'–'Sawankhalok': A Problem in History and Historiography." *Journal of the Siam Society* 78, pt. 2 (1990): 15–29.

Vickery, Michael. "On Traibhumikatha." *Journal of the Siam Society* 79, pt. 2 (1991): 24–36.

Vickery, Michael. "Piltdown 3: Further Discussion of the Ram Khamhaeng Inscription." *Journal of the Siam Society* 83, pts. 1–2 (1995): 103–197.

Vickery, Michael. "Prolegomena to Methods for Using the Ayutthayan Laws as Historical Source Material." *Journal of the Siam Society* 72 (1984): 37–58.

Vickery, Michael. Review of *A Dictionary of the Mon Inscriptions From the Sixth to the Sixteenth Centuries, incorporating materials collected by the late C. O. Blagden* by H. L. Shorto. *Journal of the Siam Society* 61, pt. 2 (July 1973): 205–209.

Vickery, Michael. Review of *Prachum chotmaihet samai ayuthaya phak I*. *Journal of the Siam Society* 60, pt. 2 (July 1972): 318–328.

Vickery, Michael. Review of *Thai Titles and Ranks Including a Translation of Traditions of Royal Lineage in Siam by King Chulalongkorn* by Robert B. Jones. *Journal of the Siam Society* 62, pt. 1 (January 1974): 158–173.

Vickery, Michael. "The 2/k. 125 Fragment, A Lost Chronicle of Ayutthaya." *Journal of the Siam Society* 65, pt. 1 (January 1977): 1–80.

Vivadhanajaya, Prince, trans. *The Statement of Khunluang Hawat*. Selected Articles from the Siam Society Journal, vol. 6. Bangkok, 1959. Originally published in *Journal of the Siam Society* 28, pt. 2 (1935) and 29, pt. 2 (1937).

Voretzsch, E. A. "Über altbuddhistische Kunst in Siam." Parts 1 and 2. *Ostasiatische Zeitschrift* 5, no. 1 (April 1916): 1 26; 6, no. 1 (April 1917): 1–22.

Wade, Geoff. "The Ming shi-lu as a Source for Thai History – Fourteenth to Seventeenth Centuries." *Journal of Southeast Asian Studies* 31, no. 2 (September 2000): 249–294.

Wales, Horace Geoffrey Quaritch. *Siamese State Ceremonies*. London: Bernard Quaritch, 1931.

Wales, Horace Geoffrey Quaritch. *Supplementary Notes on Siamese State Ceremonies*. London: Bernard Quaritch, 1971.

Wannipha Na Songkhla, ed. *Chittrakam samai rattanakosin, ratchakan thi 1*. Bangkok: Fine Arts Department, 1994.

Wat chulamani. Kananurak pratimakam nai prathet thai 3/1. Bangkok: Fine Arts Department, 1992.

Wat samkhan krung rattanakosin. Sinlapa watthanatham thai, vol. 4. Bangkok: Fine Arts Department, 1982.

Wenk, Klaus. "Notes on the History of the Art of Mother-of-Pearl in Thailand with Particular Reference to the Doors on the Ubosot of Wat Phra Chetuphon." *Journal of the Siam Society* 88, pts. 1–2 (2000): 1–14.

Wenk, Klaus. *Perlmutterkunst in Thailand / The Art of Mother-of-Pearl in Thailand*. Zurich: Iñigo von Oppersdorff, 1980.

Wenk, Klaus. *The Restoration of Thailand under Rama I, 1782–1809*. Translated by Greeley Stahl. The Association for Asian Studies: Monographs and Papers, no. 24. Tucson: The University of Arizona Press, 1968.

Wenk, Klaus. *Thailändische Miniaturmalereien: Nach einer Handschrift der Indischen Kunstabteilung der Staatlichen Museen Berlin*. Verzeichnis der Orientalischen Handschriften in Deutschland, supp. vol. III. Wiesbaden: Franz Steiner, 1965.

Winai Pongsripian, ed. *Khamhaikan khun luang wat pradu songtham: Ekasan chak ho luang*. Bangkok: Prime Minister's Secretariat, 1991.

Wisansinlapakam, Luang. *Tamra wicha chang pradap muk / The Art of Mother-of-Pearl Inlay*. Bangkok: Samnakngan Khana Kammakan Watthanatham haeng Chat, 1981.

Wiwatthanakan phutthasathan thai / The Development of Thai Buddhist Temple Architecture. Bangkok: Fine Arts Department, 1990.

Wolters, O. W. *History, Culture, and Region in Southeast Asian Perspectives*. Rev. ed. Studies on Southeast Asia, no. 26. Ithaca, N.Y.: Cornell Southeast Asia Program Publications in cooperation with the Institute of Southeast Asian Studies, Singapore, 1999.

Woodward, Hiram W., Jr. *The Art and Architecture of Thailand: From Prehistoric Times through the Thirteenth Century*. Handbook of Oriental Studies, sect. 3, South-East Asia, vol. 14. Leiden and Boston: Brill, 2003.

Woodward, Hiram W., Jr. *Asian Art in the Walters Art Gallery: A Selection*. Baltimore: The Trustees of the Walters Art Gallery, 1991.

Woodward, Hiram W., Jr. "The Buddha's Radiance." *Journal of the Siam Society* 61, pt. 1 (January 1973): 187–191.

Woodward, Hiram W., Jr. "The Dating of Sukhothai and Sawankhalok Ceramics: Some Considerations." *Journal of the Siam Society* 66, pt. 1 (January 1978): 5–6.

Woodward, Hiram W., Jr. "The Emerald and Sihing Buddhas: Interpretations of Their Significance." In *Living a Life in Accord with Dhamma: Papers in Honor of Professor Jean Boisselier on His Eightieth Birthday*, edited by Natasha Eilenberg, M. C. Subhadradis Diskul, and Robert L. Brown, 502–513. Bangkok: Silpakorn University, 1997.

Woodward, Hiram W., Jr. "The Life of the Buddha in the Pala Monastic Environment." *Journal of the Walters Art Gallery* 48 (1990): 13–27.

Woodward, Hiram W., Jr. "Monastery, Palace, and City Plans: Ayutthaya and Bangkok." *Crossroads: An Interdisciplinary Journal of Southeast Asian Studies* 2, no. 2 (1985): 23–60.

Woodward, Hiram W., Jr. Review of *Hindu Gods of Peninsular Siam*. *Journal of the Siam Society* 61, pt. 2 (1973): 210–213.

Woodward, Hiram W., Jr., with contributions by Donna Strahan et al. *The Sacred Sculpture of Thailand: The Alexander B. Griswold Collection, the Walters Art Gallery*. Baltimore: Walters Art Gallery, 1997; distributed in the U.S. by the University of Washington Press.

Woodward, Hiram W., Jr. "Structures, Names, Interpretation." Forthcoming in a felicitation volume for Dr. Piriya Krairiksh.

Woodward, Hiram W., Jr. "Studies in the Art of Central Siam, 950 –1350 A.D." 3 vols. Ph.D. diss., Yale University, 1975.

Woodward, Hiram W., Jr. "The Thai Chedi and the Problem of Stupa Interpretation." *History of Religions* 32, no. 1 (August 1993): 71–91.

Woodward, Hiram W., Jr. "Thailand and Cambodia: The Thirteenth and Fourteenth Centuries." In *Ruam botkhwam thang wichakan: 72 phansa than achan satsatrachan momchao suphatthradit ditsakun / Studies and Reflections on Asian Art History and Archaeology: Essays in Honour of H. S. H. Professor Subhadradis Diskul*, 335–343. Bangkok: Silpakorn University, 1995.

Woven from the Soul, Spun from the Heart: Textile Arts of Safavid and Qajar Iran 16th–19th Centuries. Washington, D.C.: Textile Museum, 1988.

Wray, Elisabeth, Clare Rosenfield, and Dorothy Bailey. *Ten Lives of the Buddha: Siamese Temple Paintings and Jataka Tales*. New York: Weatherhill, 1972.

Wright, Michael. "Gilt Lacquer Cabinets of Siam." *Arts of Asia* 8, no. 3 (May–June 1978): 41–45.

Wright, Michael. "Metamorphosis: The Sacred Gable in Siamese and South Indian Architecture." *Journal of the Siam Society* 84, pt. 2 (1996): 17–38.

Wright, Michael. Review of *Tamra phap thewarup lae thewada nopphakhro*. *Journal of the Siam Society* 89, pts. 1–2 (2001): 123–129.

Wright, Michael. "Towards a History of Siamese Gilt-Lacquer Painting." *Journal of the Siam Society* 67, pt. 1 (January 1979): 17–45.

Wyatt, David K. "Ayutthaya, 1409–24: Internal Politics and International Relations." In *From Japan to Arabia: Ayutthaya's Maritime Relations with Asia*, edited by Kennon Breazeale, 80–88. Bangkok: Toyota Foundation and The Foundation for the Social Sciences and Humanities Textbook Project, 1999.

Wyatt, David K. "Chronicle Traditions in Thai Historiography." In *Southeast Asian History and Historiography: Essays Presented to D. G. E. Hall*, edited by C. D. Cowan and O. W. Wolters, 107–122. Ithaca and London: Cornell University Press, 1976.

Wyatt, David K. Introduction to *Chronicle of the Kingdom of Ayutthaya: The British Museum Version, Preserved in the British Library*. Bibliotheca Codicum Asiaticorum 14. Tokyo: The Centre for East Asian Cultural Studies for Unesco, The Toyo Bunko, 1999.

Wyatt, David K. "Relics, Oaths and Politics in Thirteenth-century Siam." *Journal of Southeast Asian Studies* 32, no. 1 (February 2001): 3–66.

Wyatt, David K. *Siam in Mind*. Chiang Mai: Silkworm, 2002.

Wyatt, David K. *Studies in Thai History*, 1994. Reprint, with index. Chiang Mai: Silkworm, 1996.

Wyatt, David K. *Thailand: A Short History*. New Haven and London: Yale University Press, 1982.

Zandvliet, Kees. *The Dutch Encounter with Asia, 1600–1950*. Amsterdam: Rijksmuseum and Zwolle: Waanders, 2002.

Zwalf, W., ed. *Buddhism: Art and Faith*. New York: Macmillan, 1985.

Index

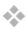

Photo Credits

(by figure number)

◆

CAPTIONS FOR UNNUMBERED PHOTOGRAPHS

Cover and p. 2: Detail of a scene from the tale of Prince Chanda, from a manuscript with paintings of the life of the Buddha and of the last ten previous lives, cat. no. 78.

P. 11: Detail of cat. no. 60.

P. 12: Detail of cat. no. 66.

P. 178: Detail of cat. no. 7.

Contributors

DHIRAVAT NA POMBEJRA
Lecturer, Department of History, Faculty of Arts
Chulalongkorn University, Bangkok

HENRY GINSBURG
Curator of Thai and Cambodian Collections
The British Library, London

TUSHARA BINDU GUDE
Assistant Curator of South Asian Art
Asian Art Museum of San Francisco

FORREST MCGILL
Chief Curator and Wattis Curator of South and Southeast Asian Art
Asian Art Museum of San Francisco

M. L. PATTARATORN CHIRAPRAVATI
Assistant Professor of Asian Art/Art History
California State University, Sacramento

SANTI LEKSUKHUM
Professor, Department of Art History, Faculty of Archaeology
Silpakorn University, Bangkok

NATASHA REICHLE
Assistant Curator of Southeast Asian Art
Asian Art Museum of San Francisco

HIRAM WOODWARD
Mr. and Mrs. Thomas Quincy Scott Curator of Asian Art
Walters Art Museum, Baltimore

This book is a catalogue of the exhibition *The Kingdom of Siam: The Art of Central Thailand, 1350–1800*, organized by Forrest McGill and M. L. Pattaratorn Chirapravati, under the general direction of Emily J. Sano, and presented at the Asian Art Museum in San Francisco, California, from February 18 through May 8, 2005, and at the Peabody Essex Museum in Salem, Massachusetts, from July 16 through October 16, 2005. The exhibition was made possible by generous support from the National Endowment for the Arts, the Bernard Osher Foundation, the Columbia Foundation, and the Flora Family Foundation with additional support from the Asian Art Museum's Jade Circle and from Lotus Fines Arts Logistics. The exhibition was also supported by an indemnity from the Federal Council on the Arts and the Humanities. Production of the book was directed by Thomas Christensen, working closely with Forrest McGill. Kaz Tsuruta traveled to Thailand to take most of the photographs. The editing was by Frances Bowles, Thomas Christensen, and Kristina Youso; Kristina Youso was also the principal proofreader. Daniela Yew provided general assistance, especially with the bibliography. Michael Brackney prepared the index. The book was designed and typeset, in Adobe Jenson with Industria display, by Thomas Christensen. It was printed on 150 gsm. Satimat Naturel paper and bound in an edition of approximately six thousand copies by Snoeck-Ducaju & Zoon in Ghent, Belgium.